Maps and
Air Photographs

Maps and Air Photographs

G. C. Dickinson

Lecturer in Geography, University of Leeds

Edward Arnold

FIRST PUBLISHED 1969 BY
EDWARD ARNOLD (PUBLISHERS) LTD.,
41 Maddox Street, London W1.
Reprinted 1970

SBN: 7131 5425 X

Printed in Great Britain by
Fletcher & Son Ltd, Norwich

Introduction

Not long ago it used to be said that the level of a country's industrial development could be assessed from the amount of sulphuric acid it consumed. In the same way one might argue today that the number of maps produced or sold in a particular country is a useful guide to its level of economic development or standard of living. Certainly as the complexity of our physical environment increases more maps are needed to record and plan it, and as educational and living standards rise so does the demand for maps to tell us more about other places, or help us to get there to spend increased leisure time. Map users are no longer confined to a narrow section of the community. Some use maps as an integral part of their daily life – students or practitioners of surveying, planning, geography or history for example – others consult a map only incidentally, to plan the weekend motoring perhaps, but it is to the whole broad spectrum of map users that this book is addressed and its essential purpose can be defined quite simply. It seeks to impart a greater knowledge and understanding of maps to all who have occasion to consult them and to show something of the range of potential uses, and pleasures which lie within them.

The general arrangement of the book follows fairly closely from this statement of its purpose, a different aspect of maps or map work being covered by each of Parts I, II and III. Part I – 'Thinking about maps' – describes the extent and variety of world mapping and the principal factors which underlie this situation. Historic maps as well as modern ones find a place here, partly because they have a fascination all their own, but especially because we shall understand modern maps that much better if we know how and why they evolved into their present form. Part II – 'Working with maps' – is equally straightforward. Its concern is with the practical side of maps and the day-to-day routine tasks which they are called upon to perform – measuring distance or area, defining position, recreating the configuration of the ground and so on. None of these processes is difficult or complicated but in most cases the map offers the easiest, sometimes the only, way of doing them, and the need to use maps in this way has acted as a powerful stimulus to map production for centuries.

For the non-specialist user of maps Parts I and II will come as no surprise: the layman may not know of all the features and processes described there but he can easily appreciate their significance. Part III – 'Looking at maps' – is rather less familiar. It seeks to show how the map, having the form of a surprisingly complete and detailed record of the landscape in an area, not only offers the quickest means of describing or appreciating that area, but also may stimulate innumerable lines of conjecture about its nature or evolution. Geographers and historians seeking to evaluate both present and past landscapes have habitually used maps in this way but even the ordinary map user looking at a map and

wondering why that hill should be higher than all the others, or that river should follow such a peculiar course, is embarking along a similar line of thought. For some people this aspect of maps has more fascination than all the others put together.

In rather different ways, therefore, both Parts II and III are concerned with the use of maps, and it is the requirements of these two sections which have defined the kind of maps studied in this book. Maps are, after all, very varied things and only the broadest of principles unites the map of Africa in a school atlas and the sketch we draw on the back of an envelope to guide a new friend to our home for the first time. Within this range some selection will have to be exercised, and in this book the overwhelming concern is with maps which can broadly be described as *topographical*, that is with maps which attempt to record the general features of the landscape in some degree of detail, say at scales of 1:1,000,000 (about 16 miles to an inch) and larger. Specialised maps recording only particular aspects of landscape such as roads, canals, mineral concessions and so on, are not specifically referred to in this book (though this does not mean that many of the features or processes described here do not have equal relevance for such maps), nor, generally speaking, are small scale atlas maps; maps devoted to showing statistical information have already been dealt with by the author in 'Statistical Mapping and the Presentation of Statistics', a companion volume to this work.

With these exceptions, however, an attempt is made to consider here a very wide range of topographical maps and in particular to describe and discuss world maps not just British maps. Used to living on a small island, well-mapped at a great variety of scales, the average Briton is quite unaware of the much more limited cartographic resources available elsewhere, or of the very different styles and contents which he might encounter on a foreign map. He may not be surprised to find no equivalent of his one-inch map for most of the Congo Basin but is quite unprepared for a similar deficiency in most of Australia, or a German map with two-kilometre grid squares, or a 1:50,000 map of Swaziland with no contours. Even more unusual, not only to British map users but to many European ones as well, is the idea that in many parts of the world someone seeking a 'representation of the terrain' might automatically turn to an air photograph rather than a map, for far more of the earth's surface is covered by air photographs than by good topographical maps. This is one reason why a short section on air photographs has been added as Part IV of this book. An even better reason is that, although good maps of an area may already exist, air photograph and map supplement one another so well that any-one connected with representation, delineation or interpretation of the terrain would certainly benefit by paying regard to both air photograph and map if this were possible.

Within Part IV a threefold approach similar to that used with maps has been adopted, though in this case, the section on 'Looking at Air Photographs', which deals with air photograph interpretation, must of necessity precede the other two. So far as maps are concerned the assumption has been made that readers of this book will already possess an elementary knowledge of map reading and be familiar with such devices as contours and conventional signs. This is no more than rudimentary knowledge, taught as such in secondary or more often today in primary schools, yet once it has been acquired the intriguing world of maps (and air photographs) lies wide open and a journey into it can provide both utility and pleasure. It is the author's hope that this book will serve as a satisfactory guide for that journey.

Contents

Part IV AIR PHOTOGRAPHS

Figures

Plates

Plate 1 appears between pages 42 and 43, plate 2 between pages 82 and 83, plates 3 and 4 between pages 242 and 243, and plates 5 and 6 between pages 258 and 259.

PART ONE
THINKING ABOUT MAPS

Chapter 1 The Developing World Scene – and Map Projections

The maps of our earth which we use today are better and more plentiful than at any time in history: mapping and re-mapping proceed apace, standards continually improve, and so well are we beginning to know our earth (topographically at least) that we confidently expect maps of any part of it to present much the same picture no matter what agency has produced them.

This has not always been so. Sixteenth-century maps of the world, for example, differ very significantly one from another, and still further back in time, when philosophy rather than fact had to fill enormous gaps in world knowledge, an even greater diversity is found, Christian and Arab, Chinese, Greek and Roman each envisaging the world in his own particular way. The concern of these first three chapters is to relate how this ancient diversity was transformed into modern uniformity and to emphasise some of the more important obstacles which had to be overcome before this transformation could occur.

Cartography in the Classical World

Although evidence of very early maps has been found in several parts of the world the western or European School of map making undoubtedly had its origins in the classical world of the ancient Greeks. As early as the fourth century B.C. Greek philosophers and scholars, working through logical analysis of known facts, were beginning to suspect the spherical nature of the earth; by the time another century had elapsed Eratosthenes of Cyrene, head of the great Library of Alexandria, was able to make the first practical attempt to measure its circumference. Like many another earth-measurer of later years Eratosthenes' theoretical knowledge was much sounder than the crude instruments with which he had to apply it, but even so his result – a circumference of 250,000 stadia (about 28,000 miles) – was surprisingly good, and as later centuries were to show, an established spherical earth measured to within 14% of its true size was no mean achievement two hundred years before Christ.

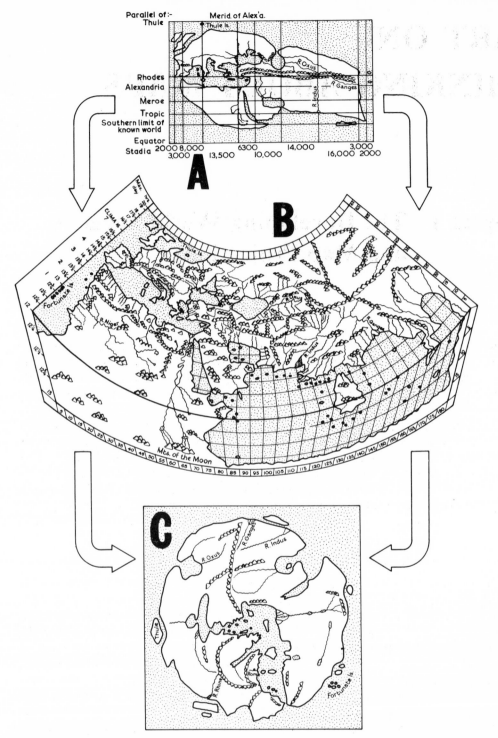

Fig. 1: Classical world cartography – rise and decline. **A:** A reconstruction of the world map of Eratosthenes (*270–195* B.C.). **B:** Ptolemy's world map (*c.* A.D. *150*) from a mediæval copy published in Rome in *1490*. (*Note:* much detail – rivers, mountains, names, meridians and parallels except in the Indian Ocean – has been omitted to preserve clarity.) **C:** A reconstruction of the Roman *Orbis Terrarum* (after E. Raisz, *Principles of Cartography*, by permission of the McGraw-Hill Book Company). Although the maps in both **A** and **B** are related to a spherical earth, that in **C** portrays the earth as a 'flat disc'.

But this was not Eratosthenes' only contribution to cartography. A spherical earth needs spherical co-ordinates to define position upon it and it is known that he also constructed a map of the classical world based upon what today we should describe as seven meridians and seven parallels, including the equator and the northern tropic. The map itself has not survived but sufficiently detailed descriptions of it permit the reconstruction shown in Fig. 1A. When one considers its antiquity the known world around the Mediterranean appears surprisingly well-shown and, as will become clear shortly, even as a world map the result can favourably be compared with many drawn a thousand years and more later.

Important though Eratosthenes' contributions to cartography may have been, they were completely overshadowed three hundred years later by the *magnum opus* of yet another Alexandrian Greek, Claudius Ptolemy (A.D. 90–168). Published under the composite title of *Geographia* this remarkable eight-volume work was essentially a description of the known world, but it included among its contents a discussion of the theoretical and practical considerations involved in making a map of the world, estimates of the latitude and longitude of some eight thousand places, and instructions for drawing twenty-six regional maps and two map projections. Unfortunately, no original of any of Ptolemy's maps has survived, nor in fact is it certain whether Ptolemy himself ever drew them, but we know from mediæval copies of them that somebody did, and in all probability Ptolemy's one world and twenty-six regional maps formed the first atlas. It was Ptolemy too who gave us the names latitude and longitude, supplementing the former by *climata* (latitudinal divisions based on the length of the longest day) and measuring the latter from the legendary Fortunate Islands, the westernmost known land, usually thought today to be the Canary group.

For reasons which will be explained shortly Ptolemy's maps were enormously important in cartographic development. In the late fifteenth century, one thousand three hundred years after their original publication, they re-emerged, much copied, as one of the twin foundations of modern cartography, and it is from one of these mediæval copies that the essential features of Ptolemy's world map shown in Fig. 1B have been taken. Coastlines, rivers and mountains, at least around the Mediterranean and its nearer neighbours, are well represented and with north at the top, the tropic almost correctly placed at 23° 51′ N., and converging meridians and curved parallels imitating their global counterparts, Ptolemy's world map has a distinctly modern look. The errors of the outer area, such as the enclosed Indian Ocean and an enlarged Ceylon, are understandable enough but in one less obvious respect there is a serious mistake – Ptolemy's earth is about a quarter too small. By using Posidonius' estimate of the earth's circumference – 18,000 miles, or 1° equals about 500 stadia instead of Eratosthenes' (better) 1° equals about 700 stadia – Ptolemy translated his estimate of the combined length of Europe and Asia as 180° instead of the actual 130°; it has been suggested many times that one of the factors encouraging Columbus and the westward-sailing explorers may have been Ptolemy's accidental 'narrowing' of the sea-gap between the Orient and western Europe.

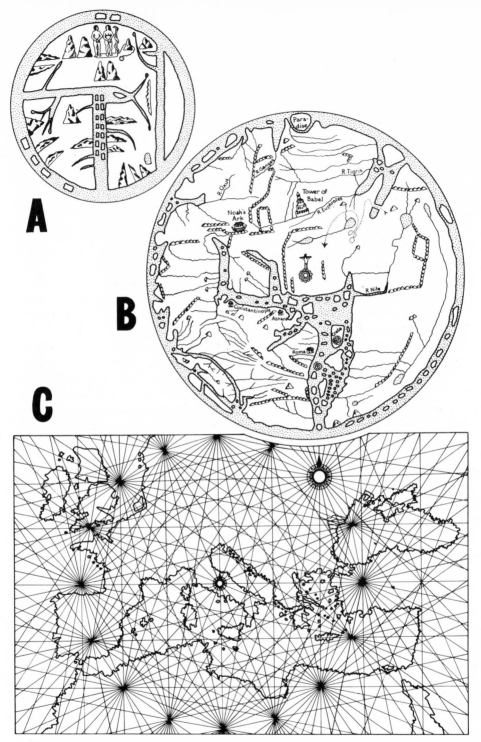

Labels within image B:
Para-dise, R Tigris, R Ganges, R Oxus, Tower of Babel, R Euphrates, Noah's Ark, R Nile, Constantinople, Athens, Rome

Fig. 2: Early mediæval cartography – nadir and re-emergence. **A:** A twelfth-century (?) world map from a manuscript in the library of Turin. **B:** The thirteenth-century world map in Hereford Cathedral. **C:** An anonymous Portolan chart of the fifteenth century in the university library, Uppsala. In all three maps much detail and many names are omitted, though in **C** the only landward detail on the original was the delta of the Danube.

Cartography in the Dark Ages and Early Mediæval Period

Unfortunately maps and ideas as sophisticated as Ptolemy's were not in vogue for long. Even in Roman times the spherical earth concept appears to have declined in favour of the idea of a flat disc (Fig. 1C) and with the dissolution of the Roman Empire the great bulk of classical learning, cartographic knowledge along with the rest, became lost to the western world.

The fact that cartography was now deprived of its former logical foundations did not, of course, prevent people wanting to know and show what the earth was like. Instead of classical logic, however, it was the teaching and philosophy of the Christian Church which were increasingly employed as the foundations of world mapping and maps now became as concerned to illustrate the divine scheme of creation described in the Bible as they were to portray geographical reality. Very often the whole range of biblical allusion is there. Pride of place is frequently given to Paradise and the Garden of Eden, putting east (since they were thought to lie in that direction) not north, at the top of the map; Noah's Ark, stuck on Mount Ararat, is usually there as well, and, for the lesser known 'outer areas', mythology and travellers' tales supplied plenty of horrifying footnotes or drawings of monsters.

The common form of these maps is almost always that of a flat disc in a surrounding ocean, a general concept inherited very probably from the Roman *Orbis Terrarum* style of map, but there is considerable diversity in style and detail. Some are so simplified as to be quite impracticable and seem merely to illustrate philosophical concepts – a Christian world centred on Jerusalem[1] or the world divided among the three sons of Noah, as in the common 'T-in-O' type map (Fig. 2A). Others, such as Fig. 2B, were more elaborate and had at least some practical pretensions as guides to travellers, incorporating within them detail from contemporary and classical itineraries which gave lists of towns and perhaps distances along principal routes. In the absence of any global framework details from these itineraries may well have given to the maps such crude local patterns and configurations as they possess; and the land-oriented approach may in part explain the noticeable weakness in the delineation of coastal features. Whatever their origins, maps of this kind, simplified or detailed, represent an amazing decline from Ptolemaic cartography, but it is just possible that we may be judging early mediæval map-makers rather too harshly. Among the maps which have survived from this period there are a few which represent the earth as a sphere or hemisphere, for example one by Joannes de Sacrobusco, significantly a teacher of astronomy and mathematics at the University of Paris. Perhaps there were many more examples of this type of map, which we do not know about; yet all the evidence points the other way, and it is not until the fourteenth and early fifteenth centuries that there are widespread signs of any cartographic revival.

The Renaissance and the Revival of Cartography

Along with many other branches of learning, cartography made tremendous progress during the period of the Renaissance, but it received its inspiration from two distinct and rather different sources. One was the rediscovery of the works of Ptolemy himself

[1] e.g. *Ezekiel* V, 5 'This is Jerusalem: I have set her in the midst of the nations, and countries are round about her.'

(his *Geographia* was translated into Latin about 1405), but the other and rather earlier
one arose simply from the needs of practical men. Maps based on Christian philosophy
might do very well in monastic libraries but for mariners on the high seas something
much more realistic was needed; fortunately for fourteenth-century sailors they found it
in the remarkable group of maps known as *Portolan Charts*, or simply *Portolanos*, an
example of which is shown in Fig. 2C.

Here indeed is work belonging to a very different school of cartography from that
which produced the maps in Figs. 2A and 2B, though many of the circumstances surround-
ing the origins of this school, and its methods, remain obscure. The oldest surviving
Portolanos date from the early fourteenth century and are largely of Italian origin, but
certain evidence suggests that these may have been copies from much earlier ones, and
all obviously owed a great deal to the magnetic compass which had come into increasing
use after about 1100.[2] So far as the early examples are concerned, many were probably
based on little more than the surprisingly detailed and accurate knowledge of sailing
distances and directions accumulated by Genoese and other sea-captains, but in the later
ones compass bearings or even compass surveys may perhaps have been used to define
the coastal detail, which is remarkably complete, if often slightly exaggerated.[3] In contrast
land detail is usually insignificant, even entirely absent, emphasising the marine nature
of the chart.

Oddly enough, despite their remarkable accuracy, the charts do not appear concerned
with either latitude, longitude or a map projection, though since at first most of them
were confined to the area of the Mediterranean and its surroundings, their extent was
not sufficient for this to cause real difficulties in plotting or accuracy. Instead, replacing
the map projection as it were, they are almost invariably criss-crossed by intersecting
networks of *rhumb* lines (lines marking the direction of the compass points) springing from
several elaborately decorated compass roses (Fig. 2C). No entirely satisfactory explanation
of these lines has yet been offered. They could have served no strictly accurate naviga-
tional purpose, for rhumb lines were not fully integrated into map design until Mercator
produced his famous projection in 1569 (see page 11), but they may have served as
rough guides for course setting, bearing in mind the relatively short distances usually
involved.

The main contribution of the Portolanos to cartographic revival was the reintroduction
of the simple idea of an accurate map to suit practical needs, and little more. On the other
hand the rediscovery of Ptolemy by the fifteenth-century western world[4] affected
cartography in both its theoretical and its practical aspects. The immediate result,
assisted by the contemporary development of printing, was the rapid production all over
western Europe of world and regional maps based on Ptolemy's descriptions, sometimes
but not always corrected and amplified by later knowledge. In some instances Ptolemy's
errors were directly reproduced even where contemporary sources might have corrected

[2] It is impossible to fix a date for the 'invention' of the magnetised needle; the properties of
magnetite or loadstone were known in the classical world but at what date these became in-
corporated into a navigational instrument is not known.
[3] The exaggeration arose fairly obviously from the immense importance of such detail to
sailors and navigators.
[4] The Arabs had 'discovered' him several centuries before this.

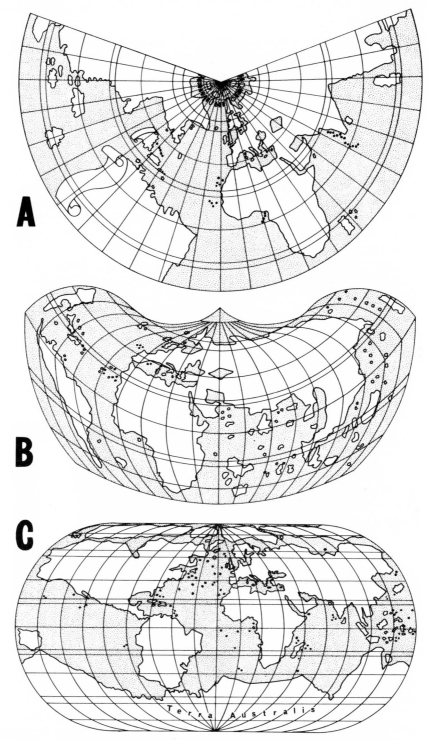

Fig. 3: Outlines of three sixteenth-century world maps. **A:** By Ruysch in 1508. **B:** By Apianus in 1520. **C:** By Ortelius in 1570. The scrolls in **A** contained notes such as 'Here came King Ferdinand of Spain's sailors', and served usefully to mask the unknown extent of North and South America.

them, for example his Mediterranean, 62° in length and almost 20° too long, was widely accepted in favour of the more reasonable 'rule-of-thumb' shape on the Portolan Charts; by 1554 Mercator had reduced this to 53° but the correct length did not emerge for another 150 years after that.

Erroneous or not Ptolemy's maps added enormously to men's knowledge of what the earth was like, conferring great benefits on all who had to use and consult maps. For men who had to *make* maps, however, they did even more; they stimulated interest in two features which are the very basis of modern mapping – the idea of the spherical earth and the need for map projections to represent it on paper. Once started map projections developed surprisingly quickly. In a very short time indeed Renaissance mathematicians had progressed well beyond Ptolemy's limited examples and one of the most striking features of world maps during the next two centuries is the great variety of projections on which they were based. This tendency to experiment with map projections was probably influenced a good deal by contemporary events. The increased use of globes (the earliest known example was made in 1492) would emphasise the need for realistic representation of shape on maps, and as the Great Age of Discovery continually enlarged the area which had to be shown on world maps, it increased the difficulty of doing so satisfactorily, and yet permitted a wider range of solutions.

Examples of world maps of this period are shown in Fig. 3, where two common characteristics may be observed. One is the vagueness and inaccuracies in the position of the lesser known parts of the world such as the Americas and the great southern 'Terra Australis', the other the representation of global position by reference to a projection representing the meridians and parallels of the globe. All too often the sophisticated nature of the projection itself contrasts starkly with the crude errors contained in the positions which are plotted on it; but once a projection giving a reasonable representation of latitude and longitude was achieved these were defects which needed only further exploration and more accurate positional determination to correct them. In effect two or three centuries were to elapse before many major errors were removed from world maps, and blanks filled. Exploration was slow and determination of longitude in particular proved a major problem, only tenuously solved before the experiments of the French Academy in the late seventeenth century,[5] but in theory and in spirit these fifteenth-century maps are the true ancestors of modern world maps. Their makers were working with a sphere, a projection, and latitude and longitude just as modern cartographers do, even if their global knowledge, their technique and hence their results were a good deal less accurate than our own.

If in Fig. 3 we disregard the variation resulting from imperfect knowledge of shape and position the maps differ only in one significant feature – the projection used. Superficially this introduces differences of shape almost as marked as those among the preceding 'ecclesiastical' maps but there is a major difference in spirit; one is the dissimilarity caused by reasoned and conscious mathematical choice, the other the result of philosophical and conceptual inadequacy. This conscious choice remains to the modern cartographer as much as to his predecessors, though the map user may overlook it in

[5] The method used involved the observation of the moons of Jupiter and indicates how rapidly both astronomy and instrument-making had advanced; a more practical means resulted from Harrison's invention of a really accurate clock (chronometer) in 1735.

favour of more eye-catching choices such as style and content. Map projections do not pre-occupy casual map users, nor normally do they form a particularly favourite field of study for more serious devotees, yet as we have seen, accurate map making could not proceed without them and no one who seriously pretends to any knowledge of maps can ignore them. If he feels so inclined there is no real reason why the general reader, interested simply in the history of maps, should not skip the next few pages, though equally well there is no real reason why he should. Much of the unpopularity of map projections in the past has come from over-detailed studies too generously larded with mathematics, most of which is quite unnecessary. Most of us do not want to *draw* map projections, nor analyse their errors in detail; we want only to know in general terms what they are like, what they are doing and how well they do it. That is why there is no mathematics in the next section, only an attempt to convey to the ordinary map user a broad indication of what map projections – 'transverse Mercator', 'Bonne's', or any other that he may find referred to in the margin of his map – are all about.

Map projections

The Basic Properties of Distance, Direction, Area and Shape

Like many other things map projections are badly named. The great majority of those in use today have little to do with the true process of 'projection'[6] but instead are strictly mathematical devices, compromises by which the global network of meridians and parallels can be rendered two-dimensionally so that global position may be defined on a sheet of paper.

The element of compromise is fundamental. A spherical surface cannot be reproduced on flat paper, nor correspondingly can all the properties of position and relative position which exist on that surface. Some of these properties, and obvious choices are true representation of distance (i.e. true scale), direction (i.e. true bearing), area and shape, can be shown correctly over the whole of a map of the globe but all of them cannot be shown correctly together and even maintaining one of them correctly over the whole map may cause intolerable distortions in the others.

Distances, for example, can be shown correctly from one, or two, but no more, chosen points on certain special projections[7] but even then distances measured between any other points will be incorrect, and grossly so when away from the centre of the projection. An identical situation exists with respect to bearings.

Correct representation of shape on a map is impossible from the start; shapes on the earth's surface are 'spherical', i.e. they are three-dimensional in form, and they cannot be imitated two-dimensionally. Nevertheless it is obvious that some projections distort shapes and outlines very much whereas others give a fairly close representation of the

[6] i.e. Allowing a source of light to 'project', or cast shadows from, the meridians and parallels of a hollow globe onto a sheet of paper. Such a device is often called a *perspective projection*.
[7] The zenithal equidistant and the two-point equidistant projections respectively.

global form, and cartographers therefore distinguish a class of projection known as orthomorphic projections, which present minimal distortion of shape over small areas. In effect this is obtained by ensuring that meridians and parallels always intersect at right-angles, as they do on the globe, and that at any one point scale in all directions is equal; but it must be emphasised that over large areas scale may vary considerably and distortion will occur: a circle drawn on the globe will not normally appear as a circle on most orthomorphic projections.

Of the four basic properties, correct representation of area over the whole map is the most easily achieved, since equivalent areas can be produced by an infinite variation of dimensions within the same shape, or by employing different shapes, for example triangles, parallelograms and so on. Many equal-area projections[8] maintain correct areas by balancing enlarged scale in one direction with reduced scale in another, often in a very exaggerated way in the outer areas of the projection.

Enough has been said here about the relationship between these important properties and projections to make it clear that the vast majority of topographical maps need a projection not with one universally correct property (and the inevitable corollary of other incorrect ones) but with a useful balance of properties, giving reasonable representation of all four factors and with errors kept to an acceptable minimum. Occasionally it may be necessary to have certain properties accurately shown, for example correct area on maps which are to show world distributions quantitatively, or certain aspects of bearing on navigational charts (see p. 14) but these are exceptional demands and most projections used today, even when they possess specific properties, such as equivalence of area or orthomorphism, are usually employed more for their reasonable balance of properties than for the particular property itself.

One further point must be made here. As we shall see, a satisfactory balance of properties is not difficult to achieve over relatively small areas; it is when the area covered by the projection increases that difficulties arise, and most projections make a poor showing at their extremities when used to represent the whole globe. Fortunately, with topographical maps most projections do not have to cover large areas and in practice the ones which are used are likely to be selected because of the small errors contained in their 'best areas'; the gross errors which would accumulate if they had to cover a very large area are of less importance in this context.

In the examples which follow, the illustrations used often do cover the whole globe, or a large part of it, but this has been done mainly to emphasise the theoretical basis of the projection or the trends of the errors found within it. Unfortunately no easy way exists of summarising these errors. A crude assessment of what is happening to shape and area can however be deduced by examination of either the *graticule* (i.e. the mesh of lines representing the meridians and parallels) or the shape of the Americas, which has been added for comparative purposes; scale errors are indicated directly on the drawings.

[8] Equal area projections are sometimes termed *'equivalent'*, just as orthomorphic projections are sometimes called *'conformal'*.

Projections which Grew from Straight Lines

The plate carrée.[9] Two thousand years ago Eratosthenes needed a map projection; we could do worse than start where he did with one of the simplest solutions to the problem – it goes like this: draw a straight equator, true to scale and crossed at the correct spacing by perpendiculars representing the meridians. Make the meridians their correct length, add the parallels as straight lines the same length as the equator and truly spaced along each meridian and we have a simple map projection, the *plate carrée* (Fig. 4B). It is not bad for a beginning. The most obvious defect is that the parallels, which should decrease in length towards the pole, all appear as long as the equator, giving the scale errors which are listed in the table below. However, scale is correct along the meridians and though exaggeration along the parallels is intolerable in high latitudes, within 10° of the equator it is only 1·54% or less and within 5° only 0·38% or less – almost negligible. Although on this projection, therefore, neither shape nor area can be correct, distortion within a narrow central band is very small and the projection, or rather a transverse form of it called the Cassini projection (see p. 25), has been used for topographical maps covering limited areas, for example the early editions of the Ordnance Survey maps of England and Wales.

Percentage Scale Errors Measured along the Parallels in Certain Map Projections*

PARALLEL	PLATE CARRÉE AND MERCATOR'S	*Polar* VERSIONS OF ZENITHAL PROJECTIONS		
		STEREOGRAPHIC	EQUIDISTANT	EQUAL AREA
0°	0·00	100·0	57·1	41·4
10°	1·5	70·4	41·7	30·4
20°	6·4	49·0	30·0	22·2
30°	15·5	33·3	20·9	15·3
40°	30·5	21·7	13·9	10·2
50°	55·6	13·2	8·6	6·3
60°	100·00	7·2	4·7	3·5
70°	192·4	3·1	2·1	1·5
80°	475·9	0·8	0·5	0·4
90°	∞	0·0	0·0	0·0
		All errors are positive		

**The values for scale errors along the parallels in zenithal projections are taken from those given in the Oxford Atlas. Oxford University Press.*

Mercator's projection.[10] Further projections are easily developed from the *plate carrée* by altering the spacing of either the meridians or the parallels. In 1569, when Mercator

[9] An unfortunate feature of map projections is that many of them have two or more names The alternative titles will be given in footnotes, for example the *plate carrée* is also known as the *simple cylindrical* and the *cylindrical equidistant* projection. The French title, the 'squared map', seems more evocative.

[10] Alternatively the *cylindrical orthomorphic* projection.

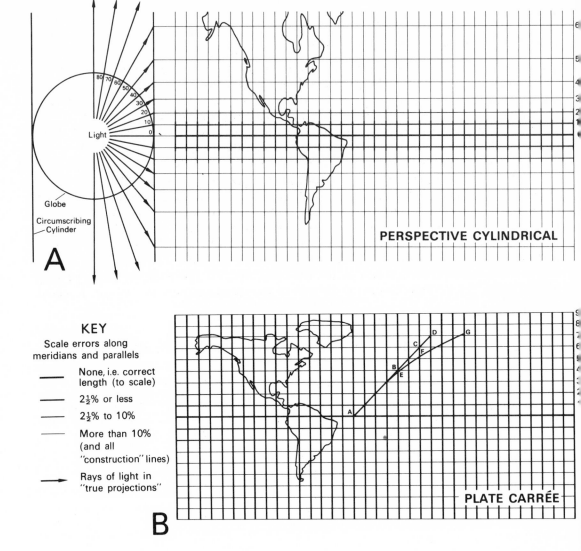

KEY

Scale errors along
meridians and parallels

— None, i.e. correct
length (to scale)

— 2½% or less

— 2½% to 10%

— More than 10%
(and all
"construction" lines)

→ Rays of light in
"true projections"

PERSPECTIVE CYLINDRICAL

PLATE CARRÉE

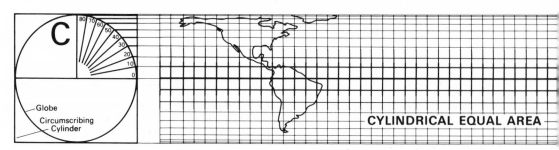

CYLINDRICAL EQUAL AREA

Fig. 4: Projections which grew from straight lines. **C, D, E,** and **F** can all be regarded as modifications of the basic network of either the *plate carrée* (**B**) or the perspective cylindrical projection (**A**). The scale errors indicated have been generalised to some extent.

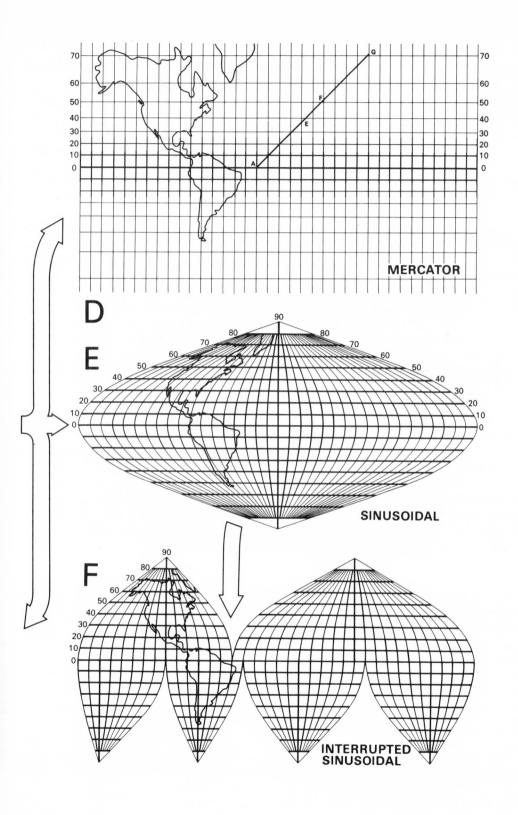

MERCATOR

D

E

SINUSOIDAL

F

INTERRUPTED
SINUSOIDAL

sat down to devise a projection which would be of real use for navigation he found that he had to choose the latter; it is not too difficult to see why.

The basic principle of navigation is simple: one sets and follows a given compass course, i.e. one follows a line of constant bearing, or *rhumb* line as it is called. On the globe this is a *curved* line crossing all the meridians at the same angle (angle *r* in Fig. 5) but for convenience of plotting navigators needed a projection on which it would appear as a *straight* line doing the same thing. Such a projection, therefore must have straight, parallel lines for the meridians, just as the *plate carrée* does, but for this specialised purpose the *plate carrée* is no use. Straight lines drawn on it look like representations of rhumb lines (i.e. they cross the meridians at a constant angle) but in practice they are not. A navigator who set out from A in Fig. 4B on a constant bearing of 45° would pass through E, F and G on the globe not B, C and D as the map seems to indicate. Mercator's problem, therefore, was to modify the *plate carrée* until E, F and G all lay on the straight line leaving A at 45°. The reason why, on the *plate carrée*, the line AD does not pass through the right places is fairly obvious. Shapes, and hence relative positions are all wrong; they have been exaggerated (or stretched) in one direction – along the parallels – but not in the other along the meridians, so that naturally the line AD misses its target. Mercator saw that if E, F and G were ever to be brought into the line AD without disturbing the straight meridians this could only be done by stretching the map north–south to balance the east–west stretch along the parallels, i.e. making exaggeration of scale along the meridian equal to that along the parallel at any point (see Fig. 4D). This was easier said than done. Since all the parallels are to be the same length the scale along each one becomes exaggerated, and increasingly so as one moves north or south from the equator. Along Mercator's meridians, therefore, scale must be *continually changing* to match this, so that when Mercator wanted to know how far from the equator his parallels would have to be placed he found himself faced with the problem of finding the sum of a series of constantly changing quantities. It is not generally known that Mercator was unable to do this exactly; not until the calculus was invented in the seventeenth century was this finally possible, but Mercator could and did find a very close approximation to the answer.

One apparent paradox must now be explained. Mercator's projection does not show bearings correctly. Mercator never said 'my map will show you the correct bearing of B from A' but rather 'my map will show you a simple way of getting from A to B. On it join A and B by a straight line; measure the bearing of this line against any meridian; set out from A on this bearing, keep to it and you will get to B.' This is not the shortest way from A to B however. Because we have drawn a straight line on Mercator's projection it must be a rhumb line as well, and this is a curved line on the globe. Now the shortest way from A to B is a straight line or *great circle*[11] course on the globe, something very different from the rhumb line, as Fig. 5 shows. The bearing, or more correctly *azimuth*, of B from A is its initial direction by the shortest route,[12] the angle Z in Fig. 5 not the

[11] A *great circle* is any circle on the globe whose *centre is the centre of the globe*. The meridians and the equator (but not the other parallels) are examples of great circles.

[12] The terms bearing (see also p. 124) and azimuth are rather confusing and not always used correctly. The azimuth is the *initial bearing of the shortest route* to B from A. As Fig. 5 shows quite clearly anyone who set out to follow this route would find his actual *bearing*, i.e. direction relative to north, continually changing. Observe angle *g* on Fig. 5.

bearing of the rhumb line, so that Mercator's projection does not show correctly the bearing of one place from another, only the correct bearing of the rhumb line course between them.

Navigators who want the best of both worlds – short great circle courses and simple easily-sailed rhumb lines can get this by finding the great circle route on another projection, the *gnomonic* (see p. 18), plotting this on a Mercator chart, where it becomes a curved line, converting this arc to a series of chords – straight lines and therefore rhumb lines – and sailing along these; not exactly the shortest way but a very close approximation to it.

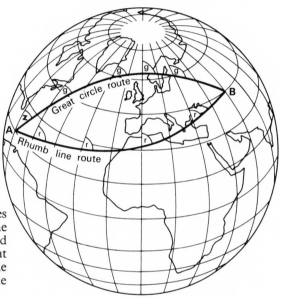

Fig. 5: Rhumb line and great circle routes between two points on the globe. Note the constant bearing r of the rhumb line route and the constantly changing bearing of the great circle route. On the globe the great circle route is a straight line, and Z is therefore the azimuth of B from A.

One not unexpected by-product of Mercator's projection is that it fulfils the conditions for orthomorphism (see above p. 10) and shapes over very small areas are therefore shown correctly. On the other hand, as the table on p. 11 shows, scale, and hence area too, is grossly exaggerated in high latitudes, and the poles cannot be shown[13]: it is common knowledge that Mercator's projection makes Greenland look as large as South America though it is, in fact, only about one tenth of the area of the latter.

Surprisingly Mercator's projection has been widely used not only for navigation charts but for general one-sheet world maps[14] and also, either directly or in its transverse

[13] Since the pole (a *point*) has been infinitely exaggerated into a *line* this must be balanced by infinite exaggeration along the meridians and the poles are therefore situated at infinity.

[14] It is not at all clear why Mercator's projection should have been so widely chosen for this purpose. Several other projections would have served as well, or better.

form (see p. 25), as the projection for many topographical map series. Scale errors are no larger than on the *plate carrée* and the orthomorphic property means that azimuths, though not correct, are less distorted, errors being almost negligible over observable distances. This gives the transverse Mercator projection an advantage over the transverse *plate carrée* and in recent years it has tended to supplant the latter as a basis for topographical maps.

The cylindrical equal-area projection. The parallels of the *plate carrée* can also be respaced to give an equal-area projection as Fig. 4C shows.[15] In effect equality of area is obtained only through gross distortion of scale in high latitudes and the projection is little used because better solutions are available.

The carte parallelogrammatique.[16] Another way of balancing out some of the worst errors of the *plate carrée* would be to shrink it east-west to make another parallel, not the equator, its correct length. This is the *carte parallelogrammatique*. It can produce a rather better spread of errors in low latitudes than the *plate carrée* but since, on the globe, each 10° parallel (beyond 30°) is at least 10% longer than the preceding one, any projection which makes all parallels equal in length must introduce considerable errors.

The sinusoidal and Mollweide's[17] projections. In the previous four examples exaggeration of scale along the parallels has been a common fault. Why not then redraw the *plate carrée* with all parallels shrunk to their correct length and the meridians spaced properly along them? The result, shown in Fig. 4E, is the sinusoidal projection. It is not at all a bad projection and gives a central area of minimum errors, rather than a band as in the *plate carrée*, but one notices that it is now the meridians (except the central one) which show exaggeration of scale and they become awkwardly skewed to the parallels towards the periphery. Oddly enough it is also an equal-area projection,[18] showing the world much better than the cylindrical equal-area but less satisfactorily than the commoner *Mollweide's* projection (Fig. 6) which is simply a mathematician's solution to the request 'Draw me an equal area projection of the world with an elliptical frame and straight lines for the parallels.' It is more pleasingly shaped in high latitudes than the sinusoidal, a fact which led J. P. Goode to produce the hybrid *homolosine* projection – simply a sinusoidal projection between the 40° parallels and a Mollweide's beyond, retaining the best areas of both components.

The worst defect of the sinusoidal and Mollweide's projections is the skewing of the meridians which results from gathering them together at the poles. If the map can be

[15] The construction is easy since the curved surface area of a zone of a sphere (i.e. the portion between two parallels) is equal to the curved surface area of a slice of similar height cut out of the circumscribing cylinder (see Fig. 4C).

[16] Alternatively the *equirectangular* projection.

[17] Alternatively the *Sanson-Flamsteed* and *homolographic* projections respectively.

[18] The proof is based on a theorem showing that parallelograms (the shapes on the map are very nearly parallelograms) with similar bases drawn between the same parallel lines are equal in area, no matter what shape they are.

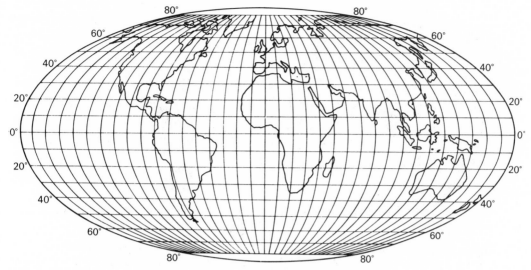

Fig. 6: Mollweide's projection.

broken in some areas that do not matter – the oceans if map is needed mainly for conti-
nental areas, or vice versa – and the meridians gathered together at several 'central'
meridians the good qualities of the 'central' areas are more widely spread. Fig. 4F shows
such an *interrupted* sinusoidal projection. 'Interruption' of a projection is a most useful
idea. Instead of having one extensive projection we use several smaller versions of the
same thing removing the intolerable errors of the 'big' example by restricting the coverage
of each component to a continent, country, or even a single map sheet (see p. 25).
'Interruption' is not, of course, without its drawbacks too, for sections of an interrupted
projection can never be pieced together again. Fig. 4F can be 'remade' into Fig. 4E only
by redrawing, not by sticking together along the breaks, and it is impossible accurately
to make assemblages of sheets from different sections of an interrupted projection.[19]

The projections in Fig. 4 may also be thought of in another way as derivatives of a
perspective cylindrical projection, formed by projecting a globe, from its centre, onto a
circumscribing cylinder. The idea, and its results are shown in Fig. 4A. Although the
projection is of little practical value, for its obvious errors have no compensating ad-
vantages, its equator and meridians have a useful arrangement and the parallels invite
modification of the kind which we have already explored in Figs. 4B–F.[20]

Projections Originating on a Flat Surface

Projecting the globe onto a cylinder did not get us very far. Let us try instead projecting
it onto a flat sheet of paper touching the globe, at the north pole to begin with, and further-

[19] In practice assemblages often can be made satisfactorily by stretching the paper to remove
small discrepancies.
[20] Other projections with differently spaced parallels exist in the cylindrical group, for
example, Gall's stereographic, but they are not of sufficient importance to describe here.

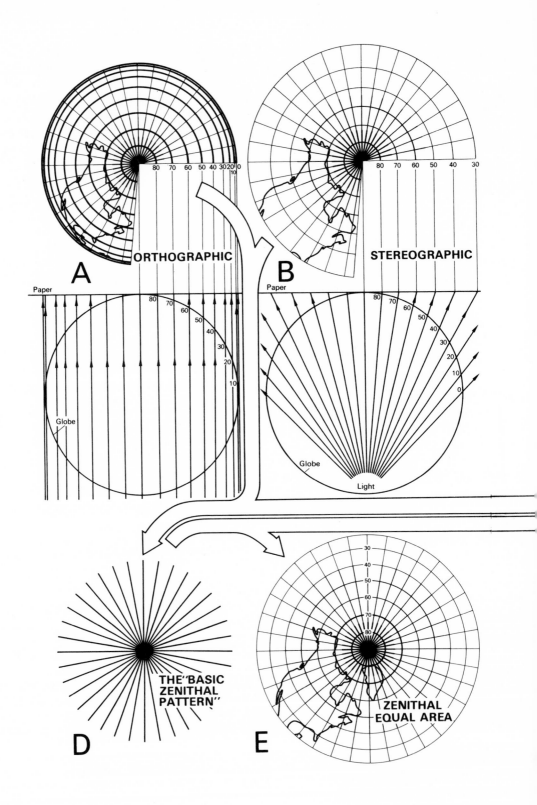

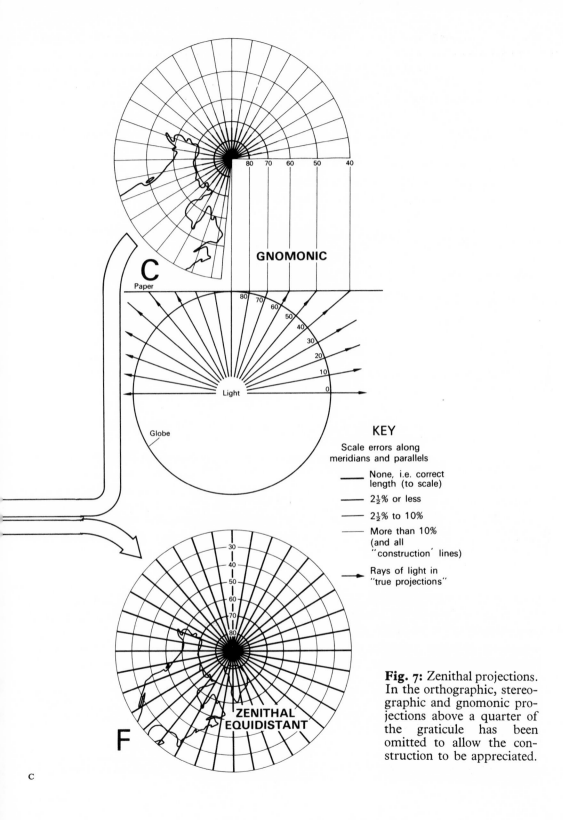

C

80 70 60 50 40

GNOMONIC

Paper

80 70 60 50 40 30 20 10 0

Light

Globe

KEY

Scale errors along
meridians and parallels

——— None, i.e. correct
length (to scale)

——— 2½% or less

——— 2½% to 10%

——— More than 10%
(and all
"construction" lines)

——→ Rays of light in
"true projections"

30 40 50 60 70 80

**ZENITHAL
EQUIDISTANT**

F

Fig. 7: Zenithal projections.
In the orthographic, stereo-
graphic and gnomonic pro-
jections above a quarter of
the graticule has been
omitted to allow the con-
struction to be appreciated.

more see what happens when we move the source of light, which we could not do effectively when it was contained in a cylinder. The results form a group of projections known collectively as *zenithal* or *azimuthal* projections.

The orthographic, stereographic and gnomonic projections. Figs. 7A, B and C, show the projections produced when the light is placed at infinity, the south pole, and the earth's centre; they are known respectively as the orthographic, stereographic and gnomonic projections.[21] The first and last are not only limited in extent to a hemisphere or less but contain such obvious distortions in their outer areas as to appear of little use. In fact both have a saving grace. The orthographic projection is simply the globe seen from afar, and is thus the easiest projection to envisage (see p. 25), while the gnomonic has the rare property[22] of making all great circles straight lines, and vice versa. A straight line from A to B on a gnomonic projection is therefore the great circle route between them; hence the complementary roles of the gnomonic and Mercator's projection in navigation as described above.

The better balanced stereographic projection is much more reasonable in its errors especially in its central portion (see table, p. 11). Strangely enough it is also an orthomorphic projection,[23] but unlike Mercator's it has been little used for topographical maps, though the Dutch official map series have been drawn on it. It is, however, a great 'cartographer's projection' and is used in the process of 'transforming' projections into transverse and oblique cases (see below).

Zenithal equidistant and zenithal equal-area projections. All the preceding projections have concentric parallels and straight radiating meridians properly spaced about the pole.[24] Let us now abandon true projection, keep the latter arrangement (Fig. 7D) but 'play about' with the parallels. Why not draw them their true distance from the pole, giving the zenithal equidistant projection (Fig. 7F), or calculate their radii so that they enclose on the map the same area as they do on the globe, giving the zenithal equal-area projection (Fig. 7E)? In the latter case the radii turn out to be the chord distances from the pole to the parallels, and the circles get (almost imperceptibly at first) closer together as one moves outwards from the pole. On both projections scale along the parallels is always exaggerated but as the table on p. 11 shows errors are very well controlled over a remarkably wide area, and there is little to choose between the two projections in this respect. Even 45° (i.e. more than 3,000 miles) away from the centre scale errors along meridians and parallels are little more than 10% and 8% respectively, though the equal-area case balances positive errors with negative ones and so gives more noticeable distortion of shape; both become intolerably distorted if extended beyond a hemisphere. Neither has been much used for topographical maps since the conicals (see

[21] Strictly the 'zenithal orthographic projection' etc., but the term zenithal is often dropped and these projections referred to simply as the orthographic projection etc. Other projections, for example Clarke's projection, are derived with the light in other positions along the axis.

[22] Long thought to be unique but now known to be shared with the two-point azimuthal projection.

[23] It is not at all obvious that this is so but it can easily be proved mathematically.

[24] Hence *bearings are correct from the centres of these (and all other) zenithal projections.*

below) can often make a still better showing over small areas, but both have become very popular in transverse or oblique form for atlas maps, especially of large areas and continents.

Projections Derived from a Conical Surface

The cone is the third surface onto which the globe can be projected to give a true map projection, but whereas only one cylinder will fit the globe, and a flat surface is invariable, any number of different cones can rest on the globe, from shallow ones touching near the pole to very tall ones touching near the equator; indeed the plane and cylinder can be thought of as the flattest and tallest of these cones respectively. Right from the start, therefore, there is an element of choice about conical projections, and the very important point of contact between cone and globe can be arranged where it best suits the area being mapped. For example in Figs. 8A – C contact has been made to occur at 50°N. because this is suitable for North America.

As with cylindrical projections the true or perspective conic projection (Fig. 8A) is of no use except to provide certain 'basic features' around which further modification can take place. These features are (1) a standard parallel which is its correct length[25] and is an arc whose radius is the slant height of the cone to that point (YZ in Fig. 8A); (2) other parallels as arcs of concentric circles, and (3) straight meridians radiating from the centre of these circles through points spaced correctly along the standard parallel. Note that the intersection at right-angles of radiating meridians and concentric circles holds out hope of reasonable representation of shape.

Simple conic projection with one standard parallel. This is the perspective conic but with the parallels spaced along the meridians at their *true distance* from the standard parallel (see Fig. 8B). The pole is not now at the centre of the circles but becomes exaggerated into an arc of small radius; in fact scale is too big along all parallels except the standard one, but close to the standard parallel errors are small and shapes and areas are quite reasonably shown. We can, however, improve on this.

Bonne's projection. This is a simple conic projection which has been modified to remove exaggeration of scale along the parallels by spacing all meridians their true distance apart along every parallel. The resulting meridians are curved and lie skew to the concentric parallels (Fig. 8C), destroying the useful rectangular intersections of the simple conic. The meridians have also become slightly exaggerated in length, but even so Bonne's is an equal-area projection[26] with very reasonable shapes and errors around the central meridian. These properties, together with the relative ease with which it can be constructed and drawn, have caused it to be widely used for topographical maps, for example early Ordnance Survey maps of Scotland and the early French and Dutch official series. It is also frequently used for atlas maps of large areas.

Conic projection with two standard parallels. As in other groups of projections, considerable benefit derives from letting loose the mathematicians on the simple basic

[25] It must be, since at this point cone and globe coincide.
[26] For the same reason as the sinusoidal, see footnote 18, p. 16.

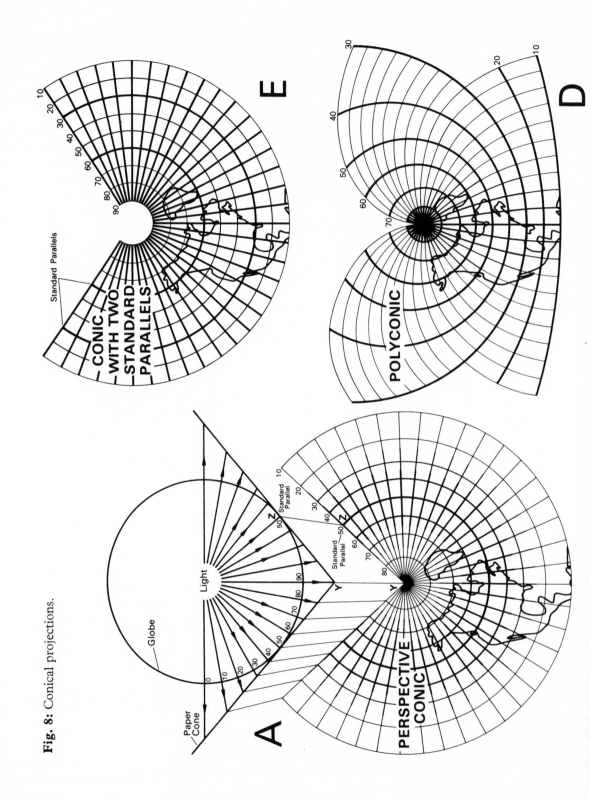

Fig. 8: Conical projections.

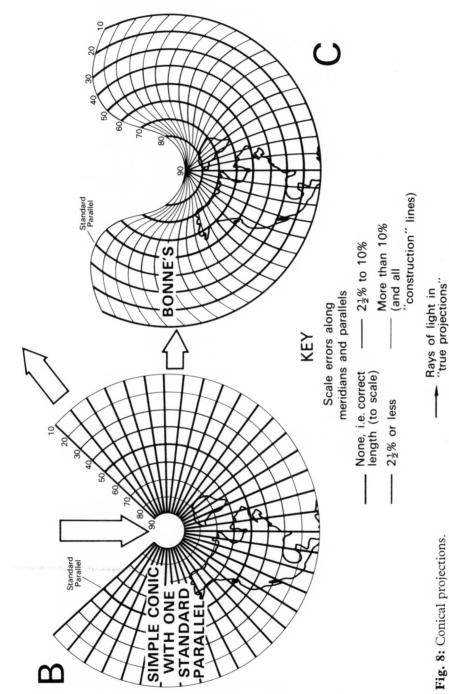

Fig. 8: Conical projections.

ideas of the group. Suppose we say to them 'Forget all about cones and globes but devise something that will look like a conic projection. I want two standard parallels, both their correct length, their correct distance apart and both concentric arcs of equal angular extent. For the meridians, proceed as in the simple conic, i.e. space them correctly along these arcs and draw them in as straight lines radiating from the centre of the arcs: add the other parallels as concentric arcs their correct distance apart along these meridians.' This is child's play to the average mathematician[27] who has only to calculate the radii for the two standard parallels to produce a very useful result, the conic projection with two standard parallels (Fig. 8E). Slightly better representation over large areas is obtained than with the simple conic with one standard parallel, especially if the standard parallels are carefully chosen;[28] scale is correct along all meridians as well as the two standard parallels, slightly too small along parallels between them and too large along parallels outside them; but errors are quite small over surprisingly large areas, and the whole of the U.S.A. for example could be mapped with less than 2% error.

Alber's projection.[29] If in relation to the parallels, the words 'their true distance apart' in the preceding specification is replaced by 'spaced so that the area between them is the same as that on the globe' we get Alber's projection. The meridians are drawn as before but all the parallels have their radii calculated so that the same equal-area condition is fulfilled. The mathematics is more complicated but the result even better; this time the maximum scale error for the whole of the U.S.A. would be no more than $1\frac{1}{4}$%.

Lambert's conformal conic projection with two standard parallels. This is the most sophisticated of the mathematical derivatives of the conic group. It is, in effect, a 'mercatorised conic': i.e. two true-to-scale standard parallels again set the curvature for all the other concentric parallels, but their radii and the spacing of the parallels along the meridians are calculated so that scale error along any parallel is exactly balanced by a similar error along the meridian at that point. Errors are slightly larger than on Alber's, but because the projection is orthomorphic bearings are only slightly distorted and it has been used for air navigation charts as well as topographical maps: for example modern French maps and many military maps, especially those required for artillery purposes, are based on it.

The polyconic projection. In one respect the standard parallel(s) of the conic group is a nuisance – it sets a shape to the other parallels and so to the map itself. This means, for example, that most conic projections for the northern hemisphere become very 'up-curved' if extended much beyond the equator, and world coverage is impossibly bad. The polyconic projection avoids this by having every parallel a standard parallel.[30] These are spaced correctly along a central meridian and the meridians are truly spaced along

[27] Hopeful 'A' level mathematicians should be able to manage it.
[28] Fig. 8E does not really do justice to the accuracy of this projection. In fact the error along both 40° N. and 50° N. is little more than 3%.
[29] Alternatively the *conical equal-area projection with two standard parallels.*
[30] It is therefore conceived as being derived from an infinite number of cones, not a single cone.

the parallels. Away from the central meridian north–south scale errors increase rapidly, and in the form shown in Fig. 8D the projection is of little use; but it does solve the problem, for conical projections, of 'crossing the equator' and in its interrupted forms (for example as narrow pole-to-pole strips along a meridian) it has been used for such important maps as the International 1:1,000,000 map of the world (see pp. 49–53) and the maps of the United States Geological Survey.

Transverse and Oblique Projections

It will have become obvious by now that, at least in the cases of the 'true' or perspective projections (for example Figs. 4A, 7A–C and 8A), far more variety could be obtained than has been considered. Why in the zenithals consider only the case where the paper touches at the pole, why not touching at the equator instead, or why not have a horizontal instead of a vertical cylinder in the perspective cylindrical? Why not indeed? If we do this we shall get projections which, because they are derived in the same way, must have the same properties as the 'normal' cases which we considered, though they will look entirely different at first glance.

Fig. 9A shows part of the equatorial case of the gnomonic projection superimposed on a faint outline of the polar version (Fig. 7C). The resemblance is there, and plain to see if in the latter case we stop talking about pole, parallels and meridians and talk instead about 'centre', 'circles joining all points so many degrees away from the centre' and 'straight lines radiating from the centre'. Thus, in Fig. 9A, points 10, 20, 30 or 40 degrees away from the centre of the projection (along, for example, the central meridian or the equator) are spaced at exactly the same distances as in the polar case, becoming rapidly further apart as we go outwards, just as the parallels do in Fig. 7C. The properties of this projection are exactly the same as those of the polar case: great circles are all straight lines, and there are the straight meridians (all of which are great circles of course) to prove it.

Zenithal projections with the paper touching at the equator are called simply 'equatorial cases', whereas projections derived from a horizontal cylinder or cone are called *transverse*; but there is no need to stop there. We could use paper touching anywhere or a cylinder or cone placed 'cock-eyed' on the globe to give the oblique cases of the same projections. Fig. 5 is in fact an oblique orthographic projection of the globe. Like the polar case it looks like the globe seen from afar and is almost the only oblique projection the layman can visualise.

What of the other, much better, projections that were derived from the perspective ones? They too can be drawn in transverse and oblique forms. The process is not difficult to envisage though the results may be. Suppose we want to make a *transverse* Mercator's projection based on (say) 90°W. and not the equator.[31] We need a globe[32] and a 'normal' Mercator projection on which the finished result will be plotted. On the globe we draw in a new set of 'meridians' and 'parallels' using the meridian 90°W. as 'equator' and having 'poles' at 180° and 0°. On the transverse projection 90°W. is the new base line or

[31] The meridians are the same length (approximately) as the equator so that the one can be replaced by the other without difficulty.
[32] In practice a stereographic projection is used but the argument is clearer when expressed in this form.

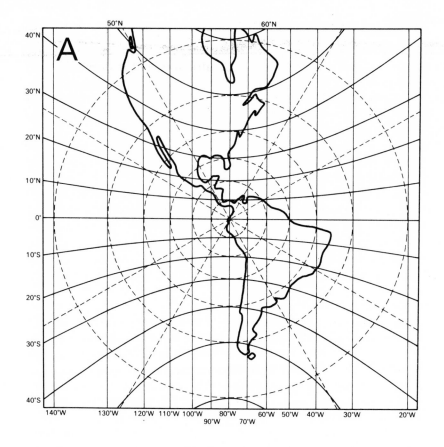

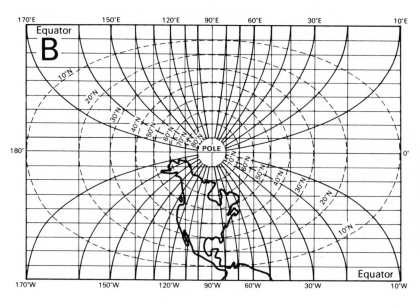

Fig. 9: Transverse versions of projections. A: Transverse gnomonic projection, centre 80°W, 0°. **B:** Transverse Mercator projection, central meridian 90°W. The pecked lines (9A) and feint lines (9B) mark the patterns of meridians and parallels in the normal versions (see Figs. 7C and 4D). In **B** only a hemisphere is shown.

'equator' so that we can rule in the equator on the normal projection but mark it 90°W. Suppose now that we wish to plot the position on the transverse projection of the 100°W. meridian; we simply notice on the globe what are the 'latitudes' and 'longitudes' on the new network of the points through which it passes, plot these points on the normal projection, and join them by a line. This is the representation of the 100°W. meridian and we can do this for any other line that we require.

The result is shown in Fig. 9B, again with faint meridians and parallels from the normal case for comparison. Notice that, just as before, the 'pole', or better 'a point 90° away from the base line of the projection', cannot be shown. Since all meridians are alike the projection would show the same overall shape whatever meridian was chosen as the base line. In the transverse form, therefore, the useful properties of orthomorphism, and small scale and bearing errors found only in the equatorial regions of the normal case, can be obtained instead about any meridian anywhere on the globe.

Choice of Projection

The properties of various projections which influence their use for particular purposes have already been touched upon, but other factors should be mentioned. Size and shape of the area to be covered are obviously important here, and so is the possibility, or other-wise, of 'interrupting' the projection. Until recently the tedium and difficulty of calcula-tion and construction hindered the introduction of some of the better but more compli-cated transverse and oblique versions, though many surveys have changed from an older 'simple' projection to a more sophisticated one in recent years, for example from Bonne's to Lambert's conformal conic in France.

Similarly projections without a definite centre, such as the polyconic and transverse Mercator which can be started about any meridian and for the plotting of which standard tables can therefore be calculated, have a considerable appeal, especially for the smaller survey department. Orthomorphic projections are popular at the moment but in any review on a world scale there are no standard rules of choice; history and expediency, no less than properties, play a significant part in many cases.

Chapter 2 Recording the Local Scene – Commerce and Surveying

The problems involved in mapping the whole world, or even a continent, reveal carto-graphy at its most impersonal and scientific. Matters such as projection and the size and shape of the earth are remote from normal experience and, compared with other features, have only minor visual impact on the map itself. Quite different, and rather more obvious, aspects of the cartographer's work are revealed in a study of the evolution of local maps.

Local maps mean larger scales, more potential detail, and often the need to choose which features to include or omit, a not unimportant choice when we remember that local maps appeal to a much smaller audience than do continental ones. This possible choice of content serves as a useful reminder that map making is a commercial enterprise, successfully accomplished only by combining the surveyor's ability to measure the land and the cartographer's judgement of the kind of map his customers need and are prepared to buy.

The problems of surveying, too, are more real and more apparent when studied through their effect on the form of local maps. Many of the surveying techniques which form the basis of modern mapping were developed first around the simpler problems of smaller areas, though paradoxically they had to grow and be considered on a world scale before our really accurate modern local maps could be made.

A brief review of the development of local maps in Britain offers a very satisfactory way of indicating just how closely connected all these factors are in determining map design.

The earliest known detailed maps of Britain are four related ones drawn about the year 1250 by or for Matthew Paris, monk of St. Albans Abbey.[1] As Fig. 10 shows their style was essentially pictorial, with broad sinuous rivers, and exaggerated drawings of battle-ments or buildings to represent towns. More than three-quarters of the places marked had important monastic houses or land, so that the map shows quite small places as well as important towns and strongly reflects the monastic interests of its compiler. Accuracy of shape and position are poor, but these were only two among many considerations. One of the copies carries a revealing note that if there had been more room on the parchment the island would have been longer, and all appear to have been constructed around a

[1] The four maps are not identical but seem to derive from a common, unknown source. For a discussion of this and many other aspects of these and the Gough Map (*v. inf.*) see Mitchell, J. B. & Pelham, R. A., 'Early Maps of Britain', *Geographical Journal*, Vol. 81 (1933), pp. 27–39.

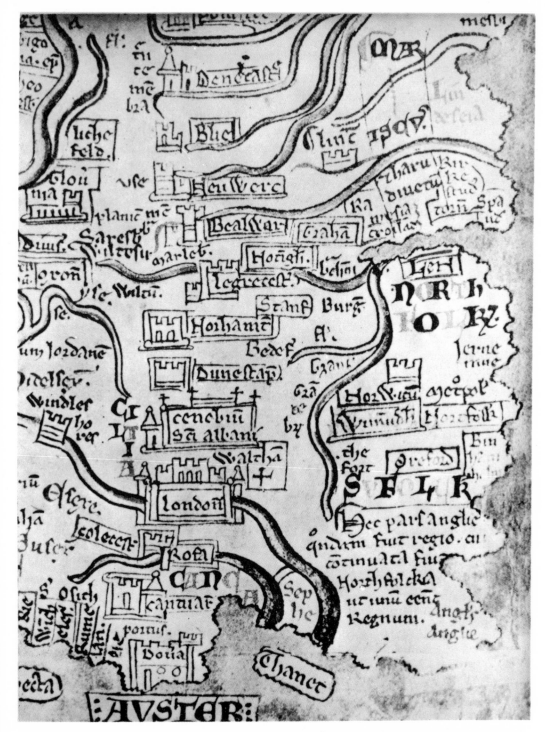

Fig. 10: Part of a manuscript map of England by Matthew Paris, *c.* A.D. 1250: reduced to two-thirds original size. (Reproduced from Edward Lynam, *The Mapmaker's Art*, Batchworth Press, 1953: by permission of Mr. J. P. O'F. Lynam.)

straight line representing the route from Durham or Berwick to Dover (Dou'a), bringing the latter place into the middle of the south coast (see Fig. 10).[2] Scale is indicated merely by a crude marginal reference to the overall size of the island.

The anonymous Gough (or Bodleian) Map (Fig. 11) is much better.[3] Drawn about 1360 it seems to have been compiled for travellers, very probably as an official map for couriers or Crown representatives. Though east-orientated it is much more complete and accurate topographically than Matthew's crude attempts, and conforms remarkably well to an overall scale of about 1:1,000,000. Once again the style is pictorial and detail largely confined to towns, rivers and some roads. The last-named feature, marked by thin red lines and showing some distances, probably in 'customary miles', present something of a problem. Several main roads, for example London to Dover, are omitted while other relatively unimportant ones, for example Caernarvon to Cardigan (the route of one of Edward I's itineraries) are marked, and it may be that these features were included not so much as roads but as a framework of distances, helping to fix the essential shape of the map.[4]

Knowledge of the distances separating places is one of the easiest ways (in theory) by which their relative position can be established (Fig. 12A), and must in fact have been one of the earliest ways of getting anything like reasonable representation of shape and position onto maps. Measurement of long distances is difficult however, and since for a long time the values used were almost always estimates, this could never have offered a really satisfactory basis for mapping.

From about 1450 onwards there developed new and better techniques which reduced the amount of distance-measuring by relying on measuring angles instead (Fig. 12B), a principle which still underlies much modern surveying. By the late sixteenth century angle-measuring instruments such as the *plane table* and *circumferentor*[5] were in use in Britain, and two Englishmen, the Digges' father and son, had invented a crude theodolite[6] and published *Pantometria*, a complete treatise on surveying. At the same time contemporary developments in printing, first from wood blocks and later from engraved copper plates (see chapter 5), were making possible the cheap mass production of maps.

Fortunately the course of English history provided increasing amounts of work for the newly trained 'surveighors'. Landowners of all kinds, and not least those who had newly acquired considerable estates following the dissolution of the monasteries, found it increasingly convenient to have maps of their lands, especially in settling legal actions and boundary disputes. A very early example of such a manuscript local map is shown

[2] The road, which may have been a sort of 'Pilgrim's Great North Road', is not marked on the map but the alignment is there.

[3] A cheap facsimile of the Gough Map is produced by the Ordnance Survey, Chessington, Surrey. A better, and much more expensive reproduction is published by the Royal Geographical Society.

[4] For a discussion of the roads and the map generally see Stenton, Sir F., and Parsons, E. J. S., *The Map of Great Britain c. A.D. 1360 known as the Gough Map*, Oxford, University Press, 1958. This volume was prepared and sold as an introduction to the second facsimile of the map referred to in note 3.

[5] A crude fore-runner of the prismatic compass.

[6] Really accurate instruments had to await the incorporation of a telescope, which was not itself invented until 1608.

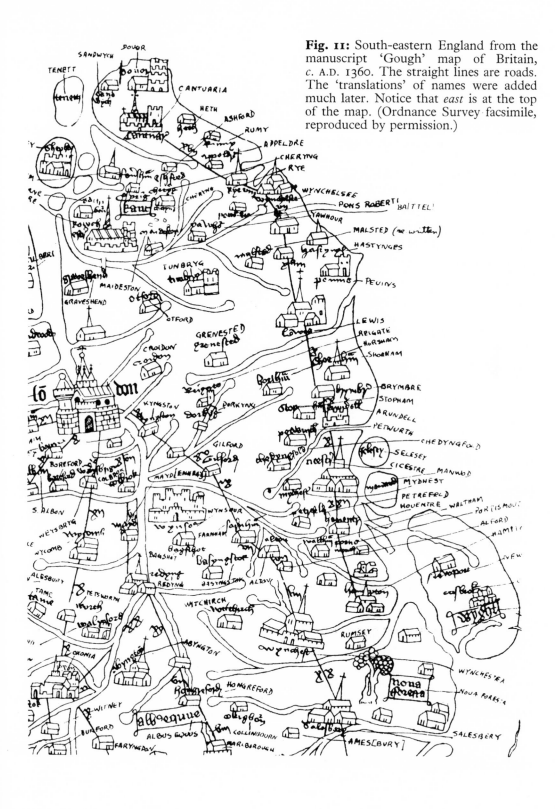

Fig. 11: South-eastern England from the manuscript 'Gough' map of Britain, c. A.D. 1360. The straight lines are roads. The 'translations' of names were added much later. Notice that *east* is at the top of the map. (Ordnance Survey facsimile, reproduced by permission.)

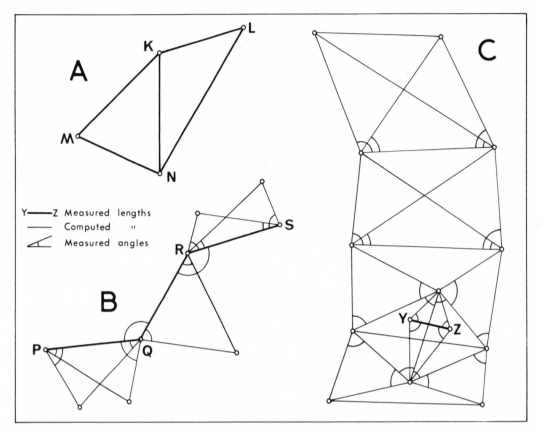

Fig. 12: The development of surveying techniques. **A:** Fixing positions by measuring or estimating all distances. **B:** Fixing positions by traversing, using a mixture of angular and linear measurements. **C** Fixing positions by triangulation using only one measured length, the *base* YZ, and thereafter measuring angles only.

in Fig. 13. Despite the increased scale the pictorial style persists, even down to true-to-life representations of churches and manor-houses, and detail though not plentiful is significant: the bridges, windmills, sea-bank (*fossatum maris*) and salt-marshes (*salsus mariscus*) beyond were important elements in the Fenland landscape. The two Fenmen of course are purely decorative, typical of the ornament with which the mediæval cartographer loved to fill the large blank spaces on his maps.

Many early estate maps covered much smaller areas than this and showed considerable detail at quite large scales. Often each portion of land was numbered, its area marked in acres, roods and perches and perhaps its use as well, either on the map or in a written description or *terrier* which accompanied it. In Fig. 14A, which is an example of such a map, the style is still half-pictorial, but the potential of the larger scales must have suggested the need to replace this by some more accurate representation and pictorial detail becomes gradually eliminated until we get the clear 'all-in plan' style typical of estate maps of the late eighteenth century and after (see Fig. 14B).

Fig. 13: Part of a manuscript map of the Hundred of Wisbech, fifteenth century, revised 1597 and 1657: reduced to two-thirds original size. (Reproduced from Lynam, *op. cit.*)

The new sixteenth-century surveyors who had learned their trade mapping country estates were soon ready to tackle larger areas, and in Britain the county was an obvious choice. Most counties were of moderate size, and sales were likely to be helped by their social and administrative significance as well as by the enormous national interest in England and things English which accompanied the country's contemporary rise to world-power status.

Although maps of English counties must have existed before 1570 (for there are references to them in contemporary accounts) the earliest known extant are those produced by Christopher Saxton, the 'Father of English Cartography', between 1570 and 1579. In nine years this remarkable man surveyed and published a map of every county in England and Wales, separately at first but in atlas form in 1579. Remarkably little is

Fig: 14: The evolution of the estate map. **A:** Part of a manuscript map of Beckley, Navenden and Nathiam by Giles Burton, 1635. Note the numbered fields marked with their areas. **B:** Part of a manuscript plan of Heythrop Estate, Oxfordshire, 1791. Both maps are reduced to two-thirds original size. (Reproduced from Lynam, *op. cit.*)

known of how he accomplished this tremendous feat, which was without parallel at that time. To have completed the work so quickly there could not have been any elaborate basic survey, such as triangulation (see Fig. 12C) and Saxton probably began from church towers and vantage points, establishing angles to neighbouring towers and villages and guessing or asking the distance to places which he could see, much as in Fig. 12B. Earlier maps and writings may also have been consulted and though Saxton worked single-handed he would often have had local assistance; his project had Queen Elizabeth I's blessing and he carried from her an open letter asking that he be 'conducted into any towre Castle highe place or hill to view that countrey and that he may be accompanied by ii or iii honest men such as do best know the countrey.'

In another sense too, Saxton was not entirely alone. Such an ambitious and expensive project as this was far beyond a surveyor's means; it had to be commissioned and financed by some gentleman of substance, in this case Thomas Seckford, one of the Queen's Masters of Requests. Seckford's patronage no less than Saxton's skill was essential to the success of the work,[7] though this does not belittle Saxton's achievement. His merit was not that he knew how to survey but that he conceived and accomplished his Herculean task, and it is as a pioneer, no less than as a surveyor and cartographer, that he is honoured.

The maps themselves, of which a typical portion is shown in Fig. 15, are perhaps a little disappointing on casual inspection. Detail is far from complete and the style is entirely pictorial with symbolic villages and towns, 'sugar-loaf' hills, groups of trees for wooded areas, and ring-fences enclosing trees for the parks of the gentry; of other detail, apart from rivers and bridges, there is little, and roads, for example, are not shown. The scale varies from about two to four miles to an inch to give an almost uniform sheet size for binding in atlas form.[8] As an artistic production, especially after being hand coloured,[9] the maps are very fine, deriving a considerable part of their appeal from the elaborate borders, *cartouches*,[10] incidental ornament and flowing lettering used by the Flemish engravers who made many of the printing plates. But Saxton's work must be judged by the standards of his day, not ours, and as Tooley has remarked his maps are 'excellent in every way – valuable as being the first printed map of any county; important as an original work; accurate considering the means at his disposal, and well produced.'[11] Indeed so high a standard did they set that they were still being issued, corrected and improved, well over a hundred years later.

A man who aspired to improve on Saxton's work was John Norden, estate surveyor and

[7] Particularly to support the expense of making the survey, drawing the maps and making the plates, all of which would have preceded any returns from sale of the finished product.

[8] There is also a variation in length, from $8\frac{3}{4}$ to $12\frac{1}{2}$ furlongs, in the actual miles marked on the line scales of the different maps, due no doubt to the use of a mixture of Old English miles (2,140 yards) and 'customary' miles in their compilation. This type of difficulty was not completely eliminated until the introduction of the statute mile in 1593, though this measure was by no means universally accepted for a long time after that.

[9] The printing from the engraved plates was in black and white. The rich colouring was applied by hand, as was the rule with all maps until colour printing came into use in the nineteenth century (see chapter 5). Excellent colour-printed facsimiles of Saxton's maps are published by the British Museum.

[10] Decorative motifs enclosing titles, scales, etc.

[11] Tooley, R. V., *Maps and Map Makers*, Batsford, London, 1949, pp. 65.

D

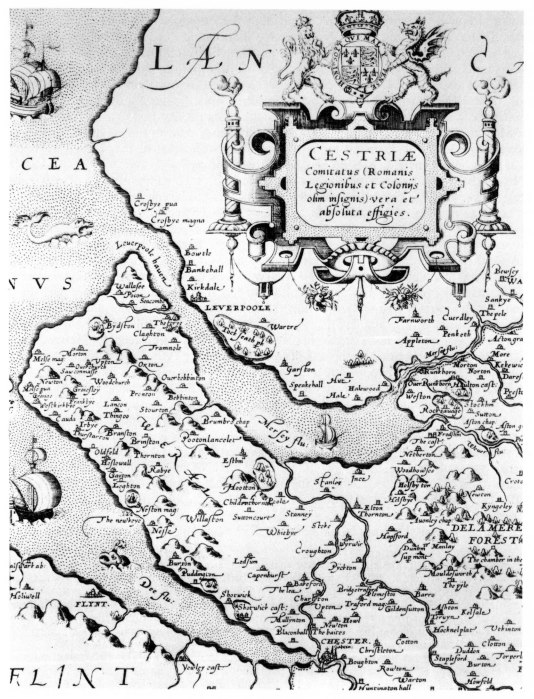

Fig. 15: Part of Saxton's map of Cheshire, 1577. The detail and style are typical of Saxton's maps. The scale of the original was 4½ miles to an inch: this reproduction is slightly less than two-thirds original size. (Royal Geographical Society facsimile, reproduced by permission.)

attorney. Norden set his heart on producing *Speculum Britanniae*, a series of pocket volumes each describing an English county and accompanied by maps with such cartographic improvements as roads, an index, standardised (pictorial) symbols for market towns, villages, Bishop's Sees, etc., 'bird's eye' plans of the larger towns, a marginal scale and smaller size for more convenience in carrying. So ambitious a project stood in great need of wealthy patronage but the first part, Northamptonshire – chosen probably to entice Lord Burghley (who lived there) into the role of patron – was a poor thing; Burghley was sympathetic but little else. The second part, Middlesex, was much better, containing excellent plans of London and Westminster; but Norden had to publish it at his own expense and, although most of his improvements were sound enough subsequently to become standard on later county maps, lack of proper financial backing brought the inevitable failure of the project with only a handful of counties ever completed.

A much more successful cartographer than Norden was John Speed who, though he did little original work, compiled in 1611 his *Theatre of the Empire of Great Britain*, a series of county maps based on Saxton, Norden and other sources. The style is very like Saxton's but the maps show the boundaries of the hundreds or similar county divisions, and each contains a 'bird's eye' plan of the county town (see Fig. 16), while the borders

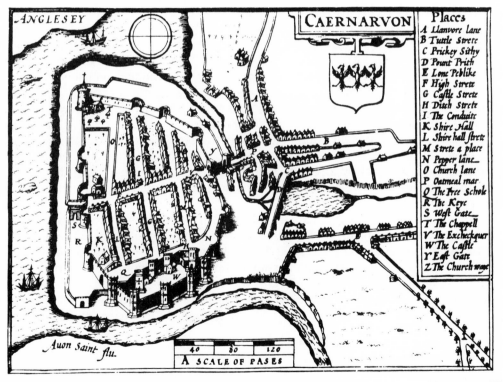

Fig. 16: The town plan of Caernarvon, inset into Speed's map of Caernarvonshire, 1610. The 'bird's eye' or 'aerial' type of representation is typical of early town plans. (Reproduced from J. A. Steers, ed., *Field Studies in the British Isles*, Nelson, 1964.)

are richly ornamented with the arms of the local gentry, presumably to encourage patronage and arouse local interest. These highly decorative maps, which were extremely popular and ran to many editions, are often seen today in use as wall decorations in houses, hotels and inns.

The county map continued to dominate the English cartographic scene until the appearance of the Ordnance Survey maps in the early nineteenth century, though considerable changes were introduced into its style and form during this period, largely because of changes in the social and economic life of the country and the increasing part which maps could play in assisting them. Travellers, both private and official, began to increase rapidly in numbers; turnpike Acts diverted or newly created many lengths of road; the construction of canals demanded a closer knowledge of topography than anything which had gone before; in some areas factories and mines developed and formed important elements in the landscape, as also did the increasingly numerous parks of the gentry and the newly arranged holdings and farmhouses of the enclosure movement. These were important changes which brought not only a greater range of detail for the county maps to show, but also the need for greater accuracy in its representation, leading to the gradual replacement of the relatively inaccurate pictorial style by the 'plan-type' rendering which we have today.[12]

Figs. 17 and 71 show some examples of the introduction of these modifications. On Symonson's map of Kent, made in 1596[13] (see Fig. 71 p. 181), main roads and hundred boundaries are marked, and villages are shown by a likeness of the church to aid recognition, with a circle and dot at the church door to mark its true position in the interests of accuracy. Bugden's map of Sussex in 1724 (Fig. 17A) has main roads and side-turnings (but not the actual side-roads), pictorial symbols for the churches and more important houses but a *plan* representation of the rest of the village; the important Sussex iron industry is represented by symbols for its water-wheels[14] and the furnaces and forges were shown by hammers. On Yates' map of Staffordshire in 1775 (Fig. 17B) almost the only pictorial element left is the church, the rest of the detail, much of which is 'industrial', being shown in plan or by conventional symbols. With the elevational 'sugar-loaf' hills, replacement of a pictorial by a plan-type rendering was a little more difficult, but from about 1680 hachures (see p. 58) became increasingly used, and these are another feature of Yates' map.

These changes mirror those we have already seen on estate maps, and are found similarly in the large-scale town plans of this period, for example Fig. 18, where there was now little room for the inaccurate pictorial style Norden and Speed had introduced a century and a half earlier (see Fig. 16). Another interesting development of this period was the production of strip-maps for travellers. This was begun in 1675 by John Ogilby's publication of *Britannia*, a hundred page atlas of strip-maps based on a survey (made with Royal approval) of all the main roads of the kingdom. The maps, at one inch to a

[12] The pictorial symbol is still far from dead, of course, e.g. those used for a windmill and lighthouse by the Ordnance Survey, and there are many more.

[13] An excellent black-and-white facsimile of this map is also produced by the Ordnance Survey, price 4/6.

[14] The toothed-wheel symbol is still widely used on continental maps for a factory or water-mill.

Fig. 17: Stages in the evolution of the County Map. **A:** Part of Bugden's map of Sussex, 1724. **B:** Part of Yates' map of Staffordshire, 1775. In many ways – style, amount and nature of detail – Bugden's map is roughly half-way between Saxton's county maps (*see* Fig. 15) and Yates'. (Reproduced from Lynam, *op. cit.*)

mile,[15] show much information to guide travellers along the roads and are in half-plan, half-pictorial style with the hills in particular remaining as awkward 'sugar-loaves' (see Fig. 19A). Like Saxton, Ogilby was a pioneer in his field. His idea was much emulated and strip-maps suffered rather a similar transition in style to county maps, so that by 1790 John Cary was producing the neat, stylish versions shown in Fig. 19B, almost as much a social register as a map – and no doubt selling the better for it.

Contemporaneously with these strip-maps Cary was producing his famous county maps which, almost devoid of ornament, precise in style and remarkably accurate, were typical in many ways of the last development phase of this map-type. From about 1750 onwards a few of the better cartographers had begun to accept the need, for accuracy's sake, of providing a full triangulated framework for their county maps, though this added enormously to the cost and labour of the work.[16] Indeed maps of this kind were so costly as to be rather an uncertain commercial proposition, and without advance subscriptions for copies from interested persons, such as the local gentry, many of the better county maps might never have been made.

[15] The statute mile of 1760 yards was used; Ogilby was among the first cartographers to adopt it.

[16] Donne's (triangulated) map of Devon, it was claimed, cost £2000 to produce.

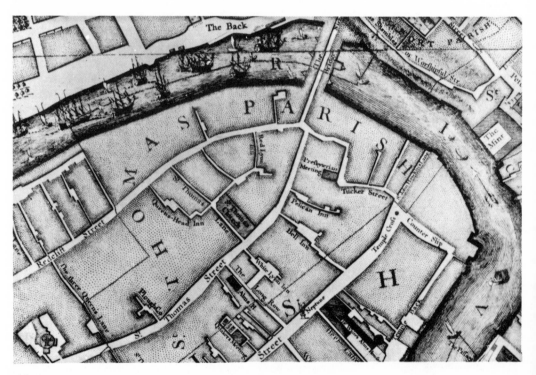

Fig. 18: Part of John Roque's plan of Bristol, 1742. Detailed plans of this kind mark a complete transition from the 'bird's eye' style of Speed (*see* Fig. 16). This reproduction is reduced to about three-quarters the scale of the original. (Reproduced from Lynam, *op. cit.*)

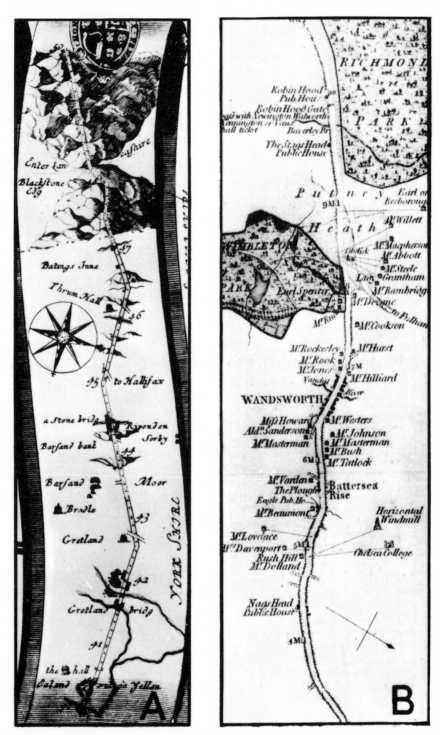

Fig. 19: The evolution of the 'strip' road map. **A:** Part of the road from York to Westchester (Chester) in Ogilby's 'Britannia', 1675. **B:** Part of the London to Richmond road by John Cary, 1790. The half-plan, half-pictorial style of **A** is similar to that of many contemporary county maps, just as the neat clear style of **B** is mirrored in most of Cary's other works. Both maps are reduced to about three-quarters the scales of the originals. (Reproduced from Lynam, *op. cit.*)

Here was the rub. So long as cartography remained a private, commercial concern the country was not going to be uniformly mapped. Maps would almost certainly be better and more plentiful in the populous rather than in the remoter areas simply because in the former parts interest and potential sales were greater. In 1759 the Royal Society had sought to remedy this situation, and improve standards generally, by offering £100 and other prizes for the best maps of a county at more than one inch to a mile, but though this venture produced some admirable results the overall picture of county mapping remained one of lack of uniformity in scale, style, content and accuracy. In Scotland the so-called 'pacification' of the Highlands after 1746 was so hampered by lack of satisfactory maps that the army undertook to produce one for itself, at a scale of 1,000 yards to an inch. As for making a good map of the whole country rather than a county, so long as errors of 10% or 15% were suspected on some county maps piecing these together might produce a map of Britain, but it would be lacking in overall checks and would certainly contain accumulated errors.

The writing here, and elsewhere, was on the wall, though Parliament took a long time to read it. Good, uniform, accurate maps of the whole kingdom, related everywhere to *one national* triangulated framework[17] were beyond the scope of any private agency. Here was a job for the state.

[17] In a few cases the triangulation of the private cartographers had extended beyond one county, or could be linked by common points, but this was still too small in scale and approach to be satisfactory for national purposes.

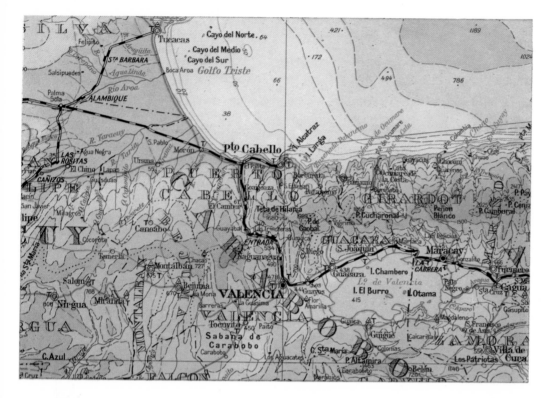

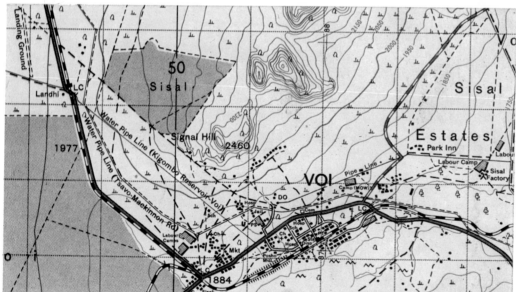

Plate 1: **A:** Part of sheet NC-19 (Caracas) of the 1:1,000,000 International Map of the World (IMW). (Reproduced by permission of the American Geographical Society of New York, 1945.) The sources from which this map is derived are shown in Fig. 21 (p. 48); the style and content should be compared with that in plate 2A. **B:** Part of sheet 190/III (Voi) of the Kenya 1:50,000 series (SK61). (Reproduced by permission of the Survey of Kenya, Nairobi.) The style and content are typical of those of many maps covering 'colonial' or 'former colonial' territories. The grey areas are cultivated land; the background symbols refer to different types of vegetation.

Chapter 3 The State Intervenes – Wars, Colonialism and National Planning

The Duke of Cumberland, 'pacifying' the Highlands in 1746, was not the first statesman to feel the lack of good maps. In 1668 Colbert, working to restore an exhausted France for Louis XIV, had met a similar deficiency by asking the newly-formed Académie Royale des Sciences[1] to prepare a map of the country more accurate than any then existing. There was no doubt in that body's mind how this should be done; the map must be based on an accurate national framework of triangulation (see Fig. 12C, p. 32) tied to and checked by astronomically observed latitudes and longitudes.

Experimental work on both triangulation and detail was begun around Paris under Picard and Vivier, producing a useful local map at 1:86,400,[2] but war and financial difficulties prevented further work even though widespread astronomical determinations of latitude and longitude revealed serious errors on existing maps, for example up to $1\frac{1}{2}°$ error in longitude in Brittany (see Fig. 20). Similar periods of alternate activity and stagnation, for much the same reason, characterised all further attempts to pursue the work and it was not until the 1730s that France was eventually covered by the chains of triangles which could form a foundation for all later official surveys, and not until 1746 that Louis XV ordered Cassini de Thury to complete the detailed survey.

The resultant map, which even then was not completed until 1789, may indeed claim to be one of the great milestones in cartography. Drawn to a scale of 1:86,400 and published in one hundred and eighty sheets (it was 33 feet wide by 34 feet high) the *Carte de Cassini*, as it was always known, was without parallel at that time and was greatly admired. Like many early surveys, however, its accuracies were soon outdated; in 1817 work was begun on a re-survey of France to produce the famous *Carte de France de l'État Major* at 1:80,000 (finished in 1880) which in turn promoted detailed maps at 1:10,000 and smaller scale maps at 1:200,000.

French experience in these matters was in many ways repeated in Britain. Urged on by a group of enthusiasts among whom a prominent military surveyor, William Roy,

[1] Academic scientific institutions played a large part in the developments of surveying and 'earth-measuring' techniques. Apart from the army they were often the only bodies large and able enough to organise early national survey operations.

[2] Published in 1678 this was probably the first map to use hachures (see p. 58) to show relief.

was the dominant figure,[3] Parliament toyed with the idea of a national survey from 1763 onwards, but with no results until a joint Anglo-French project was suggested by Cassini de Thury in 1783. Cassini's idea was to measure the difference in latitude and longitude between the Greenwich and Paris observatories by triangulation and since this suggested to Roy a means of obtaining the necessary instruments, experience and initial work for a

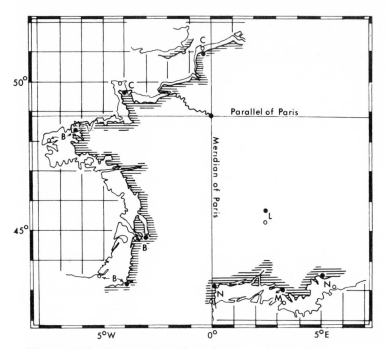

Fig. 20: The improved outline of France (shaded) after the early surveys under Cassini and Picard in 1681, compared with that on Sanson's map of 1679. Towns shown are (anticlockwise) C, Calais; C, Cherbourg; B, Brest; B, Bordeaux; B, Bayonne; N, Narbonne; M, Marseilles; N, Nice; L, Lyons. (Redrawn from Lloyd A. Brown, *The Story of Maps*, 6th edition, Little, Brown & Co., Boston, 1949.)

possible national survey he enthusiastically undertook the direction of the project once it had received official approval. Work on the British section could not be started until 1787, due to tedious delays in obtaining new and sufficiently accurate instruments but after that triangulation was steadily pushed forward from a base on Hounslow Heath to the Channel coast, and ultimately linked to the French work by night observations onto blinking white lights across the Straits of Dover. Computation of the cross-Channel distances showed that British and French estimates differed by only seven feet, a remarkably accurate observation for that time.

Roy's untimely death soon afterwards might have allowed interest in a national survey to lapse, had it not been for his friend and supporter the Duke of Richmond. As Master

[3] In 1765 Roy became 'Surveyor General of Coasts and Engineer for Making Military Surveys', but in his earlier years he had worked on the military map of the Highlands.

General of His Majesty's Ordnance,[4] the Duke held a key position in this matter and in 1791, a good deal on his own initiative though stimulated no doubt by the threat of war with France, he bought Roy's instruments and initiated the *Trigonometrical Survey*, later to become the Ordnance Survey. Its immediate pre-occupation was a triangulated framework (not finished until 1853) and a one-inch map covering the whole country, but these are described in chapter 6.

There were many lessons to be learnt from these early surveys. They were slow and costly and made hitherto unprecedented demands on staffing, accuracy and equipment.[5] Furthermore the calculation and plotting of the results of such accurate work both demanded and promoted greater knowledge of the size and shape of the earth ultimately establishing, for example, in the 1730s the existence of the flattening of the sphere at the poles.[6]

Other countries quickly followed France's example. Denmark was surveyed and mapped at 1:120,000 scale by its Royal Society between 1768 and 1841 and again (as in France) more accurately by the General Staff after 1830; Sweden's 1:100,000 map was begun in 1815; the Austrian Empire was officially mapped between 1760 and 1860, and between 1830 and 1864 General Dufour, in Switzerland, produced his brilliant and artistic 1:100,000 map of that most difficult terrain (see Fig. 24C, p. 59). Something of the implications of such surveys in larger nations can be seen in Russia; the famous 1:126,000 map of European Russia and Poland begun in 1816[7] occupied no less than eight hundred and fifty-one sheets, and there were smaller scale military maps of the Caucasus, Turkey, Turkestan and Siberia too. By 1900, therefore, much of Europe was covered, or being covered, by properly triangulated surveys which gave maps at scales of from 1:50,000 to 1:100,000 generally, though often larger than this in the smaller countries; and in all this work military considerations had formed a strong, perhaps even the strongest, stimulus.

Outside Europe things were very different, for rather obvious reasons. Many states emerged late as political units and when they did, for example Brazil and Australia, they were often handicapped by vast size coupled with extensive unexplored areas. In the 1840s when Britain was being mapped at six inches to a mile much of the western U.S.A. was scarcely explored, let alone mapped. Furthermore mapping had to await the establishment of a government fully in control of its territory and financially stable enough to support lengthy survey operations, which were themselves often aggravated by physical difficulties far beyond those encountered in temperate regions. For far too long in many countries a general topographic survey, which could provide the key to a systematic exploitation of resources, was regarded as an unnecessary luxury and governments

[4] 'Ordnance' is the department responsible for military stores and equipment, hence the rather odd title of the British national survey organisation.

[5] For example as early as 1669 Picard had fitted telescopic sights to his instruments to improve accuracy. Roy used first wooden rods then glass tubes (to counteract expansion) to measure his Hounslow base, and a giant theodolite to measure the angles. With sides of up to 50 miles long in some triangles small errors could cause serious discrepancies.

[6] Three conflicting schools of thought – absolutely spherical, polar flattening and equatorial flattening – had been thrashing this out theoretically for decades.

[7] The survey ingeniously incorporated a base line 6½ miles long set out on a frozen lake. Could any surveyor ask for a more level (or impermanent) base line?

preferred to leave those maps which *had* to be made, for example for railways, mining or land concessions, to the activities of the private bodies who were most concerned. The same piecemeal approach often continued when for various reasons certain government departments began to need maps, for agriculture and land settlement, boundary disputes or defence purposes (though the strategic stimulus was usually much less pressing than in Europe). Early cartography in many countries was plagued by a multiplicity of official mapping agencies, lacking uniformity of style and approach and with no-one responsible for providing the *national* triangulated framework which might have tied all these together.

The United States, for example, had the Survey of the Coast (established 1807), the Corps of Topographic Engineers (formed in 1813 and working largely in the West) and, after 1879, the Geological Survey, also working at first west of the 100th meridian. Fortunately in 1878 the Survey of the Coast was given the task of establishing throughout the whole country a basic triangulation network[8] on which the Geological Survey could base detailed *topographical* maps. These were, initially, incidental to geological require- ments but so great was public demand for them that funds were voted for this specific purpose, and the Geological Survey subsequently became the basic national topographic mapping agency, its truly geological work being an important but minor activity. This perfectly satisfactory two-fold organisation remains to this day, the Coast and Geodetic Survey providing the framework, the Geological Survey, the detailed maps: but with so late a start and so extensive a territory map coverage is still far behind European standards. The United States is not yet completely mapped at basic scales (1:62,500 or 1:125,000) (see Fig. 22) and sheets, once published, have often become sadly out of date before any revision has been made.

In some federal or semi-federal states the position was often made worse by the indi- vidual states as well as the various federal government departments each having their own mapping programme. In Brazil, for example, it was not until 1937 that the federal govern- ment created the Conselho Nacional de Geografica to co-ordinate all cartographic work, avoid duplication and initiate a national triangulation network; in Canada not until 1947 were all civilian agencies engaged in surveying and mapping consolidated in the Surveying and Mapping Bureau, and all civilian mapping on scales of 1:250,000 and larger assigned to the Topographical Survey Division.[9] In many smaller nations obstacles of a different type, especially lack of political stability and of the necessary financial backing similarly retarded the establishment of national mapping programmes.

One major exception must be made to this rather gloomy picture of early cartographic progress outside Europe. Stimulated by various motives, among which the discovery of potentially exploitable areas and resources and the more complete delineation of boundaries against possible counter-claimants are two obvious ones,[10] most European nations with colonial possessions carried out various surveys in them, often very actively. Early surveys usually produced reconnaissance-type maps at about 1:200,000

[8] In consequence it was more suitably named the Coast and Geodetic Survey in 1903 (Geodesy = the study of the size and shape of the earth).

[9] There still remains a separate Army Survey Establishment.

[10] Several classic boundary disputes arose because boundaries had been verbally defined before the terrain was properly mapped, for example those between the U.S.A. and Canada, and between Argentina and Chile.

scale, relying on a framework of astronomically determined positions rather than tri-
angulation; but in this century a second round of triangulated surveys with maps in the
1:50,000 to 1:100,000 scale range was often begun and in some areas very high standards
were maintained from the start, for example in India where excellent maps at one, two
or four miles to an inch were produced.

Strategical considerations, too, prompted (and indeed still prompt) the military
organisations of the great powers to map extensive areas well beyond their empires, the
resultant maps often forming the best available cover for many parts of the world. Such
maps, of course, could rarely be based on detailed surveys but had to be *compiled* from
all available sources, a technique which was also used by national governments to produce
maps of their own territories where detailed survey work had not been started. Compila-
tion involves piecing together any cartographic information which exists for an area to
produce the best possible results, and sources may be very varied in type and accuracy –
good, but local, triangulated surveys, cruder surveys or traverses made along lines of
communication, rudimentary surveys made by exploring parties, naval charts of coastlines,
odd astronomically fixed positions, even travellers' tales and descriptive accounts of little
known areas. Many compiled topographic maps are still in use today. Because of the
varied accuracy of their components they should always state their sources and map users
should not be lulled into a sense of false accuracy by good draughtsmanship or attractive
production.[11] Fig. 21, which shows the compilation diagram for one of the excellent
1:1,000,000 maps of Hispanic America,[12] gives a good indication of the varied nature of
the sources which may be used, and a comparison of Plates 1A and 2A, where there are
at least three differences, illustrates something of the weakness of this type of map.

There are, therefore, many reasons why topographical mapping progressed only very
slowly outside Europe and European possessions. Describing the situation as late as 1933
Hinks could still write 'the maps of the United States are still very incomplete . . . Egypt,
Japan and Siam have made good progress . . . the Russian 40 verst (1:168,000) map is in
process of revision . . . a good map of Turkey . . . is in progress. Apart from these and
from British maps treated elsewhere there is little to describe',[13] but fortunately the
position has changed radically since then. The strategic considerations of a global war
have brought new and revised mapping to many remote areas, as also has the incessant
search for raw materials like oil and uranium. Governments have at last accepted
the completely fundamental role of the national map series in planning national resource
development – for projects such as power and irrigation schemes – as well as the ultimate
wastefulness of mounting any survey for these ends in a piecemeal fashion; but probably
the biggest single factor has been a technical one. Air photography and associated
mapping techniques[14] have completely revolutionised surveying and allowed *rapid*
production of much more detailed maps than could ever have been envisaged using the

[11] For example in 1949 it was found that a mountain range 120 miles long, 5000' high and no
more than 60 miles from the Panama canal *did not appear on any map*; many coastlines in Latin
America had not been surveyed since the attempts of British or Spanish mariners a hundred
or more years ago.
[12] Published by the American Geographical Society.
[13] Hinks, A. R., *Maps and Survey*, 5th edition, p. 108.
[14] Known as Photogrammetry, i.e. the making of maps from air photographs.

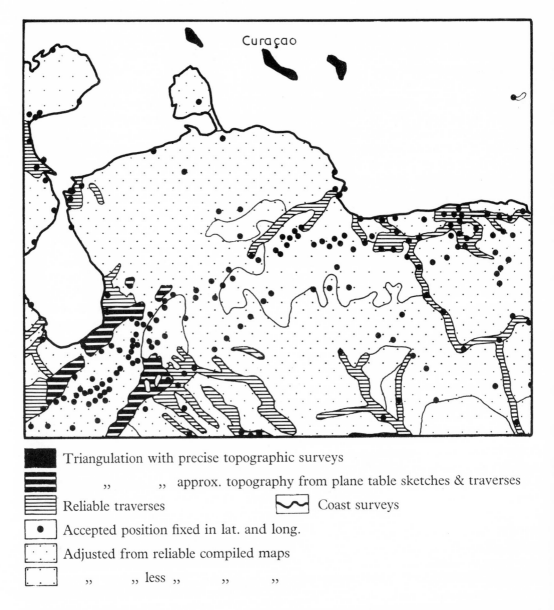

Curaçao

Legend:

- Triangulation with precise topographic surveys
- „ „ approx. topography from plane table sketches & traverses
- Reliable traverses
- Coast surveys
- Accepted position fixed in lat. and long.
- Adjusted from reliable compiled maps
- „ „ less „ „ „

Fig. 21: Sources used in the compilation of sheet NC19 (Caracas) of the American Geographical Society's 1 : 1,000,000 series of Hispanic America. Only the Netherlands' Antilles had 'European-type' surveys, and the enormous area prepared from *compiled* maps indicates how widespread was the lack of systematic survey. Since the sheet was published in 1945, however, much of this area has been surveyed and recorded on new map series at 1 : 1,000,000 or 1 : 250,000 scales. (Reproduced by permission of the American Geographical Society.)

old ground-survey methods. The importance of these new techniques is immense and the initiation all over the world of map series derived from air photographs has completely transformed the depressing picture Hinks outlined thirty years ago.

There is still a long way to go, of course. Fig. 22 shows that there are blanks to be filled and many more areas where better, more detailed maps are needed but, this apart, the next step is to co-ordinate individual national map series into a *world* mapping project, and there are already indications that this process has begun. In western Europe agreement has been reached between several countries to produce map series at the same scale,[15] and unofficially elsewhere the scale of 1:50,000 is increasingly becoming universal, even in places where the metric system is not normally in use, for example in Canada and many former British Commonwealth territories. One standard grid, the UTM (see page 119) is already adopted by many nations. Less obviously too there is co-operation in linking triangulation networks together to produce world not national triangulation, though the different measures of the size and shape of the earth used by various countries cause difficulties here.[16]

Oddly enough, international cartography was already being mooted as long ago as 1891 when Penck first outlined proposals for what eventually became the *International Map of the World* (IMW) at 1:1,000,000 scale.[17] Specifications for such a map ultimately emerged from an international conference at Paris in 1913, aiming at a world map uniform in style and scale and drawn on a modified interrupted polyconic projection.[18] Only important features were to be shown – relief using contours and layer colouring, hydrography, towns, main roads, railways, political boundaries, etc. – and the sheets were to cover six degrees of longitude by four of latitude.[19]

Unfortunately the results have been rather disappointing and have emphasised the difficulties inherent in the conception and execution of such a project. Because no centralised production unit was established sheets had to be prepared by the individual countries concerned and response varied enormously.[20] In Europe it was simply a case of reducing and redrawing existing maps but elsewhere production was slow, particularly as many countries with an enormous back-log of routine mapping were reluctant to undertake any new projects. The rigid sheet lines often fell awkwardly within national territories making the map expensive and inconvenient to use (Britain appeared on

[15] e.g. at 1:250,000. Norway, Sweden, France, the Netherlands, the United Kingdom and Eire are all producing such a series to replace (ultimately) maps at 1:300,000, 1:200,000 and ¼ inch to one mile (1:253,440).

[16] Some half-dozen or so different measures are still in use as a basis for calculating the results of triangulation.

[17] Originally known as the *Carte du Monde au Millioneme* and often listed as such in library catalogues, etc.

[18] Each 6° wide pole-to-pole column of sheets has its own central meridian but this, instead of being its correct length, is reduced to make the meridians 2° east and west of it become correct. Resulting scale errors are less than 1:1,300.

[19] Beyond 60° two or three adjacent sheets could be published as one since the convergence of the meridians made them very narrow.

[20] Normally the country which occupied most of any sheet was responsible for its preparation. A Central Bureau, for liaison only and with no technical or executive function, was established at the Ordnance Survey Office but this was transferred to the U.N. Cartographic Office in 1953.

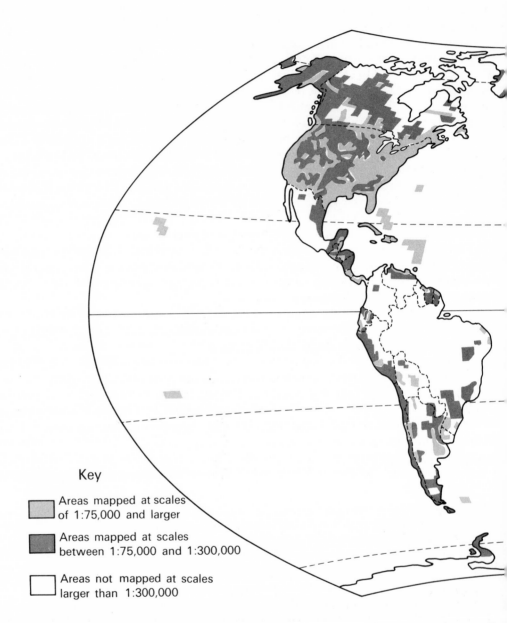

Key

Areas mapped at scales
of 1:75,000 and larger

Areas mapped at scales
between 1:75,000 and 1:300,000

Areas not mapped at scales
larger than 1:300,000

Fig. 22: The state of world mapping in the mid-sixties. The fact that an area is shown as 'mapped' does not necessarily indicate that the maps are (a) up to date or (b) available on public sale. Based on a map showing the state of world mapping in 1960 in McGraw-Hill's *International Atlas* (by

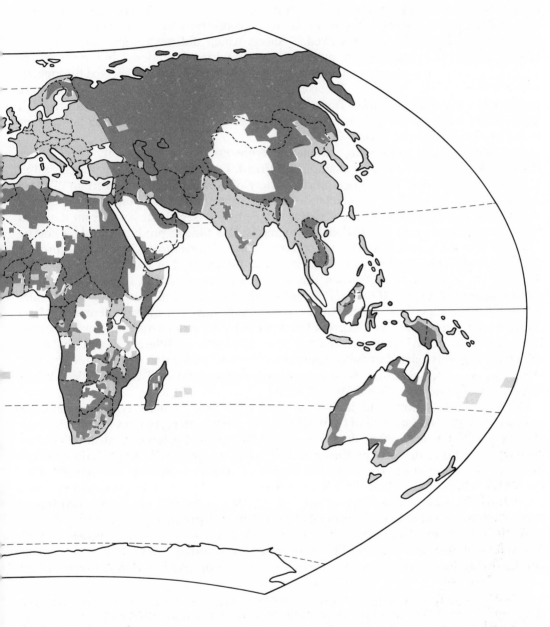

permission of the publisher), it has been corrected and amended for many areas up to dates
between 1963 and 1966. The major areas not so revised are the U.S.S.R., China, Venezuela,
Colombia, Mexico and Brazil.

E

portions of *seven* sheets), transliteration of foreign names into the western alphabet caused many difficulties, so did relief, which was often absent or but poorly represented on many then-existing maps, making it impossible to obtain conformity to certain contour intervals and layer colours which were required.[21] Sheets which did not comply fully with the official specifications were often published as 'provisional editions' but even where uniformity of style was maintained uniformity of content could not be expected throughout a map which covered the world. To take an example, the road classes shown (three were permitted) vary, quite sensibly, from 'roads passable by automobiles'; 'wagon roads'; 'pack-roads, trails and paths' on the Caracas sheets to simply 'main roads' and 'other roads' on the Amsterdam sheet.

The slow response from many national governments has prompted other agencies to enter the field of production, for example the British General Staff, the Engineering Club of Brazil and the American Geographical Society of New York (though certain of these excellent maps still had to be accepted only as 'provisional'); but one of the severest obstacles to the completion of the series as originally envisaged has come from the need for a second venture into international cartography, this time to produce world air charts.

These have developed from the 1:1,000,000 *World Aeronautical Chart* (WAC) project of the United States Air Force, which was put at the disposal of the International Civil Aviation Organisation (ICAO) when this was set up, and which in turn has sponsored the production of the *ICAO World Aeronautical Chart Series* also at 1:1,000,000 scale. There are some superficial resemblances to the IMW map but many differences. Many sheets are six degrees by four degrees but both size and arrangement are varied to suit land shapes and converging meridians;[22] the projection is different,[23] and the detail shown is essentially related or subordinate to assisting air navigation not resource development and economic planning, so that content differs a good deal from IMW maps in nature, amount and style (see Plates 1A & 2A).

Practical considerations and immediate need have prompted many governments to produce ICAO charts rather than IMW sheets, and, what is more, to revise them relatively frequently, a refinement often denied to the IMW series. Fortunately an international conference at Bonn in 1962 produced modifications to the IMW specifications which bring the two series closer together. The ICAO's Lambert projection may now be used for IMW sheets as well,[24] and sheet lines may be varied slightly to fit particular circumstances so that, though the differing aims of the two maps still necessitate two series, much common detail may be incorporated into both and production costs reduced.

With all this in mind the person who wishes to buy 1:1,000,000 map coverage may be forgiven for finding the situation a little confusing. The standard IMW series is incomplete and has many sheets which are 'provisional' or in need of revision. Alternatively almost

[21] Incompatibility of contours in metres and feet on source maps was an obvious source of difficulty; so was uniformity of colouring in the absence of a central printing agency.

[22] Sheets keep to a more uniform size, and so occupy greater longitudinal extent in high latitudes.

[23] Lambert's conical orthomorphic projection with two standard parallels (see p. 24) is used. It is interrupted so that each tier of maps has its own two standard parallels. The stereographic projection (see p. 18) is used beyond 80° N. & S.

[24] The difference is not noticeable on casual inspection.

the whole world is covered by a co-ordinated U.S./U.K. military series on which military needs have prompted more frequent revision and slight departures from IMW specifications (often for the better). There is also the American Geographical Society's Series of Hispanic America and if too close a background of topographical detail is not needed the sheets of the ICAO charts or the WAC series of the United States Air Force will suffice. The IMW sheets are not, then, in practice quite the fundamental first tier of cartographic base mapping which it was hoped they would be, but the project has been of immense value. It has spotlighted the problems arising from such a venture and provided useful experience in dealing with them; its sheets or sheet lines may yet form obvious choices for the detailed maps of world population and land use which are at present being considered, and it will almost certainly stimulate further attempts at co-operation in the international cartographic field, perhaps at even larger scales.

Chapter 4 What's on the Map? – Scale, Style and Content

If, as chapter 3 has shown, the world is becoming increasingly well mapped it is pertinent to ask what these maps are like. Are the end products produced by different mapping agencies similar or dissimilar, and if the latter, how and why? Can one use a foreign map easily, and are there any cartographic conventions so widespread that they make the map an 'international language', at least for the description of landscape? This chapter is concerned, in a very general way to provide answers to these, and other similar questions. It does so firstly by considering the effects of certain overriding factors which must inevitably affect the design and content of maps as a whole, and secondly by considering in more detail specific classes of feature, the extent to which these have been shown on maps and the manner in which this has been achieved.

Scale and Map Design

The scale of a map inevitably controls its design to a very great extent. On very large scale maps almost all of the permanent features of the landscape can be shown truly to scale, in plan form, and named as well if their importance warrants it:[1] at smaller scales not only must the greater part of this detail be ignored, but even that important enough to remain must be shown *conventionally*, with symbols, colour or abbreviation, to preserve legibility in the very limited space available.

Fig. 23 illustrates just how difficult this problem of redrawing detail to smaller scales is, and how very radically it affects the content of the resultant maps, particularly in urban areas with close detail. Not many of the crowded features of a capital city have weathered the reduction from 6″ even to a 1″ scale, and almost all of these have had to be rendered more distinctive to avoid them getting 'lost'. The churches and railway stations now have conventional signs to mark their presence; the parks and principal roads (on the original maps) rely on colour: but for most other features the problem of specific representation has been abandoned,[2] sometimes in a rather puzzling way, as

[1] Maps of this kind where everything is shown correctly to scale are often called '*plans*' rather than maps.
[2] This is perhaps something of a British failing. Conventional signs are not highly developed on British (or United States) maps: a European map at similar scales would probably have attempted rather more.

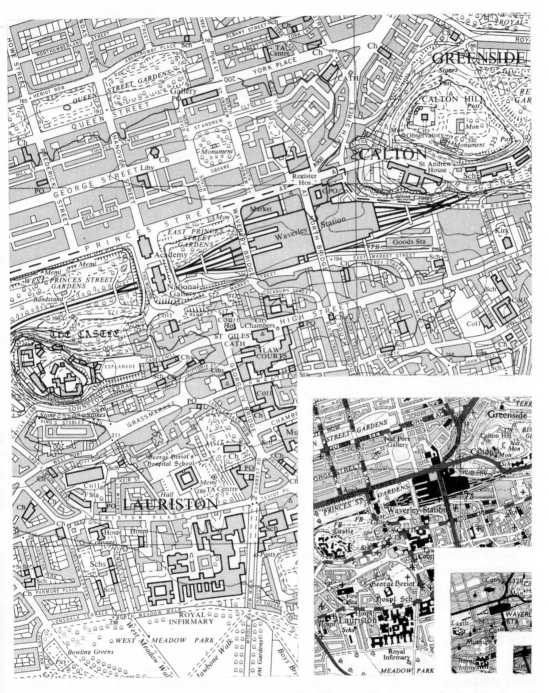

Fig. 23: A portion of central Edinburgh at 6″ to 1 mile, 2½″ to 1 mile (1:25,000), 1″ to 1 mile and ¼″ to 1 mile (1:250,000). The sequence emphasises vividly the extent to which detail must be omitted, simplified or conventionalised at the two smaller scales. Part of the 'New Town' can be seen in the north-west corners of these maps. (Reproduced from Ordnance Survey maps with the sanction of the Controller of H.M. Stationery Office, Crown copyright reserved.)

with the awkward 'blanks' which mark the squares and formal gardens of the planned New Town. At scales as small as 1:250,000 (Fig. 23) both reduction of content and generalisation of detail have been pushed very far indeed, and maps at scales like this normally tell us very little about any particular place or area.

Although in the originals for Figs. 23B, C and D the use of colour is invoked mainly to distinguish and emphasise detail, the frequent relative colourlessness of large scale maps is not entirely explained by lack of this need. Large scale maps are essentially maps to be worked *on* rather than *with* and since engineers, planners, etc., may wish to add to them their own (usually coloured) detail, colour in the map itself would be a nuisance. For the same reason many authorities publish outline versions even of small scale maps.

Landscape and Map Design

The type of landscape to be represented must also have quite an important influence on map design. Rugged or broken relief, for example, may cause a map to be so filled with hachures or hill-shading (see below) that it is difficult to portray other detail satisfactorily against such a background, and particularly was this so on the old 'black and white only with hachures' type of map. Colour printing helped but did not entirely remove this problem, and it is perhaps significant that the Dutch, with less relief detail to show than anyone else in Europe, manage to represent land use as well as topography on their 1:25,000, 1:50,000 *and* 1:200,000 maps.

Quite apart from relief the total sum of what needs to be shown is important. In less developed areas there is less to show and more space to show it, so that almost everything of importance can be marked (and often named) even on maps at small scales. The Icelandic 1:100,000 map marks farms, deserted farms and sheepfolds; the South African 1:50,000, kraals, stockades and dipping tanks; the Bahamas' 1:25,000, clubs, hotels, jetties, and so on. Since the reverse problem occurs in dense urban areas awkward problems of design and content arise when the same series has to cover both types of environment.

One further point might also be noted here. Alongside the great mass of 'normal' landscape detail many maps portray, additionally, features of peculiar importance to that nation or locality. Three typical examples are the inclusion of considerable detail relating to waterways on Dutch maps;[3] native location boundaries on the South African 1:50,000 series; and the cane fields, field tramways and sugar factories of the sugar industry on many West Indian sheets.

Map User, Map Maker and Map Design

The entry of the state into the mapping field on a grand scale has done nothing to break the centuries-old link between potential map user and map design. Official mapping agencies are just as keen as their mediæval counterparts to see that their products appeal to the enormous market provided by tourists and travellers of all kinds, and in this respect

[3] Locks, sluices, culverts, earth culverts, weirs, draw-bridges, bascule bridges, swing bridges and footbridges are all differentiated on the 1:50,000 map.

at least, there is still plenty of competition from privately produced maps to keep them on their toes. So it is that we find on maps features such as continually improved road classifications and isolated telephone boxes to help the motorist[4]; youth hostels, camping places, mountain refuge huts, ski routes, lifts and jumps to cater for the more active recreationists, as well as landmarks such as high chimneys, radio masts and churches of various sorts which, in part at least, may serve to guide the general traveller.[5] For the more important tourist areas there are usually additional, especially detailed and attractive sheets as well.[6]

Important though they may be today, however, it was not the needs of tourists which first prompted the state to enter the field of map making. From the very first military considerations had a strong influence on the design of officially produced maps, and continue to do so, particularly in the many countries where official map production is still in the control of a military authority. Though all might claim a place on the map as elements of landscape, it is significant that features such as areas with trees (vineyards, orchards, woods), cemeteries or the differentiation between fenced and unfenced roads also have military importance because of the varying amount of cover which they afford: all of these are particularly well represented on European maps. Similarly the rather pedantic distinction between bridges of concrete, wood and iron, suspension, lifting or transporter type must surely have its origins in this sector of interest.[7]

The situation where the map maker is also an important map user is not of course confined to official surveys operated by quasi-military bodies. Governments and their agents are generally important users of maps, and one is not surprised therefore to find on official map series detailed representations of many of the offices and 'end products' of national and local government. The Survey of India $\frac{1}{4}''$ map, for example, marks circuit houses, inspection bungalows, rest houses, police stations, jails, post and telegraph offices and reserved, state and protected forests. The widespread practice of marking official boundaries on maps is another example of the same tendency.

The content of maps

The preceding pages have outlined some of the principle factors which affect map design as a whole. The final section of this chapter examines rather more specifically the kinds of features which are shown on maps and the manner of their portrayal. The enormous variety of detail concerned will be described under five headings – relief, communications, settlement and buildings, land use and vegetation, and other information.

[4] A.A. and R.A.C. telephone boxes are marked on the British 1″ map.
[5] All of these categories appear, e.g., on the Swiss or German 1:50,000 maps.
[6] e.g. the Ordnance Survey Cairn Gorms 1″ Tourist Sheet shows hill-shading, layer colouring and sites for angling, canoeing, caravanning, camping, climbing, parking, pony trekking and view points, all of which are additional to the normal 1″ map information.
[7] Though not found on British maps this distinction is widespread elsewhere, e.g. French, German and Portuguese 1:50,000 maps.

Depiction of Relief on Maps: (1) *Qualitative Methods*

The methods which the cartographer uses to represent relief on maps can be divided basically into qualitative and quantitative ones. The terms are almost self-explanatory, *quantitative* methods being those concerned with the representation simply of specific altitudes whilst *qualitative* ones try to indicate quality (i.e. kind) of relief, giving an impression of altitude, ruggedness, slope, etc., but no specific information. The qualitative methods are therefore essentially 'pictorial' or 'vivid' in their approach, and in their attempts to make the relief look three-dimensional may be considered as the direct descendants of the 'sugar-loaf' hills of early maps.

Hachures, employed on maps well into the present century,[8] were the earliest sophisticated method of representing relief in plan form. The hachures themselves are short lines running down the slope of the land and drawn closer together, and sometimes thicker too, where the slopes are steepest; collectively they build up dark tones on steep slopes, often producing surprisingly vivid 'three-dimensional' results, as in Fig. 24 which shows examples of hachured maps, including some with variations on the basic principle.

At its most exact hachuring demands that both the number of hachures per centimetre and their thickness be strictly related to slope, but less precisely drawn versions are more usual. An advantage of the method is that it can pick out quite small relief features (see Figs. 24A and B) and very rugged or broken terrain usually comes out well; conversely gently undulating or flattish areas are much less easily represented (see Fig. 24D). The vividness of well-drawn hachuring made it a popular method for showing relief, but it was slow to execute and expensive and consequently has largely been replaced by later devices.

Hill shading or shadowing is the cheaper successor to hachuring and seeks to produce the same 'solid' effect by adding 'shadows' to the map so that it takes on the appearance of an illuminated relief model (see plate 2). There are two possible approaches. The first gives the effect of a model illuminated from above, so that all level surfaces are light and slopes become darker with increasing steepness (as with hachures); this is *vertical* hill shading. The second assumes an *oblique* source of light, usually from the north-west,[9] and gives shadows increasing with steepness on certain sides of relief features only, the 'light-facing' sides being strongly illuminated (as with 'oblique' hachures, Fig. 24C). Vertical hill shading always gives shadows on both sides of a steep ridge, but oblique hill shading can give anything from this (where the ridge is parallel to the light) to one side dark, one side light (with the ridge at right-angles to the light), though variations on the north-west light rule may be introduced if this does not suit the grain of the country.

Generally speaking the method resembles hachures in effectiveness, but a disadvantage with shading is that its effect may be confused by other areas of solid colour on the map,

[8] e.g. this was the basic method of showing relief on the German and Swedish 1:100,000 series until they were replaced by new editions or series in the post World War II period.

[9] This is the 'natural' direction in that a right-handed person examining a map would preferably sit with the light coming from his left and slightly in front of him, i.e. from the north-west corner of the map, so accentuating the illusion of solidity produced by shadowing based on a north-west source of light. It is usually best to orientate a shadowed map with the shadows cast towards the observer as otherwise a strong illusion of inverted relief may be obtained.

Fig. 24: Examples of hachured maps. **A:** 1st edition 1″ Ordnance Survey map of England: part of sheet 102. **B:** Germany, Topographische Karte, 1:100,000: part of Grossblatt Nr 73. **C:** Topographische Karte der Schweiz (Carte Dufour), 1:100,000: part of sheet XXIII. **D:** France, Carte de l'Etat Major, 1:80,000: part of sheet 178. All of these maps have now been replaced by other series. Notice the *oblique* hachuring in **C**, which gives light and dark sides to hills, and the difficulty in dealing with the very gentle slopes of the Plaine de Bièvre in **D**.

especially woods and vineyards, where these sometimes, but not always, occupy characteristic positions relative to relief. Oblique shadowing, too, may produce 'false escarpments', as where only one side of a steep sided plateau surface has any shading.[10]

Depiction of Relief on Maps (2) Quantitative Methods

The last fifty years have seen a very considerable displacement of qualitative relief methods on maps by quantitative ones, and for good reasons. Quantitative methods not only obtrude far less on the general design of the map, but also by dealing in specific altitudes allow many more features, such as slopes, profiles, and other devices described in chapter 11, to be derived from them. Unfortunately, on the debit side, quantitative methods are often less graphic in their portrayal of relief than are the qualitative ones.

Spot-heights. Little need be said about this simplest quantitative method of showing relief. Ineffective when used alone spot-heights are a most useful adjunct to other methods, though their distribution on maps is frequently very uneven, and they are often found only on crests and summits or along roads.[11] On British maps spot-heights should not be confused with *bench marks* which do not indicate ground level and are recorded on maps merely as a basis for further levelling.

Contours, which appear first to have been used in submarine form on a map of the Golfe du Lion made by Marsigli in 1730, are now the most widely used method for representing relief on maps. Many a schoolboy has defined them as 'imaginary lines joining all points which are the same height above (or depth below) sea level' but they have sometimes, briefly, had rather more tangible form than this. In the best surveys some contours at least were instrumentally surveyed, i.e. the position of the contour was determined by levelling, its course pegged out on the ground and the positions of the pegs surveyed in;[12] but because instrumental contours are very expensive to provide, they are usually supplemented to a greater or lesser degree by contours *interpolated* or *sketched* in between them. Many maps do not distinguish between the two types,[13] but where interpolated contours are known to be present it may be as well to make some sort of check on their accuracy if they are needed for precise calculation or deduction, since the accuracy of interpolated contours on some maps has occasionally been called in question.[14] Fortunately the position has recently been much improved by the practice of deriving

[10] The author has repeatedly had relatively flat-topped steep-sided areas in central France described to him as 'escarpments', even though the contours on the same 1:100,000 map gave obvious evidence to the contrary.

[11] These may be less useful than they appear, e.g. where roads are carried across flood plains on embankments.

[12] The many dots which occur along the contours of the first edition of the British 6″ map presumably mark the positions of these pegs.

[13] Distinction is more often made between regular-interval contours and additional ones, but this is not the same thing as some of the regular contours may be interpolated.

[14] Fig. 25B underlines this point – the reliability of their sketched contours is a touchy point with some surveys, but since these may be either well sketched in in the field, badly sketched in in the field, or even added later in the drawing office it is as well to treat them with reservations at first.

Fig. 25: Aspects of contours. **A:** Two possible configurations of the ground both producing the same contour pattern; a smoothly sloping surface should not necessarily be expected between contours. **B:** Contours relating to the same area on an old (*top*) and more recent (*bottom*) Swiss 1:50,000 sheet. **C:** Contours from a 1:62,500 map of part of the Hudson Valley, U.S.A. **D:** The same contours generalised at 1:62,500 for reduction to 1:250,000. It is not often appreciated how much contours must be generalised on small-scale maps. **E:** Representation of relief by form lines; part of sheet 16, British Honduras 1:50,000 Sketch Map [*sic*]. (**B, C,** & **D** are reproduced here from A. J. Pannekoek, 'Generalisation of Coastlines and Contours', *International Yearbook of Cartography II*, by permission of the publishers, Kartographisches Institut Bertelsmann, Gütersloh. **E** is reproduced from Directorate of Overseas Surveys Map D.C.S. (Misc) 8, first edition 1955, by permission of the Controller of H.M. Stationery Office: Crown copyright reserved. A new series based on new sheet lines (E 755 DPS 4499) is available: to compare this with **E** above, see sheets 23, 24, 28 & 29.)

contours instrumentally from air photographs and by this means it is relatively easy to provide accurate contouring at quite close intervals.

Although contours are widely understood several aspects of their significance are not always fully appreciated. For example their effectiveness in representing terrain is closely controlled by the *vertical interval* (usually written simply V.I.) between adjacent contours; it must be stressed that the ground does not necessarily slope evenly from one contour to the next, and that any feature of height less than the V.I. will probably not be discernible in the contour pattern, and, exceptionally, one of height up to almost twice the V.I. may not be either (see Fig. 25A). Conversely in areas of very gentle relief it does not follow that anything observable will occur at a contour line; there ma*y* be an isolated hill or the ground may merely rise imperceptibly above a critical level.[15] Both situations contrast with well-drawn hachures which are much more positive in recording the presence or absence of small features.

The all-important vertical interval between contours is naturally a very variable quantity, controlled jointly by cost, terrain and scale. On small scale maps there is less room for close contours and several rough rules are available as guides to indicate what to expect, for example (1) V.I. = 20–25 × miles per inch or (2) V.I. = 50 ÷ no. of inches per mile; but even these show considerable latitude (one gives almost twice the answer of the other), and almost certainly other factors besides scale will influence the final choice. In mountainous areas the V.I. is kept large to avoid overcrowding but in gentle relief it may have to be small to pick up subdued but important features. Alternatively it may be attuned to need: maps of irrigated areas often have contours at 5′ V.I., and the Dutch 1:25,000 map has a V.I. of $2\frac{1}{2}$ m (*c*. 8′). British map users, accustomed to series with a constant V.I.[16] are sometimes surprised to find that elsewhere within one series the V.I. may be adjusted to suit terrain. The United States 1:62,500 series has V.I.'s ranging from 20′ to 100′ and some European series occasionally add intermediate contours which, rather disconcertingly, may not even be present over the whole map sheet. In all cases it is necessary to safeguard against the misleading visual impressions which may be produced by variations of the V.I. *within* a series, an irregular V.I., or by the necessarily simplified contour patterns often found on small scale maps (see Figs. 25C and D). It is sensible also to examine the actual numbering of the contours, to notice in particular whether they are in metres or feet,[17] and to keep an eye open for any which may mark depressions, though such contours are usually differentiated by ticks or arrows pointing into the depression.

The zero altitude to which contours refer is known as *datum* and is usually the mean level of the sea as determined by that survey authority. There is no consistency here and contours across a national boundary may not join: for example the Germans and Dutch use the same datum, but the Belgians take a value 2·32 m below this. It is, in fact, an important world cartographic need today to accept and establish a uniform datum over

15 e.g. a very gently undulating plain lying between 93′ and 98′ above sea-level would appear flat to the eye and contourless on a map even with a 10′ V.I. Had it lain between 98′ and 103′ it would probably have carried an intricate pattern of the 100′ contour.

16 This is true of the 1″ and 1:25,000 series, but not the 6″.

17 In the author's experience many students continually overlook this distinction when interpreting European maps.

wide areas. Submarine contours need watching too. They may be referred to normal datum, or to a mean low water mark, and may be in feet, fathoms or metres; lake contours may be either 'flooded' land contours or referred to lake level, which should be marked on the map.

Layer colouring. Because intricate contour patterns do not necessarily present an easily assimilated impression of the overall relief of an area [18] they are often supplemented by layer colouring: i.e. the area between selected contours is differentially coloured according to altitude. Layer colouring is widely used in atlases, small scale maps and topographical maps up to about 1:50,000 scale where it can be extremely effective, though rather expensive (see chapter 5). The conventional colour sequence, which follows spectrum order from violet through shades of blue, green, yellow and orange to red (or more commonly brown), accords well with the psycho-visual properties of colours – blues for submarine areas are 'recessive', reds for hills 'stand out' – but there can be unfortunate suggestive overtones. Green, for example is most misleading in lowland desert areas, and brown hills tend to look bare though in fact they may be forested or cultivated.[19] Unfortunately the usage is enshrined by tradition and will be difficult to replace by some less misleading system such as monochrome layer colouring.

Form lines. This is really a qualitative method but is so analogous to contouring that it is discussed here. Form lines are lines which behave like contours but are not tied to any specific altitude: i.e. they show the shape of features but not their vertical extent, as in Fig. 25E where the depth of the valley or the height of the hill cannot be judged. When supplemented by spot heights they can be remarkably useful since, unlike contours, they always indicate observable features, and on early maps they were a welcome cheaper substitute for contours. Today they are rare, having largely been displaced by contours derived from air photographs (see above).

Combinations of methods. Although described separately above most methods are encountered in combinations, particularly of qualitative and quantitative types to get the best of both worlds. Hachures with spot-heights were an early combination, replaced by hachures, contours and spot-heights, and later by hill shading, contours and spot-heights; but there are more elaborate systems than these. The fifth edition 1″ map of Great Britain employed no less than four superimposed methods, namely (1) contours at 50′ V.I. plus spot-heights, (2) hachures in very pale brown, (3) the same hachures printed again in grey on the eastern and southern sides only of features to give a shadowed effect, and (4) layer colouring (fine brown hatching above 1,000′ and cross hatching above 1,500′). Another common combination is vertical hill shading in one tone plus oblique hill shading in another, but with complex methods of this sort the full combination is often not deducible by casual inspection.

[18] Elementary text-books on the subject continually suggest the opposite. This is nonsense. *Simple* forms may be apparent from contour patterns but to envisage much beyond this (or even to translate it into an expectation of slope in reality) is beyond most people's ability.

[19] This impression can be very strong. The author has two editions of a Bartholomew's ½″ map of Surrey; on one the change from green to brown occurs at 100′, on the other at 400′ The former gives the impression of a dreary upland area with little of 'Lowland Britain' about it.

Depiction of Communications and Linear Features on Maps

As with relief, communication patterns are distinctive enough as a *class* to be recognised on any map: for example railways would be recognisable even on a map printed in Chinese, so that the 'international language' characteristic seems strong here. In some respects this is so, for relative importance within each type is often recognisable as well, but, paradoxically, *detailed* interpretation may be difficult without the aid of a dictionary.
Railways. Within this group there are usually distinguished not only differences of gauge (either by writing as on the Indian $\frac{1}{4}''$ map or by symbol), but also the number of tracks and the type of line – 'industrial',[20] electrified, rack, funicular, cable railways for goods and/or passengers, street tramways, inter-urban railways, underground lines (though these are often omitted) and so on; the symbols used for the various types, are rarely recognisable on sight (see Fig. 26).
Roads. Because of their greater potential variety road types present the cartographer with rather more problems than do railways. Early road classifications were often crude enough, for example 'main roads, other roads', but as motor traffic developed there was a tendency to introduce useful, strictly objective, classifications related to surface and width. Unfortunately this trend was cut across in the 1920s and '30s by the development of an official classification and numbering of roads which, because it was fundamental to signposting, directions, etc. had also to be shown on the map. In many countries the representation of this official classification has now become the dominant cartographic element, though in practice such a designation often relates more to a road's position in a communications hierarchy than to its physical characteristics: many a British 'A' road is surpassed in surface and width by others classified only as 'B' roads. Alternatively map makers have frequently settled for the official classification modified slightly in some objective way, usually by reference to road width. In less developed countries where roads may be more variable a strictly utilitarian or objective classification seems even more desirable, though it is not always found. Table 2 gives an idea of some of the solutions adopted, and shows their weakness as a group: common elements are rare and are often of the broadest type, for example motorways, metalled and unmetalled roads. Unfortunately the map's key will not always help either. It is not uncommon to find there some national terminology, virtually untranslatable and meaningless without actual experience, like the Dutch '*kunstweg*' and '*landweg*', the first, literally, 'artificial road' i.e. made road (but not given in an ordinary dictionary), the second, literally, 'country road' which could mean anything but is near to 'occupation road' in English.[21]

British and American map users might note here two common European practices relating to the representation of roads on maps, which sometimes cause confusion. The first is the use of *single* black lines only for minor roads; the second that of placing dots at intervals along roads (or streams) to mark, conventionally, sections bordered by trees.
Other forms of communication, communication detail. Canals are usually more summarily treated on maps than roads and railways: navigational, drainage and irrigational types

[20] i.e. works 'tramways' or light railways: in English the terminology is uncertain, let alone the map representation.
[21] The term *kunstweg* is not used on the present series which also very conveniently incorporates a tri-lingual key (Dutch, French, English) as well, eliminating all possible difficulties.

are only rarely distinguished; on the other hand it is not unusual to find telephone lines marked on maps of less developed countries, partly for their intrinsic importance and partly perhaps as landmarks. The various minor features of communications such as bridges, embankments, cuttings, stations, mileposts, ferries, locks, etc., are usually distinguished, often in considerable variety, on many European map series.

Table 2

PORTUGAL 1:50,000	FRANCE 1:50,000		GT. BRITAIN 1:63,360	SABAH 1:50,000	CANADA 1:50,000
'Highways': 1. 'Autoroutes' 2. National (with no.) 3. Municipal and others 'Roads' 1. Municipal and others 2. Local 3. Paths and Tracks	'Routes Nationales' (all numbered) 1. Excellent viability 2. Good viability 3. Average viability 'Routes Departmentales' (all numbered) 1. Good viability 2. Average viability 3. Mediocre viability Other Roads 1. Regularly maintained 2. Not regularly maintained	all numbered	Ministry of Transport Roads (all numbered) 1. Motorways 2. Trunk and class 1 dual carriageway 3. As above single carriageway 4. Class 2 Other Roads 1. 14' metalling and over 2. Less than 14' metalling tarred 3. As above untarred 4. Unmetalled roads	1. All-weather road, bound surface 2. As above loose surface (1. and 2. marked either one-lane or two-lane traffic) 3. Dry weather road, loose surface 4. Track, jeepable 5. Footpaths, jungle paths, bridle-paths	1. Hard surface all weather road (subdivided into more than 2-lane, 2-lane and less than 2-lane) 2. Loose surface road all weather (subdivided into 2-lane and less than 2-lane) 3. Loose surface road, dry weather 4. Cart tracks and
NIGERIA 1:50,000 1. Main Roads 2. Secondary Roads 3. Main paths 4. Minor paths	Field and Forest Roads Mule Tracks Footpaths		5. Footpaths and tracks		trails

Road classifications from recent maps in six countries. Notice the transition from almost completely 'administrative' approaches (for example, Portugal, Nigeria) through to strictly objective ones (Sabah, Canada). Free translations or untranslated terms are in inverted commas.

Boundaries. Not surprisingly the map is the place, *par excellence*, for recording boundaries and though their terminology may be local and confusing their position is usually clearly indicated. The German practice of adding also a small marginal inset of the boundaries of administrative divisions found on the map is extremely useful, and could be emulated with advantage by other countries.

Depiction of Settlement, Buildings, etc., on Maps

As Fig. 23 has already hinted here is a tough nut to crack, so much so in fact that (unlike communications) all that can be attempted at small scales (say 1:200,000 and less) is virtually a diagrammatic representation – some indication of shape, a few really important features and perhaps differential printing of names to emphasise population

size or administrative function.[22] At slightly larger scales the presence of certain important urban features can be indicated by symbols or letters, either adjacent to the town, as on the Indian ¼″ and Sierra Leone 1:50,000 series, or properly located within the town. The latter process, which demands small yet legible symbols is helped enormously where some colour other than black is used for general settlement detail: red is the most frequently encountered choice, for example on the Spanish, Portuguese, French (some sheets) and Dutch 1:50,000 series and the Indian 1″ and ¼″ maps, though the grey formerly used on the seventh edition of the British 1″ map was excellent. Black symbols show up much more clearly against such backgrounds, but even so it is best not to attempt too much and items shown are usually confined to such important public buildings as churches, town halls, hospitals, head post-offices and barracks. Places like factories or power stations which are fully recorded in rural areas may or may not be so treated in towns, and one of the greatest difficulties in obtaining information about urban areas from maps is the inability to determine whether patterns shown are actual and complete or generalised.[23] Some United States and Canadian maps show city blocks coloured pink where only 'landmark' features are marked (even minor streets may be omitted); but many maps consistently shade city blocks either solid or merely peripherally, irrespective of their actual building pattern.

Greater space and less congestion assist the more complete rendering of settlement detail in rural areas, so that quite small features such as post-offices, schools, windmills and windpumps, monuments, inns, mines and quarries are often recorded. Oddly enough distinction between permanent and temporary settlement is rarely made, nor is that between farms and other buildings, though Scandinavian maps form a notable exception on both counts (see however p. 177). It is irritating to realise that though a map may satisfactorily establish the pattern of *buildings* in an area it may be impossible from it to establish the pattern of *settlement*.

Depiction of Land Use and Vegetation on Maps

On most topographical maps of scales of 1:100,000 or larger, a greater variety of land use is distinguished than many people expect. Man-made land use is perhaps the easiest to record and most categories which have any permanence may be marked – for example: tree crops (vines, olives, hops, nuts, orchards, osiers, tea, rubber, coffee, coconuts, cacao); specialised 'croppings' such as rice, sugar cane, glasshouses, bulb fields, oyster beds, salt pans, and other 'permanencies' such as water meadows, moors and heaths, bogs, cemeteries and urban parks.

'Natural' vegetation presents more problems, partly because of the great variety possible within broad categories such as 'forest' or 'grassland' and partly because of the

[22] Differential printing of names is widely employed at larger scales as well, of course. On the French 1:50,000 map the population (in thousands) of each place is conveniently printed under the name – a useful addition which takes up little space.

[23] At small scales this problem can apply in rural as well as urban areas: e.g. on the Swiss 1:100,000 map the number of buildings shown represents about 40% of the actually existing single houses. Huber, E. 'The National Maps of Switzerland', *International Yearbook of Cartography*, II, London, 1962.

lack of sharp boundaries. It is here also that interpretational difficulties begin. Areas marked as 'forest' in, say, England, Spain, Ghana and Siberia would have very different connotations, yet it is not easy for the map to be precisely objective without embarking on a very detailed classification. Nevertheless today, thanks to the ease with which vegetation may be identified and plotted from air photographs, many maps can be quite ambitious in this respect, and topographical maps in some areas may be regarded almost as vegetational maps as well: the Kenya 1:50,000 map distinguishes nine types of natural vegetation, the British Honduras 1:50,000 series nineteen.

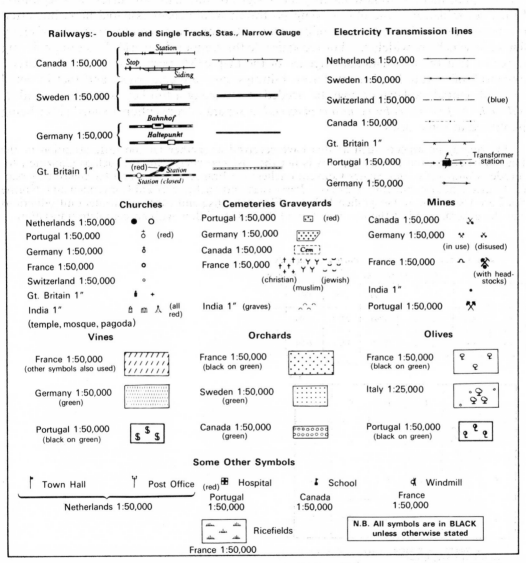

Fig. 26: A selection of conventional signs taken from current European and foreign official map series at about 1:50,000 scale. All signs and symbols shown are actual size.

Conventional Signs on Maps

The ability of the map to record the enormous variety of detail described in the preceding sections rests very largely on the successful use of symbols and colour: so much so that the *conventional signs* which are used really form the essential vocabulary of any international cartographic language, and their range and complexity might form a study in itself.[24] A comprehensive review of so extensive a subject is quite impossible within a book such as this, but in Fig. 26 a cross section has been selected and the reader may form his own judgement as to how far they show signs of international currency or legibility. Visual resemblance to the object being portrayed would seem essential here, but often this must be subordinated to ease of drawing and compactness and there are surprisingly few signs which are widely used or recognisable throughout the world. It is disappointing to realise that the international language of the map exists perhaps only so far as broad categories of feature (settlement, forest, railways, etc.) are concerned, and that in detail very substantial explanation may be needed; fortunately a full key is usually provided, *although the practice is by no means universal*, a separate 'conventional signs' sheet being published in some cases.

[24] Cartographic aspects such as this have received altogether far too little attention in the English language, but fortunately this is not the case elsewhere. Studies such as Couzinet, M. 'Etudes Comparative des Signes Conventionelles: (1) France 1:20,000 and Germany 1:25,000: (2) France 1:20,000 and Italy 1:25,000', Paris 1947 and 1948; or 'Segni Convenzionali e Norme Sul Loro Uso', Istituto Geografico Militare, Florence, 1954 and 1955 are excellent introductions and the general trend of the text is not at all difficult to follow without complete translation.

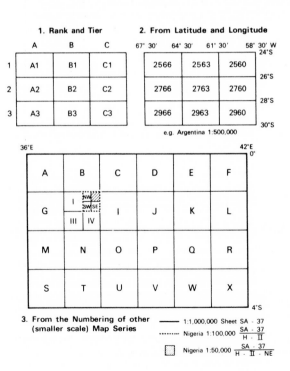

Fig. 27: Different types of sheet numbering.

Other Information on Maps

The most neglected part of a map is normally that portion lying outside the main frame line. This is unfortunate for there is often much recorded there which may enhance or qualify what is shown on the body of the map or which may be essential to its practical use. The margin of the map *should* indicate, for example, who published the map, the date of survey, the date, extent and perhaps method of any subsequent revision, and information regarding latitude and longitude, magnetic variation, the reference system (if any) and the projection. There will also be such obvious features as the scale, a line scale, the sheet number and the numbers of adjoining sheets. Most of these items are either self-explanatory or dealt with elsewhere in this book, but a possible exception is sheet numbering, of which quite a variety of systems is in use. The essential ideas, however, are all simple and are explained in Fig. 27.

Chapter 5 Map Printing and Reproduction

It is always interesting for those who use maps to have some knowledge of the methods by which they are printed, but the inclusion in this book of a chapter on this topic rests on much firmer foundations than that. Map printing and production techniques have a most important part to play in affecting both the design and cost of the modern map; they have been the principle factors behind the remarkable change in the appearance of maps during the past century, and the fact that one can still buy a multicoloured representation of Britain at 1″ scale at the ridiculously cheap rate of ten square miles for one penny is closely tied to technological changes in map production.[1] Fortunately many of these changes, though complex enough in their technology, are simple and easily understood in principle. It is no part of the intention of this chapter to do more than explain the main processes in sufficient detail to allow the map user to appreciate the way in which they affect and contribute to the design of the finished map.

Map Printing from Engraved Copper Plates

The replacement of the manuscript map by the printed version appears to have begun in the fifteenth century soon after the introduction of printing into Europe, and the process which developed at that time of printing atlases and sheet maps from engraved copper plates, remained the standard one until the mid-nineteenth century.

The essential stages of this process are shown in Fig. 28A and the end product was often a map of considerable beauty, for very fine line work indeed could be produced whilst the lines still remained sharp and clear because each was formed of a tiny ridge of ink. There are disadvantages too, however. The cutting of the plate is a slow, highly skilled and hence expensive process,[2] and the relatively soft copper wears fairly quickly in use, needing recutting after about three thousand copies have been taken. Printing by this method is slow, corrections involving erasures from the plate are difficult to make, and the method is not really suited to colour reproduction; coloured line work, for

[1] For comparison four-colour copies of the third edition at the turn of the century work out at about 12 square miles for one penny. Increased demand has undoubtedly helped to spread production costs but technological change must have done a great deal to counteract rising wages and raw material prices.

[2] This is easily envisaged. Take any early closely hachured map such as a first edition 1″ Ordnance map or the Swiss 1:100,000 *Carte Dufour* (Fig. 24) and imagine the work involved in cutting each line, letter and hachure on that map as an individual groove in a copper plate.

example for rivers, comes out well enough but coloured areas are too easily 'wiped thin' during the wiping of the plate.

In the mid-nineteenth century the introduction of *electrotyping* allowed the production of duplicate plates by electrolytic deposition of copper, thus preserving unworn the valuable originals; but even so, printing from engraved copper plates remained too slow and expensive and, excellently though it served cartography for four hundred years, the method has been almost entirely superseded by later developments.

Printing by Lithographic Processes

From the mid-nineteenth century *lithography* began to displace engraving as a means of map printing. Fig. 28B shows the main stages in this process, which was reputedly discovered accidentally by Senefelder, a Bavarian, in 1790. Provided that the 'plate' (i.e. stone) is inked and wetted between each copy the printing process can be repeated almost indefinitely,[3] and since large areas of colour reproduce as satisfactorily as line

[3] The surface of the stone wears in time but much more slowly than a copper plate.

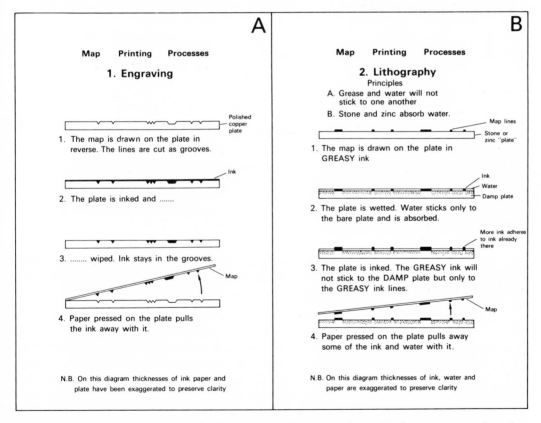

Fig. 28: Map printing processes: **A:** from engraved copper plates; **B:** from stone or zinc plates by lithography.

work, the introduction of lithographic techniques made possible the appearance of the 'modern' type of coloured map as opposed to the older black and white one.

Unfortunately the smoothed, prepared stones were expensive and their bulk and fragility made them relatively inconvenient to store as original plates, so that often an engraved copper plate was made as a 'master', fresh copies in greasy ink being taken from it and laid down on any clean stone whenever printing was needed. In this way the image of the map was 'transferred' to the stone and printing could begin.

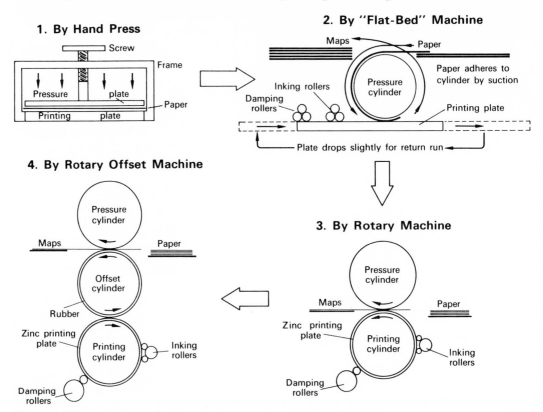

Fig. 29: The evolution of map printing techniques. The illustrations shown here are entirely diagrammatic and are intended to convey an impression of the principles involved only, not of the actual machines which are used.

The realisation that thin sheets of zinc (later aluminium too) could be substituted for stone in the lithographic process gave rise to zincography which removed several disadvantages, and increased the potential of the method. Not only were zinc sheets cheaper and easier to store than stone but their flexibility allowed them to be used in modern high-speed *rotary printing machines*, instead of the slower *flat-bed* type necessitated by the rigidity of the stone (see Fig. 29). Wear of the printing plate by friction demanded renewal of the plate after between thirty thousand and fifty thousand copies with stone and a flat-bed machine, as against about ten thousand copies with zinc and a rotary machine: but in the latter case, wear has been considerably minimized in modern presses

by the introduction of an *offset* cylinder, i.e. a plain cylinder covered with a blanket of rubber. In a rotary offset machine (Fig. 29)[4] the printing plate prints the map onto the rubber cylinder which in turn prints it on the paper: the worst friction occurs between the paper and the rubber cylinder (which can easily be renewed), and coarser, more absorbent paper which will take fine line work can be used without excessive wear of the printing plate. It should be noticed in Fig. 29 that the essential requirement of lithography – that the plate should be inked and wetted between each copy – is met by ensuring that during each revolution (rotary) or 'run' (flat-bed) it comes into contact with rollers continuously supplied with ink or water.

Heliozincography

The thin zinc sheet had one further advantage: photo-sensitive coverings could easily be applied to its surface and used to overcome the difficult process of establishing the initial map drawing on the printing plate without resorting either to drawing direct (in

[4] Flat-bed machines may also similarly incorporate an off-set cylinder.

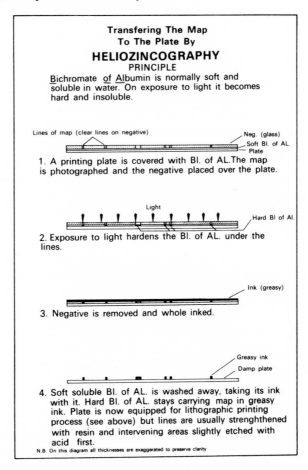

Fig. 30: Heliozincography.

reverse, of course) or transferring. *Heliozincography*, which makes use of such a photo-sensitive coating, is a process commonly used to achieve this in map printing and its essential stages are shown in Fig. 30. The glass negative needed in stage 1 is at the finished scale of the map and is usually obtained by photographically reducing an enlarged drawing. By this means finer line work can be incorporated than would be possible working at the reproduction scale, lines are sharpened and any errors in draughting minimised; the negative itself can be used to produce any number of plates as these wear out and corrections are easily made by painting out lines no longer needed or scratching in any new detail.

Photographic methods of transferring images to the printing plate, and the subsequent use of these plates in a rotary offset printing machine have now become so widely employed that the processes are often referred to as *photo-lithography* ('photo-litho' for short) and *offset photo-lithography* respectively, though the first term is sometimes used to cover the whole process, not just the transference of the image to the printing plate.

Colour Printing of Maps

The development of lithographic techniques greatly facilitated the incorporation of colour into map design; but the full implications of this can only be understood when something is known of the main considerations in the colour-printing process. In particular one fundamental principle stands out above all others – only one colour can be printed at a time. An eight colour map, for example, will need eight trips through the printing press with consequent increase in cost. Some modern presses do in fact print two or more colours in the same trip or pass, but the principle still applies, since each colour is printed at a different place on the machine. This factor indicates quite clearly why the maps of many countries are printed in only two or three colours, and why in those of others steps have recently been taken to reduce the number of colours used in former editions or printings.[5]

The second point follows quite obviously from the first. If only one colour is printed at a time a set of plates will be needed in which each carries only the detail to be printed in one particular colour. That detail must also be in perfect *register*: must, in other words, fit exactly, in respect of both shape and position on the map, with detail from other plates once this is superimposed: the coloured filling of a road, for example, must fit exactly into the printed black outline.

The necessary printing plates, one for each colour, are made by heliozincography from negatives each of which shows only the detail relating to that colour. The perfect register between detail printed from these plates is ensured by deriving them from a common 'ancestor', usually a negative of a drawing which contains *all* the detail of the finished map, unwanted portions being subsequently eliminated, often by one of the following methods:
1 *'Blue pulls.'* The negative is used to prepare (by heliozincography) a plate of the *complete* map from which copies are printed in pale blue, one for each colour plate needed.

[5] The Ordnance Survey have recently reduced the number of colours on both the 1″ and ¼″ maps. As long ago as 1922 the Institut Géographique National eliminated the red and purple plates from the design of the French 1:50,000 maps, except in special areas.

On these 'blue pulls' there is inked in (in black)[6] only the detail appropriate to one particular colour, and the drawing is then photographed in strong blue light; the pale blue background does not reproduce (because of the blue light) and the resultant negative therefore carries only the detail which was inked in. Provided inking in is done accurately over the pale blue guide lines, detail will be exactly right in shape and position to fit that similarly prepared from other plates.

2 *Opaquing negatives.* Sufficient copies of the 'whole map' negative are made to allow one for each colour and on each of these in turn those lines which are not needed for that colour are opaqued, i.e. painted out. The method can only be used for relatively simple maps but an adaptation of it assists in the following process.

3 *Scribing.* Scribing is increasingly replacing drawing in cartographic work and consists in producing a *negative-type drawing* by scraping away an opaque coating applied to glass or dimensionally stable plastic sheets. It is thus the opposite of drawing which gives a positive-type image by adding ink or other media to some surface. Special scribing tools known as *gravers* are used to draw (i.e. scrape away) the lines and the method generally gives speedier and better results than ink drawing with pens. In addition to the opaque scribing-coat the sheets may also carry a second, photo-sensitive coating onto which the design of the map may be contact-printed, usually from a series of opaqued negatives made as described above. The difficulty in producing fine, intermeshed line work with opaqued negatives does not prove troublesome here since the contact-printed lines are used only as a guide, the subsequent scribing producing the necessary sharp and accurate negative needed for each colour plate.

To ensure, as printing proceeds, that each plate prints its detail in exactly the right position relative to the others, certain *fitting-marks* are always incorporated on all plates. These are usually small ticks marking the corners of the sheet, and each must be superimposed on those already printed for perfect register between plates. The resultant brownish or greyish superimpositions are easily seen in the corners of many coloured maps.

The description above is no more than the briefest outline of essential parts of the colour-printing process, but it will suffice to re-emphasise the point that, attractive though coloured maps may be, colour printing increases the cost of a map very considerably. In particular greatly increased amounts of draughtsmanship are needed to produce a coloured map, and it is not surprising that most survey establishments are constantly seeking new ways to reduce preparation cost, especially by eliminating slow hand-draughting. With colour itself it should be remembered that several shades can be obtained from one colour by using variations from solid colour through different types of shading and stipple to almost white, in the same way that several shades are obtained using only black and white in some of the maps in this book, for example Fig. 68, p. 173. In layer colouring of relief, for instance, nine shades with reasonable transition could easily be built up from three colours by shading and overprinting.[7] In the actual drawing process shadings, stipples and symbols are often applied to negatives or drawings by

[6] In all colour processes the actual colour itself is not introduced until it is applied as coloured printing ink in the press during the last stage in the process.

[7] e.g. hatched yellow, cross-hatched yellow, solid yellow, hatched orange on solid yellow, cross-hatched orange on solid yellow, solid orange, hatched brown on solid orange, etc.

cutting out portions of ready-printed transparent adhesive sheets, and in the vast majority of establishments hand-drawn lettering was replaced years ago by printed lettering, again usually on adhesive material, to be cut out and stuck on the map. With scribed negatives lettering can now even be scribed by machine directly into the scribing-coat; indeed, in all aspects of map production technological change and mechanisation of time-honoured hand-processes proceed at a rapid rate.

There is nothing new in this. The Ordnance Survey were replacing hand-drawn ornament and names on the 1:2500 map by stamped and typed versions as early as the 1860s, and though purists at first objected to the 'mechanical' appearance such innovations produce, the whole trend has long since been accepted as an integral part of map production. Ironically enough the differences produced in design by this mechanisation may be so slight as to escape the notice of the casual observer: but they are there nevertheless, playing their part in ensuring that attractive modern maps are produced as cheaply as possible.

Chapter 6 The Evolution of a National Map Series—The Ordnance Survey Maps of Britain

Chapters 1 to 3 have described the events which led to the entry of the state into the field of topographical mapping, and chapters 4 and 5 some considerations which affect the design of maps generally. This final chapter in the section on 'thinking about maps' uses a review of the evolution of one national map series to gather together and illustrate many points made in the earlier chapters. A study of the evolution of the old-established and very complete range of Ordnance Survey maps lends itself particularly well to this purpose, and the description may also help to further an understanding of the potential of such a series for research work. Unlike certain continental counterparts, the history of the Ordnance Survey maps was, until recently, very imperfectly recorded,[1] and though the situation has now been remedied by Harley and Phillips[2] this chapter will provide at least an outline guide in a field where literature is still too scanty. It begins with a rapid review of the origins of each map series and passes onto a consideration of their form, characteristics and history.

General development

The initial aims of the official survey newly-established in 1791 were modest enough – to establish a national triangulation framework and produce a basic map of the country at 1″ to a mile. Work on both was slow, and the triangulation was not finished until 1853, but fortunately the parallel progress of the detailed mapping allowed a map of Kent to be published by 1801, and from there coverage spread gradually westwards and northwards.

Military considerations were important to this early venture, as they were to mapping elsewhere in Europe, but promptings of a civil kind soon began to affect development. In 1824 a House of Commons committee recommended that a survey at 6″ to a mile be

[1] e.g., there is nothing to compare with M. Huguenin's *Historique de la Cartographie de la Nouvelle Carte de France*, Paris 1948.

[2] Harley J. B. and Phillips, C. W. *The Historian's Guide to Ordnance Survey Maps*, published by the National Council of Social Service, 26, Bedford Square, London W.C.1, price 5/-.

undertaken to help the recording and assessment of local land taxation in Ireland, and since no other body could undertake such a task the work was entrusted to the Ordnance Survey. Large numbers of personnel were immediately despatched to Ireland, and on the completion of the work in 1846 that country became the first portion of the globe to be mapped fully on such a scale: the cost was £800,000.

Once the great usefulness of this Irish map became apparent Parliament was naturally urged to provide a comparable one for the rest of Britain, and in 1840, when the 1″ mapping had progressed as far north (roughly) as the Hull–Preston line, consent was given to the mapping of the six remaining northern counties of England[3] and all Scotland at the 6″ scale – though not without misgivings about the cost in the years that followed.

Meanwhile a considerable body of opinion was agitating for even larger scale maps in both rural and urban areas. Maps of this kind were certainly much in demand from bodies concerned with activities as varied as urban building, mineral exploitation, land registration and conveyancing, tithe commuting or the laying out of land drainage, water mains, sewers and railways; and so long as no uniform national map series was available this demand continued to be met by innumerable, expensive local surveys, unsatisfactory because they lacked any uniformity of style, scale or reliability. In circumstances such as these tacit acknowledgement of the need for an official very large-scale map series was not long delayed, though unfortunately this triggered off a protracted dispute as to the best scale for the series, the so-called 'Battle of the Scales'. Eventually in 1853 a survey of County Durham was authorised at 1:2500 scale (approximately 25″ to a mile) and in 1856 this was adopted as the basic scale for all parts of the country except mountainous and moorland areas. A re-survey of the country, lasting from 1853 to 1893 was needed to produce the new 25″ map and the 6″ and 1″ scales were then derived from it by reduction.

1:2500 was not, however, the largest scale adopted by the Ordnance Survey. When the 6″ map of Lancashire and Yorkshire was being made in the 1840s towns with more than four thousand population were mapped at 1:1056 scale (5′ to a mile), and in the next ten years further developments (for example the need to plan sanitation schemes following the Public Health Act of 1848) led to the decision to produce a 1:500 map of all towns of four thousand population and over throughout the country.[4] More than four hundred towns were mapped in this way before the series was discontinued in 1894, even the state forbearing to undertake so costly and protracted a piece of work.[5] After these remarkable 'Town Scales' anything else was anticlimax, and from the turn of the century until after World War II (see below) the 1:1056 map of London and enlargements of some of the 1:2500 sheets to 1:1250 scale were the largest scale maps produced by the Ordnance Survey.

So far as mapping at scales smaller than 1″ to a mile was concerned the state was slow

[3] Lancashire, Yorkshire, Durham, Westmorland, Cumberland and Northumberland.

[4] 1:500 equals just over 10′ to a mile. The Ordnance Survey had already prepared, on private contracts, surveys of some towns at 1:528 scale (10′ to a mile) and both groups are sometimes termed the 'ten-foot plans'.

[5] Until 1908 the Ordnance Survey would *revise* any such plans at the local authorities expense and a few towns took up this option. London was exceptional in all this. The basic scale was 1:1056 (not 1:500) and the maps *were* revised at intervals until their replacement by the modern 1:1250 series.

to enter a field already competitively supplied by private publishers,[6] and the official series often had specific and utilitarian beginnings. For example a $\frac{1}{4}''$ to a mile map was begun in 1859 as a base map for indexes of the larger scales, but it received low priority and was not finished until the 1880s when it was also needed as a base for the $\frac{1}{4}''$ Geological map series. Similarly the little known Ordnance Survey $\frac{1}{2}''$ series was begun in 1902 in response to a War Office demand for a map at this scale for military training purposes. Private competitors were well established,[7] however, and though the $\frac{1}{4}''$ series was popular enough the official $\frac{1}{2}''$ map never managed to establish itself quite so successfully, and with the destruction of the plates in the Blitz it eventually disappeared.[8]

Two other maps, at ten miles to $1''$ (1:633,600) and 1:1,000,000, completed the Ordnance Survey's small-scale maps. The former was much used as a general and motoring map;[9] the latter grew from the International Series, recast onto more convenient sheet lines.

In 1935, for a variety of reasons (see below) Parliament established the Davidson Committee to investigate and review many aspects of Ordnance Survey maps. The range of maps available for their inquiry has just been described, but oddly enough this was, perhaps, one of the few occasions on which it had been looked at as a whole. The range had developed, as we have seen, in rather an *ad hoc* fashion and, though the Committee's inquiry showed that there was little fundamentally wrong with the maps, these betrayed their separate evolutions in minor but irritating ways. Following the committee's recommendations Britain obtained for the first time, a fully integrated national map series; but this involved so many fundamental changes in map design and layout that it will be as well to consider the 'pre-Davidson' maps first, as a group, before bringing the story up to date.

The 1" and Small scale Ordnance Survey Maps

Between 1801 and 1935 the 1" map ran to no less than five editions, the first two, from 1801 to 1890, covering a period of fairly static design, and the final three one of much more rapid response to technological change and to public interest and demand. The maps of the first edition or *Old Series* were relatively simple and unsophisticated productions. Drawn on a Cassini projection (see p. 11) they covered England and Wales in one-hundred-and-ten sheets (mostly $36'' \times 24''$) printed in black only from engraved copper plates and showing relief (by hachures), together with the general features of the landscape (see Fig. 31). Lack of colour,[10] and the hachures, clearly distinguish them from modern maps, but so do other less obtrusive features. ·Conventional signs, for

[6] Often, of course, with maps derived from the Ordnance Survey's products, after due payment of royalties.

[7] e.g. Bartholomew's $\frac{1}{2}''$ map of Britain in thirty-seven sheets (the ancestor of the one still widely used) was begun in 1888 and is claimed to have been the first map in the world to show relief by contours and layer colouring.

[8] A post-war attempt to reissue this scale has been abandoned.

[9] Now also discontinued but replaced by similar maps in the 1:625,000 'National Planning' Series.

[10] Coloured versions may be found but the colour was hand-applied.

Fig. 31: The Old Series (or 1st edition) 1″ Ordnance Survey map: part of sheet 15, published 1811.

example, are virtually absent (important detail is usually named) and so too are footpaths, most boundaries, information relating to magnetic variation and any reference system other than marginal markings of latitude and longitude. Characteristically a key is neither needed nor provided.

Because it was a pioneer state production, antedating its successor by half a century or so, the Old Series has considerable historic as well as cartographic significance, though few Ordnance Survey map series present more difficulties in this respect. The essential problem is to date copies of sheets 1–86, which were originally published between 1805 and 1840[11] (see Fig. 32). The date shown on the maps is that of the original *publication* and as such is only of limited usefulness. Survey date (which is recorded only on the manuscript drawings now in the British Museum) may precede this by anything from ten to twenty years and, moreover, this publication date remains unaltered on subsequent printings, many of which incorporate partial or complete revision no details of which are given. Railways were often added at these later printings, and may help to date a sheet, but it cannot be assumed that the whole sheet was revised along with the railway detail.

After 1840 the 1″ map was obtained by reduction from the 6″, and in consequence sheets 87 to 110 not only show a more finely drawn, precise style but are also found, from the 1850s onwards, published additionally in a *contoured* version, the contours being taken from the 6″ map. The advantage of these later sheets over the cruder earlier members of the series led to a decision to produce a second edition, similarly derived, for the rest of the country. This was the *New Series* which, though it contains certain additions, for example parish boundaries,[12] still closely resembles the Old Series. The most striking

[11] The very first Ordnance Survey map of Kent, published in 1801 does not form part of the series. It had odd echoes of contemporary private practice, being published privately, by William Fadden, as a county map in four sheets. When national sheet lines were laid down and official publication began in 1805 these maps were redrawn to fit in with the series.

[12] In the north of England these are ecclesiastical parish boundaries. The township boundaries (equivalent to parish boundaries in the south of the country) are not shown.

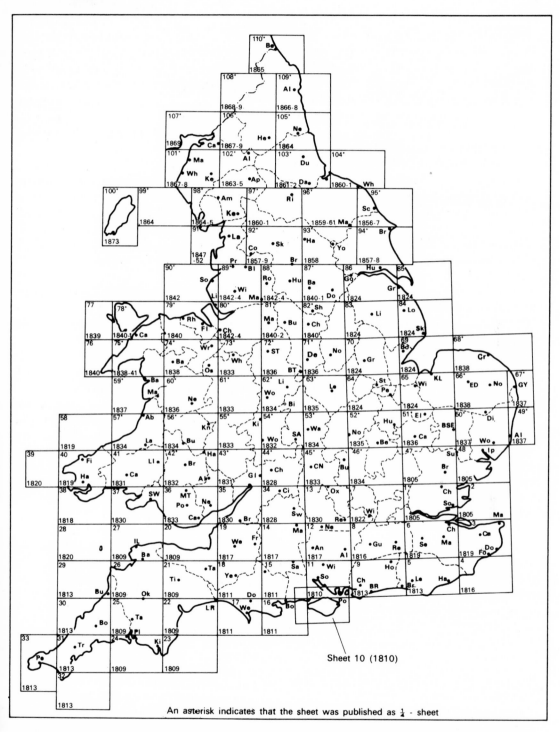

Sheet 10 (1810)

An asterisk indicates that the sheet was published as ¼ - sheet

Fig. 32: The sheet lines of the Old Series (or 1st edition) of the 1″ Ordnance Survey map of England and Wales. Dates given are those of *publication*: either of the whole sheet, or the range of dates of the publication of the quarter-sheets. Towns are indicated by their first two letters.

changes are the reduction in sheet size to 18″ × 12″ entailing three-hundred-and-sixty sheets to cover the country (see Fig. 33)[13] and the introduction of two styles, one contoured only, the other carrying contours and hachures though still in black and white only. Historically the co-existence of the more detailed 6″ map renders the New Series of less significance than the Old; the survey ran from 1840 to 1890 with many sheets published between 1870 and 1885, and, as with the Old Series, some reprinting and revision occurred. This is usually fully recorded on the map, but even so doubt exists as to whether such revision was complete or confined to major items only.

Between 1893 and 1898 a new revision, at 1″ scale only, heralded the appearance of the complex third edition which was to begin the transformation of the 1″ into a modern map.[14] In its earliest form this third edition was simply a black and white outline map, beautifully printed from engraved copper plates and using only contours to show relief, but a second version was available with the same detail, plus hachures in black or brown. This marks the first application of lithographic colour-printing techniques to the 1″ series, and an even wider incorporation of colour into the design was an obvious further development. This would increase the map's appeal against privately produced competitors as well as meeting a contemporary demand from the Army for a clearer map; and the series soon appeared in a fully coloured version at first in five, later in six colours. The popular market was further cultivated by the production of a cheap version (usually in only two colours) on special sheet lines covering the areas round major towns.

These 'modern' trends were amplified by changes in the detailed design of the map itself, which became far more specific and practical. For the first time much of the detail is rigidly classified: a crude road classification is used, railways are differentiated into double-track, single-track and mineral lines, churches into 'with spire', 'with tower' and 'without'. New details such as orchards, footpaths and a full range of *civil* parish boundaries appear,[15] whilst for the map user there are village postal facilities, magnetic variation and marginal markings for a reference grid of 2″ squares. Still more modern trends were apparent in the so-called 'Large Sheet Series' of one-hundred-and-fifty-two sheets, mainly 27″ × 18″, derived from a further revision of 1901–12 (the small format was retained for the *outline* form), and in special tourist sheets even more elaborately coloured and with contours, hachures and layer colouring to show relief.

Great hopes were centred on the elaborate use of colour at this time. Stimulating French experiments had been matched, in 1913, by an Ordnance Survey trial sheet of Killarney

[13] Many sheets of the Old Series had already been published as quarter-sheets at this size and in the north of England the sheet lines of the New Series and the quarter-sheets of the Old Series coincide. Whereas in southern England there were *two* 1″ maps produced from *two* surveys (the first for the original 1″ scale, the second for the 25″ and 6″ scales), in northern England there was only *one*. The Old and New Series here coincide, the same detail and sheet lines being used but differently numbered.

[14] There is some disagreement about the nomenclature of this edition. Harley and Phillips (*op. cit.*) treat this as another printing of the New Series, but the Davidson Committee's Report regards it as the third edition. In view of the many changes derived from it the latter terminology is to be preferred.

[15] The Civil Parish was introduced in 1871 to replace the Ecclesiastical Parish for many purposes. After 1879 Ecclesiastical Parishes, Hundreds and Wapentakes were discontinued on Ordnance maps and replaced by Civil Parishes.

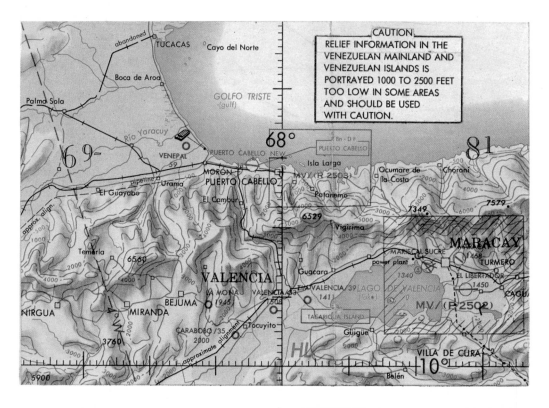

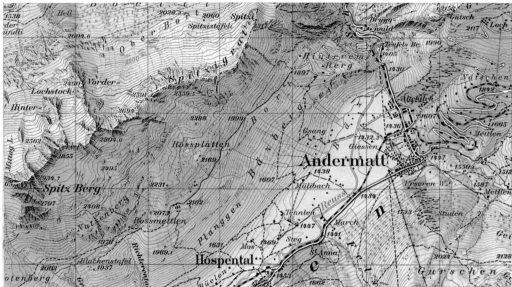

Plate 2: **A:** Part of sheet K-27 of the Operational Navigation Chart at 1:1,000,000 scale. (Reproduced by permission of the United States Department of Defense: USAF chart copyright.) The style is similar to that of the 1:1,000,000 World Aeronautical Charts, the purple detail being aeronautical information. Like plate 1A this is a compiled map and on at least three occasions – the railway from Palma Sola, drainage north of Temerla and lakes near Maracay – the maps contradict one another. **B:** European cartography at its best. Part of sheet 255 (Sustenpass) of the Swiss 1:50,000 series. The fine effect is achieved with a minimum of colour by rendering all communications in black only. (Reproduced with the permission of the Topographical Survey of Switzerland.)

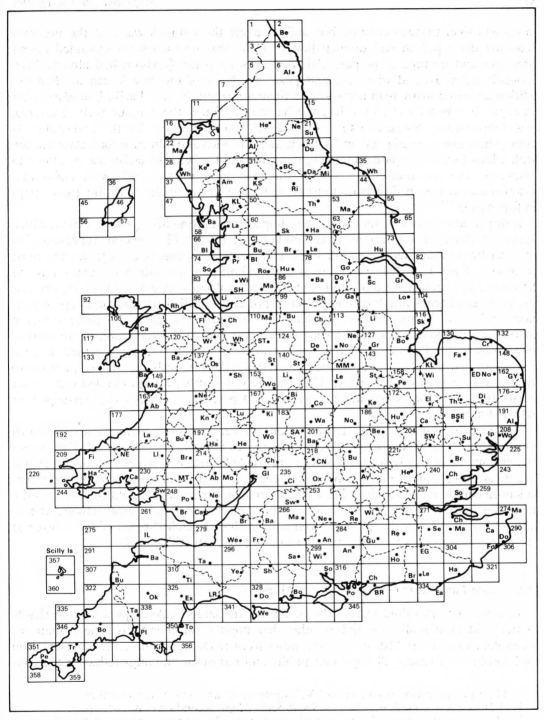

Fig. 33: Sheet lines of the New Series (or 2nd edition) and of the outline and *small* coloured sheets of the 3rd edition of the 1″ Ordnance Survey map of England and Wales. These sheet lines are *still* used for the 1″ Soil Survey map and the 1″ Geological map. Towns are indicated by their first two letters.

G

in no less than thirteen colours, but unfortunately the 1914–18 war and the post-war economy drive put an end to such hopes. There was no money for extended colour processes and no time to prepare elaborate printing plates (revision had already been seriously delayed); and when the first post-war sheets of the new fourth or '*Popular*' edition appeared many map users saw in them a retrograde step. Parish boundaries, for example, had gone, and so too had the hachures, though the contour vertical interval was stepped up everywhere to 50′ to offset this.[16] On the positive side there were slightly better sheet lines (see Fig. 34) and a much more detailed and objective road classification with which to woo a rapidly increasing motoring public. With its lavish use of colour to emphasise the communications system the Ordnance Survey might well claim that 'Motorists, cyclists, pedestrians, tourists and travellers generally will find these maps indispensable.'[17]

Indispensable or not better things were hoped for, and the fifth (relief) edition, which appeared after 1931, was nearer to the high hopes of 1913.[18] The elaborate representation of relief by contours, hachures, hill shading and layer colouring (see p. 63) was the most ambitious style yet attempted and moreover the whole map was redrawn so that improved lettering and many changed or improved conventional signs appeared. Quarries, wireless masts, isolated telephone boxes and electric power lines filled out the landscape detail; new symbols for Youth Hostels and National Trust property reflected a growing tourist market; parish boundaries came back, latitude and longitude intersections were marked by crosses on the face of the map and, most important of all, a grid was added. Even if references had to be by cumbersome full co-ordinates (in yards, see p. 114), a modern reference system was there at last. Unfortunately the fifth edition extended only as far north as Birmingham when war intervened, and post-war 1″ map series developed on rather different lines.

Although their smaller scales left less room for variation in content, the style of most of the other small-scale maps showed similar trends towards popular appeal. Each series began unprepossessingly with a coloured hill-shaded form, which was not too successful in representing gentle English topography, replaced in the 1920s by a contoured, layer-coloured edition on better sheet lines. Later versions particularly sought to appeal to the motoring public; road networks and classification were given priority among detail, and folded versions of the $\frac{1}{4}$″ maps eventually included detailed plans of the centres of the larger towns, a very useful attraction in a highly competitive field.

The 6″ and Large-scale Ordnance Survey Maps

In contrast to this fluid picture the designs of the larger-scale maps were remarkably static, yielding, if at all, to technical rather than popular considerations. The 6″ map, for example, changed very little in its first century from 1840, the true-to-scale representation and naming of virtually all important public and industrial buildings reducing the con-

[16] The rule had previously been 100′ V.I. up to 1000′ and 250′ V.I. above that.
[17] *A Description of Ordnance Survey Small Scale Maps*, second edition, 1920, p. 3.
[18] There was also a 'normal' edition with relief shown by contours only, as well as the usual black-and-white outline edition.

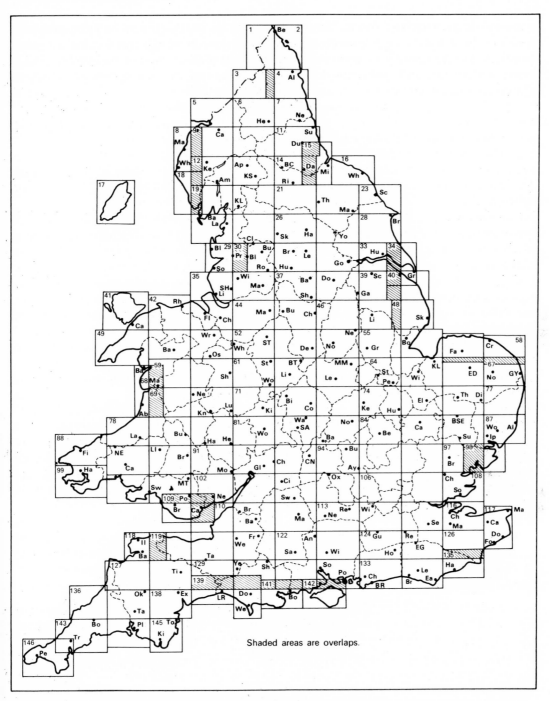

Shaded areas are overlaps.

Fig. 34: Sheet lines of the 4th (or Popular) edition of the 1″ Ordnance Survey map of England and Wales. These sheet lines were also used for the maps of the *first* Land Utilisation Survey of England and Wales. Towns are indicated by their first two letters.

ventional signs needed to those for double track railways, boundaries and various 'unusual' land uses (woodland, rough pasture, furze, marsh, osiers, reeds, sand, mud, pits and quarries). A very similar style and content was found on the 1:2500 maps (see Fig. 35A). From time to time minor changes occurred on both series: for example hedgerow trees and gates were not shown after 1892; certain public buildings were coloured solid black on the 6″ after 1897[19]; various types of 'filling' were used for buildings on the 1:2500 maps. But these were of small importance and the impression given is of two map series whose design was little affected by the passage of time.

In one important respect, however, the two series differed; there were no contours on the 1:2500 maps, only bench marks and spot heights. Contours were one of the great innovations of the 6″ map, though no constant vertical interval was maintained throughout the country and the variation in the relative numbers of the 'instrumental' and 'sketched' varieties was considerable.[20] Until 1912 altitudes on both scales were referred to the *Old* or *Liverpool Datum*, but from that date relevelling onto the new and more satisfactory *Newlyn Datum* was begun, and from 1929 onwards a factor allowing conversion from one to the other was printed on all revised maps.

If contours were the distinctive feature of the 6″ map, the peculiar prerogative of the 1:2500 scale was the numbering and recording of the area of each 'parcel' of land, at least in rural and 'open' built-up areas (the practice is impossible in 'close' development). Parcels were numbered in each parish[21] and the method is further described in chapter 9 (p. 141); it need only be noted here that areas given are for whole parcels until 1922, but to the plan edge only after that date.

Representation of boundaries formed an important consideration of both scales. Many sorts are shown, for example those of all local administrative units as well as parliamentary divisions, wards, poor law unions and catchment areas,[22] and on the 1:2500 scale they are 'mered' as well, i.e. their position is exactly defined relative to detail shown on the map.[23] Unlike many European counterparts the large scale British maps are not *cadastral* plans: they do not show property boundaries. They have always concerned themselves entirely with the physical details of the landscape – walls, hedges, buildings, for instance – and where property boundaries run close to, but not co-incident with these, the onus of defining their position is left to the landowner, not the survey.

In design both series eschewed colour. Hand-coloured 1:2500 sheets were available until 1892, and 6″ sheets with water hand-coloured blue for a while after that; but the 1:2500 maps remained devoid of printed colour, and the 6″ used it only for contours (from 1909) and later for classified road numbers. An exception was the series of special plans of the major towns at 6″ scale which appeared in the 1920s; they had yellow roads,

[19] e.g. churches, schools, railway stations. The list was considerably extended after 1922

[20] 50′ or 100′ V.I.'s were the most common. A full list is given in Winterbotham, H. St. J. L., *The National Plans*, London H.M.S.O. 1934, pp. 46–48.

[21] Only the parcel numbers were shown on the maps until 1886, the areas being listed in 'Parish Area Books' until 1872 and 'Books of Reference' from 1873 to 1886.

[22] Poor Law Unions and their boundaries are now discontinued; Catchment Area boundaries are not on the 1:2500 scale and the elusive Ward boundaries were marked on 6″ maps only until 1889.

[23] e.g. 4′ R. H., i.e. four feet from the Root of the Hedge on the side shown, and so on.

red buildings, blue water, green parks and purple boundaries and tramways,[24] a welcome change from the 'black and white' sheets of the normal series.

The detail and completeness of the 6″ and 1:2500 scales naturally makes them of considerable importance as historical records, and fortunately their history is better known and recorded than that of the early 1″ series. Both are national in coverage but, for technical reasons, were organised on county lines. In 1840, because no projection was then known which could carry a 6″ map of the whole country without showing appreciable distortion near the edges, the map was prepared in sections, all on the Cassini projection but with each county or group of counties having its own central meridian. Sheet size of 6 miles × 4 miles (36″ × 24″) was uniform, but sheet *lines* were unique to the county or group, which formed a complete cartographic unit, any areas on the maps beyond the county or group boundary being left blank at first.[25] Numbering was everywhere by counties, for example Dorset XXXIII, and when the 1:2500 series was added it was arranged so that sixteen sheets covered the same area as one full 6″ sheet and could be numbered from it, i.e. Dorset XXXIII.12.[26]

After the adoption of the 1:2500 scale the same survey formed the basis for both this and the 6″ maps, though the 1:2500 was usually published first. The 6″ was then made by reduction and re-drawing and it was the introduction of photographic reduction in 1891 which caused the 6″ to appear in the familiar quarter-sheets (i.e. NW; NE.; SW. and SE.); the camera could not take the sixteen 1:2500 maps needed for a full sheet and, with a few exceptions, publication in quarter-sheets became standard. Between 1912 and 1919 the institution of a scheme to reduce the number of county meridians from forty-three to eleven resulted in the sheets for six counties[27] being redrawn on new sheet lines to fit with their neighbours, but no more were so treated after the economy cuts of the early 1920s.

To maintain the usefulness of large scale series such as these, a systematic programme of revision was of prime importance, and in 1886 therefore, when the initial survey was nearly complete, the principle of *cyclic revision* was laid down, the maps for each county being revised every twenty years. Two revisions were attempted under this programme: the first took from 1891 to 1914, the second was started in 1904 but was interrupted by the War and never finished.[28] In 1919 in an attempt to cope with economies, staff shortages and accumulated back-log it was decided to revise the more sparsely populated counties only every forty years; but by 1922, with the situation little improved, revision in the 'twenty-year counties' was being confined to urban areas only, and after 1928 even this

[24] Unlike their continental counterparts British maps never really came to terms with the problem of clearly representing tramways. This series and the 1:2500 maps were the only satisfactory renderings.

[25] Later the area was filled in by 'adjusting' detail from the adjoining county or group.

[26] Until 1873, however, the 1:2500 series was published as a parish map; areas outside the parish boundary were left blank.

[27] Essex, Northumberland, Dunbarton, Linlithgow, Roxburgh and Stirling. The new sheets had their numbers prefixed by N.

[28] The reason for the overlapping dates is only partly obvious. Revision took twenty-three years, and the second revision should therefore have started in 1911; the 1904 start was caused by the need to revise Yorkshire and Lancashire which had been *re-surveyed* to bring them up to 1:2500 scale in the late 1880s but not therefore included in the first revision.

degree of order was abandoned, sheets anywhere being selected for revision simply according to need. The enchanting prospect of a long-continued twenty-yearly carto-graphic representation of the British landscape has thus never materialized, but that portion which does exist provides an enormously important and complete record that is of great value for research purposes. An account of its progress county by county, will be found in the table below.

Dates of Original Survey and Subsequent Cyclic Revisions of the County Series of 6″ and 1:2500 Maps of Great Britain

COUNTY	SURVEY	1ST. REVN.	2ND. REVN.
England			
Bedfordshire	1876–82	1898–1900	a
Berkshire	1866–83	1897–1899	1909–12
Buckinghamshire	1867–81	1897–1899	a
Cambridgeshire	1876–86	1896–1901	a
Cheshire	1870–75	1896–1898	1904–10
Cornwall	1859–88	1905–1907	a
Cumberland	1859–65	1897–1900	a
Derbyshire	1871–82	1896–1900	1913–21
Devonshire	1855–89	1902–1905	a
Dorset	1862–88	1900–1902	a
Durham	1854–57	1894–1897	1912–19
Essex	1861–76	1893–1896	1911–22 N
Gloucestershire	1873–85	1898–1902	1912–22
Hampshire	1856–75	1894–1897	1906–10
Herefordshire	1878–87	1901–1904	—
Hertfordshire	1865–85	1895–1897	1912–23
Huntingdonshire	1882–87	1899–1901	a
Kent	1858–73	1893–1897	1905–10
Lancashire	1842–49*	1888–1893*	1904–12
Leicestershire	1879–86	1899–1902	a
Lincolnshire	1883–88	1898–1906	—
London	1862–72	1891–1895	1912–14
Middlesex	1862–68	1891–1895	1910–13
Monmouthshire	1875–85	1898–1900	1915–19
Norfolk	1879–86	1900–1906	a
Northamptonshire	1880–87	1898–1900	a
Northumberland	1856–64	1894–1897	1912–22 N
Nottinghamshire	1876–85	1897–1899	1912–19
Oxfordshire	1872–80	1897–1900	1910–21
Rutland	1883–84	1899–1903	—
Shropshire	1973–84	1899–1902	a
Somerset	1882–88	1900–1903	a
Staffordshire	1875–86	1897–1902	1912–23
Suffolk	1875–85	1900–1904	a
Surrey	1861–71	1891–1896	1910–13
Sussex	1869–75	1895–1898	1907–10
Warwickshire	1880–88	1898–1904	a
Westmorland	1856–59	1896–1898	1910–13
Wiltshire	1873–85	1898–1900	1921–24
Worcestershire	1880–88	1898–1904	a
Yorkshire	1845–54*	1888–1893*	1901–14

Wales

Anglesey	1886–87	1899	1913–23
Brecknockshire	1875–88	1902–1904	a
Cardiganshire	1885–88	1900–1904	—
Carmarthenshire	1875–87	1903–1906	a
Caernarvonshire	1885–88	1898–1900	1910–14
Denbighshire	1870–75	1897–1899	1909–12
Flintshire	1869–72	1897–1898	1909–11
Glamorgan	1867–78	1896–1899	1913–16
Merionethshire	1873–88	1899–1900	a
Montgomeryshire	1874–87	1900–1901	—
Pembrokeshire	1860–88	1904–1906	—
Radnorshire	1883–88	1901–1904	—

Scotland

Aberdeenshire	1864–71	1899–1903	a
Argyllshire	1862–77	1897–1898	a
Ayrshire	1854–59	1893–1896	1907–09
Banffshire	1865–70	1900–1903	—
Berwickshire	1855–57	1896–1898	1905–06
Buteshire	1855–64	1895–1896	1914–15
Caithness	1870–72	1904–1905	
Clackmannanshire	1859–63	1895–1899	1920–21
Dumbartonshire	1858–61	1894–1898	1912–14 N
Dumfriesshire	1854–58	1898–1899	—
Edinburghshire	1852–54*	1892–1894*	1905–06
Elginshire	1866–71	1903–1904	—
Fifeshire	1852–55*	1893–1895*	1912–13
Forfarshire	1857–62	1898–1902	1920–23
Haddingtonshire	1853 *	1892–1893*	1906
Inverness (Mainland)	1866–74	1899–1903	—
Inverness (Outer Hebs.)	1876	1901	—
Inverness (Inner Hebs.)	1874–77	1898–1901	—
Kincardineshire	1863–65	1899–1902	1922–23
Kinross	1852–55*	1893–1895*	1913
Kirkcudbrightshire	1848–51*	1893–1894*	1906–08
Lanarkshire	1856–59	1892–1897	1908–11
Linlithgowshire	1854–56	1894–1896	1913–14 N
Nairnshire	1866–69	1903–1904	—
Orkney	1877–78	1900	—
Peebleshire	1855–58	1897–1898	1906
Perthshire	1854–64	1894–1900	—
Renfrewshire	1856–58	1892–1896	1908–12
Ross & Cromarty	1868–75	1901–1905	—
Ross & Cromarty (Isle of Lewis)	1848–52*	1895–1896*	—
Roxburghshire	1857–60	1896–1898	1916–19 N
Selkirkshire	1856–59	1897	—
Stirlingshire	1858–63	1895–1896	1913–14 N
Sutherland	1868–73	1903–1905	—
Wigtownshire	1846–49*	1892–1895*	1906–07
Zetland	1877–78	1900	—

Notes

a 2nd revision started but never fully completed.
— 2nd revision never started.
N 2nd revision redrawn onto new central meridian.
* No 1:2500 scale at original survey. '1st revision' is therefore a resurvey at 1:2500 scale.

If the older editions of the 6″ and 1:2500 series are a historian's delight, the even larger 'Town Scales' are surely his dream. The incredibly complete urban detail recorded on these maps (see Fig. 35B) deserves to be far better known than it is, and it is unfortunate that few sheets ran to more than one edition before the series was discontinued in 1892.[29] Sheet lines were individual on the 1:1056 scale, but the sheets of the 1:500 series were arranged twenty-five to each 1:2500 sheet giving numbers such as Yorkshire (East Riding) Gt. Driffield CLXI.12.17 – 'CLXI.12' being the number of the 1:2500 sheet of which the larger-scale map was part.

The Davidson Committee[30]

A review of the styles and scales of the range of Ordnance Survey maps which has just been described formed one of the main terms of reference of the Davidson Committee when it was set up in 1935; the other was to consider how to accelerate and maintain revision. Almost all the Committee's recommendations were, in fact, later adopted and it will be convenient in many cases to review the proposals and the results of their implementation together.

The first item to be dealt with was a technical one. Evidence was forthcoming that the 1:2500 series could now be carried throughout the whole country on one projection without serious error or distortion, and it was consequently recommended that a new *National Projection* be adopted and that all map series be redrawn onto it.[31]

The second recommendation was almost a corollary of the first, namely that a new grid, the *National Grid*, should be derived from that projection and superimposed on all maps; for a variety of technical reasons it was suggested that the metre, not the yard, should be the basic unit of the grid. Both recommendations have been adopted, and in addition a useful 'shorthand' method of giving grid references has superseded the cumbersome full co-ordinates of the 1930s (see p. 114).

The implied necessity of ultimately redrawing all the large scale series onto the new projection with its new grid led to some very interesting possibilities. Not the least disadvantage of the county arrangement of the 6″ and 1:2500 series had been that a whole book of index diagrams was needed to cover the country; to avoid this it was suggested that all re-drawn series should consist of square sheets bounded by grid lines so that the grids on the smaller scale maps, for example the 1″, could act as indexes, and the sheets could be numbered by a version of the grid reference of their south-west corner (see below).

Here then were three basic principles of map design which might be applied to the whole range of Ordnance Survey maps, but the Committee had first to consider just what scales that range should be composed of. Arguments in favour of changing from easily

[29] The towns of Lancashire and Yorkshire were among the few to be systematically surveyed twice, first at 1:1056, later (1888–92) at 1:500 scale.

[30] Officially 'The Departmental Committee on the Ordnance Survey'. Its findings were published as the Interim (1936) and Final (1938) Reports of the Departmental Committee on the Ordnance Survey, London (H.M.S.O.).

[31] The National Projection was in effect simply a transverse Mercator projection (centre 49°N., 2°W.), modified by shrinking the central meridian by 1/2500 of its correct length, thus obtaining a better balance of the very small errors found throughout the projection.

visualised 'British' scales to metric-type 'natural' scales, for example 1:50,000, were sensibly resisted[32] and a 'no change' verdict ensued, save for the suggestion that two new scales might be considered, one at 1:25,000 scale, to fill the rather large gap between the 6″ and 1″, the other at 1:1250 to provide a better map for urban areas than the enlargements of the 1:2500. Both proposals were later adopted. A War Office version made by photographically reducing blocks of 6″ maps had already proved the usefulness of the former scale, and a variety of circumstances helped the introduction of the latter. By 1945 many of the old 1:2500 sheets were so out of date that virtual re-survey rather than re-vision was necessary, and the cost of surveying in sufficient detail to carry the larger scale was not so greatly in excess of ordinary re-survey. Moreover a new primary triangulation of the country, to modern standards, had been begun in 1935, and from this the complete re-survey of the 1:1250 areas could be undertaken.

So far as details of style rather than scale were concerned the Committee were prepared to leave matters largely in the hands of the Ordnance Survey themselves, though two points warranted special recommendations. One was for more contours. The relative novelty of contours had caused them to be rather sparingly introduced onto the 6″ maps of the 1840s, and though additional ones had been added after recommendations made in 1893, many witnesses requested that still more be provided, especially on the larger scale maps. The other point was that the old system of numbering parcels on the 1:2500 map should be discontinued (it had been much confused by patchy revision), and some other system of reference substituted instead.

With styles and scales disposed of the Committee was left with the difficult problem of revision. For the smaller scales (1″ and less) the existing method was adequate. Since 1893 these scales had been revised separately from the larger series every fifteen years or so, with further revision incorporated at reprintings, but for the larger scales it was recommended that the old 'cyclic' revision be replaced by 'continuous' revision, i.e. that any sheet should be revised as soon as the amount of new detail warranted it. By and large the innovation has been most successful, and though the historian may complain that he has lost his complete record of an area at a given moment in time, almost all other map users have benefited by obtaining much more up-to-date maps.

The Contemporary Range of Ordnance Survey Maps

The implementation of sweeping changes along the lines recommended by the Committee has naturally taken a considerable time, but production of a fully integrated range of national maps is now well advanced, especially at the smaller scales where changes were less marked. With the ¼″ map a post-war fourth edition carrying the national grid has already been replaced by the new Fifth Series, at 1:250,000 (see p. 49) covering the whole of Britain in one series for the first time,[33] and using hill shading to supplement

[32] The only existing 'natural' scale was the 1:2500 and this was so near (25·344″ to a mile) to a 'British' scale that it caused no difficulty. The 1:2500 series is commonly referred to as the 25″ map.

[33] Previously England and Wales, and Scotland had been in separate series, sharing a joint sheet 1. Similarly until the Seventh Series of the 1″ (see below), the 1″ map of Scotland had always been separate and slightly different from that of England and Wales. The history of the Scottish 1″ is recorded in Harley and Phillips (*op. cit.*).

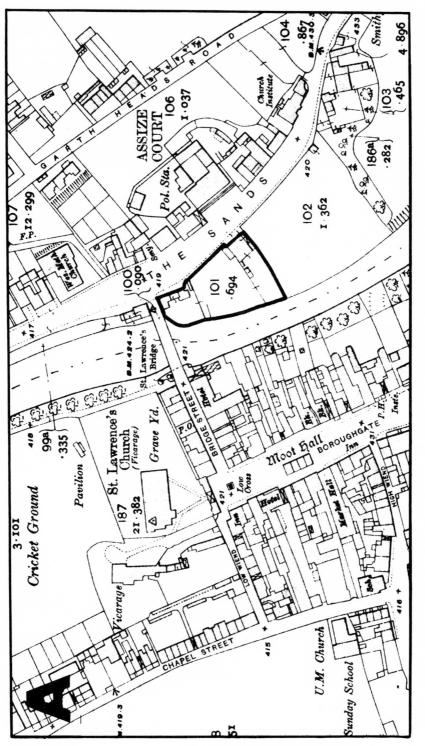

Fig. 35: Examples of two large-scale map series produced by the Ordnance Survey. **A:** Part of the 1:2,500 (25") sheet Westmorland IX.15, edition of 1916 (County Series). In larger towns and urban areas this series has usually been replaced by modern sheets of essentially similar design but arranged on National Grid sheet lines (see p. 98); for smaller towns and rural areas, however, County Series sheets sometimes up to half a century out of date, as here, still form the largest scale map cover available. The dark line in **A** encloses parcel 101 in Appleby Municipal Borough. **B:** (*below*) Part of the 1:500 sheet Yorkshire (West Riding) Knaresborough CLIV. 12.12. Something of the amazing potential of this series can be deduced here: each bush, tree, flower bed, etc., is correctly shown, even boundary walls need double lines, and a considerable amount of 'urban information' is included as well.

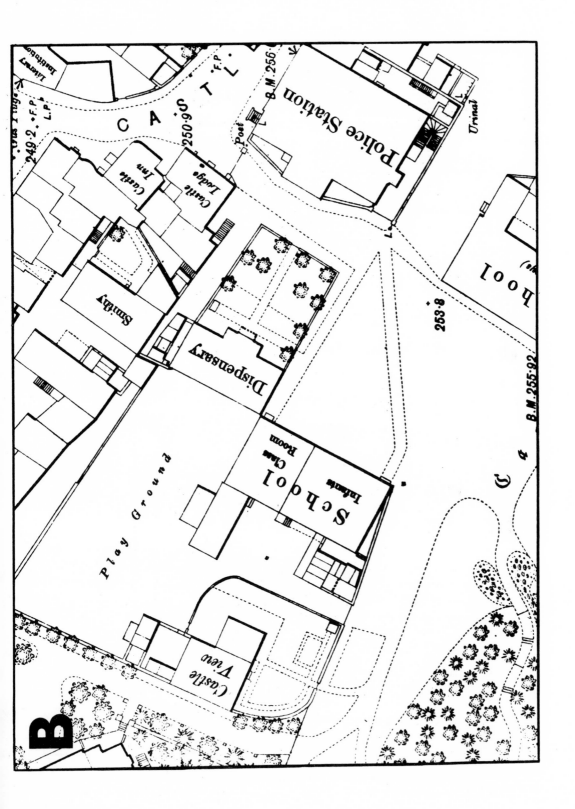

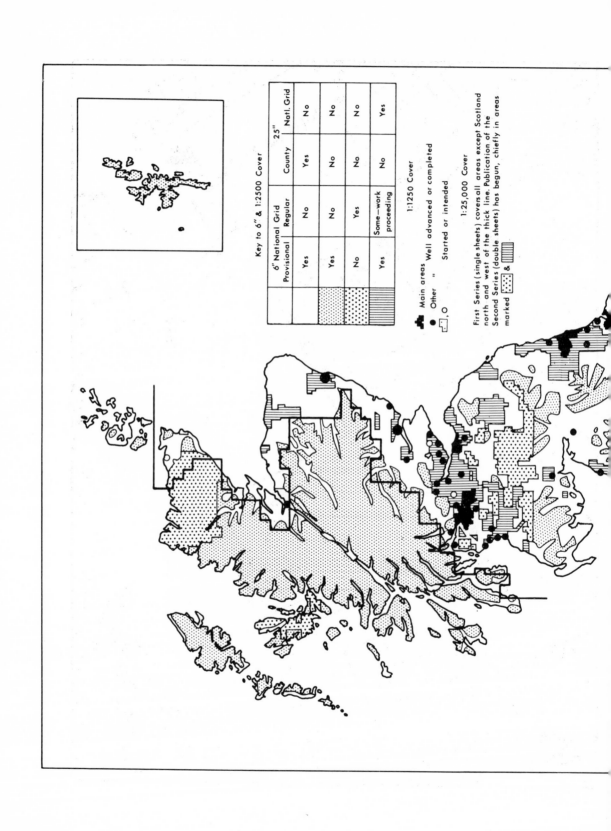

Key to 6" & 1:2500 Cover

	6" National Grid		25"	
	Provisional	Regular	County	Natl. Grid
	Yes	No	Yes	No
	Yes	No	No	No
	No	Yes	No	No
	Yes	Some—work proceeding	No	Yes

1:1250 Cover

- Main areas
- Other " Well advanced or completed
- ▪ , ○ Started or intended

1:25,000 Cover

First Series (single sheets) covers all areas except Scotland north and west of the thick line. Publication of the Second Series (double sheets) has begun, chiefly in areas marked ▦ & ▩

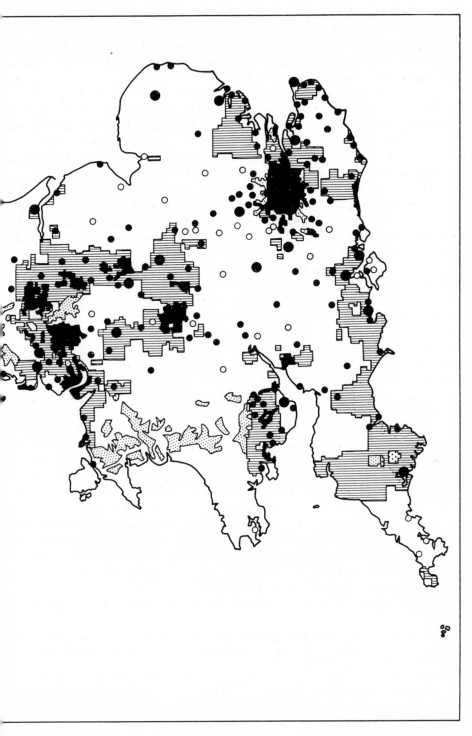

Fig. 36: Coverage of Great Britain by Ordnance Survey maps at scales greater than 1″ to a mile, 1966. (Compiled and redrawn from plate I of the *Annual Report of the Ordnance Survey*, 1965–6, with the sanction of the Controller of H.M. Stationery Office, Crown copyright reserved.)

contours and layer colouring in the representation of relief. To keep abreast of contemporary changes sheets are to be reprinted every three years.

At the 1″ scale the economy 'War Revisions'[34] were replaced by a stop-gap sixth or 'New Popular' edition, derived from revised portions of fourth or fifth edition maps, reissued on new sheet lines and carrying the National Grid. This has now, however, been replaced by the much improved Seventh Series on the same sheet lines but drawn on the new National Projection, and incorporating many 'popular' innovations.[35] No less than eight colours were used at first, three of these being devoted, in typical British fashion, almost entirely to the road classification; but unfortunately recent economies have led to a reduction to six colours in all, involving particularly the replacement of the very successful grey tone for buildings by a much heavier black stipple. Because indexing at such small scales presents no problems square sheets have not been adopted, nor has the very extensive pre-war range of sheets covering special areas been fully revived, though the number of special district and 'Tourist Sheets' is at last on the increase, many of these having hill shading and layer colouring to supplement contours, as well as a good deal of useful additional information not marked on normal maps.

Almost all sheets of the new post-war 1:25,000 series have been published as 'provisional edition', though subsequent events (see below) have made these, in effect, the 'First Series' of a map which covered the whole of the country except the Scottish Highlands (see Fig. 36). Because it is roomier than the 1″, provides a 25′ contour vertical interval, and contains almost the whole of the detail of the 6″ series, the 'two-and-a-half-inch map'[36] has become extremely popular, not least as a working 'field' or 'record' map. This provisional edition (or First Series) of the 1:25,000 map is the smallest scale map for which sheets have appeared in square format: they are 10 km square, and numbered by the full 10 km (two-figure) grid reference of the south-west corner (see Fig. 37).

Very recently, however, the first sheets of the Second Series of the 1:25,000 map have begun to appear. These are found only in areas where full *resurvey* of extensive areas at larger scales (6″ and 25″) has occurred (see Fig. 36), at the moment chiefly in the south-west and in the Highlands of Scotland *beyond* the area covered by the First Series. They differ in certain minor respects from the provisional sheets, chiefly in the use of a fourth colour, green, to represent woods and rights of way (the latter in England and Wales only), but they are published in *double* format, i.e. two sheets 'joined together' east-west and numbered by the numbers of both sheets separated by a stroke. For example, the sheet SK 83 in Fig. 37, when republished in double format, would appear as part of sheet SK 83/93, joined to the sheet SK 93 to the east, the western sheet of the pair being always the one whose number begins with an even digit.

The first post-war development of the 6″ map was the re-issue of the old county series

[34] The Fourth or Fifth (non-relief) editions in only four colours, heavily overprinted with the 'War Office' or 'Cassini' grid. Though based on the metre this was *not* the same as the National Grid since it was derived from a different projection.

[35] e.g. new or improved symbols for National Trust property, Bus Stations, Town Halls, A.A. and R.A.C. telephone boxes, Golf Course Club Houses, etc. Unlike the ambitious Fifth (relief) edition, however, only contours and spot heights are used to portray relief.

[36] Actually 1:25,000 = 2·534″ to a mile.

in 'Provisional' form, i.e. revised and with the national grid 'adjusted' (see p. 121) onto it. This has now been replaced everywhere, except in parts of the Highlands and Western Isles, by 'Provisional Edition' sheets of the National Grid Series, which are the same map reissued on new sheet lines 5 km square, each covering a quarter of the area of one 1:25,000 sheet and numbered therefrom (see Fig. 37). In a very few areas sheets of the

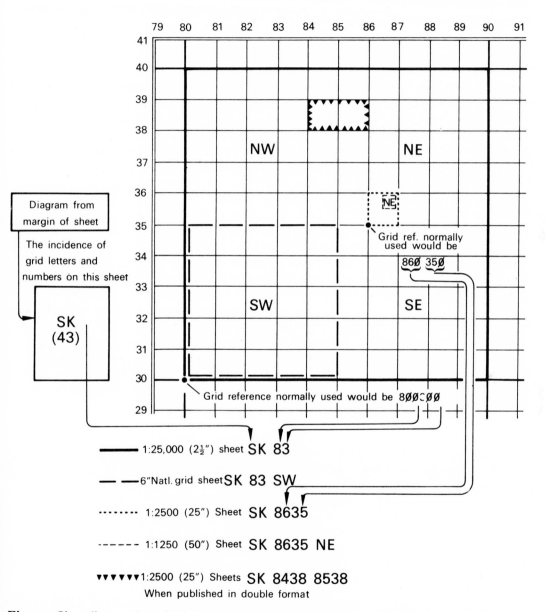

Fig. 37: Sheet lines and method of numbering of 1:25,000 (2½" to a mile), 6", 1:2500 (25" to a mile) and 1:1250 (50" to a mile) National Grid Series Ordnance Survey maps.

'Regular' National Grid Series have appeared (see Fig. 36), derived not by revision of old county maps but from the re-survey of the country plotted on the new National Projection. Sheet lines are identical with the 'Provisional' National Grid Series and style very similar, save that contours at 25′ V.I. are the rule on all 'Regular' National Grid Series sheets.

At 1:2500 scale the transition has not proceeded quite so far. In the areas shown on Fig. 36 re-survey has led to the production of the new *National Grid Series* sheets, 1 km square and numbered by the 1 km (four-figure) grid reference of the south-west corner, though they are usually published in double format, i.e. an east-west pair numbered from both sheets (see Fig. 37); changes in style are negligible save that parcels are now renumbered from the national grid and not by parishes. Elsewhere, however, the old county series remains in use and sheets may be forty years or more out of date in some rural areas.

The same re-survey which has produced the new 1:2500 sheets has also allowed the production of the new 1:1250 series for the main urban areas (Fig. 36). Sheets are 500 m square with grid lines at 100 m intervals, but in style the series closely resembles the 1:2500 except that house numbers are included but not parcel numbers.

With interrelated sheet lines, one projection and one grid, the Davidson Committee's recommendations did much to integrate and stabilise the range of British official maps, though changes in technological development and popular interest will inevitably bring continual variation in detail and style. Not surprisingly too, changes similar to those recorded in this chapter could be found in the histories of other map series, at least in Europe. The changes from hachures to contours and hill shading, the increased use of colour and 'popular' symbols, the integration of sheet lines and the change to a more accurate projection and its associated grid, are widespread and in some respects even further advanced than in Britain.[37] But let this one national example suffice. If the first section of this book has any single main comment to make it is that map design is never static, nor can it be, so long as technologies improve and the interests of map users expand. Enough has been said here to give an understanding at least of the principles underlying these changes, let us now re-orientate our investigations, and take a look instead at the usefulness of the finished product rather than its evolution.

[37] e.g. the adoption of the UTM grid, see p. 119.

PART TWO
WORKING WITH MAPS

Chapter 7 Scale and Scales

No other single feature of a map is so important as its scale. Chapter 4 showed that scale controls the area available on a map for the representation of detail and affects its design and appearance, but even more important, scale expresses the relationship between the size of objects in reality and their size on the map, enabling distances calculated on the ground to be plotted on the map, and vice versa. This chapter deals with the practical implications of that aspect of scale.

Means of Expressing the Scale of a Map

The scale of a map may be expressed in two ways, either in *figures* or in *words*, for example $\frac{1}{63,360}$ and 'one inch to a mile' are merely alternative ways of stating the same thing; to take another example so are 1:80,000 and 'one and a quarter centimetres to a kilometre'. The best course is to have the scale of a map expressed in both ways for both have their uses.

The scale in figures, when written as a fraction, clearly indicates that on a particular map all features (unless they are shown conventionally, see chapter 4) will appear as that fraction of their true size. On the other hand a scale in words may provide a helpful yardstick with which to judge the implications of scale at times when a fraction conveys little: thus $\frac{1}{253,440}$ appears complicated and contrived but when expressed as '$\frac{1}{4}$ inch to 1 mile', puts the average map user much more clearly into the picture.

Though the fraction is more indicative of the meaning of scale, the scale in figures is commonly encountered written as a ratio, for example $\frac{1}{1,00,000}$ is written as 1:100,000, and it is useful to remember that the latter is merely a more convenient way of writing the former. Whether written as a fraction or a ratio, this means of expressing the scale is called the *representative. fraction* (R.F. for short) of the map. Unfortunately the dual

H

form of the scale in figures, whereby it may be written as a fraction on one hand and as what seems to be a whole number on the other, may cause some confusion when calculations involving scale have to be made and for this reason this book introduces a new device, the *scale factor*.

The scale factor is the number which must be used in all calculations concerning scale, and can be defined as either *the denominator of the scale written as a fraction* or *the second part of the scale written as a ratio:* for example in maps at scales $\frac{1}{40,000}$ and $1:75,000$ the scale factors are 40,000 and 75,000 respectively. If a map does not carry its scale expressed in both figures and words it may be necessary to convert from one form to the other, and this can easily be achieved by following the simple processes described below.

Converting a Scale in Words to a Scale in Figures

Example: Express 4″ to 1 mile as a scale in figures.

Step 1: As it stands the scale is in the form of an expression involving two units of length, inches and miles. Rewrite the expression with everything expressed in the same units, choosing the *smaller*. The scale in words thus becomes 4″ to 63,360″.

Step 2: Divide the *larger* number by the *smaller*. The answer is the *scale factor*. In this example we get 63,360 divided by 4 = 15,840 and the scale is therefore $1:15,840$ or $\frac{1}{15,840}$.

It does not matter whether the scale in words involves British or metric units of length, or even both, for example in expressing 1 centimetre to 1 mile as a representative fraction we get:

Step 1: The smaller unit is the centimetre and one mile must therefore be expressed in centimetres. Since $1″ = 2.54$ cm, 1 mile $= 63,360 \times 2.54 = 160,934$ cm and the expression is 1 cm to 160,934 cm.

Step 2: This can be omitted, since we have only to divide by 1 and the scale of the map would be $1:160,934$.

Converting a Scale in Figures to a Scale in Words

A closely parallel sequence of calculations can be used to effect the reverse process, but with one preliminary qualification. A certain inconsistency occurs when the scale of a map is expressed in words; for large and medium scale maps it is usually written with the map portion (i.e. the part involving a small unit of length) first and the real or ground portion (involving a large unit of length) second, for example, 'six inches (on the map) to 1 mile' (on the ground) whereas for small scale maps the reverse is often the case, for example '10 miles (the large, ground unit) to 1 inch' (the small, map unit). Let us refer to these as scales expressed with the 'small unit first' and with the 'large unit first' respectively; each type of scale has its own method, as the following examples will show.

Example: Express 1:40,000 as so many (x) centimetres to a kilometre. Here the expression has the small unit first and we proceed:—

Step 1: Rewrite the expression with everything expressed in the same units choosing the *smaller*. This then becomes *x cm to 100,000 cm*.

Step 2: Divide the number in the expression by the scale factor. The answer is *x*. In this example we get 100,000 divided by 40,000 = 2·5; the scale in words is therefore *2·5 cm to 1 km*.

Notice the similarity of this sequence and the one used in changing from words to figures.

For an expression with the *large* unit first proceed as follows:

Example: Express 1:1,000,000 as so many (x) miles to an inch.

Step 1: Rewrite the expression with everything expressed in the same units choosing the *larger*. In this case everything must be in miles and we must write x miles to $\dfrac{1}{63,360}$ mile.

Step 2: *Multiply* the number in the expression by the scale factor. The answer is x. Thus we have $= \dfrac{1}{63,360} \times 1,000,000 = 15\cdot8$ and the scale is 15·8 miles to an inch.

The need for two methods for converting from figures to words need cause no confusion; it is only necessary to remember that if the scale needed is 'small unit first' everything else is small, i.e. change into the smaller unit and divide, and vice versa. Stripped of the essential explanations which accompany them above all three conversions are summarised in the following table. They will be found to be quick and foolproof in use, whilst their similarities make them easy to remember.

Summary of Conversion of Scales from Words to Figures and Vice Versa

SCALE IN WORDS TO SCALE IN FIGURES	SCALE IN FIGURES TO SCALE IN WORDS WHICH HAS	
	(A) SMALL UNIT FIRST E.G. *x* INCHES to a MILE	(B) LARGE UNIT FIRST E.G. *x* MILES to an INCH
1 Rewrite scale in words so that everything is in same units choosing the *smaller*.	1 Rewrite scale in words so that everything is in same units choosing the *smaller*.	1 Rewrite scale in words so that everything is in same units choosing the *larger*.
2 Divide *larger* number in this expression by the *smaller*.	2 *Divide* the number in this expression by the scale factor.	2 *Multiply* the number in this expression by the scale factor.
Answer: scale factor	Answer: is *x*	Answer: is *x*

Scales in Common Use

The scales most commonly used for maps in different parts of the world derive essentially from two groups. In countries using British linear units scales are commonly based on so many inches to a mile, which give awkward numbers when expressed as a representative faction; in countries using the metric system scales of so many centimetres to a kilometre usually also give R.F.s with convenient round numbers, for example 2 cm to 1 km gives an R.F. of 1:50,000. As the accompanying table shows, many scales common on one system are only very roughly comparable with those on the other.

Comparison of Common 'British' and 'Metric' Map Scales

METRIC SCALES	BRITISH SCALE	INCHES TO A MILE			KM TO 1 CM
1:1,000,000		0·063	(15·78	miles to an inch)	10
	1:253,440	0·25	(4	miles to an inch)	2·534
1:250,000	1:250,000	0·2534	(3·95	miles to an inch)	2·5
1:200,000		0·3168	(3·156	miles to an inch)	2·0
	1:126,720	0·5	(2	miles to an inch)	1·267
1:100,000		0·6336	(1·578	miles to an inch)	1·0
	1:63,360	1			0·6336
					CM TO 1 KM
1:50,000		1·267	(0·789	miles to an inch)	2
1:25,000	1:25,000	2·534	(0·395	miles to an inch)	4
	1:10,560	6	(0·167	miles to an inch)	9·49
1:10,000		6·336	(0·158	miles to an inch)	10
1:2,500	1:2,500	25·34	(0·0395	miles to an inch)	40

Using Scale to Measure and Plot Distances

This is one of the principal uses of scale on a map. The basic formulæ needed are:

Ground measurement = map measurement × scale factor
Map measurement = ground measurement ÷ scale factor.

In both cases it will usually be found convenient to work with everything in small units, for example inches or centimetres, if an accurate answer is required.

Example: How wide should a 40-foot roadway appear when shown on a 1″ to 1 mile map?

Step 1: Express the scale of the map in figures = 1:63,360.

Step 2: Using the formula: map measurement = ground measurement ÷ scale factor we get map measurement = 40′ ÷ 63,360 = 480″ ÷ 63,360.

The answer, 0·008″ emphasises incidentally the extent to which roads must be shown conventionally on all but large-scale maps.

In using the second of the two formulæ, to convert from map measurements to ground measurement, difficulties sometimes arise if distances on the map must be measured

along a sinuous line such as a winding road or stream. If the line is not too sharply curved it can be measured by treating it as a series of straight or nearly straight sections whose length can be accumulated on a piece of tracing paper by the method described below.

Draw a straight line on a piece of tracing paper and place it over the map with one end of the line at the beginning of the section which is to be measured and the line itself lying along the first section. Place a sharp pencil at the point where the first bend occurs and, holding this steady, pivot the paper round until the line lies along the second section; transfer the pencil point to the next marked bend, and so on until the whole distance has been measured.

For more sharply curved lines it may be easier and quicker to use a map measurer or *opisometer* which can be bought at most good shops which sell drawing equipment. Two types are in common use, both requiring a small wheel to be pushed along the route which needs measuring. In the first type the wheel drives a pointer which moves round a dial, recording the distance travelled in inches or centimetres; in the second the movement of the wheel propels it along a threaded axle. With the latter when measurement is complete the distance traversed is found by placing the opisometer on a ruler or scale line and pushing it in the opposite direction until the wheel has returned to its starting point at one end of the axle.

Even with aids of this kind it is in fact not at all easy to make accurate measurements along very sinuous lines on maps of small scale and it is a sensible precaution to obtain the very largest scale map possible so that curvatures are reduced and measurements made more accurately.

Scale Lines

On most well drawn maps it will not be necessary to calculate ground distance, for the map will carry a scale line enabling this to be read directly. An example of such a scale line, which may be single or double, i.e. calibrated in more than one unit of length (in miles and kilometres for example), is shown in Fig. 38A, which illustrates also the manner of subdivision. Notice that two types of division, *major* and *minor*, are usually found but that only one major division is actually subdivided. This is at the left-hand end of the scale line; zero is placed at the right-hand end of this division – one unit in from the end of the scale – and the subdivisions are numbered to read *backwards* from zero, so that map distances which are not a whole number of major units long can be read off directly.

For decorative reasons scales are often shown 'diced', as in Fig. 38A, but this is not essential and a simple calibration, as in Fig. 38B will often give easier and more accurate readings.

Construction of a Scale Line

It is sometimes necessary to add a scale line to a map which does not already have one, or to provide a loose scale for use on several maps of the same scale. The essential steps in this procedure are indicated in Fig. 38B but it should be noted that a small preliminary calculation is necessary before work can begin. This is needed to determine the overall length of the scale line in major units. In most cases a maximum length for the scale line will be set by the space on the map which is available to contain it, and the calculations

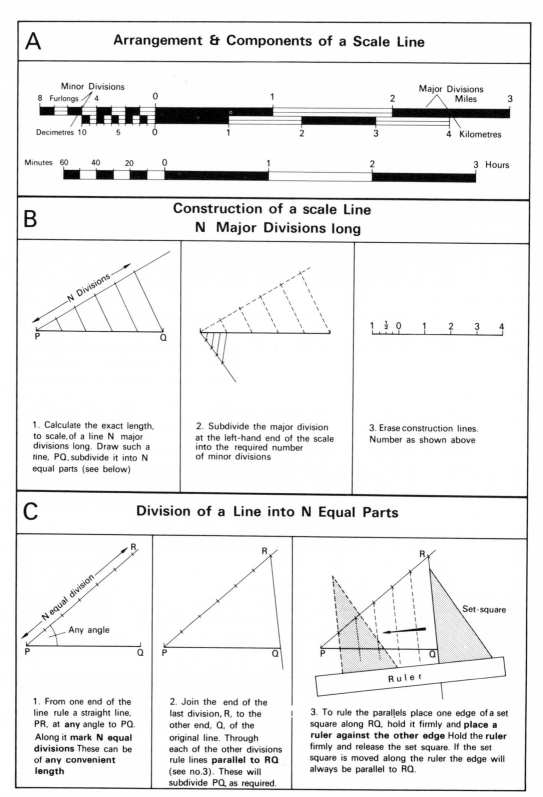

Fig. 38: Construction and arrangement of scale lines.

are made to determine the greatest *whole* number of major units which will fit into this space. The process is perhaps best illustrated through an example.

Example: Preliminary calculation for drawing a scale line with major units of one mile for a map at 1:40,000 scale. The space available for the scale line is 8″ long.

Step 1: Calculate *roughly* the length, to scale, of one major unit (i.e. one mile in this case). Using map measurement = ground measurement ÷ scale factor, we get map measurement = 1 mile (63,360″) ÷ 40,000 = 1·5″ approx.

Step 2: Decide how many major units the space will contain. At about 1·5″ per mile an 8″ space will take only five *whole* units; the scale line must therefore be five major units, i.e. *five miles long.*

Step 3: Calculate *exactly* how long this will be at the scale of the map. The same formula as in step 1 gives us:
Map measurement = 5 miles (316,800″) ÷ 40,000 = 7·92″.
Rule a line this length and proceed as in Fig. 38B.

This method of construction introduces a most important principle found in many aspects of accurate map work, namely that for accuracy's sake it is important to work from the whole to the part. By setting out the complete length of the scale and subdividing it, the only *measuring* error could be one in setting out the original length, and subdivision would reduce its effect in individual units. A scale line should never be drawn by calculating the exact length of one major division, setting this on a pair of dividers and stepping off this measurement as often as is required. By so doing any error in the setting of the dividers will be repeated and will accumulate as the scale increases in length.

There is, of course, no virtue in following elaborate constructional techniques when the major divisions of a scale are simple quantities which can be marked off from a good ruler, for example on a 1:50,000 map major divisions of 1 km would be exactly 2 cm long and could be marked out directly in this way.

Time Scales

If a uniform rate of travel can be assumed it may sometimes be more useful to measure journeys on a map in time rather than distance and particularly so where the average speed is not a convenient whole number, for example $3\frac{1}{2}$ miles per hour, which is a reasonable walking speed. For this purpose a time scale can be constructed, similar to a line scale but with major divisions of one hour instead of a unit of distance. The construction procedure is very similar to that of a line scale and needs the same preliminary calculations:

Step 1: Calculate *approximately* (a) the length of 1 mile on the map and then (b) the *approximate* map distance equivalent to 1 hour's travel.

Step 2: Use this approximate length to decide how many major units (i.e. hours) the space for the scale can contain.

Step 3: Calculate *exactly* the ground distance equivalent to this number of hours' travel and the exact length of this ground distance on the map. Mark off this distance and subdivide as in Fig. 38B.

An example of a time scale is illustrated in Fig. 38A.

A — Construction of a Diagonal Scale to Read to 1/100th of an Inch

10 Parallel lines

1 Inches 0 1

1 Rule out a scale line of any convenient length and mark it in inches. Above this draw 10 parallel lines equal distances apart (any convenient spacing may be used). Project the markings on the base line through the whole height of the scale.

1 10 Divisions 0 1

2 Subdivide the major unit at the left-hand end of the scale into 10 equal parts and project these divisions the whole height of the scale

"Hill" (see below)

3 Draw in the diagonals and number as shown

N.B. Pecked lines are construction lines only and should be erased on completion of the scale

Diagonal scales with other sub-divisions.
Construct a scale in major units first.

80 70 60 50 40 30 20 10 0

To read to 1/80 major unit
e.g. miles & chains

Rule 10 parallel lines but subdivide the left-hand unit into 8 equal parts

66 55 44 33 22 11 0

To read to 1/66 major unit
e.g. chains & feet.

Rule 11 parallel lines but subdivide the left-hand unit into 6 equal parts

B — The Principle of a Diagonal Scale

y $\frac{1}{2}y$ $\frac{1}{2}x$ x

y 1/10 of 1/10" = 1/100" = ·01" ·02" ·03" ·04" ·05" ·06" ·07" ·08" ·09" 1/10" = ·10"

$\frac{x}{10}$ $\frac{x}{10}$ $\frac{x}{10}$ x

With a hill of **uniform gradient** when one has travelled half the length of the hill one has climbed half the height : 1/10 of the length gives 1/10 height and so on.

Fig. 39: Diagonal scales.

Diagonal Scales

Whether setting out distances on maps or measuring them it is often desirable to have a scale which will enable these to be measured accurately without any need for estimation such as is involved when hundredths of an inch have to be measured on a ruler graduated only in tenths. The diagonal scale is a device intended for this purpose, its most commonly encountered form being that of a scale designed to read to hundredths of an inch. Such a scale can usually be obtained from drawing office supply shops but if one is not to hand it is a relatively simple matter to make one.

The principle of the diagonal scale is illustrated in Fig. 39B. It is, simply, that if we take a hill of *uniform gradient*, when one has travelled half way along the hill one will have climbed half the height, and so on. If the 'hill' is minute, for example only $\frac{1}{10}$th of an inch in height, then $\frac{1}{10}$th of the way along it one will have climbed only $\frac{1}{10}$th of $\frac{1}{10}$th" = $\frac{1}{100}$th" = 0·01", and if the length of the hill is divided vertically into 10 such equal parts these verticals will automatically record heights of 0·01", 0·02", 0·03" etc., up to 0·10". In the actual diagonal scale the 'hill' is seen standing on end (Fig. 39A) and the distances of 0·01", 0·02" etc., are now measured along horizontal lines back to the zero line of the scale: for example BA is 0·06". Notice that the scale also carries sloping lines parallel to the 'hill' but at $\frac{1}{10}$th" intervals away from it, so that if BA is 0·06" CA must be 0·16", DA 0·26" and so on: for example EF is 0·77".

Distances on a diagonal scale are *always measured along a horizontal line* and the rule is simple: for example to measure 1·89" first find 0·89" by counting eight units along the base of the scale from zero to give 0·80", and then count nine lines up the scale; GH is thus 0·89", and for 1·89" continue along the horizontal line one more major unit to J: GJ is 1·89".

To construct a diagonal scale. The essential features here are shown in Fig. 39A. Notice that the height of the scale is immaterial so long as the horizontal lines are equally spaced. The subdivision of the base line must of course be done accurately, and it may be better to subdivide the major unit graphically rather than by measurement.

A diagonal scale can obviously be constructed for reading any type of small sub-division of a major unit, for example to subdivide one mile into chains, i.e. $\frac{1}{80}$th of a mile, or one chain into feet, i.e. $\frac{1}{66}$th chain. One needs only to factorise the number of sub-divisions, so that, for example, 80 becomes 8 × 10, 66 becomes 11 × 6, one of these factors being used to subdivide the major unit horizontally and the other to determine the number of horizontal lines. If one of the factors should be ten, as in 8 × 10 above, it will be found convenient to use this for the vertical component because it will make numbering easier. The process is in effect more difficult to describe than to appreciate and a glance at Fig. 39A should make matters clear.

Chapter 8 Defining and Determining Position

The need to define position is a frequent requirement when maps are used and the various methods by which this may be achieved occupy the greater part of this chapter; in the last portion of the chapter methods of locating an unknown position are described.

Latitude and Longitude

The familiar ideas of latitude and longitude have been used for centuries to locate the position of a point on the earth's surface or on a map. Latitude is defined as the angular distance of a point north or south of the equator, and is represented on a map by the east-west lines known as *parallels*; longitude is the angular distance of a point east or west of a particular meridian, and appears on maps in the form of the north-south lines of the *meridians*. International or world maps commonly use the meridian of Greenwich Observatory in Great Britain as the basis from which longitudes are reckoned, but many other meridians have been, and still are, used for this purpose on national and local maps. Two examples will suffice. The official Italian topographical maps, published by the Istituto Geografico Militare, show longitudes based on the meridian of Rome (Monte Mario) which is itself 12° 27′ 08″.40 east of the Greenwich meridian. As late as 1914 sheets of the famous Austrian-produced 1:75,000 map series, the foundation of much of the modern mapping of central Europe, were being published with longitudes reckoned from Ferro (the westernmost island in the Canaries), a practice which had been widespread in mediæval times and which may have originated in Ptolemy's maps almost 2,000 years earlier when the Canaries formed the westernmost known land.

If a local meridian is used its precise relationship to the Greenwich meridian is normally given in the margin of the map so that conversion of longitude to the international standard can be made; on some maps the margins may be found marked with *two* sets of longitudinal graduation, one referring to a local meridian and one to Greenwich.

One further point needs watching. On maps of French origin latitude and longitude may be found reckoned in *grades*,[1] which are units of angular measure consisting of one hundredth part of a right angle. Each grade is subdivided into 100 *minutes centesimales*, and each minute centesimale into 100 *secondes centesimales*. Angles measured in grades are

[1] Sometimes written *grads*, especially in American literature.

written with a small ^G instead of the ° used for degrees, so that it is easy to misread one for the other, particularly since the markings for minutes and seconds are identical on both systems. Apart from this possible confusion the use of grades causes little difficulty. Where they occur map margins are often calibrated in degrees as well, and longitudes may be marked in grades from Paris but in degrees from Greenwich.

Defining Position by Latitude and Longitude

This is done by giving both values. Latitude first is the normal practice and the basis of the longitude should be stated if this is not the Greenwich meridian. For example the position of the Eiffel Tower in Paris may be variously defined as:

Latitude	Longitude
54G 28' 60" N.	0G 04' 60" W. (of Paris)
48° 51' 30" N.	2° 17' 40" E. (of Greenwich)

In this example position has been defined not only in minutes but in seconds of arc, which will normally be the case where any degree of precision is necessary. A degree of latitude is an almost constant quantity of about 69 miles, making one minute of latitude rather more than a mile in length and one second of latitude about 34 yards, so that to obtain accuracy of definition comparable to a normal grid reference on a 1:50,000 or one inch to one mile map (see page 115), where position is indicated to the nearest 100 metres (109 yards), latitude would have to be given to the nearest 3" of arc. Longitude is rather different, for a degree here is a variable quantity declining from about 69 miles at the equator to half that distance at 60° N. and to zero at the poles, but even so in most parts of the globe definition to about the nearest 5" would be required.

Defining position by latitude and longitude has several advantages. The system is simple and can be applied without variation to any part of the earth's surface, it is unaffected by map projection, and most topographical maps carry some indication of latitude and longitude whereas many do not have a grid, which is the principal alternative method of defining position. (See page 112.)

Practical Difficulties in Using Latitude and Longitude to Define Position

In the field of navigation the ability to determine latitude and longitude astronomically, or by other means, renders them invaluable for locating unknown positions, but outside this sphere of activity they are surprisingly little used. There are several reasons why this is so.

In the first place graduations along the margin of the map are rarely in finer units than a minute of arc, rendering further estimation into rather awkward sixtieths necessary to get down to seconds. This is not helped by the fact that on many maps indications of latitude and longitude are confined to the margin, and even where lines are ruled across the map these are at intervals too coarse to be of much use;[2] on a very few series, such as the British 1" map (Seventh Series) and the Danish 1:100,000 the intersections (only) of

[2] e.g. every 5' on the United States 1:62,500 series and every 10' on the current French 1:50,000 maps.

selected meridians and parallels are marked on the face of the map by a fine cross. Further-more, because of the effect of projection, parallels, meridians, or both may appear on the map as curved lines with curvature so slight as to be unnoticeable at scales such as 1:25,000 but becoming an increasing nuisance as scale decreases. A final defect of latitude and longitude lies in the rather cumbersome way in which the two-part reference has to be stated; the grid reference is much 'snappier' and more convenient.

Georef

The disadvantages listed above tend to favour the use of other methods for defining position, but interest in the use of latitude and longitude for this purpose has recently been restimulated, particularly on account of aircraft movements which often range beyond the limits of any one grid. This has led to the evolution of the *World Geographic Reference System*, more commonly known as Georef, which simplifies positional references based on latitude and longitude by omitting the tedious north, south, east and west, degrees, minutes, and seconds of the old description.

The basic ideas of Georef are extremely simple. The world is divided into vertical and horizontal bands each 15° wide and designated by a letter as shown in Fig. 40A. This produces two-hundred-and-eighty-eight 15° quadrangles, each of which is defined by the two sets of letters, the longitudinal letter being taken first, so that Newfoundland and the eastern tip of Labrador, for example, lie in the square JK (see Fig. 40A).[3] Each 15° quadrangle is itself divided into two-hundred and twenty-five 1° quadrangles by vertical and horizontal bands, one degree wide, lettered from A to Q starting at the *south-west* corner of the quadrangle, see Fig. 40B. A 1° quadrangle is identified by four letters, those of the 15° quadrangle in which it lies followed by two letters from the 1° bands, the longitudinal letter being first again. The tiny French island of Miquelon, for example is in the 1° quadrangle JKDC, neighbouring St. Pierre in JKDB (see Fig. 40B). Within each 1° quadrangle position is defined by giving the number of minutes of arc by which the point lies first east then north of the south-west corner. Notice that to avoid confusion single figures must be preceded by 0, i.e. 8' must be written 08', and that distances are always measured in this way even when the quadrangle lies west of Greenwich or south of the Equator. The reference to Cap Miquelon (Fig. 40C) thus becomes JKDC 3908 but if further accuracy is needed another figure, representing tenths of a minute, may be added to each pair (giving JKDC 392088) or, for very precise location, two figures representing hundredths of a minute may be added instead; such accuracy will only rarely be necessary.

[3] The longitudinal letter is taken first in accordance with a principle, fundamental to all modern map reference systems, that *when horizontal and vertical components are present in a reference the horizontal one is taken first*, as in normal mathematical usage. The principle has been usefully summarised by Raisz in the mnemonic phrase 'Read RIGHT UP' and is widely used in grid references. It is stressed here particularly because it runs counter to the traditional method of presenting latitude first.

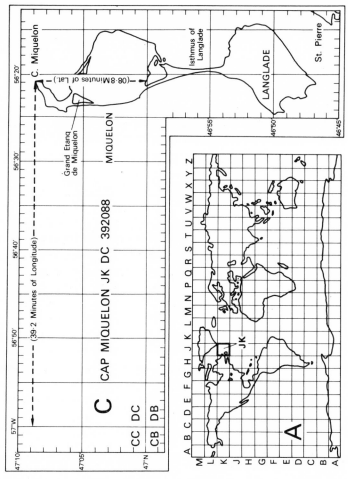

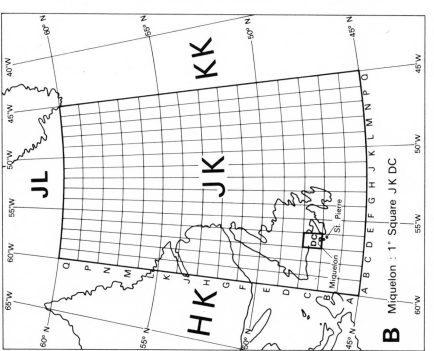

Fig. 40: The GEOREF reference system.

Grids and grid references

For many map users to-day the most effective way of defining position is by means of some form of grid reference. Although the use of grids for this purpose is little more than half a century old,[4] they are now being incorporated into most topographical maps, and once this has been done definition of position is speedy and simple.

Principle of the Grid Reference

Anyone who wishes to use maps, other than those of his own country, should understand the principle from which the grid reference system is devised. Many map users fail to realise that the type of grid reference which they normally use may be a purely national device, inapplicable to grids on foreign maps and unfamiliar to a foreigner. Once the principle of the grid reference system is known it will always be possible, using any grid, to produce an internationally intelligible form of reference.

The principle of the grid reference system could hardly be simpler. Within any rectangular area, such as a blackboard, the position of a point can be defined by giving the distances which it lies in from the left-hand edge of the board and up from the base of the board, as Fig. 41A shows. The idea is an effective one and can obviously be applied to much larger areas than this – the map of a country for example. All that is needed are two lines, one north-south and the other at right angles to it; these correspond to the edges of the board and provided that they intersect somewhere south west of the area covered by the map, the position of any point can be fixed by giving the distance which it lies *east* of the first of these lines and *north* of the second. All grid references are derived from this principle.

Many of these simple components of a grid have technical names, of course. The two base lines are the *axes* of the grid and their intersection its *origin*; the distances east and north are called the *eastings* and *northings* respectively, whilst the eastings and northings of a point are collectively called its *co-ordinates*.

The Spacing of Grid Lines on Maps

To enable co-ordinates to be read off easily, lines are ruled at regular intervals on the map, marking distances east and north of the origin, and it is the intersection of these two sets of lines which produces the network of squares which most people think of as the grid. The spacing of these grid lines will vary according to the scale of the map, for example contemporary British Ordnance Survey maps use the following spacings:

Map scales larger than 6″ to 1 mile – grid lines 100 metres apart.
Map scales between 1″ and 6″ to 1 mile – grid lines 1 kilometre apart.
Map scales smaller than 1″ to 1 mile – grid lines 10 kilometres apart.

The change to the coarser spacing on the smaller scale maps is necessary to prevent the grid lines producing a 'graph paper effect' and is reflected on Continental maps by a transition from one-kilometre to 10-kilometre spacing at or around the 1:100,000 scale.

[4] Grids can be found on many maps much older than this, e.g. the famous *Topographischer Atlas der Schweiz* at 1:50,000 scale, but they were intended to help the cartographer to plot surveyed positions rather than the map user to define position.

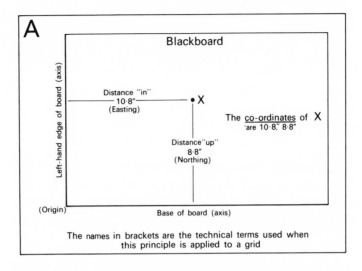

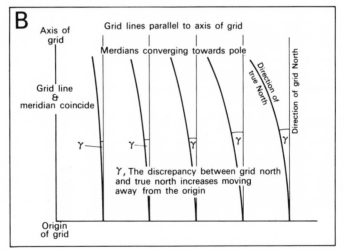

Fig. 41: Aspects of grids: **A:** The principle underlying grid references. **B:** Relationship of grid north and true north. **C:** Grids on British military maps of Europe. Several different grids are necessary partly because of the extent of the area which must be covered, but partly also because of the different projections on which the map series covering Europe are constructed. (**C** is reproduced from the *War Office Manual of Map Reading*, I, *Map Reading* (War Office code 8868), Crown copyright reserved.)

For a variety of reasons the metre is usually used as the basis for grid measurements, even in countries which do not use the metric system, but there is no *a priori* reason why this should be so, and other units have been and still are used. The first British Ordnance Survey map to carry a grid (the fifth edition of the 1″ map, published in the 1930s) had grid lines every 5,000 yards, and a similar grid has been designed in zoned form to cover the United States. Alternatively in that country many states have their own grids as well, and these are normally calculated in feet with grid lines every 10,000 feet.

Grid References

Giving a grid reference by full co-ordinates. The position of any point on a grid can always be defined by stating its full co-ordinates, i.e. the full distance which the point lies first east, then north, of the origin. The distance is given in any unit convenient for the markings of the grid. The result may be rather lengthy (see below) but the method works for *any* grid, and will be universally understood.

In practice most grid lines carry only a shortened version of their distance from the origin (usually simply as one, two or three figures for use with grid references, but see below), though the full version is often given against each tenth line or at the corners of the map so that the shortened form can be 'translated'. The distance from the relevant grid line to the point may often be estimated but for accurate work it should be measured, either by using the scale line at the foot of the map or, more conveniently, by means of a *romer*, which may be supplied with the map.[5] Fig. 42 shows a romer and how it is used, the vertical edge parallel to the vertical grid lines, the horizontal edge lying along the horizontal grid line; of course a different romer is needed for each scale.

In Fig. 42 the full co-ordinates of point X can be seen to be 288,400m E., 801,600m N., obtained as follows:

(1) Appropriate grid line east = 288 = 288,000m E. of origin
 Distance from grid line east = 400m
 Full easting co-ordinate 288,400m E.

(2) Appropriate grid line north = 801 = 801,000m N. of origin
 Distance from grid line north = 600m
 Full northing co-ordinate 801,600m N.

This method of fixing position by full co-ordinates is, for example, the standard German method, and instructions for doing this and a romer are printed on each map; there was no equivalent of the British form of grid reference on German maps until UTM grid references were introduced (see below).

Because position defined in terms of full grid co-ordinates is just as long and tedious to write as a detailed latitude and longitude position, shorter and simpler versions have been devised. These are the ordinary grid references. The method described next is the one current in Britain but other methods are developing and will be described later.

The British method of giving a normal grid reference. This is illustrated and summarised in Fig. 42. Though written as a single number all grid references are essentially composed

[5] This is almost invariably the case with German maps, for instance.

of two parts, the first half deriving from an easting and the second from a northing – a fact which should be remembered whenever a grid reference has to be read back or modified.

How effective in defining position is the method in Fig. 42 ? For example, how accurate is it ? On the 1″ map, which forms the basis of Fig. 42, grid lines are one kilometre apart and since estimation was made to the nearest tenth of this the result will be accurate to the nearest tenth of a kilometre, i.e. to the nearest 100 metres. The accuracy of a reference is often indicated in its description, and this might be described as the normal 100-metre grid reference of point Y. With a ¼″ to 1 mile map, where grid lines are at 10 kilometre intervals, estimation would produce the normal one-kilometre grid reference.

As a further test of effectiveness we may ask if the normal grid reference is unique, and here the answer is obviously no. As Fig. 42 shows, the large figures printed against the grid lines increase only to 99, reverting then to 00, so that every one-hundred squares (in this case 100 kilometres) east and west of point Y there will be other grid lines numbered 92 and the same with grid lines numbered 97 to north and south of Y as well. At any of these points there could be a position whose grid reference would be 927973; in the whole of Britain there might be perhaps twenty places with a normal grid reference of 927973[6] but none will be nearer to point Y than 100 kilometres (62 miles) and unless there is any serious danger of confusion, the normal reference will suffice.

The British method of giving a full grid reference. If it is essential to define the position of a point uniquely then the full and not the normal grid reference must be used. Unfortunately, over the past twenty years two methods of doing this have been in use concurrently, and both should be understood because references given in either form may be encountered.

Fig. 43 shows how the 'oo' grid lines divide the country into squares of 100-kilometre side, and current practice is to allot to each square two letters which, placed in front of the normal grid reference turn it into the full form. Point Y in Fig. 42 lies in square NN and its full grid reference is therefore NN 927973. The letters appertaining to all 100-kilometre squares in the area covered by a map are given in a small diagram in the margin of the map[7] and this diagram has been incorporated into Fig. 42. The rectangle represents the area of the map and shows that all points above the oo line (representing the oo grid line on the map) are in square NH, those below it in square NN.

Fig. 43 also shows how the 100-kilometre squares get their two letters. Blocks of twenty-five such squares form 500-kilometre squares within which each square is lettered A to Z, omitting I, and the 500-kilometre squares are themselves envisaged as part of a 'super-block' of twenty-five squares each of which also has a letter. For example, most of Scotland and Northern England are in 500-kilometre square N whose letter prefixes that of each constituent 100-kilometre square, giving NN, NH in the example above. For reasons to be explained later no grid is likely to extend beyond this 'super-block', and the method also explains why, for example, square NZ should have squares NU, NY, OV and SE as its neighbours.

[6] Oddly enough at only two of these places – a church at Guide Bridge near Manchester and a suburban street in Wolverhampton – does the 1″ O.S. map show any definite feature.

[7] Military maps often have the letter printed boldly on the face of the map as well as in a marginal diagram. Speed and elimination of possible error underlie this practice.

I

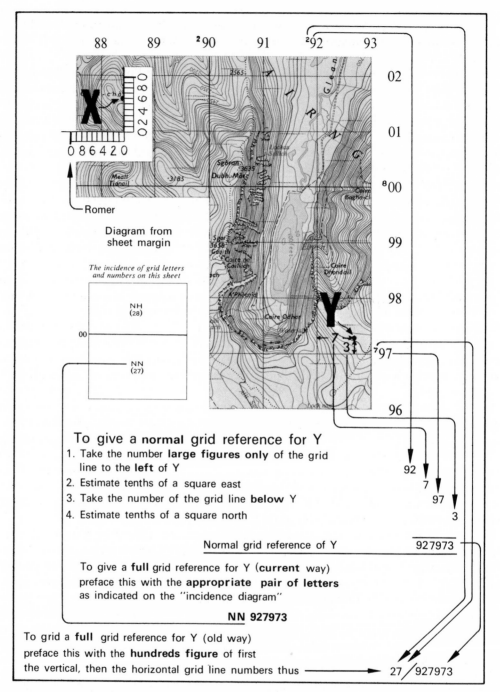

To give a **normal** grid reference for Y

1. Take the number **large figures only** of the grid line to the **left** of Y

2. Estimate tenths of a square east

3. Take the number of the grid line **below** Y

4. Estimate tenths of a square north

Normal grid reference of Y 927973

To give a **full** grid reference for Y (**current** way)
preface this with the **appropriate pair of letters**
as indicated on the "incidence diagram"

NN 927973

To grid a **full** grid reference for Y (old way)
preface this with the **hundreds figure** of first
the vertical, then the horizontal grid line numbers thus ⟶ 27 / 927973

Fig. 42: Definition of position by the British method of normal and full grid references, as used on Ordnance Survey maps. (Reproduced with sanction of the Controller of H.M. Stationery Office, Crown copyright reserved.)

Former method of giving a full grid reference. Using letters is one way of stating in which 100-kilometre square a point lies. An alternative way would be to incorporate into the reference some aspect of the hundreds figure relating to each grid line, thus differentiating ²92 from all the other 92's and so on. This idea was the basis of the method formerly used in Britain for full grid references; but instead of adding the hundreds figures directly to the normal reference, they were treated separately first so that the full grid reference of point Y would have been written 27/927973 and *not* 29277973[8]. A moment's thought will show that within each 100-kilometre square the same two figures will always occur in the full grid reference and these figures, which also defined each 100-kilometre square, are shown in brackets in Fig. 43. They are often found, similarly printed in the sheet numbers of modern Ordnance Survey maps, for example many of the post-war 1:25,000 sheets.

[8] This latter form was in fact used several years ago but was dropped to avoid confusion between a *full* reference from a grid with 10-km squares and a *normal* reference from a grid with 100 m squares.

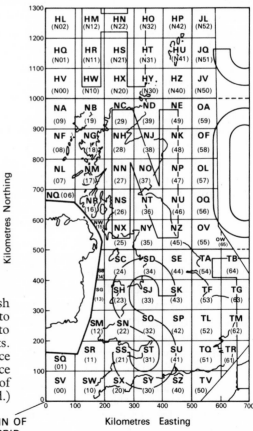

Fig. 43: The 100-km squares of the British National Grid and the letters which are used to designate them. The figures formerly used to designate each square are indicated in brackets. (Reproduced from 'The Projection for Ordnance Survey Maps and Plans and the National Reference System', with the sanction of the Controller of H.M. Stationery Office, Crown copyright reserved.)

Grids on Maps

Just as Georef has provided a world-wide reference system based on latitude and longitude, so the UTM system does the same for the grid reference; but before the basis of UTM can be fully understood, we must consider what happens when a grid is imposed on a map series covering a wide area. There are only a few points to be noted and they are easily understood.

Grid lines and north. All grids begin with a north-south line from which eastings are measured, but this is, in practice, the only true north-south line of the grid, i.e. the only line to correspond with a meridian. Fig. 41B shows why this is so. The parallel form of the grid lines and the converging form of the meridians produces a small difference between the direction of grid north (i.e. the direction of the 'vertical' lines of the grid) and true north, this difference increasing as one moves away from the origin of the grid. This is not a serious handicap but it is inconvenient. It will be explained later that it is very convenient to have grid lines which run nearly north south, and if the discrepancy between grid north and true north is to be kept within reasonable limits, a grid cannot go on indefinitely. It is for this reason that, when a grid is applied to a map series covering a large area, one grid cannot cover it all; instead when the discrepancy between the two norths becomes intolerable one grid stops and another, based on a new origin further east or west, begins. Only the east-west extent of the grid is critical and therefore grids for large countries such as the United States are broken into a series of narrow north-south *zones*. Fig. 41C shows the extent and arrangement of some of the many grids which are used on British Military maps of part of Central Europe.[9] Because grid boundaries do not necessarily coincide with sheet lines it is quite possible to find a map on which two grids meet, though this causes no difficulty. A line on the map marks the junction and references are given on whichever grid is used in that part of the map. Most grids have a name, for example Danube Zone Grid in Fig. 41C, and it is always wise to give the name of the grid used in any reference; in Britain we do this automatically when we speak of the National Grid reference.

False Origin. The increasing discrepancy between grid north and true north as one moves away from the origin, makes it desirable for the origin to be in the centre of the area covered by the grid. Unfortunately, if the origin is to have co-ordinates 0,0 only a quarter of the area of the map could then lie north and east of it and negative values would have to be introduced for points lying south or west of the origin. To avoid this happening, the grid is drawn exactly as above but the origin is given co-ordinates large enough to ensure that, working back from these to the new 0,0 lines, all the area covered will lie north and east of them. The new point 0,0 is called the *false origin* of the grid, but for all grid reference purposes it behaves exactly as if it were the real origin. In the British National Grid the true origin was given co-ordinates of 400,000 m E. and 100,000 m N. and it is the 400 km east grid line which runs truly north south; the false origin lies somewhere south and west of the Scilly Isles (see Fig. 43) and it is on this point that all British grid references are based.

[9] It also provides another example of the arrangement of letters for the 100-km squares. For reasons best known to the military authorities the lettering of the twenty-five 100-km squares in each block does not always start with A, e.g. lettering starts with L in the Italy Zone grid (see square wL) and with F in the Nord de Guerre Zone grid (see square wE at the bottom right-hand corner of the block).

Grids and Projection

Grids are closely related to the projection on which a map series is drawn. Chapter 1 showed that projection influences the shape of an area as it appears on a map, whereas a grid at any given scale has a constant shape. If, therefore, two identical grids were placed over two maps of the same area and scale, but drawn on different projections, the grid lines would pass through different places on each map and grid references on each would be quite dissimilar. War-time one-inch maps of Britain carried a grid looking very much like the National Grid but related instead to the Cassini projection on which those maps were drawn; when post-war redrawing of the maps onto the Transverse Mercator projection began, the new National Grid, based on this projection, brought different grid references which were useless on the old maps, and vice versa. This is a further reason for including the *name* of the grid in any grid reference.

UTM, *The Universal Transverse Mercator Grid System*

This recent attempt to provide a world-wide grid reference system is little known as yet in Britain, for there has been no attempt to incorporate it onto British Ordnance Survey maps. Elsewhere, and especially on the Continent, its influence is spreading rapidly and instructions for giving references in this form are now incorporated into many European topographical maps.

The preceding section has indicated that no one grid could cover the whole world, which must consequently be divided into narrow zones six degrees of longitude wide. The sixty zones are numbered and, as Fig. 44 shows, each is divided, between 80° north and south, into twenty lettered bands eight degrees of latitude high (see Fig. 44). The quadrangles of 6° longitude by 8° latitude which these produce are designated by a number and a letter, for example 18R, and these form the first element in any full UTM reference.

The second portion of the reference is derived from two letters given to a 100-kilometre square which is formed by drawing a map of each zone[10] on the transverse Mercator projection and constructing on it a grid of 100-kilometre squares. The rather complicated manner in which these squares are lettered is shown in Fig. 44; the arrangement is due to a desire to increase the distance between squares with identical letters which, in practice, re-occur at distances of 18° longitude (approximately) and either 4° south or 14° north latitude (approximately). All maps on which the UTM system is incorporated indicate in the margin both the designation of the zone and the letters appropriate to the 100-kilometre squares appearing on that map.

The third portion is simply a grid reference given in the normal way within the 100-kilometre square. An example will suffice. For the map which forms the basis of Fig. 48 (p. 127) the marginal information indicates that the sheet falls in zone 18R and that the letters of the 100-kilometre squares are TE west of the 300 m E. grid line and UE east of that line. The full UTM grid reference of Grunt Cay (Fig. 48) is therefore 18R TE 936377. The first portion 18R prevents any possible confusion arising from the

[10] Not, it should be noted, for each 6° × 8° qudrangle. In fact two grids are drawn for each zone, one covering the area north, the other south, of the equator.

repetition of the letters of the 100-kilometre square but it is often omitted where no confusion would arise and the normal UTM reference of Grunt Cay would be TE 936377.

The Polar Regions, which are not included in the UTM system, are treated on similar lines but using a grid based on the more convenient stereographic projection; this is properly called the Universal Polar Stereographic Grid system.

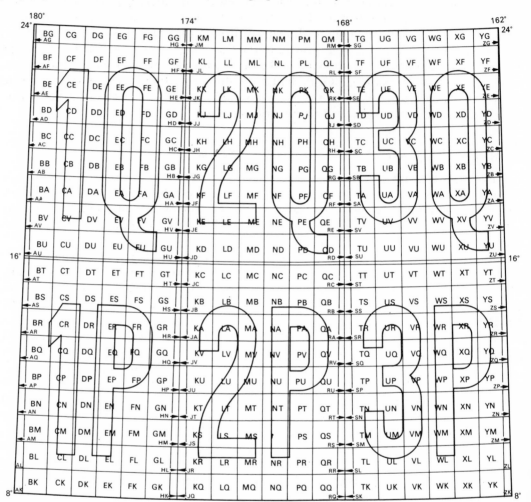

Fig. 44: The 'numbering' of squares in the Universal Transverse Mercator Grid. (Reproduced from E. Raisz, *Principles of Cartography*, 1962, by permission of McGraw-Hill Book Company.)

Adjusting maps onto UTM. At first sight it would appear that before the UTM system can be introduced all maps must be redrawn onto the transverse Mercator projection. This would be an expensive and time-consuming task, and it is fortunate that the necessity for it can be overcome by a slight technical adjustment. It is possible to calculate through which points the grid would pass if the area *were* re-mapped on the transverse Mercator

projection, to plot these points on the existing map, whatever its projection, and to draw in through them the 'adjusted' grid lines. Of course the 'adjusted' grid lines are not straight lines because they are distorted by the existing projection, but curvature is so slight that it is neither noticeable nor troublesome. The maps of several West European countries and of the United States are beginning to be amended in this way and the margins of these maps often carry markings for two grids, one the original grid based on the maps' own projection and the other an 'adjusted' UTM grid. Naturally only one (sometimes neither) is marked on the face of the map but care is always needed to prevent the 'mixing' of grid references or the use of the wrong grid.

Grids at Different Scales

Provided that the maps of a country at different scales are all drawn on the same projection the same grid can be imposed on all of them.[11] This produces the important result that, with slight qualification, grid references made on one map will be equally intelligible on maps of other scales as well. In practice the grids on the various maps will not be identical, for we have seen on page 112 that on smaller scale maps the grid-line spacing is increased. Even so a grid with the same axes and origin will be used, and so far as a reference by full co-ordinates is concerned there is no reason why identical answers could not be obtained from all maps, though it would be difficult at small scales to match the accuracy of co-ordinates measured on large scale maps.

Although differences in the spacing and numbering of grid lines prevent identical grid references being obtained from all maps, we obtain instead references which are similar and easily adapted for use on other maps. Fig. 45 illustrates some of these points. Examination of the portion of the six-inch map covering the same area as the one-inch map in Fig. 45 would reveal that the grids on each are identical in numbering and position and would therefore give the same grid reference for any point. With the quarter-inch map however the grid is different – it has ten-kilometre squares not one-kilometre squares – but inspection shows that the grid line '2' of the quarter-inch map in Fig. 45 is identical in position with grid line '20' of the one-inch, just as the '7' is with the '70'; in other words this is the grid of the one-inch and six-inch maps but with only every tenth grid line shown and numbered with one figure instead of two in the margin.

Consider now the grid reference to Halliman Skerries (Fig. 45); on the quarter-inch map this would be either 2172 or 2272.[12] Because there are ten grid lines on the one-inch map to every one on the quarter-inch map, the 'two and one tenth east', which we estimated on the quarter-inch map will be represented by the line '21' on the one-inch; in the same way the 'seven and two tenths north' becomes '72' so that the positions 2172 and 2272 on the quarter-inch map are represented by points X and Y on the one-inch. The reference to these points we should give at 1″ scale as 210720 and 220720. It is clear now why there was a choice of reference on the quarter-inch map; Halliman Skerries is at

[11] This is true in theory only. In practice 'adjusting' could occur, as with the UTM grid and the adjustment of the National Grid onto the sixth edition (New Popular) 1″ map and the Fourth Series $\frac{1}{4}$″ Ordnance Survey maps of Great Britain.

[12] Where it is difficult to decide which reference may be the correct one, either may be given with little danger.

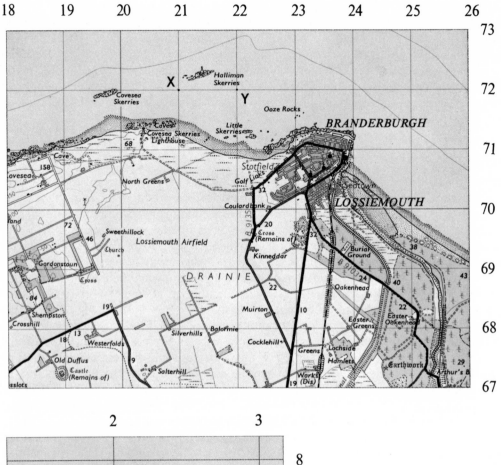

Fig. 45: Grids and grid line numbering at different scales: portions of the Ordnance Survey 1″ to a mile and 1:250,000 ($\frac{1}{4}$″ to a mile) maps of Lossiemouth, Morayshire. (Reproduced with the sanction of the Controller of H.M. Stationery Office, Crown copyright reserved.)

neither point, the greater accuracy of the one-inch map allowing us to place it at 215722.[13] The references are then:

<div style="text-align:center">

quarter-inch 2172 or 2272

one-inch 215722

</div>

They are similar, but not identical and simple rules can be devised to allow conversion from one form to the other.

(1) To convert from a reference made with ten-kilometre squares to one suitable for use with a grid with one-kilometre squares, divide the reference into two halves and add 'o' to each half. The new reference will only rarely represent the actual point in question but it will be within half a kilometre of it and will usually allow identification; for example 8643 becomes 860340.

(2) For the reverse operation again, divide the reference into two halves and bring each to two significant figures; thus 616323 becomes 6232.

Identifying a Position from a Grid Reference

Again the rules are simple.

(1) If the reference is a *full* one, identify the 100-kilometre square by its letters or numbers. This may need an index map of the grid for the whole country[14] if the general position is not known, and it will then be necessary to obtain the appropriate topographical map covering this 100-kilometre square.

(2) Divide the reference into two halves and ignore the last figure in each half. The remaining figures, whether one, two or three in number, will be found written against first a vertical and then a horizontal grid line and these should be identified.

(3) When these are found, use the last figure in each half to estimate tenths eastwards and northwards.

(4) If the map being used for identification has grid lines spaced differently to the map which provided the original reference, then its grid lines will have either less or more figures written against them than will be produced in stage (2) above. If this is so, the original reference will have to be modified according to the rules just described immediately before this section.

Other methods of defining position – squares. A network of squares of any convenient size and with rows lettered and columns numbered (or vice versa) is often drawn on maps to help the defining of position. Nothing more can be said, of course, than that a point lies in square L7 or P3, satisfactory enough if the object is unique or relatively prominent but of little use in other cases. Two-inch squares of this kind formed (apart from latitude and longitude) the only means of defining position on Ordnance Survey maps before a grid was introduced in the 1930s.

Range and township. In much of the United States west of Pennsylvania, Kentucky and Tennessee, another form of reference system is sometimes found, arising from the

[13] This defines the eastern end, approximately. Other references such as 214722 would serve equally well.

[14] One of these, for the whole of Britain, is printed inside the cover of all folded 1" Ordnance Survey maps.

method used by the General Land Office to survey and divide the land which at one time formed part of the public domain. In these areas, arranged around a base meridian and base parallel, land was divided into six-mile-square blocks known as *townships*, each of which was sub-divided into one-mile-square *sections*, numbered 1 to 36 in zig-zag fashion as shown in Fig. 46. Section and township boundaries are marked on United States topographical maps, as too are section numbers. The six-mile-square townships are regarded as being arranged about the base meridian and parallel in vertical rows

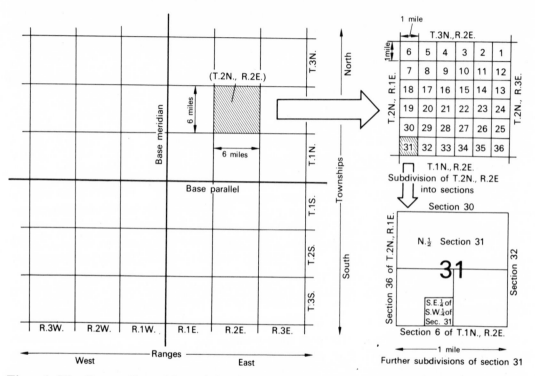

Fig. 46: The Range, Township and Section method of defining portions of land, as used in certain parts of the United States. Rather similar systems are also used in parts of Canada.

called *ranges*, and horizontal rows called, rather confusingly, *townships*; so that a six-mile-square may be designated as Range 1 West, Township 6 North, or R1W T6N for short, these designations being also marked in the margin of the map.

Bearings. A simple, and certainly very ancient way of defining the position of a point is to state its relationship to some other known object. Two components are needed – direction and distance. Distance may be stated in any convenient unit (metres, miles, hours' march, etc.) and direction was, for centuries, related to the points of the compass: the four cardinal points were further subdivided into 32 minor points thus allowing definition of direction to within $11\frac{1}{4}°$, or within $2°\ 49'$ if quarter-points were used.

Compass point directions are too coarse for accurate work however, (to say nothing of their awkward and rather confusing terminology), and they have largely been replaced

today by bearings, in which direction is indicated as *an angle measured clockwise from north*. Other variations on this theme are obsolete and should be avoided. For example, 30° E. of N. is today simply a bearing of 30° whilst 40° W. of S. and 5° W. of N. become 220° and 355° respectively.

True north. The phrase 'measured clockwise from north' in the above definition needs some qualification, for in practice three different 'norths' are commonly used for this purpose. Strictly speaking there is only one north, the *true north*, which can be defined as the *direction of the North Pole at any point*, or, since the meridians run from pole to pole, the *direction of the meridian at any point*, this latter definition being the most suitable one for map work. Bearings measured relative to true north are called *true bearings*.

Magnetic north. True north has one great defect – there is no convenient way of determining its position in the field.[15] When bearings must actually be measured in the field true north is supplanted by another north, magnetic north, which may be defined as *the direction in which the compass needle sets at any place*. Bearings given relative to magnetic north are called *compass bearings* or *magnetic bearings*.

Grid north. When bearings have to be plotted on a map it is convenient to have the direction of 'north' marked as often as possible on the face of the map. For this reason the lines of the grid are often used as a third north, grid north, defined as *the direction of the 'vertical' grid lines at any point*. Angles measured relative to these lines are called *grid bearings*.

Magnetic variation (or declination). Because the earth acts as a gigantic magnet whose north (magnetic) pole is somewhere in northern Canada, the direction of magnetic north and true north rarely coincide at any point. Instead they differ by a small angle called the magnetic variation (or sometimes the magnetic declination). On Fig. 47 lines called *isogonal lines* join places of similar magnetic variation and indicate its amount throughout the world in 1965. Notice that magnetic north may lie east or west of true north and that the difference may be up to 26° in certain parts of the world, and much more than this in the Polar regions where the compass is a relatively unreliable indicator of the direction of north.

Furthermore the earth's magnetic pole is not fixed but moves about slowly over a period of time. As it moves the direction of magnetic north throughout the world moves with it, so that magnetic variation changes not only from place to place but from time to time as well. The change in the direction of magnetic north due to this movement is somewhat irregular at any point over prolonged periods of time, but over short periods it is small and fairly predictable.

There are then two pieces of information which are needed before magnetic north can be used on any map. These are (1) the magnetic variation, which will be given for the date at which the map was drawn, and (2) the annual change in this to allow the present magnetic variation to be calculated. This information should be found in the margin of the map: Fig. 48 indicates how it is used.

Variations in grid north. The varying relationship between grid north and true north has already been studied (see Fig. 41B). The small inconstant angle which separates them is sometimes called the *convergence* and its amount will also be indicated in the map

[15] In the northern hemisphere the pole star is only a crude guide and may be up to $1\frac{1}{4}$° away from true north.

margin.[16] If it is not, draw in any meridian which cuts a vertical grid line and measure the angle between them.

Sheet north. On some maps a fourth north, sheet north, is defined. It is the direction of the east and west margins of the sheet where these are formed neither by grid lines nor meridians. Its relationship to at least one other form of north will be stated in the margin.

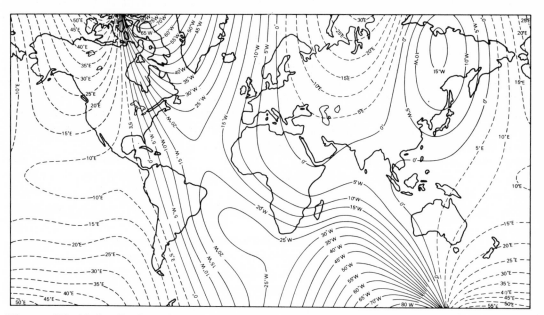

Fig. 47: World distribution of curves of equal magnetic variation (Isogonal lines), 1965. (Drawn after Admiralty Chart, 5374, Crown copyright reserved.)

Plotting bearings on maps. Many map users appreciate the theoretical differences between the three types of bearing but fail to see the practical implications of this. The matter is simple. Magnetic bearings come from field observations and are not usually used for plotting on maps; for this purpose they should be converted to grid bearings, or true bearings if the map has no grid.

It is essential therefore to know how to convert one form of bearing into another form for any map sheet, and this is almost always best achieved by means of a diagram as illustrated in Fig. 48. The difference between the various norths is not difficult to establish; confusion begins for many people in deciding whether to add or subtract this amount when going from one north to another. The easiest way to settle this is to add to the diagram the direction of a theoretical point X. Mark in the bearing to X from all three norths and it will be obvious which bearing is biggest and whether to add or subtract the difference (see Fig. 48).

[16] It is sometimes given the symbol γ. Current practice on British O.S. maps is to give the value four times, i.e. for each corner of the sheet. Values for any position may be found by interpolation, though differences in practice are very small. Note that it is increasingly becoming the practice on European maps to relate magnetic north *directly to grid north*.

Fig. 48: Determination of position by bearings: the map used is a portion of the Grand Bahama and Abaco, sheet 26, Bahama Islands 1:25,000 Series. This illustration is also used to indicate the information (which is also printed on these maps) relating to the UTM grid reference system. (Reproduced with the sanction of the Controller of H.M. Stationery Office, Crown copyright reserved.)

Before bearings can be plotted or measured at any point on the map, the direction of a suitable north through that point must be known. For grid north draw in through the point a line parallel to the nearest vertical grid line (see Fig. 48); for true north draw in from marginal markings the two meridians nearest to the point, and then add through the point a line 'parallel' to these, making any necessary allowance for convergence or curved lines.

Fixing position by bearing and distance. This may be done using any type of bearing, but because of practical difficulties involved in measuring long distances accurately it is more suitable for use on a map than in the field.

Fixing a position by cross bearings. Difficulties in measuring distance in the field can be overcome by using cross bearings. Bearings onto the object in question must be taken from *at least two* points (simultaneously if the object is moving), and when these are plotted on a map their intersection fixes the position of the object.

Fig. 48 provides an example of this and also of the stages needed to convert from one type of bearing to another: it should be remembered that bearings taken in the field will usually be magnetic bearings, while those plotted on a map will usually be grid bearings.

> *Example:* In January 1966 a vessel approaching Marsh Harbour jetty was simultaneously observed from there and the jetty near Great Abaco Club. The compass bearings taken onto the vessel were 314° 30' and 275° 0' respectively. What was the position of the vessel?
>
> *Step 1:* Determine the relationship between magnetic north and grid north for this map in January 1966. This is best done as recommended by drawing a diagram and gives magnetic north as lying 1° 40' W. of grid north. Bearings to X marked in this diagram indicate the formula: Grid Bearing (G.B.) = Magnetic Bearing (M.B.) — 1° 40'.
>
> *Step 2:* At Marsh Harbour rule a line through the jetty parallel to the nearest vertical grid line. This marks grid north at the jetty. Convert the 314° 30' magnetic bearing to a grid bearing by subtracting 1° 40' and plot the resultant bearing of 312° 50' relative to grid north.
>
> *Step 3:* Repeat this process at the second jetty where GB will be 275° 0' — 1° 40' = 273° 20°. The vessel lies at V, the intersection of the two lines.

Determining position (1), by back bearings. This is perhaps a commoner requirement than the fixing of position by cross bearing, but the method is derived directly from that process using back bearings. Whenever a bearing has been taken along a particular line, the back bearing is the bearing which would result by looking along the same line of sight but from the opposite end. It is therefore 180° different from the bearing and the formula is *back bearing = bearing* \pm 180°.[17]

From any unknown point bearings to known positions can be observed but not plotted; if, however, we convert these to back bearings, we shall get the bearings looking along these lines of sight in the reverse direction, from the known position to the unknown, and can then fix the unknown position by cross bearings. An example will suffice.

[17] The \pm sign need cause no confusion. In effect it means 'to obtain a back bearing from a bearing, subtract 180° if this can be done without giving a negative result. If not add 180° instead.'

Example: In January 1966 compass bearings were taken onto Outer Point Cay and Grunt Cay from a vessel approaching Marsh Harbour. The bearings were 62° 0′ and 145° 30′ respectively: what was the vessel's position?

Step 1: Establish the appropriate relationship between magnetic north and grid north as in the previous example giving the formula: G.B. = M.B. − 1° 40′.

Step 2: Convert the bearing to Outer Point Cay to a back magnetic bearing: in this case we must add 180° giving back M.B. = 62° 0′ + 180° = 242° 0′.

Step 3: Convert this back magnetic bearing to a back grid bearing by subtracting 1° 40′ thus back G.B. = 242° − 1° 40′ = 240° 20′.
Establish grid north at Outer Point Cay as in the previous example and plot this bearing relative to it.

Step 4: Repeat Steps 2 and 3 for the bearing to Grunt Cay giving back M.B. = 145° 30′ + 180° = 325° 30′; back G.B. = 325° 30′ − 1° 40′ = 323° 50′.

The vessel's position is at W, the intersection of the two lines.

Determining position (2), by observations. If no compass is available the position of an observer (or that from which a photograph was taken) can often be identified by observation. The method depends on the simple rule that objects which are in line *on the ground* (or *vertically* in line on a photograph) will be in line *on the map*. If two pairs of such objects can be identified on both map and ground (or photograph), straight lines through these pairs of points can be drawn in on the map and the observer's position will be at the intersection of the two lines. In Figs. 49A and B identification of hill A, viaduct B, church C and bridge D on the map allows the lines AB (produced) and CD (produced) to be drawn in; the observer lies at their intersection P. Alternatively the rule can be applied in the reverse direction and used to identify unknown positions observed from a known viewpoint. Fig. 49C shows the essential features of a view up Borrowdale from Castle Head, near Keswick, and Fig. 49D selected features from the 1″ map of the area. An attempt to identify the main summits in the view might proceed on these lines, fixing first the right hand edge of the view and working round:

There are 4 large islands in Derwentwater, the view appears to show only one. This would be impossible, therefore the feature LI in the right foreground must also be an island, Lord's Island, cut by the edge of the photograph; feature X is therefore the unnamed island, and the edge of the photograph can be established fairly certainly: it cuts one island and passes just to the right of the other. The slopes HS beyond the lake must therefore be the craggy flanks of High Spy.

At their foot these slopes pass into a prominent wooded conical hill CC, which must surely be Castle Crag. If this is so, the distant Summit GE vertically above must be in line with it on the map and is therefore Great End (*check*: Great End has a craggy north face and is fronted by a lower rather flat topped area, Seathwaite Fell. These features – the deep shadow of the crags and the preceding fell SF – can be identified in the view). A vertical line drawn through the furthest summit in the view passes through the edge of SF, just to the left of the wood Z and just to the right of wooded knoll Y. Identification of all of these on the map fixes the line which indicates that the summit must be Scafell Pike.

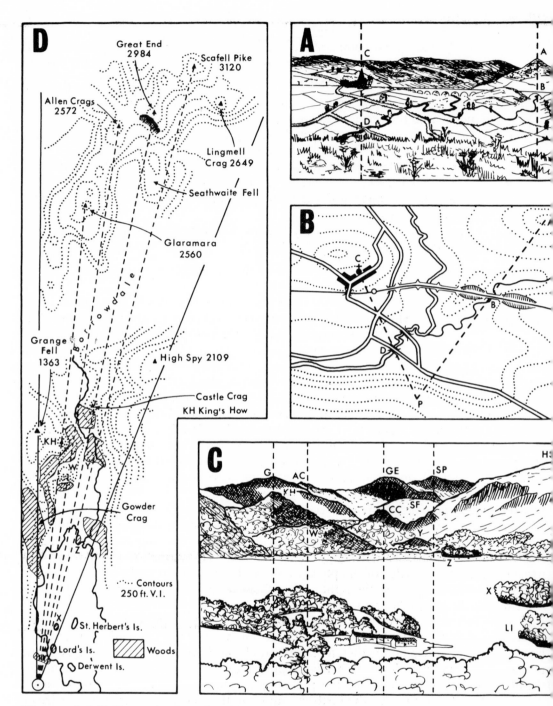

Fig. 49: A & **B:** Determination of position by observation and map comparison. **C** & **D:** Identification of distant features by observation and map comparison. **C:** shows the principle features in the view up Borrowdale from Castle Head, near Keswick in the English Lake District. (Outline traced from a postcard published by J. Arthur Dixon). **D:** *Selected* detail from the 1″ Ordnance Survey map of the area (Crown copyright reserved).

Working left again similar reasoning identifies the prominent, wooded conical hill KH to the left of Castle Crag as Kings How (checked by its position relative to the wooded twin summit hill W.), and alignment with KH identifies the more distant summits G and AC as Glaramara and Allen Crag.

Unless the features are unusually distinctive in shape, identification of distant hills in a view is much more complicated a process than the layman normally envisages, and may well need reasoning and construction lines of this sort before the answers can be obtained with certainty.

K

Chapter 9 Measurement of Area

It is often necessary to measure areas on a map, and for many people this will involve using one of the several manual methods described in this chapter. For those fortunate enough to have access to mechanical means of measurement a section on planimeters is included.

General Aspects of the Measurement of Area on Maps

Two general points should always be remembered whatever method is used. The first of these is concerned with map projections. Chapter 1 showed that although some map projections (the equal area or equivalent projections) are specifically designed to represent areas correctly, many other projections distort areas to maintain other properties instead. Most of the projections used for topographical maps (for example the British modified transverse Mercator projection) are not of this equal-area type, but fortunately, at scales such as 1:1,000,000 or larger, discrepancies in area due to projection influence are unlikely to be large enough to cause any difficulty. With atlas maps, however, where both map sizes and scales are smaller, the effect of projection may be quite marked, and with maps of this sort areas should only be measured on equal-area type projections.

The second point centres on the discrepancy between map area and ground area. The *true* area of a piece of land is its extent *projected into the horizontal plane*, i.e. as represented on a map; if the land has any slope at all, distances measured on the ground will be greater than those computed from the map[1] and areas will be affected similarly. For example, with a uniform slope of 10°, an area of 1 square mile on the map would have a superficial extent of 1·015 square miles on the ground, and if the slope were 30° the ground area would be 1·155 square miles, which is almost one-sixth more than the map area. This effect, which is only pronounced in very hilly areas, is usually ignored, the 'official' or map area of a piece of land being always used when areas, densities or similar figures are required.

Manual Methods of Measuring Area on Maps

1 *Straight-sided figures.* Where boundary lines are entirely straight, additional lines may be added to divide an area into triangles whose areas are calculated from the formula:

[1] In surveying, distances measured along slopes are corrected to the horizontal equivalent before being plotted.

Area of triangle $= \frac{1}{2}$ (*base* × *perpendicular height*). The sum of the areas of the triangles gives the area of the whole figure. Perpendiculars must be constructed in each triangle but the use, as base, of lines common to two triangles will slightly reduce the amount of measurement (see Figs. 50A & B).

2 *Give-and-take lines.* This method attempts to substitute straight boundary lines for irregular ones by constructing give-and-take lines. These are drawn so that the portions of the original shape left outside them (i.e. 'given away') are balanced by portions of the

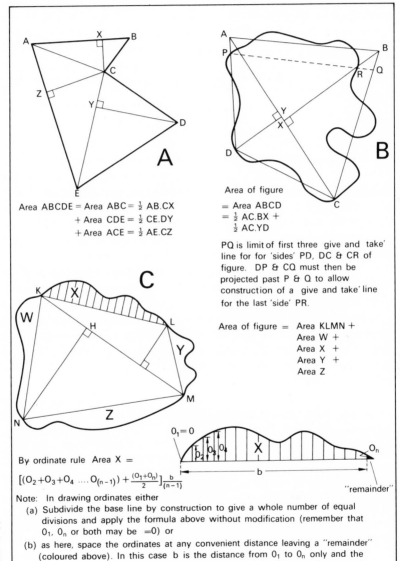

Area ABCDE = Area ABC = $\frac{1}{2}$ AB.CX
 + Area CDE = $\frac{1}{2}$ CE.DY
 + Area ACE = $\frac{1}{2}$ AE.CZ

Area of figure
= Area ABCD
= $\frac{1}{2}$ AC.BX +
 $\frac{1}{2}$ AC.YD

PQ is limit of first three 'give and take' line for 'sides' PD, DC & CR of figure. DP & CQ must then be projected past P & Q to allow construction of a 'give and take' line for the last 'side' PR.

Area of figure = Area KLMN +
 Area W +
 Area X +
 Area Y +
 Area Z

By ordinate rule Area X =

$$[(O_2 + O_3 + O_4 \dots O_{(n-1)}) + \frac{(O_1 + O_n)}{2}]\frac{b}{(n-1)}$$

Note: In drawing ordinates either
 (a) Subdivide the base line by construction to give a whole number of equal divisions and apply the formula above without modification (remember that O_1, O_n or both may be =0) or
 (b) as here, space the ordinates at any convenient distance leaving a "remainder" (coloured above). In this case b is the distance from O_1 to O_n only and the area of the "remainder" must be calculated or estimated separately.

Fig. 50: Measurement of area (1): **A:** by division into triangles; **B:** by 'give-and-take' lines; and **C:** by the ordinate rules.

surrounding area which are taken in (see Fig. 50B), the original shape being replaced by an equivalent polygon whose area can be calculated by method 1 above.

Where boundary lines are roughly rectilinear and not too irregular, quite reasonable results can be obtained from this method, if the give-and-take lines are drawn with care.[2]

3 *The Ordinate Rules.* If a polygon is inscribed inside the area to be measured, there will remain around it a number of 'strips' with one straight and one irregular side. The areas of the strips can be found by one of a group of formulae called the Ordinate Rules. These necessitate perpendiculars (the offsets or ordinates) to be drawn at equally spaced intervals along the base of the strip (see Fig. 50C) and their lengths measured. The simplest and most practicable formula for calculating the area of the strips is the trapezoidal rule[3] which gives

$$\text{Area} = \left[(O_2 + O_3 + O_4 + O_{n-1}) + \frac{(O_1 + O_n)}{2} \right] \frac{b}{(n-1)}$$

$$b = \text{length of base line}$$
$$n = \text{no. of ordinates}$$

A large number of perpendiculars gives a more accurate result but will involve more work. The total area of the figure is the sum of the areas of the polygon and the strips.

4 *By strips.* Carefully used this method will give quite accurate results. A number of parallel lines are ruled on a piece of transparent material and this is placed over the area to be measured, as in Fig. 51A–D.[4] 'Give-and-take' lines are now drawn at right angles across each strip and the lengths of the strips measured. Where the boundary of the area cuts into, but does not cross a strip as at X in Fig. 51D, either special strips must be ruled and their areas individually calculated, or allowance must be made for such features when give-and-take lines are being constructed. The width of the strips is immaterial, but a narrow strip will give more work and more accurate results; for small areas strips wider than about $\frac{1}{2}$ cm or $\frac{1}{4}''$ would be rather too coarse for good work.

A device known as a *computing scale* is sometimes used to speed up measurement by this method. It consists of a scale along which may be moved a cursor containing a cross wire. The cross wire acts instead of drawn give-and-take lines, and as it is repeatedly moved along to the other end of a strip its progress along the scale line automatically adds up the lengths of the strips.[5]

5 *By squares.* Many people find this the simplest of the manual methods of area measurement. The area to be measured is covered by a grid of squares, either drawn directly on

[2] The author was surprised to find that groups of students measuring an area by this method consistently produced answers very close to those of groups measuring the same area by strips and squares.

[3] Offsets must be numbered as in Fig. 50C, and O_1 and O_n may or may not be zero depending on the shape of the strip. For the other formulæ in this group, see Debenham F. *Exercises in Cartography*, London, 1937, p. 45; or Monkhouse, F. J. and Wilkinson, H. R. *Maps and Diagrams*, London, 1952, pp. 52–53. The method is rather tedious to use whatever formula is adopted, and the author has measured manually many hundreds of areas without ever once having recourse to it.

[4] Alternatively lines can be ruled on the map itself, of course. The advantage of the transparent material is that the strips can often be re-used.

[5] For a fuller account of the computing scale and its use see Debenham *op. cit.*, p. 46.

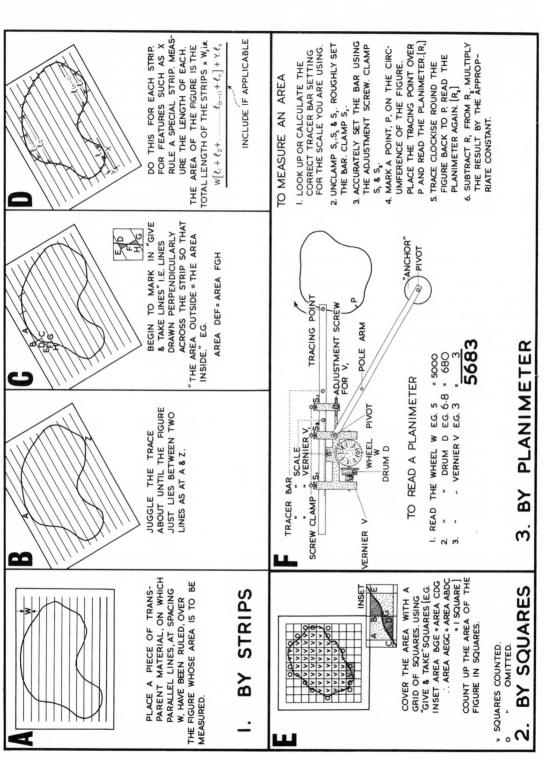

A

PLACE A PIECE OF TRANSPARENT MATERIAL, ON WHICH PARALLEL LINES, AT SPACING W, HAVE BEEN RULED, OVER THE FIGURE WHOSE AREA IS TO BE MEASURED.

B

JUGGLE THE TRACE ABOUT UNTIL THE FIGURE JUST LIES BETWEEN TWO LINES AS AT A & Z.

C

BEGIN TO MARK IN "GIVE & TAKE LINES" I.E. LINES DRAWN PERPENDICULARLY ACROSS THE STRIP SO THAT "THE AREA OUTSIDE = THE AREA INSIDE." E.G.

AREA DEF = AREA FGH

D

DO THIS FOR EACH STRIP. FOR FEATURES SUCH AS X RULE A SPECIAL STRIP. MEASURE THE LENGTH OF EACH.

THE AREA OF THE FIGURE IS THE TOTAL LENGTH OF THE STRIPS × W, i.e.

$$W[\ell_1 + \ell_2 + \ldots\ldots \ell_{(n-1)} + \ell_n] + Y\ell_x$$

INCLUDE IF APPLICABLE

1. BY STRIPS

E

COVER THE AREA WITH A GRID OF SQUARES. USING "GIVE & TAKE" SQUARES [E.G. INSET AREA BGE = AREA CDG ∴ AREA AEGC = AREA ABDC = 1 SQUARE]

COUNT UP THE AREA OF THE FIGURE IN SQUARES.

INSET

ᵛ SQUARES COUNTED.
º OMITTED.

2. BY SQUARES

F

TRACER BAR
" " SCALE
" " VERNIER V.
SCREW CLAMP S₁, S₂, S₃.

ADJUSTMENT SCREW
FOR V,

TRACING POINT

POLE ARM

"ANCHOR"
PIVOT

P

PIVOT
WHEEL
W
DRUM D

VERNIER V

TO READ A PLANIMETER

1. READ THE WHEEL W E.G. 5 = 5000
2. " " DRUM D E.G. 6·8 = 680
3. " " VERNIER V E.G. 3 = 3

5683

TO MEASURE AN AREA

1. LOOK UP OR CALCULATE THE CORRECT TRACER BAR SETTING FOR THE SCALE YOU ARE USING.

2. UNCLAMP S₁, S₂ & S₃, ROUGHLY SET THE BAR. CLAMP S₃.

3. ACCURATELY SET THE BAR USING THE ADJUSTMENT SCREW. CLAMP S₁ & S₂.

4. MARK A POINT, P, ON THE CIRCUMFERENCE OF THE FIGURE. PLACE THE TRACING POINT OVER P AND READ THE PLANIMETER.[R₁]

5. TRACE CLOCKISE ROUND THE FIGURE BACK TO P. READ THE PLANIMETER AGAIN. [R₂]

6. SUBTRACT R₁ FROM R₂ MULTIPLY THE RESULT BY THE APPROPRIATE CONSTANT.

3. BY PLANIMETER

Fig. 51: Measurement of area (2): **A, B, C & D:** by strips; **E:** by squares; **F:** by polar planimeter.

the map or on a piece of transparent material laid over it and once again the smaller-size, greater-accuracy, more-work relationship holds good. $\frac{1}{10}''$, $\frac{1}{8}''$ or cm–mm graph tracing-paper are excellent for this purpose; alternatively the grid squares of the map may be used either directly or further subdivided for greater accuracy.

The aim is to discover how many squares the area occupies and this total, multiplied by the area of one square, gives the area of the figure. The difficulty and potential inaccuracy in applying this method arises from squares which are only partially occupied and three methods are available to deal with them. These are (1) count as whole squares all those more than half-filled, ignoring the remainder or, better, (2) find pairs of squares (not necessarily adjacent) which together make a whole square; or (3) find blocks of squares across which the boundary forms a crude diagonal. The last two of these methods have been used in Fig. 51E.

Converting Map Area to Ground Area

Unless special precautions are taken (see below) the methods just described give the map area of an object in whatever unit of measurement has been used, for example square inches. This must now be turned into the ground area suitably expressed as acres, hectares, square miles etc. This is done using the formula:

Ground area = map area × (scale factor)2

Notice the squared term. We multiply by the scale factor not once but twice, giving an answer which is often literally millions of square inches or square centimetres. Proceed then as follows:

(1) For an answer in square yards or acres, divide the ground area in square inches by 1296 to give square yards and again by 4840 to give acres.[6]

(2) For an answer in square metres or hectares, divide the ground area in square centimetres by 10,000 for square metres and 10,000 again for hectares.

(3) For an answer in square miles, ignore the above formula, calculate the scale of the map as x miles to an inch (see page 100) and multiply the map area in square inches by x^2.

If the map measurement is in the 'wrong' units convert the answers using the following relationships:

> 1 sq. mile = 640 acres = 2·588 sq. km
> 1 hectare = 2·471 acres; 1 acre = 0·4047 hectares

Measuring Ground Area Direct

The calculations just described are tedious rather than difficult and they can be avoided. One way of doing this is to make all measurements direct as ground distances by using the map's scale line though this is not a particularly accurate method; the strips and squares methods may also be adapted as described below.

[6] Land areas in the British system are often expressed in acres, roods and square perches. A square perch is $30\frac{1}{4}$ square yards and there are 40 square perches in a rood and 4 roods in an acre.

1 *Area direct from strips.* The following table shows the ground area corresponding to different lengths of strip at various scales. Strips of other widths will give proportional amounts.

MAP SCALE	ACRES PER INCH OF STRIP		HECTARES PER CM OF STRIP
	STRIP $\frac{1}{10}$" WIDE	STRIP $\frac{1}{8}$" WIDE	STRIP $\frac{1}{2}$ CM WIDE
1" to 1 mile	64·0000	80·0000	20·0803
1:50,000	39·8692	49·8365	12·5000
1:25,000 (2½")	9·9673	12·4587	3·1250
6" to 1 mile	1·7778	2·2222	0·5578
1:2500 (25")	0·0997	0·1246	0·0313
Other scales	$\dfrac{64}{M^2}$	$\dfrac{80}{M^2}$	$\dfrac{50}{K^2}$

where M = no. of inches to a mile and K = no. of cm to 1 km

2 *Area direct from squares.* The aim here is to make the squares represent an acre or a hectare in size and this is not difficult to do. An acre laid out as a square has sides 208·71 feet long, so that if the sides of the squares are made this distance, to scale, the squares will represent an acre; for a hectare the square has 100 metre sides.

In practice a small modification is necessary to introduce the principle, already encountered in constructing scale lines (see page 105), of working from the whole to the part to conserve accuracy. The aim is to produce a block of squares for measuring area, the size of this block being determined by the sizes of the area to be measured.[7] The first step, therefore, is to decide how large this block must be, and here it may help to have a rough idea of what an acre and a hectare look like at various map scales; this is given in the table below.

MAP SCALE	SIZE OF ONE ACRE AS A SQUARE		SIZE OF ONE HECTARE AS A SQUARE
	EXACTLY	ROUGHLY	
1" to 1 mile	0·0395"	$\frac{1}{25}$"	0·1578 cm
1:50,000	0·0509"	$\frac{1}{20}$"	0·2000 cm
1:25,000 (2½")	0·1002"	$\frac{1}{10}$"	0·4000 cm
6" to 1 mile	0·2372"	$\frac{1}{4}$"	0·9470 cm
1:2·500 (25")	1·0018"	1"	4·0000 cm

Roughly estimate from these dimensions the number of squares needed in each direction. Suppose a block of 15 squares by 20 squares is needed, then:

(1) Calculate the size of this block on the ground if each square is 208·71 feet side (or 100 metres side if hectare squares are needed).

[7] It should be rather larger than most of the areas to be measured. Exceptionally large areas can be measured in two portions.

(2) Calculate the size of this block on the map, using the formula: Map distance = ground distance ÷ scale factor.

(3) Draw out a rectangle of this size on transparent material.

(4) Subdivide the sides into the appropriate number of equal parts (see p. 104) and join across.

Mechanical Means of Measuring Area – the polar planimeter

Manual methods are inevitably tedious if large numbers of areas have to be measured, and wherever possible it is advisable to use some mechanical aid, the most commonly encountered one being the polar planimeter.[8]

This instrument is illustrated in Fig. 51F; it consists essentially of three parts:

(1) the *pole arm* at one end of which is a weight having underneath it three fine pins that 'anchor' the instrument when pressed lightly into the paper. The pole arm pivots around the centre of the anchor weight.

(2) the *tracer bar*, carrying at one end the *tracing point* resting just above the surface of the paper.

(3) the *'works'*, i.e. the drum and dials used in reading the instrument. The 'works' portion is clamped onto the tracer bar and is attached to the pole arm by a loose ball-and-socket joint, so that the instrument will also 'hinge open' about this joint as it moves around the anchor pivot.

Reading the instrument. As the tracing point is moved about (see below), the drum, which rests on the surface of the paper, is caused to rotate either backwards or forwards.[9] This movement drives the wheel W by means of a 10:1 worm drive and from these devices a four-figure reading can be obtained as follows:

(1) The first figure is read off from the horizontal wheel W graduated from 0 to 9, using the short pointer (see Fig. 51F); take the lower figure when pointer is between two graduations.

(2) The second and third figures come from the drum itself, graduated from 0 to 99. The indicator here is the zero of the vernier V.

(3) The fourth figure comes from the vernier V. A description of verniers and their use is included below for those not accustomed to these devices.

The makers of some planimeters introduce the term 'major divisions' for the figures obtained from the wheel and the *first* figure of the drum, requiring a decimal point to be inserted after the second of the four figures, but this policy is not universal and the author's preference is to have a rough idea of the answer and insert any necessary decimal points at the end of the measurement.

What a planimeter does. It is not at all easy to explain why a planimeter works,[10] but

[8] Another type of planimeter is the hatchet planimeter. It is a cheaper, less accurate instrument than the polar type, but is so rarely met with that it is not described here. For a description of the instrument and its use see Debenham *op. cit.*, pp. 47–48.

[9] Many people using the instrument for the first time are alarmed that the drum moves backwards as well as forwards and sometimes, for short distances, does not move at all. This is exactly as it should be and is allowed for in the theory of the instrument.

[10] A discussion of this point is given in Debenham *op. cit.*, pp. 50–52.

it is very simple to explain how it is used and what it does. Take any irregular shape whose area is to be measured and place the tracing point anywhere on its perimeter, having first anchored the instrument by pressing the anchor-pins into the paper. Read the instrument and move the tracing point clockwise round the perimeter until the starting point is reached again; read the instrument once more and take the first reading from the second. The difference between the two is a number which is *proportional to the area of the figure*, i.e. suppose the difference obtained was 3294, then if the process was repeated with a shape half the area of the first we should get a difference of 1647, and so on.

'Universal' method of using a planimeter. The number obtained above is not, normally, the area of the figure, although instructions with the instrument will often indicate how it can be made so. These instructions are described below, but it may be that they are not suited to the map scale being used, are unsatisfactory or have become lost[11] and whenever these contingencies arise it is worth remembering that any planimeter can always be used in the following manner.

Before measuring the areas concerned rule out carefully a known area, say 10 square inches, and run the planimeter round this. Suppose this gives, for example, a difference of 4620, then because this number is *proportional* to the area measured 1 square inch would have given 0462 and in subsequent measurements for every 462[12] difference we have 1 square inch of area; a slide rule set to divide the difference obtained by 462 will quickly translate the results into square inches.

'Correct' method of using a planimeter. The length of the tracer bar on most planimeters is not fixed but can be set to different lengths by releasing the clamp screws S_1, S_2 and S_3 (see Fig. 51F)[13]; this affects the readings produced by the instrument. For example the theoretical planimeter which gave 4620 difference for 10 square inches above might, with the same 10 square inches but with *a different length tracer bar*, give 1296 difference[14]; a third setting might produce a difference of 0734 and the possibility now suggests itself that if we could only find the right length for the tracer bar, we might get (still with the same 10 square inches) a difference of 1000, i.e. (if we add a decimal point) the *area direct*. To enable areas to be read directly in this fashion the manufacturers of planimeters therefore calculate the tracer bar lengths applicable to different scales and for different purposes, for example measuring acres or square inches, and supply these in the instructions with each instrument. To enable the length of the tracer bar to be set accurately a second vernier V_1 is added to the instrument (see Fig. 51F), and its zero acts as the pointer for the correct tracer bar setting.

General rules for using a planimeter.

(1) *Always* read the makers' instructions first.

[11] e.g. the author regularly uses two planimeters. One is a continental one whose instructions are not concerned with acres or map scales in inches to a mile; in the other the formula given for calculating the settings is erroneous, having a ÷ sign where there should be a ×.

[12] This figure is, of course, purely imaginary and for the purpose of this example only.

[13] Fixed arm models do exist. They are usually designed to read the answer direct in square inches.

[14] The proportional rule will still hold good of course, e.g. for a figure twice the area we should get, with the new setting, a difference of 2598.

Reading a Vernier

Always remember:-

1. That a vernier is a small device placed alongside a scale so that the latter can be read more accurately

2. That the **zero of the vernier acts as a pointer** indicating the point, P, on the main scale, whose value must be found

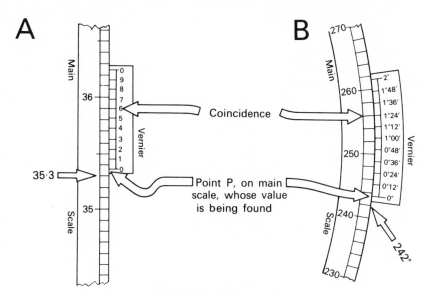

To Find the Value of P

		Example A	Example B
1.	Read the value of the last division on the main scale before the zero of the vernier	35·3	242°
2.	**Find a point where a division on the vernier coincides with one on the main scale.** Calculate or read off the value of this division on the vernier	0·06	1°24′
3.	The value of P is the **the sum of the two readings** P =	35·36	243° 24′

If the value of one division on the vernier is not obvious use the rule :-

$$\text{Value of one vernier division} = \frac{\text{Value of smallest division on main scale}}{\text{No. of divisions on vernier}}$$

Note: Verniers are usually quite small - often $\frac{1}{2}''$ or less in length

Fig. 52: Reading a vernier. The left hand illustration represents a normal 'straight' vernier, the right hand one a 'curved' vernier of the type often encountered in angle-measuring instruments.

(2) Work steadily and carefully. For accurate work measure each area two or three times and take the mean of the readings.

(3) Do not try to measure any area so big that the anchor weight must be placed *inside* the perimeter. Results obtained from this practice will be in error because of a feature, known as the datum circle, whose area is not recorded.[15] Divide any such large shapes into sections by one or more straight lines and measure the areas of these separately.

Vernier scales and their use. A vernier is a small scale placed alongside a larger scale to enable the latter to be read more accurately. Verniers are found in measuring instruments of all kinds, such as accurate barometers, and in surveying instruments where graduations may be in circular measure. Fig. 52 explains their use.

Measuring Areas by Weight

This rather unusual method may be worth considering if no planimeter is available and a large number of areas has to be measured; a great deal will depend on whether more than one copy of the base map exists or not.

Cut out the areas concerned and weigh them carefully on an accurate balance. Comparison of these weights with that of a known area cut from the same map will allow individual areas to be calculated by proportion.

Areas Already Measured on Maps

Measurement of area can often be eliminated so far as two categories of land are concerned. The areas of administrative units are usually known and recorded in publications such as national censuses, whilst in Britain the areas of individual fields and many other pieces of land are recorded, correct to three decimal places of an acre, on the 1:2,500 scale Ordnance Survey maps. Such pieces of land are known as *parcels* and each is numbered, on older maps (the rectangular County series) by a serial number commencing at 1 in each parish, and on the modern maps (the square National Grid sheets) by a four-figure-only[16] grid reference of the centre of the parcel. The former needs the parish name, the latter the sheet number for complete definition.

Where a parcel is divided on the map by a line of detail, either solid or broken, a brace ('⸺') is drawn across the line to indicate that the area beyond is included in the parcel (see Fig. 35A, p. 92). This idea is obviously unsuited to detail in closely built-up areas (far too many braces would be needed) and these areas are treated *en masse*, one composite area only being given. The boundary of these composite areas is marked by bands of colour, stipple or hatching on maps published before 1909 and by a repeated 'T' symbol on the most recent (square) maps.

Areas given are those to the plan edge only[17] on maps published after 1922, but before that date they refer to the area of the whole parcel.

[15] A fuller account of the datum circle is given in Debenham *op. cit.*, pp. 53–54.

[16] i.e. using only the last of the three digits written against the 100-m grid lines and estimating tenths in each case. No duplication can arise within each sheet as the sheets are only 1-km square.

[17] On the modern (square) maps the numbers of such parcels are marked with an asterisk.

Chapter 10 Enlarging, Reducing, Amending and Copying Maps

Anyone who makes frequent use of maps for illustrative purposes soon finds that the map he wants is at the wrong scale, or that the map at the right scale is out of date or incomplete in certain essential features. This chapter deals with methods of rectifying such a situation, and with the slightly different, but equally frequent, requirement of copying maps.

Enlarging and reducing whole maps or large sections of maps

1 *Manually – by the Use of Squares*

When a whole map or large portion of a map needs enlarging or reducing,[1] mechanical methods, and especially photography, are most usually used today. Even so such devices are not always available when they are needed and, more fundamentally, certain aspects of the manual 'squares' method may be needed to obtain accurate results with mechanical aids, so that there are good reasons for considering the manual method first.

The basic idea is simple. The map to be treated is covered with a grid of squares which is reproduced at the scale of the enlargement, detail being copied from each original square into its counterpart on the new scale. Squares of any size may be used, subject to the 'smaller-size, more-work, better-accuracy' rule, and existing grid squares either as drawn or further subdivided are often utilised for this purpose. Fig. 53 summarises the practical stages in the work which, once again, involves the introduction of the 'from-the-whole-to-the-part' approach.

General Means of Improving the Method

In the rather crude form just described, the squares method would produce results of fairly poor accuracy but this can easily be remedied by the following means:

[1] To save tedious repetition of the phrase 'enlarging or reducing' only the term 'enlarging' will be used in this chapter; the idea of reduction is always additionally implied unless otherwise stated.

Additional guide lines. Where detail lies in an unsuitable position for transferring accurately, for example in the centre of a square, further guide lines should be drawn in. Diagonals of the squares, drawn in as required, are an obvious choice but any straight line which can be reproduced on both grids may be used to help, for example the diagonal to a block of squares. In Fig. 53 point E has been accurately fixed by this means and two dozen or so lines of this sort may considerably improve the accuracy of the work.

Proportional dividers.[2] These are the most important single asset for work of this kind and their use will increase accuracy enormously. They consist, as Fig. 54 shows, of two

[2] Also known occasionally as proportional compasses.

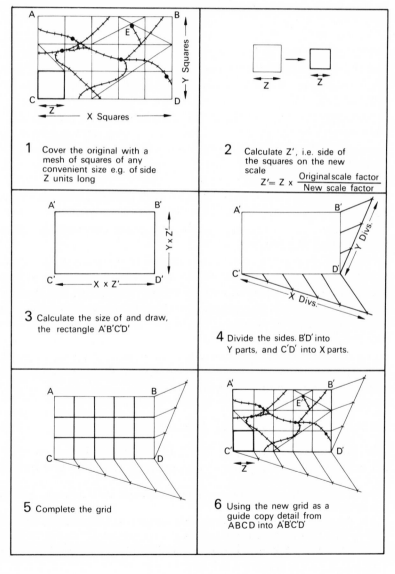

1 Cover the original with a mesh of squares of any convenient size e.g. of side Z units long

2 Calculate Z′, i.e. side of the squares on the new scale
$$Z' = Z \times \frac{\text{Original scale factor}}{\text{New scale factor}}$$

3 Calculate the size of and draw, the rectangle A′B′C′D′

4 Divide the sides. B′D′ into Y parts, and C′D′ into X parts.

5 Complete the grid

6 Using the new grid as a guide copy detail from ABCD into A′B′C′D′

Fig. 53: Reduction or enlargement by squares.

legs of equal length pivoting about a milled wheel attached to a slide-piece. If the wheel is unscrewed slightly the slide-piece can be moved along the slots in the centre of the legs, altering the position of the pivot and the proportion of the legs above and below it. Marked on the slide-piece is a fine line which can be set against the scales graduated on the legs. There are usually two, but sometimes four of these scales, used as described below.

Fig. 54: Proportional dividers (proportional compasses). (Drawn from F. Debenham, *Exercises in Cartography*, Blackie & Son, Ltd, 1937.)

The scale of *lines* is the most important scale. The slide is set at any desired mark, say 3, and the wheel tightened. When the dividers are opened the distance between the large points will be three times that between the small points so that in reducing a map to one-third size, any distance measured on the original with the large points will automatically be correctly reduced by the small ones and may be plotted directly onto the new map. Enlargement to three times original size can be effected by reversing this process. For intermediate ratios – for example reducing from 1:50,000 to $\frac{1}{2}$" to a mile which gives a ratio of 2·534:1[3] – the correct setting must be found by trial and error, though the scale of lines will act as a rough guide.

The scale of *circles* is used to subdivide the circumference of any circle into a desired number of equal parts. When the large points are opened to the radius of the circle the small points show a distance which, stepped-off around the circumference, will produce the necessary subdivision.

The scale of *plans* is related in principle to the scale of lines but produces areas proportional to the value set, not lengths;[4] while the scale of *solids* similarly produces a drawing with volumes proportional to the setting. Neither of the two last-mentioned scales has much application in cartographic work and they are not found on all instruments.

The usefulness of proportional dividers in the squares method should now be obvious. Once they are correctly set for the work in hand, the point at which any detail, for example a railway, cuts one of the squares may be measured on the original and transferred exactly to the new drawing. Even if important detail only is treated in this manner the accuracy of the work will be much improved.

2 Mechanical Enlargement and Reduction

Photography. Photography has largely superseded all former mechanical means of enlarging maps and if proper equipment is available[5] few difficulties are involved. The

[3] For this purpose ratios must always be expressed as more than unity, e.g. 0·67:1 must be re-written as 1:1·5.

[4] It follows from this, of course, that lengths will be reproduced as the square root of the set value (cube root in the case of 'solids').

[5] Commercial firms which will undertake work of this kind are widespread.

only really serious problem is to ensure that the correct degree of enlargement has been obtained and here the previous method can help. Rule out on the original a grid of large squares[6] and redraw this grid, at the scale of the new map, on a separate piece of paper. Place this paper in the enlarger and project the image of the negative onto it; when the projected grid and the paper grid exactly coincide, the correct setting has been obtained and photographic paper can be substituted.

By pantograph. The pantograph, and in particular the Coradi type of instrument, was formerly extensively used for work of this kind. In its drawing-office form it is considerably larger, more cumbersome, and heavier than the tiny counterpart sometimes sold as a toy in department stores. In particular it is equipped with refinements allowing it to be set at various ratios and with suspension wires to reduce friction; but even so it is not entirely satisfactory in use, particularly for enlargements, and this combination of size, expense and difficulties in use has caused the pantograph to be superseded very largely by photographic methods. For this reason no further description will be attempted, but a full account of pantographs and their use is given in Debenham (*op cit*, pp. 37–40).

Enlargement or Reduction using a Combination of Manual and Mechanical Techniques

By Grant Projector. Grant Projectors, or similar machines, specifically designed for enlarging or reducing drawings are becoming increasingly available in drawing offices. A map placed in the machine can be projected, enlarged or reduced, as required, onto paper laid over a glass screen, the only problem being to ensure that the correct degree of enlargement has been obtained. This can be done using a grid of squares drawn on map and paper as described above. Once the correct setting is obtained the lines of the map are drawn in on the paper.

By slide projector or epidiascope. These are cruder methods, using equipment not specifically designed for the purpose, but more widely available than the Grant Projector. Only enlargements can be produced with these instruments and for the former a slide of the original must be available. The projector or epidiascope is used to project an enlarged image of the map onto a sheet of paper fixed vertically and the lines of this image are drawn in on the paper.[7] The principal difficulty here arises from the fact that unless the axis of projection and the paper are at right angles in both dimensions, distortion of the projected image will occur.[8] Once again a grid of large squares drawn on the original and, at the new scale, on the paper is the best safeguard, allowing the detection and subsequent correction of any distortion, as well as checking when the correct degree of enlargement has been reached.

If a slide forms the 'original', a slightly different technique must be used. Most maps on slides carry a line-scale and this is used to measure roughly the *ground* size of the rectangular frame of the map.

[6] Very large squares may be used as they are only needed as general guides, and for small maps simply the rectangular frame line would suffice.

[7] An awkward feature of this process is that one's shadow tends to obscure the projected image but this can largely be overcome by standing well to one side while drawing in the lines.

[8] This distortion can often be seen when a slide is projected onto a badly placed screen.

At the scale of the enlargement, redraw both this rectangular frame (on the paper to be used for the finished work) and the line-scale itself (on a separate piece of paper). When the projected image is exactly the same size as the redrawn line-scale, the correct degree of enlargement has been reached and the rectangular frame can now be used to check for any distortion; because of inaccuracies in the rough measurements the two frame lines will not necessarily coincide, but they should everywhere be parallel to one another.

Although these methods may seem rather improvised and somewhat rough and ready, for really big enlargements, for example making a wall map from a small scale map, they are often as quick and satisfactory as any other method.

Enlarging and reducing detail: amending and correcting maps

The need to enlarge a particular feature or a small area on a map is, if anything, a more frequent requirement than dealing with the whole map itself, and finds its most frequent expression in the amending or correcting of one map from another. In this type of work manual methods come into their own and several are available, some closely related to those already described.

(1) *By squares.* The squares method is equally adapted to dealing with detail, particularly where several items occur scattered over a small area. A portion only of the map is covered with the squares, and the only modification needed is that the grid *must be constructed on two rectangular base lines which can be imposed on both maps*, thus ensuring complete correspondence of position.

(2) *Similar triangles.* This is a method which is particularly suited to dealing with linear features such as lines of communication, contours, boundaries, etc., and detail close to them. Fig. 55 gives details of the procedure. The example shown there is of a reduction but the method can be used for enlargement as well, in which case the setting out of the length O units produces a point beyond X and the working is outside the triangle formed by X, Z and O, instead of inside it as in Fig. 55.

(3) *Projected lines and proportional dividers.* Adding new buildings to large scale plans is one of the chief uses of this method but it may also be used for other work – adding a new road to a small scale map for instance. On the drawing of the new detail, project any line until it reaches two other lines which are recognisable on the map, for example at A and B in Fig. 56A. Using proportional dividers measure AX and BY on the detail drawing, then establish A and B, and thus the line AB on the map. Other lines can be inserted in the same way or, with rectangular buildings, one corner can be fixed in this way and the other sides added in turn, using a set square for the angles and proportional dividers for measurements.

(4) *By radials.* For dealing with a small block of land with relatively simple boundaries, such as an area bounded by roads or a single large field, this rather simple method will often suffice. Calculate the ratio of the enlargement, and set this on a pair of proportional dividers. Mark any point near the centre of the area and from it draw radials through all salient points of detail; measure these distances with the dividers and step off, with the

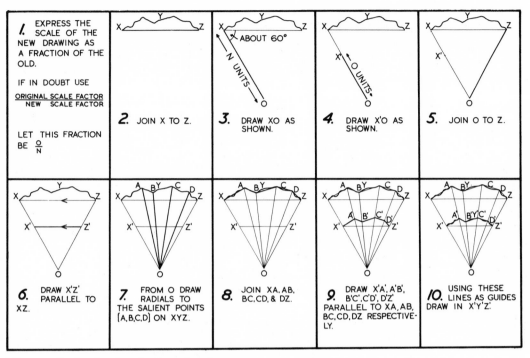

Fig. 55: Reduction by similar triangles.

other points, the corresponding distance along the same radial. The detail can then be drawn through the new points. If distances are too large for the proportional dividers to take at one go, set them at *any* spacing and set this off '*n* and a bit' times along each radial; reverse the dividers, step off *n* times again, and then deal with the 'bit' by separate measurement (see Fig. 56B).

General Considerations of Enlargement and Reduction

Whatever method is used, enlarging and reducing bring with them problems of a general kind. Reduction is the simpler and more successful operation; any errors present in the original will be reduced and the only difficulties arise from the style and content of the finished map. With severe reductions some of the content of the original map will almost certainly have to be sacrificed because of lack of space on the smaller scale; detail may increasingly have to be shown by conventional signs, and many names omitted. Nevertheless the general standard of map design today will often permit photographic reductions to about half size without serious loss of legibility, for example the quite successful wartime reduction of the British six-inch map to the 1:25,000 scale.

The converse problems produced by enlargement to, say, double scale or larger are rather less soluble. Lack of detail appropriate to the larger scale becomes noticeable, not merely in quantity but in quality as well. Where features such as roads, churches, mills, etc., are shown conventionally on small scale maps they should not be enlarged proportionately, for they are already too large on the smaller scale and the only solution is to

L

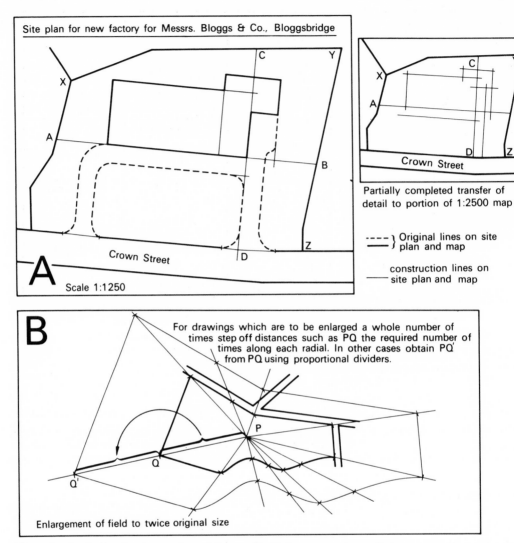

Site plan for new factory for Messrs. Bloggs & Co., Bloggsbridge

A Scale 1:1250

Crown Street

Partially completed transfer of detail to portion of 1:2500 map

- - - - } Original lines on site
———— } plan and map

———— construction lines on site plan and map

B

For drawings which are to be enlarged a whole number of times step off distances such as PQ the required number of times along each radial. In other cases obtain PQ' from PQ using proportional dividers.

Enlargement of field to twice original size

Fig. 56: A: Reduction by projected lines. **B:** Enlargement by radials.

re-conventionalise them in an appropriate way, even though they might normally be represented true-to-scale on maps of such a size. Thus whilst photographic reductions may be highly successful, photographic enlargements of any magnitude rarely are, lines and lettering in particular becoming unnecessarily coarse and large.[9] On the other hand slight enlargements may be very successful, witness the German wartime redrawing of the British 1-inch and ¼-inch maps to 1:50,000 and 1:200,000 scale respectively; both of the latter seem much more spacious maps on which to work.

[9] This was well shown on the photographic enlargements of the 1:2500 maps to 1:1250 scale which were at one time sold by the Ordnance Survey. They were not attractive maps, though they could still serve a useful purpose.

Copying maps

Mechanical Methods

Here again is a field where modern methods are becoming so cheap, efficient and widespread that tedious hand-tracing has been superseded on many occasions. Photography, or processes essentially akin to it, underlie almost all methods and the ultimate choice among them may depend on availability, cost, number of copies needed and the nature and possible use of the finished product.

(1) *Photography.* Normal photographic processes will produce contact prints or enlargements from film or glass plate negatives, but the method is highly expensive and the papers used are often unsuited for drawing on in ink or colour. The results, however, may be very 'black and white' and have a sharpness which will allow them to be used for making line-blocks for illustrative purposes.

(2) *Photostats.* The photostat is one of the commonest forms of copied map and many establishments such as large libraries or museums, as well as commercial firms, have a photostat camera. The process, which is much cheaper than ordinary photography, produces a paper negative from which further copies are made and enlargement or reduction can be effected at the same time without any difficulty. The paper too is easier to draw and colour on than photographic paper (though still far from ideal for this purpose), though copies made from rather dirty originals may have a slight or pronounced greyness in contrast to the photographic 'black and white'. A not dissimilar type of result is produced by the various document-copying machines, though these give true-to-scale copies only.

(3) *Dye-line prints.* Copies of *transparent* originals can be made very successfully and cheaply by the dye-line or diazo process, which gives only true-to-scale copies on paper, tracing cloth or a variety of transparent media. Additional advantages are the ease with which the paper used takes both ink and colour, whilst the machines can normally handle quite large originals. Opaque originals may be used either by painting them with a special fluid which renders them transparent or, better, by making a transparent 'negative'[10] first, though this increases the cost very considerably.

(4) *Xerography.* This is a recently developed process which produces results not unlike those of the previous methods but which employs an entirely different technical principle. It is relatively cheap and becoming very widely available, and though the standard machine in Britain at the moment will produce only true-to-scale copies from originals up to a maximum size of $9'' \times 14''$, there exist also more elaborate machines which will produce enlargements or reductions, and which, especially, will produce cheap paper lithographic plates or 'masters' allowing unusually inexpensive copying in very large numbers by lithography.

The results produced by all the processes just described are, of course, in black and white only and differentiation of colours found on the original must inevitably be as tones of grey which may or may not be distinctive.[11] The advantages of the methods differ widely

[10] Actually a diapositive, i.e. black lines on transparent material.

[11] In addition certain colours reproduce badly in various processes, e.g. blue which reproduces only weakly or not at all in the dye-line process.

according to the type of variables already described, and it is often best to seek advice on any copying problem from commercial firms able to provide a wide range of processes; most firms will gladly supply this advice as well as literature and price lists.

Manual Methods of Copying – tracing

Mechanical methods of reproduction are unlikely to supersede the use of hand tracing for hundreds of smaller or less important jobs. The best asset for this purpose is a *tracing table*, which consists essentially of a sheet of plate glass with lighting and often a mirror as well arranged underneath. Light from this source is able to penetrate the original drawing laid on the glass and allows tracing direct onto opaque media such as cartridge paper. Where no tracing table is available, and the drawing to be traced is not too large, the author has found that a rather uncomfortable but surprisingly effective substitute can be made by taping both paper and original onto an ordinary window with fairly strong sunlight behind it.

If tracing paper itself is used for copying, it should be remembered that it is among the least stable, dimensionally, of common drawing media. A large tracing will change size slightly but noticeably over relatively short periods of time, and for this reason it is as well to try to complete large tracings at one operation.

Chapter 11 Bringing in the Third Dimension

Chapter 4 described both qualitative and quantitative methods of representing relief on maps and, though representatives of both groups are found on modern maps, they tend to be there for rather different reasons. Whereas quantitative techniques (and this means essentially contours and/or spot-heights) are regarded as indispensible on any map which has real pretensions to showing relief, qualitative methods are often employed only as an extra to add visual attraction and sales appeal.

The reasons for this distinction are not far to seek. Quantitative methods not only depict relief but *measure* it as well, and in so doing provide measurements which can be adapted by a wide range of map users to yield further information on many aspects of the relief of an area. This chapter describes some of the methods by which this further information may be obtained from a contoured map; it begins by describing techniques which seek to reconstruct the terrain and passes on to those which analyse more closely some of its characteristics.

Techniques for reconstructing the terrain or part of it

1 *Profiles*

The profile or cross-section,[1] with its reconstruction of the vertical qualities of the relief, forms a useful complement to the plan-patterns emphasised by the contours on a map. Construction is simple, and is briefly described below and illustrated in Fig. 57A.

Construction of a profile

(1) Mark in the line of the profile on the map, and lay the edge of a blank piece of paper along it.
(2) On the paper mark in the ends of the profile, the position and altitude of each contour crossing and any intervening ridges and 'troughs', for example the rivers marked 'R' on Fig. 57A.

[1] The term 'profile' has now displaced 'section' for this type of drawing; the latter is used only when details of the features revealed by the cut (e.g. geological strata) are shown. The distinction is perhaps a little pedantic.

(3) Decide on a suitable vertical scale for the profile (see below) and, on a second sheet of paper, rule a base line and sufficient parallel lines above it to represent all altitudes included in the profile.

(4) Place the marked paper along the base line and project verticals from each mark up to the appropriate point on the altitude scale. Join these points with a line which should also take account of any features on the map which indicate the nature of the surface between the contours.

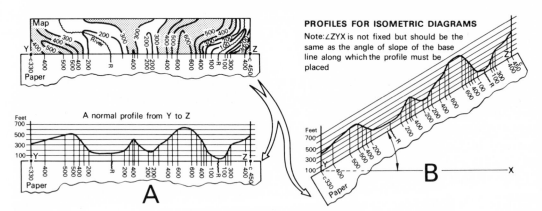

Fig. 57: Profiles. **A:** Construction of a normal profile. **B:** Construction of a profile for isometric diagrams.

Few cartographic techniques can be more widely known than this simple construction, yet in the author's experience several important points are usually overlooked in its execution. What constitutes a suitable vertical scale for example? If we draw a completely true-to-scale profile, as in Fig. 58A, employing the same scale for vertical and horizontal measurements,[2] the result may be rather disappointing; shown in this way relief even of Alpine dimensions can look insignificant and fundamental relief divisions, such as that of Switzerland into the Plateau, Alps and Jura, may become difficult to recognise. Most profiles are better for some exaggeration of the vertical scale but the question remains – how much? For probably nine out of every ten profiles drawn, this question is never answered consciously. Instead an arbitrary choice is made, derived solely from the type of lined or graph paper being used, giving more often than not very considerable vertical exaggeration and a profile which is misleading and sometimes grotesque, for example, Fig. 58C.[3] Convenience of construction should *not* be allowed to take precedence over effectiveness and a vertical exaggeration suited to the purpose of the profile, the terrain and the map scale should be consciously selected. For general purposes a vertical exaggeration of between 2 and 4 is often suitable (see Fig. 58B) but gentler terrain or smaller map scale may need greater exaggeration to give noticeable results;[4] in any event the

[2] The easiest way to do this is to mark out the vertical scale from the scale line on the map.
[3] It is a fair bet that in Britain with profiles drawn on $\frac{1}{10}''$ graph paper a good half adopt $\frac{1}{10}'' = 50'$ or $\frac{1}{10}'' = 100'$ for their vertical scale irrespective of the map scale.
[4] E. Raisz suggests the rule V.E. $= 2\sqrt{\text{scale in miles per inch}}$ for hilly areas, less in mountains, more in plains (*Principles of Cartography*, New York 1962, p. 71).

vertical exaggeration (V.E.) should always be stated on a profile and is easily calculated as follows:

$$\text{Vertical exaggeration (V.E.)} = \frac{\text{scale factor of the horizontal scale}}{\text{scale factor of the vertical scale}}$$

Example: Calculate the V.E. for a profile drawn with a vertical scale of $\frac{1}{10}$th inch = 100 feet on a 1″ to a mile map.

Vertical scale is $\frac{1}{10}$″ to 100′ = $\frac{1}{10}$″ to 1200″ = 1:12,000
(see p. 100)

Horizontal scale is 1″ to 1 mile = 1″ to 63,360″ = 1:63,360

therefore V.E. = $\dfrac{63360}{12000}$ = 5·28

Fig. 58: Aspects of profiles. **A, B & C:** Effects of variation in the vertical scale of a profile across Switzerland from near La Chaux des Fonds to the Matterhorn. **D:** Profiles and intervisibility.

The nature and location of the line along which the profile is drawn is also worth some consideration. A straight profile line almost invariably hits awkward or atypical features somewhere in its length, for example X in Figs. 58 A, B and C is no high plateau but an area where by chance the profile runs along local crests and not across them; alternatively should any feature be crossed obliquely its slopes will appear more gentle than if it had

been crossed at right-angles, producing misleading and non-comparable results. An irregular profile line will sometimes overcome these defects and may improve results, particularly where a 'typical' profile is needed. Occasionally profiles may have to be drawn along extremely irregular lines such as a winding road or river and in this case direct construction is impossible; the distances between contour crossings must first be measured carefully (see p. 103), and then transferred to the profile base line.

Profiles and intervisibility. The construction of a profile or partial profile (i.e. one containing only those parts likely to be critical or important as in Fig. 58D) is often suggested as a means of testing intervisibility between points, but the method has many snags and is perhaps best used *negatively* as a test of non-visibility (as at A, Fig. 58D), or doubtful visibility (as at B) rather than the other way round. Apparent visibility (as at C) may easily be interrupted, particularly by objects close to the observer; woods, buildings, and features of lesser height than the contour V.I., are all troublesome, and particularly so are convex hillslopes as at D, since they are easily overlooked and it is difficult to draw sections accurate enough to determine their precise effect.

2 *Block Diagrams*

The block diagram is a representation of the relief of an area showing all three dimensions on the same drawing. It resembles in effect a *drawing of a relief model* of an area and is a more general aid to understanding and illustration than is the profile. Several techniques are available for constructing block diagrams and they are, on the whole, more complex than most constructions described in this book. Before the actual methods are described, however, certain points relating to block diagram construction generally must be mentioned.

The first of these is that despite the plurality of techniques and the usefulness of the results, neither the ability nor the inclination to construct block diagrams appear to be widespread, and this defect must in part at least stem from the existing literature on the subject. In many works the description of the construction process is confused and incomplete[5] and, equally important, the simplified examples used as illustrations give no hint of the very considerable amount of effort which will actually be needed. Moreover the end result is not achieved entirely by construction. Really attractive block diagrams demand a good deal of artistic ability in the final stages of the drawing, and instruction in this aspect is often the weakest part of all so that would-be constructors of block diagrams are soon dismayed and deterred. Can this book then stimulate interest and enthusiasm where others have failed? The answer may perhaps lie in the adoption of two fundamental attitudes; the first is to state categorically at the outset that block diagram construction is a *tedious* and *meticulous* task, but one which produces results very well worth the effort involved,[6] the second is to eschew all aims at highly artistic products and concentrate on simpler but still effective results more attuned to the average person's competence.

[5] A major exception to this is Schou, A. *The Construction and Drawing of Block Diagrams*, London, 1964. This is well worth consulting by all who have block diagrams to draw and contains much more detail than is possible in this book.

[6] Meticulous working is essential to prevent confusion of lines arising during the construction process.

In all block diagrams the 'artistic' stage is the final one, and essentially involves drawing a 'skin of landscape' over a framework which has been constructed from the contours themselves. In this book the framework is always produced by drawing multiple profiles across the area. Alternative methods do exist: for example constructions which reproduce the contours themselves as framework, but profiles allow simpler and easier construction.[7] An essential requirement therefore in all processes described in this section is that the area to be drawn shall have a rectangular frame with profile lines ruled across this parallel to either pair of sides. The profiles need not occur at regular intervals and indeed are best drawn selectively to pass through prominent features; more profiles mean more work yet easier drawing and better results. With frame and profile lines in position we are ready to start.

2A *Construction of a Perspective Block Diagram*

The normal way of drawing any three-dimensional object (and this would include both a relief model and a complete landscape) is in perspective. The idea of perspective is fortunately a familiar one to many people but Figs. 59A and B emphasise some of its particular properties which are relevant here. One of these is that all parallel lines *converge* towards vanishing points on the horizon, this convergence implying that in perspective drawing there will be no constant scale, no line will be its correct length, and all dimensions will be reduced by varying amounts.[8] Distances in the drawing cannot therefore be transferred directly from the map, but must be transformed by the relatively elaborate construction methods described below. Since these involve some of the most complicated constructions described in this book, it is sensible to consider first whether the easier *isometric* or *sham-perspective* constructions (see below) would not suffice equally well; the true perspective block diagram is, however, marginally superior to all other results, and where perfection is important the following construction may be used:

Construction of a perspective block diagram of a rectangular area ABCD using multiple profiles. The rectangle is x″ by y″ and corner A will appear nearest to the observer.[9]

Stage 1. Preparation of a base drawing containing the perspective version of the rectangular boundary ABCD (see Fig. 60 bottom right), a master scale for all altitudes and all vanishing points.

Note: a sheet of paper rather more than $4x″$ wide and $2x″$ high is needed. Fig. 60 should be consulted throughout this description.

[7] The contour methods are described in Monkhouse, F. J. and Wilkinson H. R. *Maps and Diagrams*, second edition, London 1963, pp. 135–6 and Debenham, F. *Exercises in Cartography*, London, 1937, pp. 81–6. The simple examples shown look well enough but in practice it is very difficult to avoid an incredible confusion of lines.

[8] There are two exceptions to these rules. Lines parallel to the horizon, i.e. lines at right-angles to the direction of view, do not converge and similarly the 'first' of the horizontal lines of this type (ST in Fig. 59B), and any verticals drawn from it are usually made true to scale.

[9] As many readers will realise the perspective rendering of an area is infinitely variable depending on the height and distance from which it is viewed (e.g. compare Figs. 59A and B). Space here does not permit construction details being given for *all* perspective renderings; instead only one has been chosen for description. It is a 'middle-of-the-road' version suitable for most purposes.

Fig. 59: True perspective, isometric and sham perspective renderings of a rectangular area ABCD (*see bottom right*). **A** & **B:** are two different true perspective renderings. **C** & **D:** are two different isometric renderings. **E:** is a sham perspective rendering (*see text*). The thick lines in each drawing are those which remain their *correct length*: all other lines differ from their correct length.

(a) Rule a horizontal line HH and through its mid-point O rule EO at right-angles to HH. Fix F and E so that OF $= x''$ and FE $= x''$.
(b) At F rule lines sloping upwards at 45° to FO. Fix G and K so that FG $= y''$ and FK $= x''$. Use FK and FG to construct the rectangle FKJG, which is a replica of ABCD.
(c) At E rule lines sloping upwards at 45° to EO. These cut HH at V_1 and V_2 (alternatively fix V_1 and V_2 so that $OV_2 = OV_1 = 2x''$). Join V_1 and V_2 to F.
(d) N is the intersection of KE and V_1F; L the intersection of GE and V_2F. Join N to V_2 and L to V_1. M is the intersection of LV_1 and NV_2. FNML is the perspective rendering of ABCD and forms the 'lid' for all subsequent constructions.

Fig. 60: Construction of a *perspective* block diagram of a rectangular map area ABCD using multiple profiles.

(e) Decide upon the vertical scale to be used (either true or exaggerated – see above under profiles) and mark off from F along FE sufficient of this scale to contain the maximum altitude in the area. Calibrate this scale upwards from the lowest point P.

(f) Join all points on FP to V_2 and Rule LQ vertically across these lines. This establishes FLQP a master vertical scale for all altitudes required.

Stage 2. Transferring to the perspective drawing profiles taken along any line parallel to AB, for example RS.

(a) Measure DS and mark off this distance along GF and JK to fix U and T. TU occupies a corresponding position in FKJG to RS in ABCD. Join U to E.

(b) X is the intersection of UE and FV_2. Join X to V_1. Y is the intersection of XV_1 and NV_2 and XY the position of the top of the profile line in the perspective drawing. At X rule a vertical line XZ. Join each intersection of this line and lines on the master vertical scale to V_1. This establishes a vertical scale for the profile line.

(c) Transfer the contour crossings on RS to the corresponding positions on TU, using a piece of paper as in drawing a normal profile. Join each of these points on TU to E but rule in the lines only as far as XY. From the intersection of these lines with XY drop vertical lines to the appropriate line on the altitude scale and complete the profile in the normal way.

Any number of profiles can be drawn in this way, but to avoid confusion it is best to carry out all construction in stage 2 on a separate sheet of tracing paper laid over a drawing of stage 1, after which the completed profile only can be transferred to the master drawing. Little is lost and much construction work saved by keeping the number of points on each profile to a minimum, and supplementing these by interpolation and eye-sketching when the final perspective profile is being drawn. The drawing is completed by adding the 'landscape skin' to the multiple profiles in the manner described below under isometric block diagrams.

Note: If profiles are needed parallel to AD not AB the appropriate directions in the construction should be reversed, for example profile lines will emerge parallel to FG not JG, points on FP are joined to V_1 not V_2 and so on.

2B *Construction of an Isometric Block Diagram*

Block diagrams differing only slightly from perspective ones, but much more easily constructed, can be obtained using isometric drawing. This is a type of three-dimensional illustration much used in engineering, and which gives a perspective-like appearance by altering angles but keeping correct all dimensions parallel to two main axes. Fig. 59C and D illustrate the idea. In Fig. 59C the forward corner F of the rectangle is 'opened up' from 90° to 120°, so that the sides slope upwards in perspective fashion. However dimensions along these sides are correct and remain so along all lines parallel to them. Thus RE is parallel to and the same length as FG, and the same applies to RG and EF so that the rectangle has been replaced by a parallelogram of similar dimensions. As with perspective drawing, isometric rendering is variable and the angle at F can be altered freely so long as ∠ EFG is not reduced much below 120°;[10] for example in Fig. 59D one angle has been reduced to zero and ∠ EFG = 150°, an isometric form which corresponds to the perspective view in Fig. 59B above. For isometric block diagrams the 30°–30° form

[10] If ∠ EFG is reduced below 120°, the drawing becomes much more planlike and less effective.

of Fig. 59C is both suitable and convenient, but Figs. 61–63 are drawn on a 15°–30° base to illustrate other possibilities. Unfortunately isometric drawings have the defect that the rear corner of the rectangle looks too high (cf. Figs. 59A and C) but in block diagrams this is not always a disadvantage as the 'lift' tends to decrease the amount of dead ground which may occur in the 'flatter' perspective.

Construction of a 30°–30° isometric block diagram of a rectangular map area ABCD using multiple profiles. The rectangle is x″ by y″ and corner A is to appear nearest to the observer.

Reference should be made throughout to Fig. 59C.

(a) Rule a horizontal line and on it choose a position F to represent the corner A. At F rule FE and FG inclined at 30° to the horizontal. Fix E so that FE = AB = $x″$ and G so that FG = AD = $y″$.
(b) Draw RG parallel to EF and RE parallel to GF. FERG is the isometric rendering of the rectangle ABCD.
(c) Rule in on the map parallel to AD, the positions of all profiles which are needed and on a piece of paper mark the intersections of all these profiles with AB. Transfer these spacings to FE and GR and rule the profile lines across the parallelogram.[11]
(d) Construct an *isometric* profile for each of these lines as shown in Fig. 57B (p. 152). Two points should be noted: (i) the slope of the profile base line must be the same as that of the profile lines just constructed in stage (c) (in this case they will all slope upwards at 30°): (ii) whatever the slope of the profile base line, lines are drawn *vertically* from it to the appropriate altitude *not* at right-angles to it. The drawing would now resemble Fig. 61, but with a 30°–30° not a 15°–30° base.

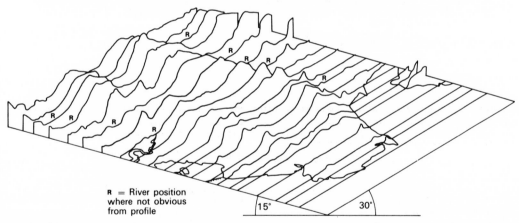

R = River position where not obvious from profile

15° 30°

Fig. 61: The first stage in the construction of a 15°–30° *isometric* block diagram of a rectangular map area ABCD, using multiple profiles. The area shown is the Cartmel peninsula in north Lancashire.

Finishing the drawing. The addition of a 'landscape skin' to this framework constitutes the most difficult part of block diagram construction and, as stated earlier, only a relatively simple method will be attempted here. This is as follows:

(a) Mark in on the map the lines of all important watersheds and crests.

[11] If profile lines run the other way they can be similarly transferred to FG and ER instead.

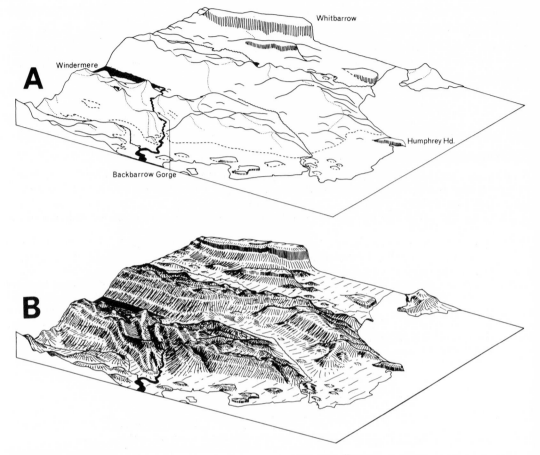

Fig. 62: The final stages in the construction of a 15°–30° *isometric* block diagram of a rectangular map area ABCD based on multiple profiles. The area shown is the Cartmel peninsula in north Lancashire. **A:** Drawing of crest lines and sky lines (*see text*). **B:** Finished drawing. This is not the most artistic result which could be achieved, but has been produced by adhering to the simple rules in the text.

(b) Lay a clean sheet of tracing paper over the finished drawing containing all the isometric profiles and using the profiles and map as guides sketch in the position of these crests, marking them continuously and boldly where they seem likely to form skylines and in dotted form where they do not.

(c) In similar fashion draw in the position of all coastlines, lakes, rivers, important breaks of slope and add also any other possible *skylines* which will occur where minor crests, knolls, spurs, etc., run *across* the direction of view. Fig. 62A shows the appearance of this 'crest-line' sheet at this stage.

(d) When all these features have been established, place a second sheet of tracing paper over both profile and 'crests' sheets and, using *both* as guides complete the drawing. This is most easily done by adding *hachure-like lines running down all slopes*; on longer slopes lines broken into two or three parts are easier to handle, though they may produce apparent breaks of slope if the breaks are too regular. Crests not forming skylines are

best left bare and horizontal or level areas are very lightly shaded with broken lines parallel to the profile base lines (see Fig. 62B).

Note: In drawing any block diagram a knowledge of the actual terrain helps enormously. Thus in Fig. 62B an attempt has been made to show the rocky nature of the Silurian fells, the 'smooth-summits-with-crags' of the limestone areas, for example Whitbarrow, the smooth *roche-moutonnée* form of Humphrey Head, and so on. At all stages the use of a 'finished drawing' sheet superimposed on construction sheets allows errors to be erased and redrawn without removing important earlier construction detail.

2C *Construction of a Sham-Perspective Block Diagram.*

For those for whom the 'high corner' of the isometric and the elaborate constructions of the perspective methods are both unattractive, the author has devised a *sham-perspective* construction, which gets the best of both worlds in that profile lines converge to a vanishing point yet remain dimensionally correct. This can only be achieved at the expense of distorting other straight lines into slight curves (see Fig. 59E), but the effect is not noticeable on a block diagram.

Construction of a sham-perspective block diagram of a rectangular map area ABCD using multiple profiles. The rectangle is x'' by y'' and corner A will appear nearest to the observer (see Fig. 59E)

Note: a piece of paper just over $3x''$ wide and x'' high is needed.
(a) Rule a horizontal line HH across the paper and about two-thirds of the way across rule HJ at right-angles to HH.
(b) Fix J and V so that HJ $= x''$ and HV $= 2x''$. Fix N so that JN $= y''$.
(c) Through J rule a horizontal line KJL. Rule in JM so that \angleMJK $= 26\frac{1}{2}°$ and JM $= x''$ (*Note*: \angleNJL also $= 26\frac{1}{2}°$ by construction). Join M to V and fix P so that MP $= y''$.
(d) Along the edge of a piece of paper mark off the spacing of all profile lines on AB and transfer this spacing to JM. Join all points so marked to V. Mark off y'' along each of these lines and draw in PN as a smooth curve passing through the ends. JMPN is a sham-perspective rendering of ABCD.
(e) Profiles can now be drawn along each profile line in one of two ways either (i) using iso-metric-type profiles (see Fig. 57B), the only difference being that each will have a *base line of a different slope*; this slope can be found by projecting the profile lines until they meet KJL, or (ii) using perspective-like profiles obtained as follows. Project JM to cut HH produced at a second vanishing point and use this to establish a master vertical scale along JM as in the case of perspective block diagram, stages 1(e) and 1(f). In this case, however, it is easier to establish the master vertical scale above JM not below it: this scale can then be transferred to each profile line using V as vanishing point.

Notice that in both cases *linear* dimensions on the profiles remain unchanged since each profile base line is its correct length.

As in other constructions if the profiles run the other way the construction details should be reversed, with V established to the left of HJ, and so on.

3 *Diagrams Derived from Professor Tanaka's Inclined Profile Method*

In 1932 Professor Tanaka described a method of obtaining a three-dimensional impression of an area entirely by construction using multiple *inclined profiles*.[12]

[12] See Tanaka Kitiro, 'The Orthographical Relief Method of Representing Hill Features on a Topographical Map' *Geographical Journal*, London 1932, Vol. 79 pp. 213–19. H. St. J. L. Winterbotham's note on the method in Vol. 80 of the same journal, pp. 519–20 is also interesting.

Unfortunately the work involved was considerable and the theory rather complicated, so that the method has remained little known or used, despite occasional attempts to revive it, for example by Robinson and Thrower in 1957.[13] This is to be regretted. Modifications can be made to reduce the amount of work whilst there is still retained the unique quality of allowing repeated construction alone to approach very near to the finished product – much nearer than with block diagrams for example – and it is for this reason that the method is discussed at length here. The discussion will be more intelligible if an outline of the mechanical construction is described first and the details and theory added later.

Construction of inclined profiles on a map, using Professor Tanaka's method

(a) Enclose the area to be treated in a rectangular frame and rule closely spaced parallel lines across it.

(b) Draw in the inclined profiles in the manner of FFF in Fig. 63A. These pass through the *intersections of the contours and the parallel lines*, starting with that of the lowest contour and the bottom horizontal line and *moving up one contour interval for each line* as they 'climb up' the area. When this condition can no longer be fulfilled, they turn and descend in the reverse manner. Thus FFF in Fig. 63A joins the intersections line 1, 100′; line 2, 200′; line 3, 300′; line 4, 400′ but since no 500′ contour intersects line 5 FFF turns and descends through the second intersection of line 4 and 400′ and so on.

When this line is complete a second line is started, based on the next series of contour-parallel intersections moving outwards. In Fig. 63A no other contour intersects line 1, pass on then to line 2 where GGG starts at line 2, 100′ and moves up to line 3, 200′, line 4, 300′ and line 5, 400′, there to turn and descend.

More and more of these profiles are constructed (the process is very rapid) until *every contour-parallel intersection has one* passing through it.[14]

So much for the construction: what are its implications? In Fig. 63A FFF at first moves upwards and backwards over the area, climbing one contour interval for each horizontal line. This is similar to the plane PP in Fig. 63D, since the slope at which PP cuts through the hill also makes it climb one contour interval in the distance between each pair of parallels. The line FFF is therefore being drawn out somewhere on the plane PP, and it requires little imagination to see that FFF is actually the profile made by the hill when it is cut by the inclined plane PP, hence the name *inclined profiles*.[15] The lines in Fig. 63A are therefore similar inclined profiles taken through the hill at regular intervals each having one of the parallel lines as its base (see Fig. 63D). Because they are profiles, each reflects the shape of the features it crosses, and in combination they may produce a three-dimensional visual effect (see Figs. 63A–C).

Let us now look a little more closely at some more of the details of the method – the spacing of the parallel lines, for example, and its effect. Figs. 63A to E show something of this. One obvious relationship is 'more lines = more work but more sections and a stronger suggestion of form', but this is not the only consideration. With closer parallel

[13] Robinson, A. H. and Thrower, N. J. W., 'A New Method of Terrain Representation', *Geographical Review*, New York, October 1957, pp. 507–20. This is one of the fullest and most lucid accounts of the method.

[14] The rule is, therefore, that all intersections must be *trisections*, one contour, one parallel and one profile to each; there are no other intersections on the drawing.

[15] Tanaka called these 'inclined contours' which is both misleading and self-contradictory The author has used 'inclined profile' throughout, as being a more descriptive term.

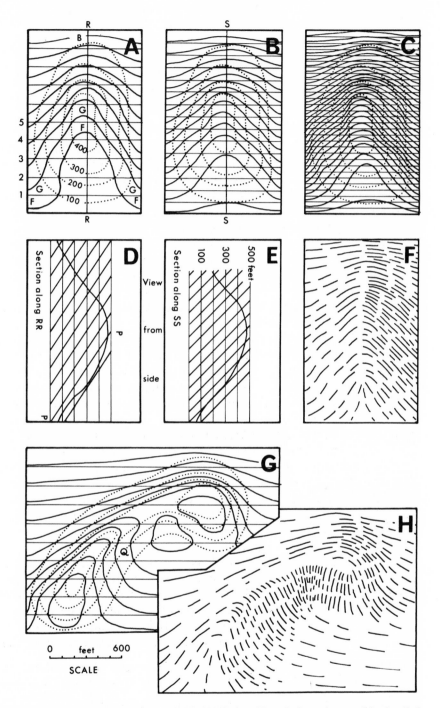

Fig. 63: Aspects of the inclined profiles associated with Professor Tanaka's orthographical relief method of relief representation. Notice that closer horizontal lines in **B** produce more profiles but 'flatter' ones (compare **A**). **C:** Even closer lines have been used here, but further flattening is prevented by *ignoring alternate horizontal lines* when drawing a profile. This method is not recommended, however, since confusion is hard to avoid in the construction process.

lines each profile must climb more quickly to the next contour, i.e. its slope increases in accordance with the relationship:

$$\text{gradient of inclined profile} = \frac{\text{contour vertical interval}^{16}}{\text{horizontal spacing of lines}}$$

and, as this steepening occurs, the appearance of the profile becomes more flattened: compare, for example, Figs. 63A and D with 63B and E. The slope of the profiles is therefore very important and their shapes will vary with it. The extreme limits would be reached when profiles were vertical, when they would emerge simply as the parallel lines, or horizontal, when they would reproduce the contours; but between these limits profiles with low inclinations will give an exaggerated three-dimensional effect, whilst steeper ones will play down this aspect. Moreover, since the contour interval on a map is already fixed the slope of the profiles will be dictated by the spacing of the parallel lines, and it was here that Professor Tanaka's original specification proved unattractive. For a variety of reasons[17] he suggested an inclination of 45° for the profiles: this implies parallel lines as far apart horizontally as contours are vertically, which entails a line-spacing of only 0·016″ for a 1″ map with 50′ V.I., and every 2 mm for a 1:50,000 map with 100 m V.I. If this can be done (and enlargements of the map are usually necessary before it can), the results produced with this type of spacing are often attractive and need no further drawing to produce a strong three-dimensional effect,[18] but the whole process is tedious in the extreme. Is there a way round this difficulty? One could, of course, use only selected contours, widening the V.I. and hence the horizontal spacing of the lines too, but confusion easily arises and a crudely pragmatic approach may offer better prospects. Let us assume that $\frac{1}{10}$″ spacing is reasonably practicable for the parallel lines[19] and experiment from there to find a suitable V.I.-slope combination. For example, in areas mapped at 1″ to 1 mile, and having moderate relief (say up to 1000′ amplitude) and simple land forms, a profile inclination of as little as 100′ per $\frac{1}{10}$″ appears to give satisfactory results (i.e. draw the construction described above using $\frac{1}{10}$″ lines and 100′ contours, for example the original of Fig. 64). This represents a profile gradient of 1 in 5·28 ($\frac{1}{10}$″ = $\frac{1}{10}$ mile = 528′; V.I. = 100′), giving very reasonable results here but too low for hillier or more dissected areas where the profiles would emerge too much like contours. Robinson and Thrower (*op. cit.*) used a gradient of 1:2·3 for a very successful rendering of part of Colorado, though this necessitated using a 500′ V.I. to give lines 0.188″ apart,[20] and such a V.I. would only be feasible in mountainous regions. There is no reason to believe, however, that experiment with gradients somewhere between these two values would not yield satisfactory and practicable compromises in difficult terrain.

Unfortunately profile slope is not the only likely source of trouble and disappointment with this modification of the method; the nature and direction of the terrain appear to

[16] Alternatively V.I. ÷ spacing of parallels = tangent of slope of the profile in degrees.

[17] See Tanaka *op. cit.* An attempt to simulate the reflection of light from a three-dimensional surface was one of them.

[18] e.g. see the illustration reproduced with Tanaka's original article.

[19] A major attraction here is that the lines of $\frac{1}{10}$″ graph paper laid over the map can be used and this obviates the need to rule any parallels.

[20] The resultant drawing is shown in Robinson and Thrower, *op. cit.*

be fairly critical. As Fig. 63A shows, the profiles are at their best when they run *across* relief features and are much less successful when running along them, or obliquely to them, and in the last case with low profile inclinations the lines may obviously 'slant up' the hillsides, weakening the three-dimensional effect, for example at Q in Fig. 63G.[21] The impression is weak too at the rear of features (for example B, Fig. 63A), where too gradual slopes are suggested and frontal slopes often emerge bare because there are considerable areas not intersected by a profile at all (compare the foreground of Fig. 63A and the corresponding part of Fig. 63D). In extreme cases sections will cut clean through shoulders on some frontal slopes, giving 'ring profiles' as in Fig. 63G, and these must be added wherever a double contour-parallel intersection remains *after* the normal profiles are completed. Where several such intersections occur on a frontal slope they should be joined up into one ring as in Fig. 63G using the normal 'rise or turn' rule stated earlier, in their construction.

Finishing the drawing.　The defects just described will not prevent the resultant profiles for many areas giving a strong sense of three-dimensional relief (see Fig. 64), but this will usually need augmenting.[22] Fortunately this can be done quite simply. Place a sheet of

[21] For all of these reasons attempts with varied profile inclinations in the Quellyn Lake area of Snowdonia proved relatively unsuccessful. Only valleys parallel with the line of view came out well and corries at the 'backs' of hills were poorly represented.

[22] As stated earlier this was *not* necessary with Tanaka's original technique.

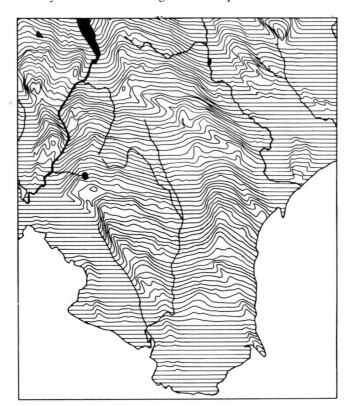

Fig. 64: Inclined profiles for the Cartmel peninsula, north Lancashire. The original drawing was constructed on $\frac{1}{10}''$ graph paper, and the 100′ contours on a 1″ map were used to obtain these profiles.

paper over the inclined profiles and trace them in using the following conventions:

(a) Break the lines irregularly.
(b) On the *right-hand* side of the hills sketch in an additional profile between the existing ones.[23]
(c) On frontal slopes *ignore any profiles which might mislead*, especially the 'ring-profiles' and instead draw in *hachure-type lines* running down the slope.

Figs. 63F and H were derived from Figs. 63B and G in this manner, and Fig. 65 represents a larger scale application made from Fig. 64 by the same method. As can be seen it is a complete three-dimensional rendering of the terrain produced almost entirely mechanically.

If further detail (of drainage, or roads, for example) has to be added to a drawing, such as Fig. 65, something of the implications of the construction process must briefly be considered. A strong point in favour of Tanaka's original method is that the profiles are truly 'lines on the ground' and must therefore be in their correct position planimetrically, so that detail can be traced directly from the map and will fit the profiles. For the same reason it follows that the profiles are not drawn three-dimensionally; they are drawn in plan and merely *look* three-dimensional. In the modified construction just described, however, these basic principles have been altered and largely abandoned, since we use the profiles as three-dimensional guide lines, letting their slopes be the slope of the ground. In doing so therefore, position is distorted, though only slightly, and detail traced from the map would not be strictly in its true position, though the displacement is very small and often negligible. Even so detail may *look* wrong: for example, the stream from Bigland Tarn (B on Fig. 65), when traced from the map seems to run *across*, not down, the slope because the profiles, which really run across the slope, i.e. inclined obliquely up it, are being used instead to simulate lines running *down* it. For the same reason we have introduced into the drawing vertical exaggeration equal to the *secant* of the inclination of the profiles,[24] but these points, though difficult to grasp in theory, are relatively minor quibbles in practice. For many circumstances and terrains here is a method of representation which, though needing meticulous work, is 95% construction and well within the artistic competency of most people. It deserves to be more widely known and used.

Techniques for the further analysis of the terrain

In recent years techniques concerned with this second aim have increased quite rapidly, originating particularly with geomorphologists who have sought to obtain from the relatively complete record of the well-contoured map, indicative or confirmatory evidence of the existence of certain features in an area.

[23] To give a 'left-hand-light' hill shading effect. This is not necessarily a north-west light since the horizontal lines need not run east west, but are best arranged to suit the run of the topography.
[24] Because a given vertical distance is now represented by the inclined distance measured up the slope.

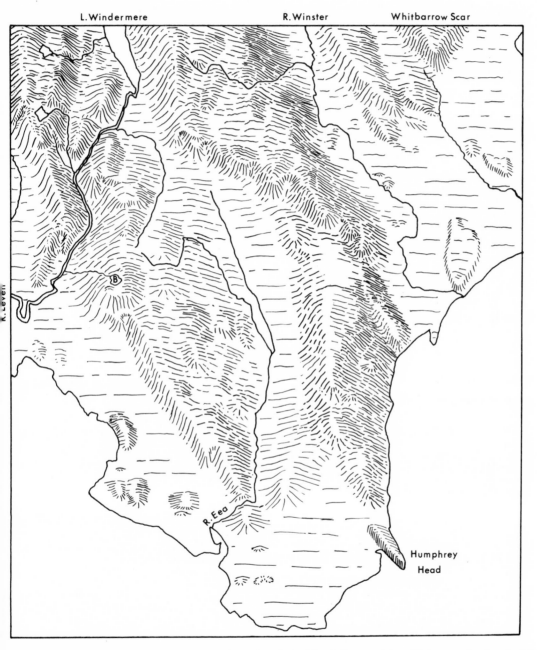

L.Windermere R.Winster Whitbarrow Scar

R. Leven

B

R. Eea

Humphrey
Head

Fig. 65: A representation of the Cartmel peninsula in North Lancashire. This was obtained with the use of a modified version of Tanaka's inclined profile method of relief representation. The drawing was derived from Fig. 64 as described in the text; it also covers very nearly the same area as the block diagram in Fig. 62B. This is by no means the most artistic result possible, but has again been obtained by keeping strictly to the rules described in the text.

As is often the case in cartographic work the techniques which have developed for this purpose are not, in themselves, complex; but it must be stressed that their use is only likely to be successful when it is coupled with a full understanding of the characteristics of the features being investigated, and the effects and limitations these will have on the results. In short these are techniques for specialised geomorphologists working within their own field, and as such lie outside the more general scope of this book. This section of this chapter will therefore be confined to a description of two simple techniques which, though capable of more specialised adaptation, have widespread usefulness for anyone seeking a more detailed understanding of the general physical characteristics of an area.

Slope and Slope Mapping

The slope of the ground, with its frequent interrelationship with the physical evolution or human occupation of an area, is one of the most fundamental of the quantitative aspects of terrain that can be measured from a contoured map.[25] In practice, slope may be defined in several ways, in degrees, as a gradient, as a percentage and as so many feet per mile for example, but all are easily derived from the relationship between the vertical interval between two contours (the V.I.) and the horizontal distance (the horizontal equivalent or H.E.) which separates them. These relationships are as follows:

To obtain the slope:

(1) in degrees $\quad\quad\quad\quad\quad\quad \dfrac{\text{V.I.}}{\text{H.E.}}$ = the tangent of the angle of slope. Find the angle whose tangent has this value in a table of natural tangents.

(2) as a gradient $\quad\quad\quad\quad$ Let H.E. \div V.I. $= x$. The gradient is 1 in x.

(3) as a percentage $\quad\quad\quad \dfrac{\text{V.I.}}{\text{H.E.}} \times 100$ = the slope as a percentage.

(4) as so many feet per mile $\quad \dfrac{\text{V.I.}}{\text{H.E.}} \times 5280$ = the slope in feet per mile

Interconversion is also relatively simple:

(5) with a slope in degrees $\quad\quad\quad$ the *cotangent* of the angle of slope is the same as the slope expressed as a gradient.

(6) With a slope in degrees $\quad\quad\quad$ 100 × the tangent of the angle of slope gives the slope as a percentage.

(7) With a slope as a gradient of 1 in x \quad x *is the cotangent* of the angle of slope in degrees.

(8) With a slope as a gradient of 1 in x \quad *100 ÷ x is the slope as a percentage.*

For more rough-and-ready purposes the fact that a slope of 1° is approximately equal to a gradient of 1 in 60 (actually 1 in 57·14) may be used to obtain the following *crude* conversion formulae:—

(1) slope in degrees = slope as a gradient (expressed as a fraction, i.e. $\dfrac{\text{V.I.}}{\text{H.E.}}$ or $\dfrac{1}{x}$) × 60.

(2) slope as a gradient (expressed as a fraction) = slope in degrees ÷ 60.

[25] It must be stressed again here that measurement on the map will only yield the *average* slope between contours which may or may not be representative of ground conditions – see for example Fig. 25A, p. 61.

These will give tolerable results up to slopes of about 20° or 1 in 3, for example, if slope is 1 in 3, then slope in degrees is approx. $\frac{1}{3} \times 60 = 20°$ (actually 18° 26'); or if slope is 20°, then slope as a gradient is approx. $\frac{20}{60} = \frac{1}{3}$ or 1 in 3 (actually 1:2·75).

Construction of a scale for slope measurement.[26] If large numbers of slopes have to be measured it is quicker and more convenient to construct a scale for this purpose. This indicates the spacing of contours corresponding to particular slopes for a map of given scale and contour V.I., and allows the slope of the ground to be measured by direct comparison with the contour spacing. Fig. 66 illustrates such a scale which can be constructed, on durable transparent material, as follows:

(1) Using the formula *H.E. = V.I. × cotangent of the angle of slope* calculate the H.E.'s corresponding to various angles of slope chosen at suitable intervals (every degree from 1° to 10° and every 5° from 10° to 40° will often suffice).[27]

(2) Mark out these intervals along a suitable horizontal scale line, which need not be regular (see Fig. 66) and mark off at each point perpendiculars of length 10 × the H.E. for that value.

(3) Subdivide these perpendiculars into 10 equal parts thus: let the perpendicular which has to be divided be MN; at some distance away construct another perpendicular PQ 10 units high; join PM and project this line to cut the base of the scale at R (see Fig. 66); join all 10 divisions on PQ to R when these lines will subdivide MN as required.

[26] Such scales are provided in the margin of some foreign map series, e.g. many official German maps have one.

[27] For more accurate construction, and especially where intermediate values are to be read off, additional intervals will be needed, e.g. every $\frac{1}{2}°$ below 5°. It will rarely be necessary to go beyond 40°.

Fig. 66: A scale for measuring slope on maps from the spacing of contour lines. The original drawing showed the spacing of contours at 50' V.I. on a map of 1" to a mile. This reproduction is reduced to exactly half original size and therefore represents the spacing of contours at 50' V.I. on a $\frac{1}{2}$" map.

(4) When all the perpendiculars have been divided join all corresponding subdivisions with curved or straight lines. Curved lines are essential if intermediate values are to be read off from the scale but straight lines are easier and will suit most purposes.

Whilst many people can judge variations in slope from contour patterns, few can relate contour spacing on a map to a visual impression of the kind of slope they would encounter in practice, and it is always useful to take a contoured map into the field to compare contour spacing with reality. Working towards a somewhat similar end of relating slope to every-day experience, McGregor[28] has evolved the useful classification listed below.

DESCRIPTION	SLOPE	GRADIENT	COMMENTS
very steep	35°–45°	1 in 2 *to* 1 in 1	At 40° teracettes are usually well marked. Scree accumulations often show an angle of rest of about 30°.
steep	25°	1 in 2	
steep	18°	1 in 3	About the maximum slope under cultivation and then generally under permanent grass.
fairly steep	11°	1 in 5	Often critical. About the limit for ground that has to be ploughed and cut annually. Also about the maximum that could be used for housing[29]; would need stepped profile of roofs and gables.
moderate slope	6°	1 in 10	Still clearly noticeable when walking. Well drained; easily cultivated and built on.
gently sloping	3°	1 in 20	Drainage good.
flat	1° or ½°	1 in 60 to 1 in 100	Difficult to distinguish, but water shows no tendency to meander on its own account until the slope is less than ½°.

Construction of a slope map. It is often useful to map the slope of the ground within an area to study its possible correlations with other features, as in Fig. 67, and there are several ways of making such a map.[30] In this book the method devised by Raisz and Henry[31] has been selected because of its relative simplicity and obvious adaptation to correlative studies.

The principal aim of the Raisz and Henry method is the definition on the map of *areas of similar slope*, these being differentially shaded according to steepness. In practice this amounts to defining areas which fall within a given category or range of slope, since only some 6 or 7 shadings are feasible and these must embrace all slopes encountered in the terrain. It follows from this that an important preliminary step is the choice of limiting

[28] McGregor, D. R. 'Some observations on the geographical significance of slopes', *Geography*, Vol. 42 (1957), pp. 167–73.

[29] Conventional housing. Flats might be built on steeper slopes.

[30] A brief description of some of the other methods is contained in Monkhouse and Wilkinson, *op. cit.*, pp. 106–10.

[31] Raisz, E., and Henry, J. 'An average Slope Map of Southern New England', *Geographical Review*, Vol. 27, pp. 467–72, New York 1937.

values for these slope categories, and this is best made from a variety of considerations. Certain critical values, for example the slope of land too steep for building or ploughing where this is relevant, may be suggested by the intended use of the map; but one should also sample, and be guided by, slopes over the whole area, particularly those associated with different types of terrain. In Fig. 67 the slope of the surface formed by the Rough Rock around Halifax averages about 5°, so that a choice of 6° as limiting value for one category ensured that this surface would remain distinctly defined. Category limits should also be chosen so that prominent breaks of slope are marked by the boundaries between different types of shading, and not lost within larger areas.

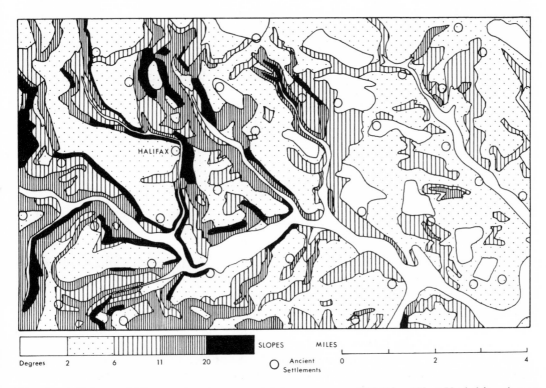

Fig. 67: A Raisz-and-Henry-type slope map of the area around Halifax, West Yorkshire. A map of this sort emphasises quite strongly the relationship between the sites of ancient settlements and areas of more gently-sloping land.

Once limiting values for the slope categories have been selected the contour spacings corresponding to these should all be marked on the edge of a piece of paper: this is moved over the map until slopes of the critical values are found, and the boundaries of the areas can then be drawn in. In practice this process is more difficult than one might suspect, and the following points may help:

(1) Slopes must always be measured at right-angles to the contours.

(2) Unless extremely precise or detailed correlation is envisaged, only the generalised slope across groups of *similarly spaced* contours can normally be considered. As slopes approach the limiting values there will often be found within a fairly homogeneous slope contours whose spacing exceeds the limit; the definition of such deviations will often confuse rather than clarify the result.

(3) At crest lines and in valley bottoms two kinds of slope, longitudinal and transverse will meet; the steeper of the two should be selected, though in some cases it may be possible to define narrow gently sloping valley floor and crest-top facets, for example the main valley floors in Fig. 67. Crests, cols, spur ends and similar features do, however, provide some of the more difficult situations for this type of map, and in these cases much may indeed 'depend upon individual judgement'.[32]

The mapping of relative relief or 'local relief'.[33] In Britain, as in other islands and countries near the sea, there is often a distinct correlation between altitude and the incidence of mountainous or hilly terrain, but this is by no means always the case elsewhere. In the Canadian prairies for example, at altitudes of almost 2,000 feet, local terrain may be no more than 'rolling' and to obtain a satisfactory impression of what an area is like it may be important to study and map the amplitude of the relief as well as its altitude. Once again several methods are possible but only one, that of G. H. Smith,[34] which is widely known and illustrates many of the principles of this group of techniques, will be described.

Construction of a map showing the amplitude of relief in an area.

(1) The area to be studied is divided up into areas of uniform size (Smith, working in Ohio used rectangles 5' longitude by 5' latitude – 4·40 miles × 5·75 miles).

(2) Within each of these the amplitude of relief (highest point – lowest point) is calculated and plotted as a spot value in the middle of the area.

(3) Isolines are drawn in as required between these values[35] and the map hyposometrically shaded or coloured, as in Fig. 68B.

Within these elementary principles there is often scope for modification and experiment, particularly in response to the type of terrain and the essential purpose of the finished map. The size of the square or rectangle can be varied and will affect the result: too large a square gives generalisations little related to 'on the ground' impressions; too small a square allows local detail to blur regional patterns. The same amplitude within a square can, of course, be produced by quite different types of terrain, for example widespread dissection or gradual rise across the square; but careful choice of square size may help to minimise this effect. Further examples of potential variations in this method are illustrated in the construction of Fig. 68, which simply attempts to answer the question: 'What kind of terrain shall I find in Northern England?'. The modifications made to

[32] Monkhouse and Wilkinson, *op. cit.*, p. 106. In some terrains endless judgements of this type have to be made, e.g. in very hummocky country, and it is doubtful whether this method is really feasible in such cases.

[33] The terms 'relative relief', 'local relief' and 'amplitude of relief' have all been used to describe this type of map.

[34] Smith, G. H., 'The Relative Relief of Ohio', *Geographical Review*, Vol. 25, pp. 272–84, New York 1935.

[35] See Dickinson, G. C., *Statistical Mapping and the Presentation of Statistics*, p. 57, London 1963.

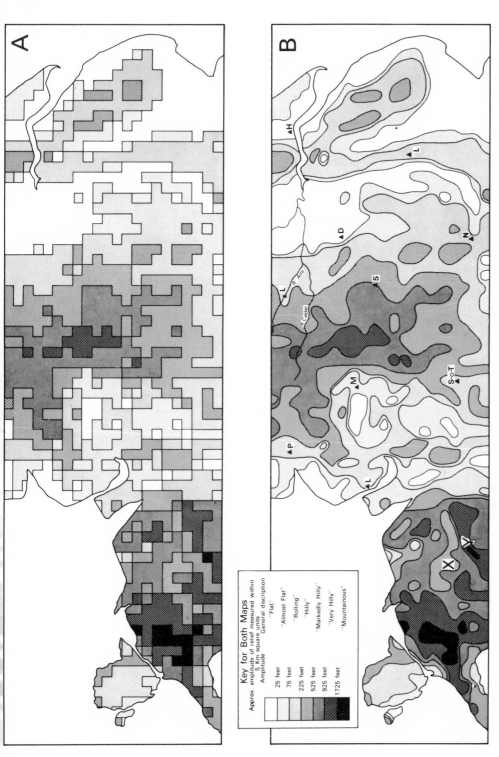

Fig. 68: Amplitude of relief in northern England. **A:** Amplitude within 5 Km squares, determined as described in the text, and plotted for whole squares. **B:** The same, but with the amplitude treated as a 'spot value' at the centre of each square, and with isolines drawn between the 'spot values'.

Smith's method are listed below; the aim was to make a map which would reflect as closely as possible impressions obtained on the ground:

(1) A national grid square 5 km × 5 km (3·14 × 3·14 miles) was selected as the basic unit. This is convenient, slightly smaller than Smith's unit but not too small, and is not dissimilar to the extent of an observer's 'immediate surroundings' in the field.

(2) To obtain more typical amplitude values within each square these were measured between the highest and lowest *contours* (not spot heights), using only contours which enclosed at least an area of 1 sq. km above them (highest) or below them (lowest) within the square.[36]

(3) Where squares were incomplete because cut by the coastline, this minimum 1 sq. km was modified proportionately, and the lowest contour was taken as 0 only where valleys penetrated to sea-level; otherwise the lowest contour on the cliff top was used.

(4) The resultant values were plotted in two ways, direct as complete squares and using spot values and isolines. In the former case 25′ (half the V.I.) was added to all calculated values, so that more realistic figures were obtained at the lower end of the range where squares with no contour, or only one contour, would have emerged with a misleading amplitude of 0. In Fig. 68B however the isolines were deliberately chosen at values intermediate to the calculated amplitudes (i.e. 25's and 75's, not 50's and 100's), so that this modification was not necessary.

(5) The seven amplitude divisions used were suggested by plotting a dispersal graph[37] of all amplitudes and selecting divisions compatible with this, and yet amenable also to simple description.

One rather surprising point about maps showing amplitude of relief is that they are a little difficult to interpret at first impression. The layman invariably tends to equate the higher amplitudes with the occurrence of hill masses, but this is far from being a simple correlation. Many hilly areas with flattened summits are marked by ring isolines of *lower* amplitude, and higher values may occur peripheral to such masses, or where they are penetrated by a major valley unit. This occurs on Fig. 68B where the hills of the Denbigh Moors at X are bounded, and partly penetrated, by the Dee Valley Y.

This chapter has described several methods which can be used to come to a clearer understanding of the 'solid form' of an area. Each offers its own emphasis, and though many are time-consuming to execute, none is difficult to understand in principle. Between them they allow some investigation to be made of all the main characteristics of the relief of an area, and whether this is a prelude to other detailed work or simply undertaken for more general purposes, there can be few areas where the application of one or more of these techniques would not result in greatly increased understanding of the three-dimensional nature of an area.

[36] This works well except where prominent isolated hills rise above much lower surrounding areas, e.g. in the Lleyn Peninsula. In this case the first contour which has 1 sq. km above it, may be much lower than the summit and the map value does not reflect reality; fortunately such terrain is unusual in the North of England.

[37] See Dickinson, *op. cit.*, pp. 43–44.

Chapter 12 The Map as an Historical Record

Anyone who wishes to study past landscapes or the changes by which the present land-scape evolved, must sooner or later consider the possibility of using historic maps as a source of information. This chapter discusses the advantages and, more significantly, the less obvious disadvantages inherent in this type of source material.

Chapter 3 described how in many advanced .countries official surveys, comprehensive of landscape detail and of good accuracy, have a history extending back almost a century and sometimes much more. Should there also have been during this period several re-visions or re-surveys, then these maps may yield much historical information relevant to studies of many kinds, particularly those relating to the development of urban and rural landscapes. In Britain this is especially the case: the table in chapter 6 (pp. 88–9) listing the revisions of the large scale Ordnance Survey maps gives some idea of the range and amount of material available up to about 1920, which Fig. 69 re-affirms with a practical example of a study made entirely on this basis.

Unfortunately the considerable success of this type of study is rather atypical, and can lead to unawareness of the dangers inherent in the method generally if it is more widely applied, particularly when maps are used which are not official surveys or are more than a century and a half old. Official surveys are important here because the State, as carto-grapher, was distinctive in two respects: its maps were unusually comprehensive, and it could afford far more than the private cartographer to pursue high standards of accuracy. If, for example, we were to try to fill gaps in the sequence in Fig. 69 by additional informa-tion from privately published maps, we should enter a cartographic field where both accuracy and reliability are poorer than in the official surveys;[1] if we go back beyond the nineteenth century then the limitations and inaccuracies inherent in privately published maps become so serious and widespread as to warrant systematic description.

In the first place, as chapter 2 emphasised, early maps are grossly incomplete as to content. Generally speaking they show only fundamental landscape details such as towns, villages, mountains or main rivers; and there are many features, such as roads (for a time) or the boundaries of enclosed land, which are not recorded. Additionally the small scale

[1] This statement does not, of course, apply uniformly to non-official productions. The best of these can often match official surveys (not least because they are often derived from them), but this was far less true 70 or 80 years ago than it is today, and in particular revision was often less complete and reliable. It is not uncommon to find, e.g. railways which were only projected and stations which had closed 10 years before the map was published, marked on nineteenth-century maps of Britain.

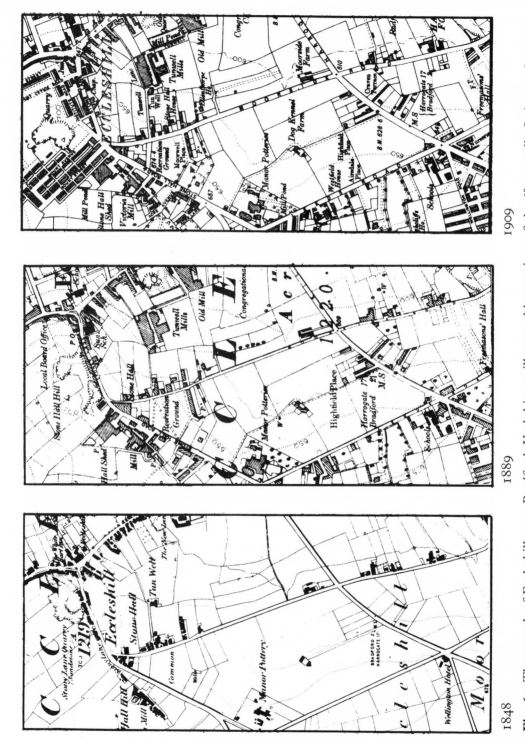

1848

1889

1909

Fig. 69: The growth of Eccleshill, near Bradford, Yorkshire as illustrated by portions of the 6" to a mile Ordnance Survey maps of 1848, 1889 and 1909. Detailed maps of this sort present a remarkably clear picture of the sequence of industrial and 'civic' developments during this period, the predominating residential growth being easily noted as well.

of many early maps proves a severe limiting factor so far as detail and content are concerned.

Secondly much detail which is shown on old maps is inaccurately placed as regards both its absolute and, often, its relative position. This again is not surprising bearing in mind the limitations of early surveying techniques (see chapter 2), and even where accurate techniques were known, lack of time and money often prevented their use. Triangulation, once it had become common practice, might improve the general overall accuracy of a map, and the *triangulated* points (usually villages, churches or hilltops) would thereafter be well defined; but other detail was often fixed by much less accurate means, perhaps even by sketching or copying from pre-existing maps (see below), so that quite serious errors could result. Early official surveys too are apt to show similar characteristics, for example Carr records, significantly, that the first edition of the one-inch Ordnance Survey map of Devon in 1809 shows a rocky cliff over quarter of a mile inland from its present position, and that even in 1906 a former Director-General of the Ordnance Survey pointed out that 'old charts and maps in the Ordnance Survey Department furnished no evidence of any real value as to changes on the coastline'.[2] It was for such reasons, of course, that many countries later undertook complete resurvey of their official maps.

Undoubtedly certain types of feature are more prone to errors of shape and position than others. Features of little direct use, such as forest boundaries, river courses and coastlines are more likely to be erroneous than villages or roads, though understandably Admiralty Charts may portray marine features better than topographical maps. Nor do large scale and abundant detail necessarily entail accuracy, and some of Roque's large scale, very detailed maps have been criticised on this count. Some idea of the Ordnance Survey's accuracy is given in *Survey Computations*,[3] but even in this work it was admitted that 'most topographical maps show traces of bad survey here and there', and it was not until the use of air photographs became widespread that completeness and accuracy in the recording of much intricate topographical detail became relatively easy to achieve.

Whilst lack of completeness and inaccuracy of position might be expected on old maps, errors arising out of inconsistent definition are less obvious. Land use and vegetation features are the most likely sources of error here: for example, Ordnance Survey one-inch maps of Britain have traditionally marked the boundaries of 'rough' land, such as moor, heath, rough pasture; but can we be sure that a consistent definition has been applied over a century and a half? 'Rough' cannot be equated with 'unenclosed', for there has been some reversion, and similar difficulties might arise on maps showing the margins of marshy areas or unenclosed woodland. Scandinavian maps are unusual in differentiating not only farms but different types of farm settlement, but as Sund and Sømme have pointed out there have been inconsistencies here, too.[4]

The final class of inaccuracy on old maps concerns date. It cannot be stressed too

[2] *Royal Commission on Coast Erosion & Afforestation*, Vol. III (Pt. 1). Third (and Final) Report, London H.M.S.O. 1911, pp. 43–4 – quoted in Carr, A. P. 'Cartographic Record and Historical Accuracy', *Geography*, Vol. 47, pp. 135–43. This is an extremely useful and informative paper on the topic, discussing principally coastal features.
[3] Properly *Survey computations to be used in conjunction with the Text Book of Topographical and Geographical Surveying*, third edition., 1926, London H.M.S.O., p. 4.
[4] Sund, T. and Sømme, A., *Norway in Maps*, Text Volume pp. 12–13.

strongly that the recording of a particular date on a map does *not* necessarily imply that the map is a record of that area *at that date*.[5] In many cases the map must be regarded as the best delineation of an area which the publisher could *compile* at that date, and the element of compilation is extremely important. Large portions of many old maps contain little more than detail taken unchanged, unchecked and unacknowledged from even earlier maps, so that inaccuracies were perpetuated for decades and whole 'families' of maps, obviously derived from one another, can be observed. The notes 'revised in . . .' or 'amended in . . .' carry no real guarantee, for revision may have been confined to important detail only, new roads, railways or urban extensions for example. It is not until the official maps arrive, based on complete surveys or full revision, that this weakness entirely disappears. It is this uncertainty as to the completeness of revision at the dates given which renders privately published maps less useful than official ones in a study of the type illustrated in Fig. 69.

Enough has been said here to indicate that historic maps rarely provide unequivocal answers to straightforward questions such as 'what was there?', 'when was it there?' or 'where was it?'. The answers may need qualifying because of the nature of the object, the type of locality where it occurs, or the reputation of the cartographer; and it is therefore worth noting that better results may sometimes be achieved by approaching the problem from the opposite direction. Where fragments of a historic landscape have survived to the present day old maps may help to establish a successful interpretation of their nature, whilst their remaining physical traces establish their position far more accurately than any ancient cartographer might have done.

In practice, of course, the difficulties which have been described systematically above appear on old maps integrated to a considerable degree. This chapter concludes, therefore, with three brief examples which will illustrate some of the general and specific difficulties involved in using old maps to answer historic problems and considers also the relationship of cartographic to other forms of historical evidence.

Example 1 Investigation of early routes in Britain using the fourteenth-century Gough Map

As the earliest map of mediæval Britain to show roads, the Gough Map has considerable significance for anyone tracing the evolution of our national highways. Let us compare part of today's 'Great North Road' with its counterpart marked on the Gough Map.

The general course of the Gough Map's Great North Road is easily traced and passes from London through Waltham, Ware, Royston and Caxton to Huntingdon (see Fig. 70) coinciding not with today's A1 but with the A10–A14 roads. This is no surprise for the use of this latter and essentially Roman route as the Great North Road, persisted quite late and is well known; but between Huntingdon and the Nene crossing at Wansford quite a different sort of deviation occurs. The Gough map distinctly marks one intermediate place on this section, namely Ogerston, which, though it takes some finding, survives today simply as 'Ogerston Manor, remains of' (O.S. 1″ map sheet 134 G. Ref. 121905), some 2 miles *west* of the present A14–A1 route but lying on the line of a remarkably direct system of country lanes which might well, reasoning along lines which

[5] In any case the date is usually that of publication rather than the more relevant date of survey; see also chapter 6, p. 80.

will be described in chapter 14, represent a 'fossil' Great North Road. Is there here, then, clear indication of a former deviation of the present route? On cartographic evidence alone the answer can only be 'no', for all that this might mean is that this was *a* route used by *some* travellers and was the one known to the compiler of the Gough Map. It does not in itself preclude the contemporary co-existence of today's A14–A1 route from Huntingdon to Wansford (it is significantly the Roman Ermine Street for much of the way), and only other types of historical information could settle the question. Certainly

Fig. 70: Part of the fourteenth-century Gough map showing the Great North Road from London to Stamford. (Ordnance Survey facsimile, reproduced by permission.)

Ogerston was an establishment of the Knight's Templar, and there are records of its use as a halting place for important travellers,[6] but we should need far more evidence than this to conclude whether one or both routes were in use and, if the latter was the case, which was the dominant one.

Example 2 Investigation of old roads in Kent using Symonson's map of 1596

Symonson's map, like the Gough Map, is an unusually early example of a map showing a road system and it makes an interesting comparison with the previous section to attempt the same sort of study on the much more detailed background of the county map. One example will suffice – an investigation of Symonson's road from Dover to Sandwich.

[6] Edward I stayed there, e.g. in 1299 and 1303. For further details see Stenton, Sir F., *op. cit.*, footnote 4, chapter 2.

N

Quite obviously (see Fig. 71) Symonson's road is not the modern A256, which lies further west and enters Sandwich via Eastry; but if this is not so, where was Symonson's road and does any trace of it survive today? The limited accuracy of maps of this period precludes placing much reliance on the actual shape and absolute position of the road as it is shown, and instead its position must be fixed relative to other detail. What we need then, to begin with, is a road passing as Symonson's does through Charlton,[7] just west of Guston and between 'Bewtfield' (an obvious mistake for Whitfield) and West Langdon. Here the old Roman road, first as a footpath, then as a lane, fits these requirements admirably (Fig. 71B), but since it eventually joins A256 at Eastry this is not the whole story. Symonson's road passes just east of Little Mongeham (Mongeham pva) and between Betteshanger and Norborne and Norborne and Ham, so that a much more likely candidate now is the quite direct country road via East Studdal to West Street.[8] Beyond this point however it is impossible to conjecture. The marshes south of Sandwich today bear little resemblance to detail on Symonson's map, which shows the main stream *west* of Worth, and there are no hints on the modern map of the whereabouts of Symonson's road with its unlikely double crossing of this stream. Presumably drainage and/or enclosure have modified the pattern here, and much more detailed cartographic evidence might be needed to get further. In any event the whole alignment suggested from Dover would need confirming from other types of evidence. But Symonson's map has, at least, offered a strong pointer to a possible older road and a good indication of localities where it might be profitable to seek further information.

Example 3 Cartographic evidence and the study of the evolution of variable coastal features, such as sand spits, shingle bars, etc.

In the study of the evolution of these relatively rapidly changing physiographic features, cartographic evidence may indeed prove a two-edged weapon. While old maps could, of course, offer a unique record of changes in the form of such features over perhaps four centuries or so, one remains very conscious of the fact that, until the coming of the official surveys at least, they may be far from the reliable guide to the definition of shape and position that is needed in this context.[9]

There is no easy solution to this particular dilemma, but there are two sensible lines of approach. The first is to assess the possible accuracy of each map through a wider knowledge of the general quality and character of a particular cartographer's work, rejecting the evidence of some maps as unreliable but accepting others: Diver's study of the evolution of the South Haven Peninsula in Dorset provides an admirable example

[7] A distinctive feature of Symonson's roads is the rarity with which they pass *through* villages. Perhaps the church symbols make it difficult to show this but the awkward relationship of the roads to these and other detail suggests, to the author at least, a possibility that the roads may have been added later.

[8] Rather oddly this road too finishes only a mile short of a Roman temple $\frac{1}{4}$-mile south of Worth; the hamlet name West *Street* is also intriguing and suggests a possible Roman by-way.

[9] Particularly so since these features would have relatively little interest for most cartographers, and would contribute little to the commercial value of their products.

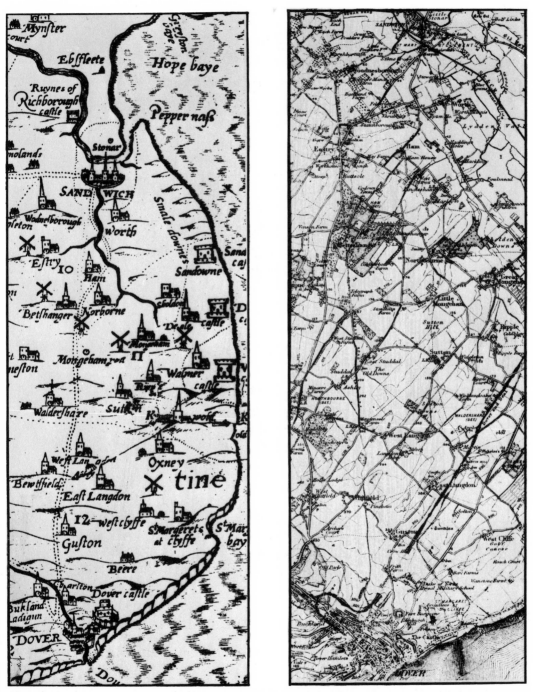

Fig. 71: Part of Kent between Dover and Sandwich as shown on Philip Symonson's map of Kent, 1596, and sheet 290 of the 3rd edition of 1″ Ordnance Survey map (1911). The latter map has been reduced to about two-thirds original size. (Symonson's map is reproduced here from an Ordnance Survey facsimile, by permission.)

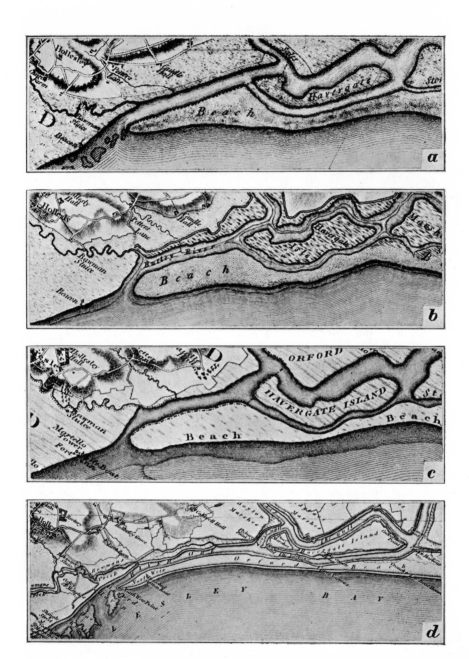

Fig. 72: The Representation of Orford Beach, Suffolk on four maps all published at 1″ to 1 mile between 1783 and 1838. **A:** Hodgkinson published 1783. **B:** O.S. first edition published 1805. **C:** C. and J. Greenwood published 1825. **D:** O.S. first edition revised, published 1838. (Reproduced from A. P. Carr, 'Cartographic Record and Historical Accuracy', *Geography 47*, p. 144, by permission of The Geographical Association and the Trustees of the British Museum.)

of the sifting and weighting of cartographic evidence in this manner.[10] The second is to question any cartographic evidence which cannot be reconciled with a reasonable estimate of the rates of physiographic processes or the dating of remains by any other method. Thus Steers, tracing the southward growth of Orford Ness in Suffolk was able to establish, from cartographic evidence, a fairly consistent development at an average rate of about 15 yards per year, between Norden's detailed and fairly accurate survey of the area in 1601 and the spit's maximum extent attained in 1897. He rejected, however, the position of the tip as shown on a coastal chart of Henry VIII's time because it would have necessitated almost double this rate of growth before 1601, which seems unlikely.[11] Similarly Carr in a further study of cartographic evidence on this subject points out that, even with nineteenth-century maps of more reliable accuracy, lack of precise information of the date of survey raises difficulties. For example, the Admiralty Chart of 1819 and the revised 1″ Ordnance map *published* in 1838 show the tip of Orford Ness in almost exactly the same position, whereas Bullock's survey of 1847 places it 3,000 feet further south. As Carr remarks 'both experimental and documentary evidence together suggest that the rate of growth necessary – well over 300 feet per year – could never have been achieved between 1838 and 1847, nor is it likely that the spit was static for the previous 20 years.'[12] In this case the discrepancies might perhaps arise not so much from cartographic inaccuracy as from the fact that the middle map (the 1838 Ordnance map) is misleadingly dated, the survey on which it was based having occurred several years before the date of publication. On the other hand the differences between the maps which appear in Fig. 72 may derive from a much less rational explanation, and it would be difficult to know *without other evidence* how much of this difference had its roots in reality, how much in poor surveying.[13]

These three examples should go some way towards illustrating the potential of historic cartographic evidence 'in the round' so to speak. Certainly old maps will contain inaccuracies and in consequence their indications will often need to be qualified or treated with suspicion but if their historical content is viewed realistically in the light of their cartographic background, they can make a unique and valuable contribution to research studies of all kinds.

[10] Diver, G., 'The physiography of the South Haven Peninsula, Studland Heath, Dorset', *Geographical Journal*, Vol. 81 (1933), pp. 404–27.

[11] Steers, J. A., *The Coastline of England and Wales*, Cambridge, 1948, pp. 386–87.

[12] Carr, A.P., *op. cit.* – see footnote 2 above.

[13] For a much more comprehensive cartographic review of the appearance of Orford Ness since 1530 see *Orford Ness* published by W. Heffer & Sons Ltd., Cambridge 1966.

PART THREE
LOOKING AT MAPS

Chapter 13 Features of the Physical Landscape

The main concern of the first portion of this book was to impart some understanding of the factors which influence the nature and design of modern topographical maps; the second portion showed how these characteristics could be put to practical use to perform certain constructions or answer particular questions, and there is no doubt that this is how most people tend to think of maps. To the man in the street the map is essentially a practical tool to answer simple questions – 'how does one get from A to B?', 'where is C?', 'how extensive is D?' and so on – though it is obvious from their increasing accuracy and completeness that maps could be used to answer much more searching questions than these. Consider the geographer, for example, concerned with such fundamental questions as 'what is a place or area like?', 'why is it like that?', 'is it similar to or different from other places, and why?'. To him the map with its representation of both the material elements of the landscape and their spatial distribution, must be a very great asset indeed, and the third section of this book, 'Looking at Maps', centres round this idea of using maps in an 'enquiring' rather than a 'utilitarian' manner. We shall be concerned here to see how maps can be used to describe the nature of, or components in an area and, even more pertinently, how we can use them as a source of ideas about the *raison d'être* or origins of a feature or area, ideas, be it noted, which may trigger off or prompt fruitful lines of investigation using other techniques or other sources of information.

The first of these requirements, using a map to describe an area, is not intrinsically difficult. Anyone with reasonable facility at map reading and the writing of descriptive English can do it, though this section may help to improve and shorten the account by introducing the appropriate names used to designate many commonly occurring features. The second requirement presents rather more difficulties, but at the core of it lies the ability to recognise how certain features appear when shown on a map, and conversely in knowing what may be the possible significance of certain common recurrent patterns found on maps.

In one sentence then we are striving in this third part to promote the recognition on

maps of *recurrent patterns* (whether of contours, drainage, settlement, communications or any other feature) to which there can be applied a terminological description, or from which we may deduce a likely cause or probable origin.

The element of inconclusiveness which has been introduced above – *ideas* which would lead to other work, *likely* causes, *probable* origins – cannot be stressed too strongly in connection with this sort of work. It is most important to emphasise here, quite categorically at the very beginning of this chapter, that map evidence *cannot* and *should not* be used alone as a basis for conclusions concerning the nature or origins of any features. In the vast majority of cases map evidence will be only one among a wide range of possible sources of information – detailed field work, further survey, documentary and statistical evidence and so on – which together should form the basis of such conclusions. The important role of the map in such investigations is as a source of ideas not conclusions, as a possible way of directing and shortening other lines of investigation, but not as a means of eliminating them altogether. If this basic principle is adhered to, then nothing but good will result from time spent examining topographical maps. Provided that maps are of good quality with regard to scale, content and accuracy they will act as an important primary source of information regarding spatial distributions within an area, and as rather crude indicators of the quantitative aspect of many of these distributions as well; taken together the two aspects can provide for a region a sort of rough overall control or summary with which, for example, conclusions reached through other, more detailed but more local pieces of research must still be reconcilable. Here obviously, despite its limitations, is a very important research tool indeed.

Map analysis

The idea of examining maps to obtain important information or conclusions of the kind just described is often termed map analysis – not perhaps the most fortunate terminology. The word 'analysis' almost inevitably implies analogies with processes such as quantitative or volumetric analysis in chemistry in which the application of a particular technique yields very positive and definite results, whereas it is obvious from the reasoning of the previous paragraphs that no such process would be possible using topographical maps alone. In fact no one has yet tried to draw up such a technique of investigation for topographical maps;[1] yet the term has stuck, perhaps because very often in existing literature map analysis has been made to yield positive and definite results by the introduction of quite a new approach – teaching by example. Suppose one chooses, for example, an area of glacial deposition, or of large-scale iron mining, reads the literature on that area and *then* examines the topographical maps of it, naturally one can point out the distinctive features found on those maps and offer definite explanations and conclusions about them: that that low, insignificant, vaguely curving ridge is a terminal moraine; that no mines occur around X because the ore-bearing strata are down faulted, and so on. Properly done studies of this kind can be both rewarding and stimulating, especially

[1] The nearest parallel is an interesting analytical approach by G. H. Dury, in *Map Interpretation* pp. 12–15, London 1962. The scheme deals with features of the physical landscape only.

from an illustrative point of view; but they seem to be fundamentally wrong as an approach to map *analysis*. Such studies know the answers first, and because of this may be of little help, or even positively harmful, to a person confronted by a map of an unknown area, an area moreover which is probably a good deal less 'text-book' than the one previously studied. With this sort of map training the student might easily draw erroneous analogies between features on this map and the one he has previously examined, particularly if no one pointed out any alternative possibilities; and, what is perhaps even worse, he may attempt to frame his conclusions in the same definite way as in the example presented to him where these conclusions were backed by much wider evidence.

To avoid pitfalls of this kind and to try to encourage students to approach topographical maps with an open mind, a rather different approach has been tried in this book. It is concerned essentially not to show people what is on a map but to encourage them to ask 'what should I look for on a map?' and 'what might this signify?'. Inevitably when the maps of a region are examined with this type of approach, several possibilities, rather than one, will arise from many of the features studied; but *in toto* there will often be corroborative evidence from one feature to another favouring a particular conclusion, and the examination may well finish with a few very definite ideas, rather more less conclusive ones and several outright 'don't knows'. This is as it should be; the topographical map has played its part, yielded some ideas for consideration, and other forms of investigation and research must now take over – not an unsatisfactory standpoint from which to proceed to further study of an area.

Limitations of Style, Content and Scale

So far, whilst the general ideas and problems of 'looking at maps' were being considered, topographical maps were treated as a group, yet obviously the style, content and especially scale of a map are very relevant to its suitability for this purpose. With style and content unfortunately there is often little choice, one must either take the maps or leave them, but in many areas there is at least a choice of scale. What scale will be most suitable? Generally speaking and particularly if only one series can be purchased for the operation, good topographical maps at scales of between 1:40,000 and 1:126,720 ($\frac{1}{2}''$ to 1 mile) will give the best all round results. Unless the sheets are very small a sufficient area is covered to allow regional patterns and variations to emerge, yet the content is usually sufficiently full and clear to allow many patterns to be examined in detail. Below about 1:100,000 or $\frac{1}{2}''$ to 1 mile, though the maps are useful to obtain overall impressions, detail is too generalised to be much use; while scales above 1:40,000, though admirable and often necessary for studying one feature in detail, usually cover too small an area to allow wider distributional patterns to be recognised. Ideally of course all three groups of scales should be employed – a quick 'lie of the land' from the smaller scale, the main weight of the examination from the medium scales and a following-up of any more interesting points of detail on the large-scale maps.

In the examples which follow, a wide variety of scales have been employed deliberately, partly to suit the convenience of the features or areas being shown but also to present the appearance of the same feature at different scales. It should be remembered however that many of these features may themselves exhibit enormous variation in 'scale'. A cuesta

for example may be anything from a quarter of a mile to several miles across, and whilst greater size will not necessarily invalidate the explanations which are offered it will leave more opportunity for the presence of minor features which can modify the 'text-book' form.

Not all the illustrations used in this chapter are 'text-book' versions by any means, for it is extremely important to recognise features in both 'classic' and 'not-quite-so-classic' forms and of the two in fact the latter variety is probably the best 'teacher': one is likely to discover far more possible incised meanders after looking at Fig. 79G than by being shown only such classic versions as the lower Wye in Britain or the Moselle in Germany.

There is little more that need now be said by way of introduction to the idea of 'looking at maps' save two general points of technique. The first of these is to approach the study and analysis of any pattern by *working from the whole to the part*, and *from the general to the particular*. Eye-catching detail may offer tempting diversions, but it will be better appreciated and understood if first set in a more general context. The second point concerns the actual technique of examination. It is not always easy to study individual patterns on topographical maps, where they may be confused by the other patterns present, and in these cases it is useful to be able to 'take them out' and consider them in isolation. With physical features 'water and contour' versions of sheets, available in some countries, help greatly, but where no ready-made answers can be had, it is best to lay a sheet of transparent material over the maps and trace onto it those portions of a particular pattern which seem important or interesting. Ideally the whole pattern should be traced but this is an incredibly tedious and time-consuming task, often unnecessary except in areas where other detail renders a pattern completely unappreciable. Once this has been done not only can one 'see the wood for the trees', but the transparent sheet can be used as something on which to 'think aloud' by drawing freely, adding notes or queries, sketching in other relevant detail not marked on the map, for example, watersheds, or anything else which will help towards a fuller understanding of what is there. Transparent plastic sheets popularly known as 'talc' sheets are ideal for this purpose; special crayons are needed to draw on these,[2] but the lines can easily be erased with a rag moistened with methylated spirits or 'Banda' fluid and the sheet used over and over again.

Features of the physical landscape on maps
I Relief

1 *Summit Levels*

There is no more general or useful way to begin a study of the relief of an area than by examining summit levels, preferably by marking their position and altitude (approximate if no better value is available) on a plastic sheet laid over the map. It is also useful at this stage to add the altitude of any prominent shoulders or benches which surround the main hill features even though these are not necessarily summits in the strict sense of

[2] e.g. 'Chinagraph' or 'Glassrite' pencils, obtainable at most stationers.

the word. The results will not only present the quickest way of getting the 'lie of the land' in an area and of assisting a factual description of it but may also reveal the following significant features:

(a) *Areas with accordant summit levels.* It is by no means uncommon to find that over quite extensive areas summits are at approximately the same level or lie within a narrow height range. Where this occurs further work has often suggested that such hills are the remains of a former erosion surface or *peneplain*, i.e. a near-level or gently undulating surface formed during a previous erosion cycle. Only portions of this surface now remain forming the tops of hills or spurs, the remainder having been eroded away by the down-cutting of streams following a rise in the level of the land or fall in sea level.

(b) *Areas with summit levels very different from their surroundings.* Areas noticeably higher or lower than their surroundings will naturally attract attention. Where they occur on a regional scale an obvious possibility is that they may represent, in the most general way, areas of more resistant or less resistant rocks, for example in Britain the Malvern Hills and the Vale of Clwyd. Alternatively erosional influences like those mentioned in the previous section may be involved, and these generally higher or lower regions may represent areas which either were not attacked during former peneplanations, or where a further cycle of downcutting is well advanced. Fig. 73B illustrates something of both these ideas. Many of the hills between the coast and the Teifi valley, for example, have summits between 900' and 1100', a rather crude measure of accordance but one which becomes increasingly significant when it is found that a similar situation occurs widely elsewhere in Wales; from this and other evidence Brown has deduced that these hills are remnants of the gently undulating Low Peneplain of Wales.[3]

Nearer the coast, in Fig. 73B, accordant summit levels again appear. Several isolated hills just top the 600' contour and immediately below this height the wide spacing of the 500' and 600' contours in places suggests the existence of a marked bench at several points. This is a rather more narrow degree of accordance than in the previous example and is thought to represent the remains of a former wave-cut coastal platform.[4]

2 Prominent, Isolated Hills

Unlike many other features listed in this section there is no single probable explanation for these distinctive features. The following possible causes should be considered:

(a) The hill is formed from an isolated outcrop of rock, different from and more resistant than its surroundings. The distinctive landmark of the Wrekin (Fig. 74B), formed by resistant Pre-Cambrian rocks emerging from beneath the younger rocks of the Shropshire plain is a well known example of such a hill. It is not uncommon for these resistant, isolated outcrops to be of *igneous* rocks, and within this group come the often striking and craggy examples formed from old *volcanic necks*, i.e. solidified lava filling the central opening of a former volcano and remaining after the surrounding cone has been eroded

[3] Brown, E. H., *The Relief and Drainage of Wales*, Cardiff 1960.
[4] Brown, *op. cit.* Differences between remnants of marine platforms and those of subaerially formed peneplains are not confined to the generally narrower altitudinal range of the former. Differences of drainage patterns for example, would also be manifest, but these are too complex to be elaborated here.

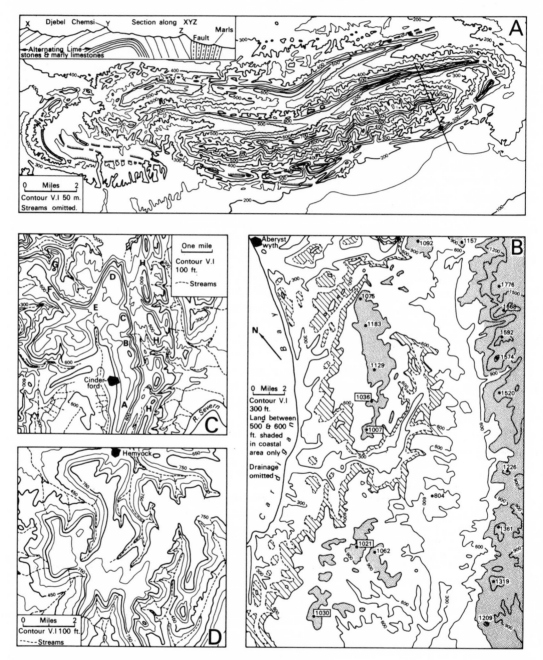

Fig. 73: A: Djebel Chemsi, Tunisia – an eroded anticlinal structure. **B:** Part of Cardiganshire, south of Aberystwyth. **C:** The north-eastern corner of the Forest of Dean, Gloucestershire. **D:** The Upper Greensand plateau, north of Honiton, Devon.

away (for example X in Fig. 74E). The Devil's Tower, Wyoming, U.S.A. is a striking example of such a feature; there are many others in the Central Scottish Lowlands, Castle Rock for instance and Arthur's Seat (rather a complex example) at Edinburgh, Bass Rock and Traprain Law, and in the Le Puy area of Central France.

(b) The whole hill is not formed from a more resistant rock but is merely capped, and hence protected, by a more resistant layer. The Brown Clee Hills, another Shropshire landmark, are protected in this way by a double capping of Carboniferous rocks and Dolerite (Fig. 74C); Billingen, in central Sweden, with a diabase capping is a further example. A special case of such 'capped' hills is formed by the many *outliers* of escarpments (see below).

(c) The feature may be a *residual* one, not associated with any marked lithological change. Erosion acting upon a resistant mass may ultimately reduce it to one or two isolated hills which may remain simply because they are 'last to go'. Occasionally these remnants may have been helped in their survival by being slightly more resistant to erosion than their surroundings, by possessing fewer joints for example, or by being better cemented; but they would not be fundamentally different from their surroundings, and would not be differentiated on a geological map. The rocky granite tors of Dartmoor are examples of residual features of this kind, as are the even more striking *inselbergs* or *bornhardts* characteristic of the plateau uplands of East Africa. It is impossible here to consider the conflicting views which have been expressed about the origin of these curious features but inselbergs in particular, rising abruptly out of plains composed of the *same* material, emphasise that lithological change need not necessarily be expected at the foot of prominent isolated hills.

(d) Volcanoes, both present and ancient, form a fourth, perhaps less obvious, cause of isolated hills. Despite enormous variety of shape and size, from hundreds to thousands of feet in height, hills of this sort usually show two distinctive characteristics. The first is a remarkable *concentricity* of contours (see Fig. 74A), the other the presence of a crater or *caldera*. Both are subject to some modification in practice. Gullying and erosion may destroy the contour pattern (but rarely the generally circular shape) while the crater may be small and unrecognisable or complex, as in the cone-in-crater or crater-in-crater type (Fig. 74A). It is worth remembering too that crater, crater rim and volcanic cone are sometimes incomplete, having been partly destroyed by later eruptions.

3 *Linear Hill Features*

(a) *Asymmetrical hills with one steep face and one gently sloping face.* Provided that both of these features, the steep scarp slope[5] and the gentle dip slope can be recognised, for example as at Whitbarrow in Fig. 75C, the feature can fairly confidently be described as a *cuesta* or *escarpment*,[5] caused by the outcrop of resistant, gently dipping rocks (see features marked A in Fig. 74E). Cuestas thus give indications of both the lithology of an area and its structure, the strike of the rocks running parallel with the cuesta and the dip at right angles to it.

[5] Sometimes called merely a 'scarp' or 'scarp face'. The English usage of such terms is rather lax since 'scarp' is commonly employed to describe the whole feature as well. For this latter purpose the terms 'cuesta' or 'escarpment' are preferable.

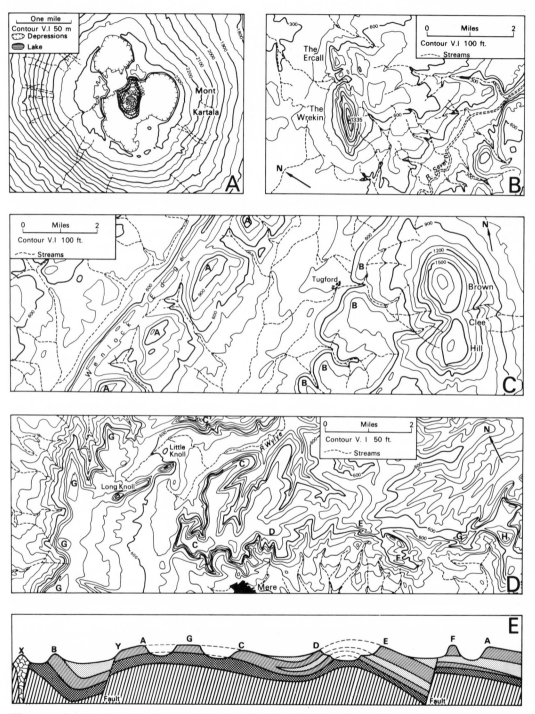

Fig. 74: A: Mt. Kartala, Comoro Islands. **B:** The Wrekin, Shropshire. **C:** Wenlock Edge and Brown Clee Hill, Shropshire. **D:** Upper Greensand and chalk escarpments near Mere, Wiltshire. **E:** Relationship of various topographical features and geological structures.

(b) *More symmetrical hill-ridges with both sides steeply sloping.* Features of this type are known as *hog-backs* and are often formed by an outcrop of resistant steeply dipping or even near vertical rocks, (see B in Fig. 74E). They are therefore really an exaggerated form of cuesta; but in this case it is often difficult to tell on the map which is really the scarp and which the dip slope, and only the strike of the rocks can be seen clearly.

(c) *Multiple cuestas, all facing the same way* usually point to erosion acting upon alternating hard and soft rocks all dipping in the same direction.

(d) *Twin cuestas facing inwards* indicate the possible presence of an eroded anticline (see D and E Fig. 74E).

(e) *Twin cuestas facing outwards* indicate the possible presence of a synclinal structure (for example C and D Fig. 74E). The twin cuestas need not be in close proximity, and indeed on a regional scale they may be many miles apart, as in the case of the North and South Downs in England which form a 'regional example' of inward-facing cuestas, and the North Downs and Chiltern Hills which form a 'regional example' of outward-facing ones.

(f) *Curved cuestas, 'concentric' cuestas.* These are merely further modifications of the themes listed in sections (a), (c), (d) and (e) above, and suggest eroded dome structures if the scarps face inwards, basin structures if they face outwards.

Further comment on (a)–(f) above. The descriptions given in (a)–(f) above are of the simplest possible cases. Let us consider for a moment features which may complicate these 'text-book' patterns both in reality and on the map. A very common feature 'camouflaging' many an escarpment is its dissection by streams into a number of short sections. This is the case in Fig. 74C where the cuesta A–A–A–A formed by the Aymestry Limestone is far less obvious than neighbouring Wenlock Edge, yet even here the ⊓-shaped hills still have the cuesta form, with a steep North-west facing side, and a more gentle south-east facing side characterised by noticeably regular contour spacing. Many cuestas show this very regular contour spacing on their dip slopes; though this does not necessarily mean that the slope of the ground is the same as the dip of the rocks. Wenlock Edge in Fig. 74C is often regarded as a classic English escarpment, yet on the map its true cuesta form is disguised because it carries a second scarp, that of the Aymestry limestone 'on its back'. However, the form of the latter, plus the straight, steep scarp face of Wenlock Edge itself give clear evidence of its true nature. Not all scarps are as straight and clear as Wenlock Edge and many that are not cut through completely by streams may be much 'fretted' by erosion. In Fig. 74D, for example, the western cuesta formed by the Upper Greensand (G–G–G–G), is fretted only in its northern portion (notice the even contours on the dip slope again); but the eastern cuesta, formed by the chalk (C–C–C–D), has been cut back into a very complicated form, so much so that in one place erosion has quite isolated a portion of the chalk, leaving it standing clear of the main escarpment and forming the prominent outliers of Long and Little Knolls. The relationship of an outlier to the main escarpment is further illustrated at F in Fig. 74E, which explains why it can also be regarded as a special example of a 'capped' hill (see 2 (b) above).

Alteration in both the thickness and angle of dip of the scarp-forming rock may also cause the form of a cuesta to vary a great deal. The rock may thicken, thin out, split into two to form a *stepped* or *compound scarp* (as at D and E in Fig. 74E), or disappear completely, for example at a fault. Faulting may also cause the line of the scarp to be set

backwards or forwards, while minor anticlines running at right angles to the strike may produce curvature in plan or give zones of weakness where erosion may cut great embayments into the scarp.[6] In Fig. 74D the Upper Greensand forms a prominent scarp, yet a few miles to the north it has thinned so much that it produces only a weak feature 150′ high. In contrast, at D on Fig. 74D, the prominent scarp which has bounded the chalk hills for many miles suddenly becomes much weaker because the chalk is 'faulted away', and when a scarp does appear, much fretted, on the southern side of the hills at E–F–G–H, it is formed by the Upper Greensand again faulted and folded round through 90° and dipping north, northeast and then east around the east–west anticline of Wardour.

The same complications beset eroded anticlines, domes etc. The Djebel Chemsi area (Tunisia) in Fig. 73A (p. 190) is clearly a 'text-book' eroded, elongated dome (though even here several of the 'rims' are incomplete); but this should be contrasted with Fig. 73C. The sinuous scarp A–G does not look much like the Djebel Chemsi, yet the curved scarp C–D–E is really a curved outward facing scarp bounding the elongated northern extension of the Forest of Dean coal-basin, while the curved inward facing scarp D–E–F–G bounds the southern end of an adjacent dome structure; notice also the dissected hog-backs of the Brownstones at H–H–H and, less obviously at J–J–J.

4 *Flat-topped Hills Bounded by Steep Slopes*

Features such as this, sometimes termed *mesas*, are often caused by resistant rocks which are nearly horizontal. They stand therefore at the opposite end of the 'cuesta variations' from the hog-back (see G in Fig. 74E) and Fig. 73D shows an example, oddly enough formed by the Upper Greensand again, in Devon. Although the hills in Fig. 73D have often been used as an example of this phenomenon, the fact that the near-level surface cuts across, rather than coincides with, the very gentle dip of the rocks has also led them to be explained as a remnant of a former erosion surface, i.e. as an area of accordant summit levels under 1(a) above. Here is an obvious case where contour evidence alone cannot decide the issue.

5 *'Stepped' and 'Terraced' Hillsides, Hillsides with 'Benches'*

(a) If multiple layers of gently-dipping resistant rocks are present, many may not be able to form cuestas or mesas themselves but will merely appear as 'steps' along the sides of such features. Wherever two or three close contours suggest a steepening of the slope on a valley or hill side, therefore, it is worth suspecting the presence of a layer of resistant rock, which may well support a gentle slope or bench above it, as in the stepped scarps at D and E Fig. 74E.

(b) Not all benches have a structural origin, however. They may be produced where an erosion surface cuts into a hillside. Thus the step at the foot of Whitbarrow (A–A–A on Fig. 75C) is truly structural, caused by resistant limestone; but that under Brown Clee Hill (B–B–B–B on Fig. 74C) is probably erosional, the accordant spur top levels proclaiming a possible hillside remnant of the Low Peneplain of Wales mentioned earlier.

[6] The presence of obvious scarps facing one another across these embayments often gives a strong clue to the anticlinal structures which underlie them.

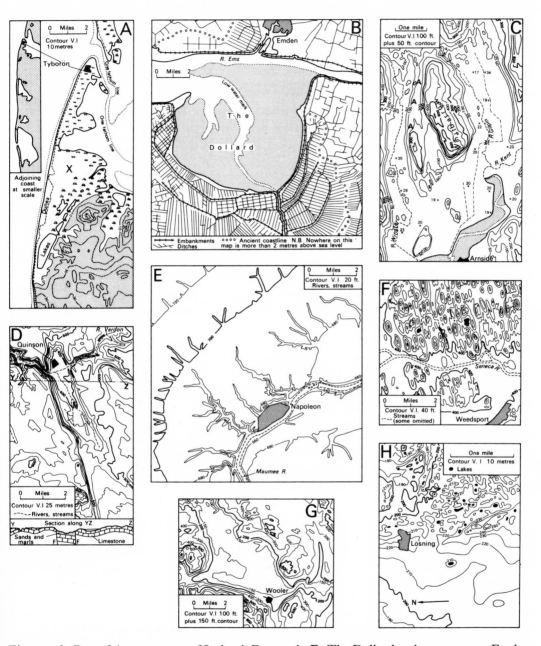

Fig. 75: A: Part of the west coast of Jutland, Denmark. **B:** The Dollard embayment near Emden,
C: Whitbarrow and the Kent estuary, Westmorland. **D:** The Quinson depression, Provençe,
France. **E:** Area around Napoleon, Ohio. **F:** 'Drumlin country', 20 miles west of Syracuse,
New York State. **G:** The site of the former 'Lake Milfield' near Wooler, Northumberland.
H: Kettle-hole country and outwash plain, south west of Vejle, Denmark.

6 *Hill Masses and other Features with almost Straight, Steep Edges*

The characteristic feature here is not steepness, as in 2–5 above but straightness. Where features have steep straight or near straight boundaries this may be caused by a fault, the steep slope then being either a true *fault-scarp*, i.e. literally caused by the movement of rocks along the fault; or a *fault-line scarp* produced where differential erosion acts on hard and soft rocks brought into juxtaposition by the fault. Notice that from the crest of a fault-line scarp ground level may rise or fall depending partly on the dip of the resistant beds (see Y Fig. 74E); if the latter is the case only the straightness of the scarp face may differentiate it from a normal cuesta. Two very clear and straight fault-line scarps can be seen bounding the Quinson depression in Southern France (Fig. 75D) where down-faulted sands and marls give rise to an abrupt hollow in the resistant limestones.

7 *Very Flat Areas*

While hill features are distinctive on a map by the closeness and number of their contours equally distinctive are the areas virtually without contours – the very flat areas. Areas of very low relief may already have been noticed above under 1(a) (possible former peneplains), and 1(b) (possible outcrops of less resistant rocks). This section is concerned with areas which show scarcely any relief at all and once again several possibilities must be considered.

(a) *Very flat areas with a coastal location.* These often represent land which has 'emerged' from the sea due to the deposition of material either by rivers or by the sea. Typical locations are in embayments or estuaries, for example around the Wash in Britain, and in parts of the coast sheltered by spits (for example at Tyborön in Jutland, Fig. 75A) or offshore islands (for example in the Wadden See between N.W. Germany and the Frisian Islands). Areas of this sort are often completely 'contourless' on maps because of their low altitude and usually show several other characteristic associated features as well. Extensive sandbanks offshore are common, so is a fringe of coastal marshes, where plants help the emergence by trapping sediment, while man has often hastened the natural process by land reclamation, and a succession of sea-banks and the rectilinear artificial drainage of the land mark his efforts. All of these characteristics can be recognised in the Dollard area, Fig. 75B; alternatively if reclamation has not taken place there may be widespread coastal marshes or swamps.

The part played by rivers in this sedimentation process is easily imagined, indeed river deltas would be included here in this category, but the part played by the sea should not be overlooked. This may account, among other things, for very flat areas produced by such sedimentation but related to a former sea level, for example, around Morecambe Bay where the prominent flat areas at about twenty feet above mean sea level were so formed (see Fig. 75C), while the extensive sand-banks and coastal marshes hint at the continuance of the process today, related to the present sea level.

(b) *Very flat areas in an inland location.* Rather more possibilities present themselves here. For example the areas may be either (i) *the flood plains of large rivers* (see below) – a very obvious form of flat area, or (ii) *formed from the floors of now vanished lakes*, sedimentation within the lake having created a level floor which became exposed when the

lake was drained. Many such lakes, some tens of miles across, were formed when ice sheets blocked and impounded pre-existing drainage in the glacial period and Fig. 75E shows part of the now exposed floor of a very large lake of the sort, a glacial extension of the present Lake Erie. With smaller scale examples the idea of an enclosed lake basin may be a little more obvious, as in the Northumberland example shown in Fig. 75G, which was formed when ice blocked the northward-flowing River Till. Once exposed of course, these former level areas may become subject to downcutting and dissection by streams, as for example in Fig. 75E where the River Maumee is now incised into the old lake floor.

A third category of very flat area is formed by either natural or reclaimed areas of bog, fen and marsh. The former are easily recognisable, the latter usually show signs of reclamation similar to those described in 7(a) above.

8 *Areas which Slope Extremely Gradually in One Direction*

A very gradual, sometimes almost imperceptible, slope in one direction, indicated by widely and often fairly regularly spaced contours, may point to the existence of single or coalescing large-scale *alluvial fans*, or similar features comprised of depositional material (for an example of a small-scale fan see X in Fig. 79H). In certain circumstances these may be very large-scale features: Fig. 76 shows a portion of one some 15 miles or so across with a slope of only 1 in 80 to 1 in 170 and with the *bowed contours* often characteristic of these features; the coalescence of adjacent fans of this type may produce a *piedmont alluvial plain* in front of a mountain range.

Other depositional features which have similar characteristics are *glacial outwash fans and plains* (the edge of one occupies the lower portion of Fig. 75H), the aprons of debris which may surround hill masses in desert areas, (for example around the Djebel Chemsi in Fig. 73A), and the similarly situated *desert pediments*, though these are thought to be erosional rather than depositional in origin. As in the case of volcanoes the classic form of these features may be confused by gullying and renewed dissection, but the remnants are often still quite recognisable.

Between the distinctly hilly and the very flat area lies an enormous range of potential shape and form which quite obviously it would be impossible to categorise. Within this range however three features may be selected as both distinctive and usually associated with the presence of certain features.

9 *Very Hummocky Areas*

These will show a generally intricate and close contour pattern; two distinct types may be recognised.

(a) *Those with many closed 'ring' contours*, the rings usually being elongated and some-times joined laterally also (see Fig. 75F). Contour patterns of this type almost certainly indicate an area of drumlins, i.e. elongated smooth hills formed largely of boulder clay, not unlike half an egg in shape and often of considerable size (up to 200 feet high perhaps).

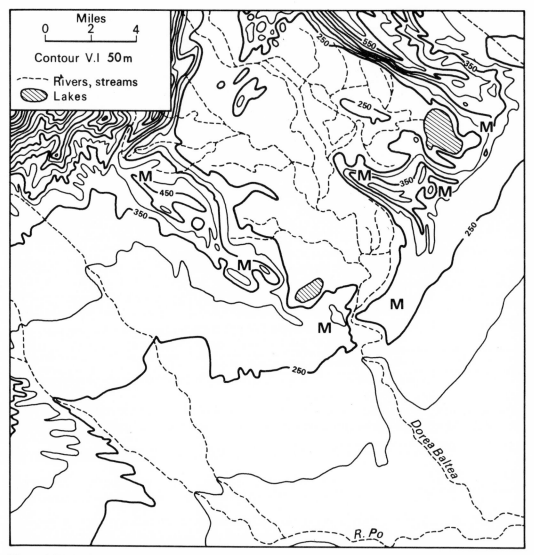

Fig. 76: Twin-lobed glacial moraine 'blocking the mouth' of the upper valley of the Dora Baltea valley in northern Italy. In front of the moraine is a fragment of the extensive piedmont alluvial plain, of fluvioglacial origin, which fronts the Alps in this area.

In the 'classic' areas, for example County Down, N. Ireland, they occur in very great numbers with the long axis aligned parallel to the direction of flow of the ice.

(b) *Those with contorted contours, often with small enclosed depressions and perhaps small lakes* (see Fig. 75H). Features of this kind are often found associated with extensive *glacial moraines* (for more restricted morainic features see 10 below). They reflect the uneven nature of the original deposition of the morainic material further confused by the subsequent melting of buried masses of ice, which leads to the formation of depressions

or *kettles*, hence the terms *knob-and-kettle* or *knob-and-basin topography* often applied to such areas.

10 *Low, Arcuate Hills*

Low hills, crudely arcuate in plan and not associated with similar concentric features[7] may be indicative of the presence of a *terminal glacial moraine*. As such the arcuate form is the only consistent characteristic, for slopes may vary from quite gentle to steep on one or both sides (but often steep on the up-valley side), and heights from a few feet to well over a hundred. Likely situations, however, are running across a major lowland or large valley,[8] as in Fig. 76 which shows a rather more unusual twin-lobed version almost blocking the 'mouth' of a valley, that of the upper Dora Baltea in Italy; the river has breached the barrier, of course, but there is confused drainage with small lakes behind it.

II Rivers and streams

The patterns of rivers and streams in an area will often give indications of characteristics which underlie its nature or origins. Because it is often advisable to treat stream and valley as one unit, valleys are included in this section and, as before, a general inspection should be made before a more detailed examination is begun. Such an inspection may reveal the following features:

11 *Areas with no Drainage Pattern, Disappearing Streams or with Rivers only in the Main Valleys and Many Dry Tributary Valleys*

Aridity may, of course, cause a drainage system either to be absent in an area or to peter out; but where there is no reason to suspect such an explanation the presence of an outcrop of pervious rock will be the most likely explanation. Although occasionally porous sandstones may be responsible chalk or limestone outcrops are the most usual causes, and it is often possible from other evidence to guess which it is. As the right-hand portion of Fig. 74D shows, dry valleys in a chalk area typically show smooth rounded contours and a fairly regularly branching *dendritic pattern*; those in hard limestones on the other hand often have a more angular appearance with sharp bends in plan and crags or steep slopes on the valley sides.

Figs. 77B and G show two different examples of such streamless areas, the one almost completely 'dry' the other with actual disappearing streams; but in both cases the correlation between streamless area and limestone outcrop is remarkably good. Disappearing streams with associated caves, pot-holes etc., are characteristic of many limestone areas; but isolated disappearing streams should be treated with caution. Very often they are

[7] Curved cuestas might obviously also qualify for such a description. In the case of curved cuestas however there is often more than one, exhibiting crude concentricity as in Fig. 73A.

[8] Where such features formerly blocked smaller valleys they are often so dissected today that their remains, on the map at any rate, show little resemblance to the classic form.

streams which do no more than pass into a roadside ditch (unmarked), or are piped temporarily under some obstacle, for example a built-up area. Notice too that the beginning of a stream on a map is often of no significance: it may be a cartographic averaging-out of a very variable feature, or it may mark an actual spring or source. The last-named features are not at all easy to detect on maps: for example in Fig. 73D many streams begin significantly just below the 750' contour, but this is not in fact a spring line, even though the hills are capped with greensand overlying Keuper marls.

12 *Drainage Patterns where the Main Elements cut across or through Prominent Relief Features*

In many areas the main rivers do not, as might be supposed, always follow the alignment of the principal lowland units, but sometimes flow across rather than along them, and subsequently cut across or through the main upland units. A slightly different version of the same idea can be seen in Figure 79J where the River Argens, in southern France, instead of flowing along the main lowland to Le Muy, abruptly leaves it to cut through a corner of the hill mass to the south. Where features of this kind occur the drainage may have been superimposed on the relief or be antecedent to it, though on the map it is rarely possible to tell which. In superimposed drainage the alignment of the streams was initiated on a now vanished cover and maintained even when erosion revealed the underlying structures which form the present relief, this being the case in the area shown in Fig. 79J. Antecedent streams on the other hand have maintained their course across obstacles which have risen in their path. A further possible explanation is that the drainage may have been glacially impounded until it overflowed across the former watershed (see section 21, p. 208).

Having looked at drainage in general, more detailed aspects can now be considered. What, for example, is the general arrangement of streams within the network or parts of the network and what kind of patterns do they make?

13 *Dendritic Drainage Patterns*

A drainage system which branches evenly and continuously as one proceeds from its lower to its upper portions is said to be *dendritic* (i.e. like a tree). Since this is the kind of drainage pattern which evolves 'where the rocks have no conspicuous grain and offer nearly uniform resistance to erosion',[9] it hints at the presence of such conditions, either today or in the past, for superimposition may have occurred. Notice that 'nearly uniform resistance to erosion' is all that is implied, not uniformity of composition, and this may perhaps indicate why in Fig. 77A a fairly even dendritic pattern has evolved on the sandstones and slates of the Portscatho Series in Cornwall.

14 *Drainage Patterns showing Marked Alignments in One or more Directions*

Conditions uniform enough to lead to extensive dendritic drainage patterns are not particularly common, for more usually the rocks of an area contain certain lines of weakness along which drainage will develop more easily, giving predominant alignments or

[9] Holmes, A., *Principles of Physical Geology*, London 1966, p. 557.

Fig. 77: Drainage patterns: **A:** Around Truro, Cornwall. **B:** Central Derbyshire. **C:** Wenlock Edge and Corve Dale, Shropshire. **D:** Tweed valley, near Coldstream, Berwickshire. **E:** Near Crediton, Devon. **F:** South west of Rö, Bornholm, Denmark. **G:** Around Ingleborough, Yorkshire.

characteristics within the patterns. Common features causing weakness are outcrops of less resistant rocks, and structural features such as anticlines, shatter belts, faults and major joints in the rocks; where these have an extensive influence, certain characteristics in the pattern may give some indication of which factor is responsible. Conversely where only one or two examples occur they will be less easy to distinguish and differentiate.

(a) *Drainage patterns with remarkably straight stream courses aligned in one, two or more directions*, (for example Fig. 77F). These are more likely to have been influenced by faults or joints, though it is not easy in many cases to suggest which. In areas where examples are widespread, or where there are several alignments running in different directions, joints are more likely to be the cause, and this is particularly so in extensive outcrops of igneous rocks, (though in Fig. 77F joints, in the granite of Bornholm, produce only the two very definite alignments). Conversely in Fig. 77E where a crudely dendritic main drainage pattern has marked east–west-aligned tributaries, the latter probably followed parallel lines of weakness resulting from the widespread and intense folding which characterises the carboniferous rocks of this part of Devon. Drainage patterns which show two dominant alignments, (for example Fig. 77F) are sometimes referred to as 'trellissed', though this term is also applied to rectangular arrangements (see below).

(b) *Drainage patterns with rather irregular stream courses showing one predominant alignment* (for example Fig. 77D). Ground moraine moulded by the movement of ice does not always assume the characteristic drumlin form. In some areas less pronounced relief, formed by more elongated subdued mounds, or swells, roughly aligned to give a gently grooved or grained topography, may be found. Drainage patterns associated with this type of landscape often resemble that in Fig. 77D, long sections following the 'grain' of the country being linked by rather indirect portions as streams find their way from one 'groove' to the next.

(c) *Drainage patterns with irregular stream courses but one predominant alignment and another minor one at right angles to it* (for example Fig. 77C). This is a rectangular drainage pattern and is often associated with alternating outcrops of hard and soft rocks, the latter forming the zones of weakness along which the dominant alignment is found. In contrast the outcrops of more resistant rocks are often crossed by short tributaries at right angles to the first element and which bifurcate to give a characteristic T-form as soon as the next outcrop of soft rocks is reached. With this type of pattern the topography will naturally reflect these lithological characteristics as well, the hard rocks usually forming parallel cuestas or hogbacks, as in the area covered by Fig. 77C, which is the classic scarp and vale topography of the Wenlock Edge area, part of which is also shown in Fig. 74C (p. 192). The T-pattern of tributaries, which is much in evidence in Fig. 77C, is a useful indicator, and, even when the rectangular main pattern is not widespread, a T-shaped tributary will often indicate the presence of an outcrop of softer or weaker rock. A further variant of the rectangular drainage pattern is the 'concentric' pattern which may emerge for similar reasons around eroded anticlines and synclines. If the Djebel Chemsi area (Fig. 73A) (p. 190) were not too arid, it would obviously support a drainage pattern of this type.

15 *Abrupt Changes in the Direction or Alignment of a River*

Features of this sort are often distinctive enough to attract attention, though their

explanation is not necessarily simple or possible from map evidence alone. A river may turn sharply, to follow a line of weakness of any of the kinds described in section 14 above, and sudden bends are intrinsic characteristics of rectangular or trelissed drainage patterns. See for instance Figs. 77C and F and also 77B where the pronounced double bend of the River Wye between Buxton and Matlock is caused by the river adjusting itself to underlying structures in the limestone. Alternatively the bend may be caused by *river capture* (being then known as an *elbow of capture*) or by *glacial diversion* of a section of the rivers course. In both these cases there will usually be some trace of the former alignment of the stream – a wind-gap or through valley (but see also below under section 21) in the former case, perhaps a lowland unit in the latter. Very often of course the explanation may be a compound one, for lines of weakness – faults or softer rocks for example – may obviously assist in the development of river captures where the circumstances are favourable. Fig. 78E shows a clearly marked bend in the course of the main river, the Rheidol, and an obvious open wind-gap marking its former alignment before it was captured and diverted into its present lower course (see Figs. 78A–D).

III Valleys

It is obviously quite impossible to formulate descriptive categories which will cover all the many forms of valleys which may be encountered on maps, and the policy adopted here therefore will be the same as in the description of hill features, i.e. to concentrate on a few distinctive and commonly recurrent types for which fairly probable explanations may be conjectured. What we are looking for, of course, is really abnormal examples of river, or valley development and it may be as well to attempt some sort of very general definition of normality in this respect even though such 'text-book' conditions are seldom if ever encountered. For example, as one follows a river from source to mouth one might expect to find, in the most general way, a progressive decrease in its longitudinal gradient, in the slope of the valley sides and often too in the amplitude of the relief bounding its valley, but a progressive increase in the width of the valley floor and openness of the plan of the valley consequent upon the formation of meanders and the creation of a flood plain by lateral erosion (compare Fig. 79A, showing the upper portion of the River Plym on Dartmoor and Fig. 79B the lower portion of the River Ribble in Lancashire). In extreme cases the meandering may ultimately create a flood plain several miles wide, not so much a valley as a very flat area worthy of inclusion under 7 above and easily recognised by the intricate patterns of existing and abandoned meanders (see Fig. 79C).

Once equipped even with so broad a generalisation we are now in a position to recognise where something has 'gone wrong', where either stream form, or valley form, or both have unusual characteristics, pointing to the occurrence of some feature or event preventing the normal course of river development from taking place, or modifying it once it has occurred.

Fig. 78: A & B: Capture of the upper portion of the R. Teifi, Cardiganshire, by the rivers Rheidol and Ystwyth. **C & D:** Development of river capture (after Davis). **E:** Rheidol valley near Devil's Bridge, Cardiganshire. **F:** Geological map of the part of the Torbay area, Devon. **G:** Geological map of the Swanage area, Dorset. **H:** Valley of the Colden Water, near Hebden Bridge, Yorkshire. **J:** Effect of rejuvenation on valley form.

16 *Constriction of a Valley; Steepening of the Valley Sides; 'Big River-in-Small Valley'*
Types of Situation

Any or all of these features point to a section of the valley where the forces such as
slipping, rainwash and gullying normally responsible for valley widening are unable to
do so as effectively as in the adjoining section. Several possible reasons may underlie
this happening, though evidence outside the valley itself may often hint at which is most
likely. The possibilities are:

(a) *Increasing rock hardness.* Where an outcrop of more resistant rock is crossed by a river
valley widening will naturally be retarded, but one would also expect some other indica-
tion of the presence of the resistant rock, for example as a cuesta or hog-back, perhaps
with similar constrictions where other rivers crossed it also. In Fig. 79H the remarkable
constriction of the valley of the Garonne at St. Breat is caused by an outcrop of resistant
limestone sandwiched between schists upstream and gneiss downstream, though glacial
erosion has here exaggerated initial differences; a second ridge, half-a-mile to the north
provides a further, less obvious, example. The limestone outcrop in Fig. 79H is a re-
stricted one: more extensive spreads of limestone often produce narrow, gorge-like valleys
in rivers that cross them, the permeability of the rock sometimes accentuating its resistance
to widening agents. The gorge-like valley of the River Verdon in Fig. 75D is not un-
typical of many valleys crossing limestone outcrops in semi-arid areas, while the contrast
between the gorge and the open section across the softer rocks of the Quinson depression
is very clear.

(b) *Increasing aridity.* As rivers pass into increasingly arid areas the lack of tributaries
and rain-wash may result in the narrowing of the valley to a gorge-like form. Since the
aridity will be widespread one would expect all the rivers in the area to be affected
similarly.

(c) *Lack of time.* If one portion of a river valley is much more recent than the remainder
there may have been insufficient time to widen it to similar dimensions. Glacially diverted
sections of rivers not infrequently show this steep-sided characteristic, which in this case
would be an isolated example, and would perhaps have a sudden bend at its beginning
(see 15 above) and may also cross a major watershed (see 12 above and 21 below).

(d) The feature may be the *upper portion of a 'rejuvenation head'.* (See 22 (b) below.)

17 *'Small-River-in-Big-Valley' Types of Situation*

This situation, where a 'misfit'[10] stream occupies a valley much too large for it to have
cut itself, is to some extent the opposite of that just described. It is often encountered
where drainage has been diverted, either by capture or by glacial interference. In Fig. 77K
the broad open valley A–A drained by two insignificant streams contrasts with the much
more restricted valley which actually takes the drainage from Lake Bassenthwaite,
offering at least a suggestion that the former may represent the original outlet from the
lake, later blocked by drift or ice and replaced by the present course of the River Derwent.

[10] Sometimes termed an *underfit* stream.

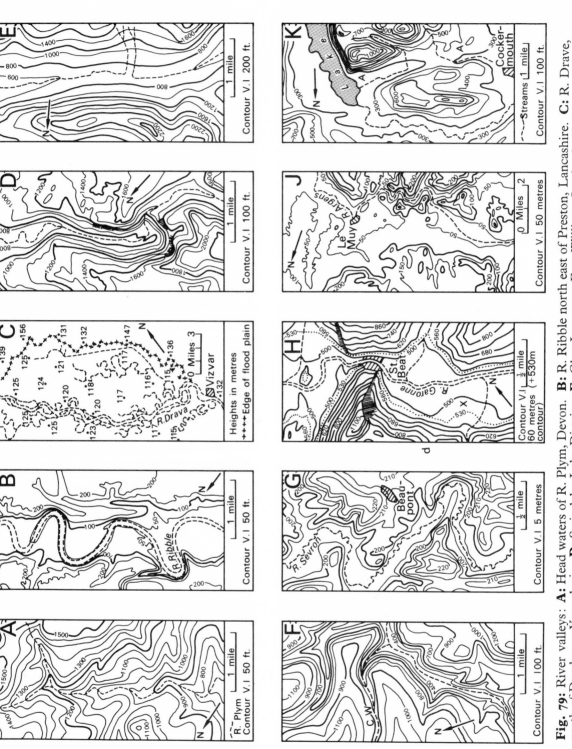

Fig. 79: River valleys: **A:** Head waters of R. Plym, Devon. **B:** R. Ribble north east of Preston, Lancashire. **C:** R. Drave, north of Durdevac, Yugoslavia. **D:** Swindale, Lake District. **E:** Glen Loy, near Fort William, Scotland. **F:** Upper Calder valley, Yorkshire. **G:** R. Sevron, Bresse, France. **H:** R. Garonne at St. Béat, Pyrénées, France. **J:** R. Argens, Provence, France. **K:** R. Derwent, draining Bassenthwaite Lake, Lake District.

18 *Valleys U-shaped in Cross Section in Hilly or Mountainous Areas*

It is common knowledge that in mountainous areas, valleys which show an atypical U-shaped rather than V-shaped cross section have probably been modified by glacial erosion. Fig. 79D, illustrates an example of such a valley at Swindale in the English Lake District, and comparison with Fig. 79A will also help to emphasise the existence of other useful 'give-away' features associated with glaciated valleys. The U-shape here contributes the steep sides and obvious valley floor, but there can also be seen the relatively open plan of the valley and its abrupt 'amphitheatre' head into which the stream 'hangs' abruptly. The blunted or *truncated* spurs often associated with such valleys are not shown here, nor are they always easy to recognise on maps.

19 *Valley-in-Valley Forms, with Widespread 'Shoulders' or 'Benches'*

In some valleys the sides do not slope regularly down to the floor but show a marked slackening of slope to produce a pronounced shoulder (either continuous or eroded into fragments), before steepening again as the river is approached. The result, in profile, gives the impression of a broad, open upper valley, into the floor of which a second inner valley has been cut, and this, in fact, is often how such valleys have been formed. For some reason – for example rise of the land, fall of sea level or removal of a glacial obstruction – the base level of the whole river, or part of it, has been lowered and the river has thus become rejuvenated enabling it to begin to cut down again into its former valley floor. Alternatively the bench may be structural, caused by an outcrop of more resistant rock on the valley side (see 5 above), though a characteristic of this type of feature will often be its relatively limited extent, while the indications of rejuvenation will usually be found widespread throughout a river system and often in neighbouring systems as well. Glacial overdeepening is yet another very common cause of valley-in-valley form, in which case the inner valley will often show the characteristics of U-shaped valleys listed above. Fig. 79F, which is a portion of the Calder Valley above Hebden Bridge in Yorkshire, shows a very clear valley-in-valley form with a characteristic valley side bench through which the hanging tributaries have cut a steep notch down to the main valley floor.

20 *Intrenched Meanders and Ingrown Meanders*

Whenever meanders, particularly those with free, swinging curves, are found not on the flat flood plain of a river valley, as in Figs. 79B and C, but at the bottom of a sinuous valley and with pronounced spurs of higher land projecting into the actual meander core, they are worth considering as intrenched or ingrown meanders[11] produced by the effect of rejuvenation on a river which formerly meandered across a now-vanished nearly flat surface. Many classic examples of such features are known, for example those of the English River Wye and the River Moselle in Germany, but Fig. 79C shows a rather less obvious instance. Here it is not the tiny sinuosities of the River Sevron that matter but the

[11] Intrenched meanders have roughly symmetrical cross-sections due to rapid downcutting, ingrown ones, which formed more slowly show more asymmetrical profiles. The term *incised meanders* is applicable in both cases.

larger curves of the general plan of the stream which, if it were simplified as it would be for example on a smaller scale map, would assume a form not unlike that of the Ribble in Fig. 79B yet quite without the open, flat flood plain expected in normal meander development.

21 'Through Valleys', 'Back-to-Back Valleys' Breaching Major Watersheds

Not all valleys terminate in marked divides. A valley from one system may meet one from another system 'back-to-back' so that together they form a *through valley* with scarcely any feature separating the headwaters of the two systems as in Fig. 79E (Glen Loy, near Fort William). There are several possible explanations for this type of feature, among them:

(a) The valleys are merely aligned along a zone of weakness (see section 14 above) which has also facilitated the removal of an original divide.

(b) Ice or glacial overflow water moving across the original divide has eroded it away. The former probably explains the through valley in Fig. 79E; many such valleys occur in Western Scotland, and many exhibit other characteristics of glaciation, for example the U-shaped cross section and straight open plan clearly visible in Fig. 79E.

Where overflowing glacial meltwater is responsible, the resultant valleys may have more typical fluvial characteristics – for example, a sinuous course – but in addition they are often steep sided, almost gorge-like as well. After removal of the impounding barrier the overflow stream may continue to occupy the valley, as in the Severn Gorge in England, or a divide may emerge in the overflow valley giving a through valley with drainage flowing two ways from the summit, as in Newton Dale in North Yorkshire.

(c) Diversion of the headwaters of a river by river capture may also cause partial reversal of drainage along the main valley just beyond the capture so that the drainage now flows back to the capturing river, creating a divide where none formerly existed, for example at W in Fig. 78E (p. 204), and leaving a through valley or *wind gap* and beheaded stream (B) to mark the original alignment.

22 Waterfalls, Rapids, Steeper Sections and Similar Irregularities in the Long Profiles of Rivers

On the map a rough indication of the gradient of a river, and of change in that gradient, can be obtained by examining the distance between successive contour crossings. In theory a river whose long profile had developed under ideal conditions would show a progressively decreasing gradient from source to mouth; in practice (as on the River Castell in Fig. 78E) many minor irregularities occur, as well as possibly some major ones in the form of waterfalls, rapids or markedly more steeply graded sections, for example on the rivers Rheidol and Mynach in Fig. 78E. Map evidence alone is unlikely to yield much information about the many minor irregularities, but the more pronounced ones may be worth study. They can usually be attributed to the presence of one of two features namely:

(a) *An outcrop of more resistant rock crossing the river*. Here true waterfalls (usually marked as such on maps), rapids or simply more steeply graded sections may be found,

depending on the nature and arrangement of the rock, while in many cases a gorge-like or steep-sided section below the fall marks its gradual retreat upstream. Where major falls are produced in this way the resistant rock may produce a prominent feature away from the river (Niagara Falls and the Niagara Escarpment for example), but often there is little indication away from the river itself.

(b) *A rejuvenation head.* If, for reasons such as rise of the land, fall in sea level, or glacial overdeepening of the main valley, a river begins to cut down into its valley floor, a rejuvenation head will form at the upper limits of this downcutting, working its way progressively upstream (see Fig. 78J). Conditions below this head may vary from consistently steeply graded to gently graded (see Fig. 78J); but in either case there will be a marked knick point at the head itself, and changes in the cross profile of the valley below this with valley-in-valley characteristics and steeper sides usually appearing. All of these features can be seen in Fig. 78H where the Colden Water (CW on Fig. 79F) rejuvenated by the overdeepening of the Calder Valley now 'hangs' markedly above that feature, and also in Fig. 78E where river capture of the former headwaters of the Teifi by the more steeply graded Rheidol has caused the rejuvenation. With the exception of rejuvenation by capture it will be obvious that most 'rejuvenating agents' will affect all or large portions of a drainage system, so that one might expect to find similar rejuvenation heads on other rivers as well.

(c) In certain glaciated valleys the presence of characteristic and pronounced steps in the long profile will give rise to irregularities along the long profile of the stream draining the valley as well.

23 *Lakes and Depressions*

Since lakes may be considered as depressions in the earth's surface filled to overflowing with water, the possible implications of the existence of both features may be considered together after noting that the existence of a depression without a lake normally indicates either porosity or aridity sufficient to allow evaporation permanently or temporarily to exceed inflow. In the former case the depression is formed in a pervious material (usually limestone or glacial sands and gravels) but is not deep enough to penetrate to the water table.

Furthermore since lakes are essentially flooded portions of the earth's surface, it is clear that the detailed shape of lakes will follow as much from the type of landscape flooded as from the 'flooding agent', a moraine dammed lake in a glaciated valley being quite a different feature from one in, say, an area of drumlins. Nevertheless the general shape of a lake, or some particular feature about it, will often hint at its origin and since many of these 'pointers' relate to landscape features already discussed, the paragraph which follows merely lists the principal lake-forming agents together with any relevant comments.

Among factors forming natural depressions are:

(a) *Irregular warping* of the earth's crust. This often produces large 'regional' lakes shallow in proportion to their size, for example the Caspian Sea and the Sea of Aral.

(b) *Down-faulting* of a portion of the earth's crust. Lakes formed in this way will often be long, relatively narrow and perhaps deep as well, like Lake Baikal. In addition the depression and/or lake itself may show signs of 'fault' topography (see section 6 above).

(c) *Volcanic craters and calderas.* A relatively easily recognised type (see Fig. 74A). Lakes formed as a result of these agencies are likely to be isolated examples, not multiple forms.

(d) *Glacial scouring action.* Much depends here on where the scouring occurs. If in a glaciated valley the result will often reflect the shape of that valley, giving long, relatively narrow, deep and often straight sided finger lakes; in a corrie or cirque, tiny rounded *tarns* may result; and in more extensively glaciated lowland areas there may be a highly irregular chaos of lakes, though sometimes having a characteristic orientation corresponding to the direction of ice movement.

(e) *The irregular surface of sand dunes, glacial moraines and kettle-hole type country.* Here there are usually many small irregular depressions which may be dry or contain lakes according to the level of the water table in any area. The general setting is distinctive enough to be easily recognised and a classic example of the second type of area is the Pays de Dombes in France.

(f) *Solution hollows in limestone areas.*[12] In areas where thick limestones occur, depressions formed by solution of this limestone may be widespread and of widely varying size. Though they are usually dry those which descend to water-table level will contain lakes. Other features of limestone areas, for example disappearing streams or angular dry valleys (see section 11 above), will usually be present also, but it should be noted that the limestone whose solution formed the hollows need not be at the surface and may be covered by superficial deposits, as in the Florida lakes region where pleistocene sands cover much of the limestone bedrock.

(g) *'Depressions' resulting from the damming of existing valleys or arms of the sea.* These are most usually produced either by glacial morainic dams, as at Lake Constance or Lake Garda or by the construction of sandspits and bay-bars. In the former case the morainic dam may or may not be recognisable depending on its size and many such lakes are really compound, the morainic dam adding depth to a glacially hollowed valley floor. The second type is easily recognisable (see Fig. 75A). Less frequently blockages are produced by landslides (as at Lake Waikaremoana in New Zealand), lava flows, or alluvial fans formed by tributaries.

Man-made lakes formed by similarly impounding existing valleys are of course another version of the same phenomena. Even where the name does not indicate their true nature, such features are characterised by the presence of an obvious straight or smoothly curved portion of the 'shore' where the dam blocks the valley outlet. Other and often considerable man-induced lakes may develop as a consequence of extractive operations, for example 'flashes' developed in subsidence hollows in coal and salt-fields, marl and gravel pits and peat diggings. Lakes formed as a result of the last-named activity are particularly numerous in the Netherlands.

[12] Similar hollows have also been formed by the solution of beds of gypsum as well as limestone and of course by the man-induced solution of underground salt-beds as well.

IV Coastlines

Since few features are more clearly defined on a map than the line of contact between land and sea, the shapes of coastlines inevitably attract attention. The list below considers some of the more commonly recurring features and their possible implications.

24 *Deeply Indented Coastlines with many Inlets and often Islands Offshore*

Coastlines with these characteristics usually owe their general form to submergence[13] of a former land area. As with lakes the detailed shape of the coastline may be much influenced by the type of topography which became submerged, for example submerged glacial troughs will produce *fjords*, submerged river valleys *rias* (as in Fig. 77A), and an area where structures are generally transverse to the coast (as in S.W. Ireland) will give quite different shapes from one where trends are generally parallel to it (as in Dalmatia). Though former submergence may have contributed dominant characteristics to a coastline it is important to note that contemporary developments may be quite different, still-stand for instance or even emergence. Unfortunately contemporary or recent developments on many shorelines are often represented by features such as raised beaches or very low, new cliffs, whose amplitude is far too small to show clearly on topographical maps,[14] though in some cases compound shorelines are clearly recognisable; the general features of the coastline around Morecambe Bay include many characteristics of submergence (for example the long estuaries of the Duddon, Leven and Kent and the islands of Walney, Roa and Piel), but in detail there are also suggestions of emergence, see Fig. 75C (p. 195) and section 7(a) above.

25 *Individual Irregularities in the Coastline, Prominent Headlands or Inlets, 'Cape and Bay' Coastlines*

Although differential warping of the earths crust may ultimately impose a limit upon the extent of a submerged shoreline such a feature must, by its very mode of formation be 'regional' rather than local in extent. More individual prominences and embayments (as well as many forming part of a submerged coastline, of course) may be caused by the variable resistance to erosion shown by the rocks forming the coast, resistant areas producing capes and headlands, weaker areas bays and inlets. Lithological variations, i.e. variations in the nature of the rocks themselves, are perhaps the commonest cause of this differential erosion but lines of weakness may also be introduced by the presence of a fault or major joint. Where the last two are responsible, the inlets which result are often narrow and continued inland by a fault or joint-guided 'straight' valley; but the commoner lithological differences produce much greater variety of forms. If structures are simple and resistance very variable, a rather obvious 'cape and bay' coastline may result (as in Fig.

[13] Submerged here implies merely a rise in the level of the sea relative to that of the land: this could be produced either by a true rise in sea-level or by the subsidence of the land, or both simultaneously.

[14] The same is true of course of river terraces, which provide a similar useful indicator of changes in a river system.

P

78G), with the cape continued inland by prominent ridges, and the bays by areas of lower ground. More complex patterns of outcrops are, however, more usual (for example in Fig. 78F), and often the landward relief gives no clear indication of what is happening along the coastline, particularly since the relevant strength or weakness there need only be present at or around sea level.

26 *Gently Curving Stretches of Coastline*

Where stretches of coastline show the form of smooth, gentle curves they will usually be found to be either *eroded in or formed by uniformly weak material.* Within this general description several very varying types may be found, for example:

(a) *Coastlines continuously backed by low cliffs.* Unless there is evidence of the accumulation of material at their foot, cliffs, wherever they occur, indicate that erosion is active along a particular section of the coast. In this case then a smooth coast is being formed by the erosion of areas of relatively unresistant material such as soft sands, clays, or glacial drift, as at Holderness in Yorkshire. Characteristic accompanying features are sandy beaches devoid of rock outcrops and low ground inland of the cliffs.

(b) *Coastlines where cliffs alternate with 'low' sections composed of either very flat areas, sandspits, bay-bars or tombolos.* Coastlines of this sort are usually found where the sea is smoothing out a formerly more indented coastline. As erosion cuts back the former headlands to form the cliffed sections it provides material which can be moved along the coast to form *sand-spits* and *bay-bars* projecting across, perhaps blocking, former embayments in the coastline, or *tombolos* linking former islands to the shore. In the earlier stages of its formation such a coastline is easily recognised by these characteristic features protruding either across embayments (as in Fig. 75A), or wherever a marked change occurs in the direction of the coastline; but in the later stages these features may apparently 'disappear' as sedimentation in their lee forms more extensive flat areas: this is beginning to happen at X in Fig. 75A (p. 195).

(c) *Coastlines with offshore bars.* Although offshore bars are among the most distinctive coastal features marked on maps the only other features with which they may reasonably certainly be associated are the presence of a very gentle beach gradient yielding shallow water some distance off-shore, and (usually) the absence of very marked tidal range. In the past they have often been taken as indicative of an *emergent coast*, since emergence seemed most likely to produce such shallow-water conditions. Similar situations could however arise with the submergence of a nearly flat coastal plain, an outwash plain for example, or where large scale deltaic deposition is occurring.

27 *Nearly Straight Stretches of Coastline*

It has been shown above (see section 6) that 'straight-line' aspects of landscape often indicate the presence of faults and a similar origin might be suggested for coastal stretches which show these characteristics. In this case there would usually be highland behind the coast and, as with fault-scarps, only the *general* alignment need be straight; in detail considerable 'fretting' of the coast line will often occur.

Chapter 14 Features of the Human, Social and Economic Landscape on Maps

So far as specialised studies dealing with the nature and evolution of the physical features of the landscape are concerned, topographical maps have proved a fruitful source of both inspiration and information; the same is not nearly so true for investigations concerned with features of the human occupation of an area, and the reasons are not far to seek. Essentially two broad qualifications, inherent in the nature of map evidence, underlie this difference. In the first place for studies of the physical landscape the map is often virtually the only form of documentary evidence to set beside observations derived from the landscape itself; whereas features of the human landscape are obviously counted, measured or recorded in many other ways as well. Secondly, within its general limits of accuracy and contour interval,[1] the map normally shows a more complete record of the physical landscape than of the human one. The implications of this last-named defect are particularly serious. If a feature is incompletely or indistinctly shown on a map, as for example the distribution of industrial premises often is, a misleading impression of its distribution and relationships may be obtained, while even where a feature is properly recorded, for example the distribution of vineyards or orchards, this may be related as much to other features (such as technological change or land ownership) which are not marked on the map, as to features (such as slopes and aspect) which are.

These are important limitations to the part which map examination can play in any investigation concerning the nature and origins of the features of the human landscape; but even so the general advantages which derive from map examination, and which were stated at the beginning of the previous chapter will still hold good. *Provided that the distribution of a feature is reliably and clearly shown* (or that allowances are made for defects of this sort), the map's unique contribution is that it will reveal the extent and nature of this distribution and its relationship to at least *some* other features; in many instances it will also suggest theories of *possible* relationships or origins *which can and must be checked against other available sources of evidence*. The italicised words in the preceding sentence are intended to express a very necessary degree of caution here. In the author's experience it is, at times, almost impossible to prevent students using map evidence alone to draw the most unqualified, generalised and highly erroneous conclusions concerning the origins of features in the human landscape. To make matters worse these conclusions are rarely checked against other evidence, nor in many cases is there regard

[1] These are of course, very severe limitations in some cases.

for the need or even the possibility of doing this. A major concern of this chapter will therefore be to emphasise negative aspects of any examination, to show the kind of conclusions which cannot or should not be made, and to stress the very wide range of explanations which may exist for any particular map-pattern formed by features of the human landscape.

Settlement Patterns

Of the three broad categories of patterns discussed in this section, that of settlement is perhaps the most fundamental and in consequence attracts the most attention. It is therefore particularly necessary at the outset to stress two general characteristics which are very relevant to the representation of settlement on maps. The first of these is that, with very limited exceptions, maps are concerned to show the pattern of buildings, not settlement (i.e. inhabited buildings). The difference between the two patterns may well be considerable, not only in urban areas, where it is relatively easy to make mental allowances for the inclusion of industrial and commercial buildings in the mass of towns, but more relevantly in rural areas, particularly those where there are seasonal settlements or numerous isolated barns and storage buildings. The map in Fig. 80A for example gives no indication whether the clusters of buildings represent permanent villages or seasonal ones or whether the many isolated buildings are dwellings or not. Norwegian maps (as in Fig. 80B) are virtually alone in making this distinction clear.[2] In the absence of any definite indication of this sort the best that can be attempted is the rather inconclusive line of reasoning that an isolated building to which no means of access is indicated is unlikely to be a dwelling (permanent *or* seasonal).[3] Many map series, for example the 1″ O.S. maps, distinguish isolated farms by name, but this is not wholly reliable and even so isolated labourers' cottages or smallholdings are not clearly differentiated from other scattered buildings such as barns.

The second general point derives from the nature of settlement itself. Unlike the features of the physical landscape both the settlement pattern and the factors which may affect it (availability of water or communications, systems of land tenure, etc.) have often undergone very marked variation in relatively short periods of time, so that today's final pattern is likely to be a highly compound one and any correlation which the map suggests must be sensible with regard both to the possible age of the settlement (assuming that there is any indication of this on the map) and to the validity of this factor at that particular time. It would be ridiculous, for example, to suggest a correlation between the juxtaposition of an isolated compact village-type arrangement of buildings and the presence of a nearby railway station (rather the reverse), but quite reasonable to consider this if the settlement exhibited largely an open low-density type of street pattern more suggestive of modern development. Alternatively many settlement patterns tend to persist, with only

[2] The new Swedish 1:50,000 series makes an attempt to do so but the symbols are not particularly distinctive. See also footnote 4, p. 177.

[3] This assumes that the map is detailed enough to reveal any such means of access, which need be no more than a track or even footpath.

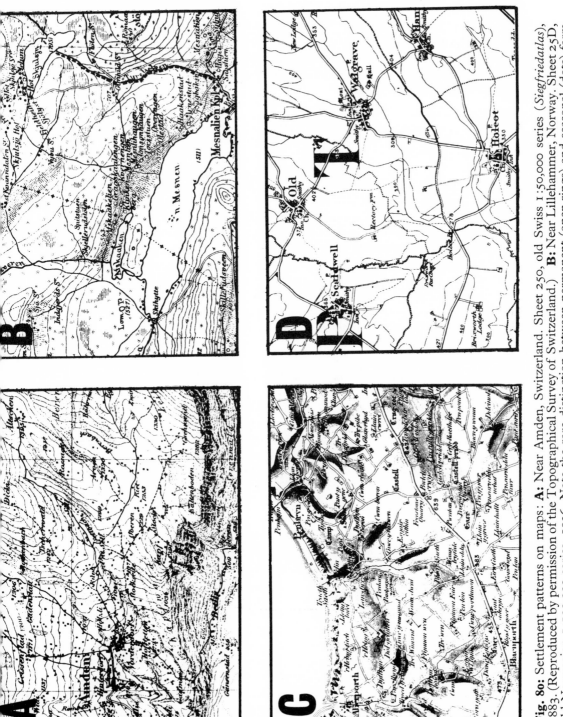

Fig. 80: Settlement patterns on maps: **A:** Near Amden, Switzerland. Sheet 250, old Swiss 1:50,000 series (*Siegfriedatlas*), 1883. (Reproduced by permission of the Topographical Survey of Switzerland.) **B:** Near Lillehammer, Norway. Sheet 25D, old Norwegian 1:100,000 series, 1936. Note the rare distinction between permanent (open rings) and seasonal (dots) farm buildings. (Reproduced by permission of the Geographical Survey of Norway.) **C:** Cardiganshire. Sheet 57 of the 1st edition (Old Series) 1″ Ordnance Survey map. **D:** Northamptonshire. Sheet 185 of the 3rd edition 1″ Ordnance Survey map.

minor modifications, long after the factors which originally conditioned them have disappeared.

With these qualifications in mind let us examine, in a guarded way, the possible significance of certain characteristic types of settlement patterns taking the more general patterns first and detailed features later.

1 *Rural Settlement Patterns which are Basically 'Nucleated'*

Reduced to its essentials the enormous variety of settlement pattern found on maps can be considered simply as an admixture, in varying proportions, of two basic forms – *nucleated* and *dispersed*. In a basically nucleated settlement pattern, such as that illustrated in Fig. 80D, the great majority of habitations (though very rarely all) will be contained within well-defined nuclei. These nuclei may vary considerably in size, but the essential feature is that scattered dwellings either singly or in tiny groups form a negligible part of the whole. With a basically dispersed pattern the reverse is the case; nuclei will not be absent entirely, and may even be substantial in size, but a very important part of the settlement form consists of scattered dwellings or tiny groups of dwellings, as in Fig. 80C. Examples where nucleation or dispersal are as strongly marked as in Figs. 80C and D are, however, somewhat unusual, and there are many areas where a mixed type of settlement pattern occurs – elements of both types being present but neither really dominating the picture. In Fig. 81A for example, clearly defined nuclei such as Bray are found, rather more loosely knit ones such as Holyport, but also many scattered buildings and straggly ill-defined settlements whose names, characteristically for England at least, are often Something-Common, -End, -Street or -Green.

A markedly nucleated settlement pattern, like that in Fig. 80D, poses one obvious question: 'What are or were the factors which might have been responsible for this nucleation?' There are several possible answers to this question but since most of these are prone to be overworked by ill-informed, if enthusiastic, map examiners the following account is concerned as much to stress their limitations as it is to point out their very existence.

(a) *'Wet-point' sites – i.e. places with an available water supply*. Of all the factors which may be invoked to explain nucleation in a settlement pattern none has probably been more overworked than this one. In areas where water is widely available, either at the surface or by the sinking of shallow wells, it is unlikely to be an important factor; alternatively in extreme cases, like desert oases, it will obviously be the dominant one, and will remain a relatively important *potential* factor in waterless areas such as wide expanses of chalk, limestone or pervious sands. Yet even in these cases it will not necessarily emerge as the decisive factor. A great deal will depend on the depth of the water-table (hence the possibility of wells), and the amount of rainfall, giving possibilities for storing water, whilst in extreme cases water may even be carried some considerable distance to settlements whose location has been determined by other factors. In parts of the Garonne valley, for example, 'people have preferred to live on low plateau tops and to fetch their water from a distance; in Languedoc there are villages located near a few hectares of good land in preference to a spring'[4]; and even in the case of the so-called

[4] Admiralty Handbook, France, Vol. III, p. 61.

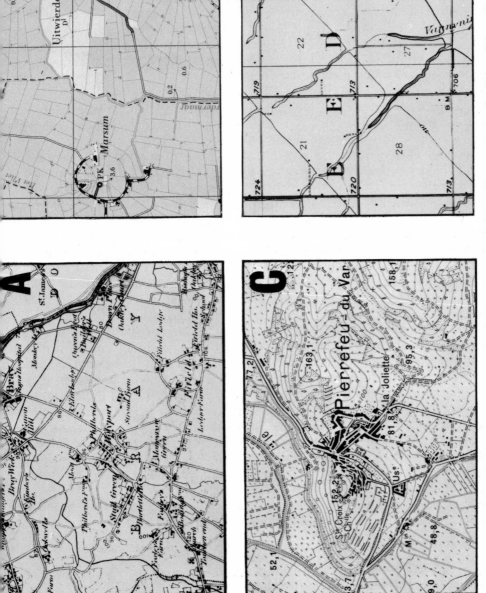

Fig. 81: A: A 'mixed settlement' pattern, Thames valley, Berkshire. Sheet 269, 2nd edition (New Series) 1" Ordnance Survey map. **B:** A completely nucleated settlement pattern near Delfzijl, north-eastern Netherlands. Sheet 7F, Dutch 1:25,000 series. The villages are built on or (now) around man-made mounds (*terps*) erected as a defence against flooding by the sea. (Reproduced by permission of the Netherlands Topographic Service, Delft.) **C:** Pierrefeu-du-Var, Provence, France, a village defensively situated on a hill-top. Sheet Collobrières no. 5, French 1:20,000 series. (Reproduced by permission of the Institut Géographique National.) **D:** An almost completely dispersed settlement pattern near Napoleon, Ohio. Napoleon Quadrangle Sheet, U.S. 1:65,500 series. In this area the establishment of dispersed farms on individual land holdings was not preceded, as it often was in Europe, by a nucleated phase with population grouped in villages. (Reproduced by permission of the U.S. Department of the Interior, Geological Survey.)

'spring-line' villages it is open to question whether they owe their presence as much to the springs (they are, in any case, by no means always *at* the springs) as to the linear zone of good mixed soils which must also mark the line of the geological junction.

To sum up therefore, nucleation resulting from scarcity of water supply is likely to be highly exceptional, and even in areas where water supply may once have been an important nucleating factor technological improvements in recent times may well have reduced or even removed its effectiveness. Other things being equal availability of water supply may, however, have played a part as a locational factor affecting the *siting* of some settlements even where it was not necessarily responsible for nucleation. There would be little point in sinking wells or building cisterns if a site where surface water was available was equally suitable on other grounds; but it is important to remember that in many areas other things were not equal, and factors such as good soil may have triumphed over water supply in determining settlement location.

(b) *'Dry-point' sites – i.e. sites offering protection from flooding by rivers or the sea.* In the flood plains of major rivers, ill-drained inland areas or flat, and often reclaimed, coastal areas, flood danger may obviously play an important part in influencing the settlement pattern. As was the case with water supply, however, this is a factor more prone to influence location of settlement generally than to force nucleation. Nucleation will result only if the dry point sites are very restricted, as they were in the area shown in Fig. 81B where they consist in fact of man-made mounds or *terps*, and in many other areas of this sort settlement is either markedly linear (see below), or even much dispersed due to later improvements, as in many parts of the English Fenland. A major difficulty in assessing the possible importance of this flood factor from map evidence is that the altitude difference required is usually much less than the contour interval, making such 'dry' sites difficult to recognise whilst, again as with water supply, later technical developments in flood prevention may permit the addition of a prominent scatter of isolated dwellings to a pattern which was once, of necessity, nucleated.

(c) *'Strong-point' sites – i.e. sites offering defensive advantages.* If the nuclei in a settlement pattern consistently occupy the tops of steep-sided hills or spurs,[5] it is obviously open to suggestion that defensive considerations may have played an important part in enforcing nucleation. Once again here is a factor which is likely to be of more use in explaining a particular location rather than widespread nucleation for, though isolated examples of nuclei with a situation like that shown in Fig. 81C are not difficult to find, areas where this forms a 'regional-type' are relatively uncommon. In Europe such villages are perhaps commonest around parts of the Mediterranean, for example in Languedoc, southern Italy and Sicily, and here liability to attack by pirates is usually cited as the explanation. Gleave[6] has recently described the abandonment of such villages in Nigeria, a reminder that where the need for a defensive location has been removed, as it usually has today, the hill-top situation has many disadvantages.

(d) *Social factors prompting nucleation.* The factors so far considered may, as we have seen, prompt nucleation in certain rather unusual physical or social conditions, but do

[5] The general siting of settlement on top of *low* hills cannot be considered decisive in this respect.

[6] Gleave M. B., 'Hill settlements and their abandonment in tropical Africa', Institute of British Geographers, *Transactions* No. 40, December, 1966.

little to explain its widespread occurrence where conditions are less extreme. In such areas some more general explanation for nucleation is necessary, and it seems likely that it is often indicative of the former existence of a group of factors of a broadly social-cum-cultural type. For example in areas where land holdings were much fragmented and/or impermanent, whether through rotation or necessary abandonment, it might be impossible for a person to establish his dwelling on his own land, and he might therefore place it alongside those of his fellows in a grouped community adjacent to the cultivated land. Such conditions of fragmented land holdings were common wherever the 'open-field' system of cultivation was practiced in Europe, and the late continuation of this type of land-tenure, in some areas even to the present day, has done much to maintain a markedly nucleated settlement pattern in parts of Europe. Alternatively in other areas the reorganisation of this system giving consolidated holdings, as occurred for example with the Enclosure Movement in England, offered the possibility of establishing individual dwellings within these holdings, thus adding a dispersed element to the nucleated pattern or, in extreme cases, resulting its virtually replacement by a dispersed settlement pattern.

2 *Rural Settlement Patterns which are Basically Dispersed*

Something of the possible explanations underlying markedly dispersed settlement patterns may already have been deduced, negatively, from arguments already put forward above. Dispersion seems to presuppose, for instance, the absence of overwhelming need for nucleation to withstand water shortage, flood or attack and, in Europe at least, the absence or early abandonment of large-scale[7] communal cultivation systems of the open-field type. As with nucleated settlement, however, there are many other social factors, often of a 'national' or traditional type which may be involved.

With any dispersed settlement pattern a very important aspect affecting its possible significance is the age of the dwellings, and here of course the map gives little guidance. In the relatively recent past the commonest factor underlying the establishment of isolated dwellings has probably been the formation of compact holdings, either as just described by reorganisation of open-field systems or by reclamation from former areas of heath, moor, forest or marsh. In many parts of North America the establishment *ab initio* of compact holdings on which a farm could be situated has produced a pattern exhibiting almost complete dispersion (Fig. 81D).

In areas where dispersed settlement is old-established a more fundamental cause has often been the occurrence of good agricultural land in units too small to support more than one, or a few families, so that individual farms or tiny hamlets became the normal settlement pattern, for example in parts of the Welsh mountains or the dry limestone *Causses* in France.

3 *'Mixed' Settlement Patterns*

Any attempt to establish the particular significance of mixed settlement patterns, such as that shown in Fig. 81A, is obviously fraught with even more difficulties than were

[7] Where open-field land was restricted in extent, a scatter of farms round its periphery sometimes replaces the expected nucleated settlement.

encountered in examining the purer forms. While the possible general correlations under-lying dispersion or nucleation can of course be brought forward as equally valid here, the essential characteristic of these patterns is their mixture of components and the variations which occur in the proportions of these, and explanations are likely to be far too complex for map evidence alone to throw much light upon them.

Once again it must be emphasised that the broad possible correlations which have been suggested above between various settlement patterns and other features or distributions are intended to do no more than create an awareness of some of the factors which may be at work underlying this particular group of map patterns. Even within these broad groups wide variations are possible, and in particular the ramification and variety of socio-cultural factors are enormous. Indeed all attempts to draw simple correlations between settlement patterns and other features have been continually confounded by exceptional cases; and modern work increasingly points to the great complexity of the factors which are involved. Even quite simple patterns may have complex origins, not least because in many areas several factors are working in the same direction. The hill-top towns of Sicily have a strong defensive element underlying their nucleation but in any case an 'upland', if not a hill-top, site would have been likely in preference to one in the originally forested and malarial valleys. Another well known simple pattern, produced by more than one factor, is formed by the remarkedly nucleated settlements of the southern Hungarian Basin (see Fig. 82A). Here in an area formerly extensively marshy, new eighteenth-century agricultural 'colonies' were established on 'dry point' sites, just as the older settlements had been; the need for defence against the Turks and particularly against wandering brigands also prompted nucleation, however, and the new and larger 'village-towns' grew as the inhabitants of the former villages fled to the greater safety which they offered.

Details within the settlement pattern

Towns and Major Nuclei

In any examination of the settlement pattern found on a map, attention will inevitably be drawn to the largest nuclei within it – the towns and cities of the area.[8] Because the factors underlying the growth and location of towns and cities are often enormously complex and owe much to factors which could not possibly be detected on a map, it is usually pointless and misleading to speculate on the significance of a town's size or loca-tion from map evidence alone. This has not prevented those factors which might leave some trace of their presence on maps being grossly overworked in map examination however, and the following qualifications seem very relevant to typical explanations which have been put forward on frequent occasions.

[8] Not all large settlements function as towns, of course: another distinction which the map is unable to draw.

(a) *X is a crossing-point of a river.* Taken as a statement of fact no quibble can be made here. Put forward as a contributary factor underlying a town's growth or size it is important that several other conditions should be fulfilled. In the first place the river which is crossed should be substantial enough to form a genuine barrier and other crossings infrequent enough to give real nodality to those which exist. Even in circumstances such as these it will often be found that not all crossing-points have urban units attached or related to them,[9] for the possible relevance of such a linkage may depend a great deal on the age and initial scarcity of such crossings. In recent times river crossings have multiplied considerably and even on a large river such as the lower Rhône bridges are only about 8–10 miles apart, though this was not always so in the past. Indeed it may often be more sensible to examine the relationship between towns and river crossings from the opposite point of view, and investigate whether major river crossings which do not have towns or nodal route systems related to them are not more recent than those that do.

(b) *X is a route centre.* Here again it is not the fact but an inferred relationship with growth or size which may be misleading. It is relevant to point out that the focusing of main roads or railways on a town has little unusual significance. Since in almost all cases the establishment of towns preceded the creation of railways and the *classified* road system,[10] and since towns are notorious generators of road and rail traffic it seems only natural that main roads and railways should have been designed to converge on them. These factors may have reinforced a town's position but they can rarely be used to explain it, at least in so far as map evidence goes. What might be more relevant to the argument would be that the convergence was of unusually important routes – 'main lines' so to speak – but the map shows no such differentiation normally,[11] and even where important routes are involved some actual transfer of traffic from one to another is usually needed as well, not simply a 'cross-roads'. In the English Midlands there has never been an important town at or even near to the crossing of the Roman Fosse Way and Watling Street; Tamworth at the crossing-point of two railway trunk routes has gained little advantage from this;[12] whilst towns such as Crewe and March, which have grown largely because they were railway junctions, are conspicuous by their rarity. Alternatively towns where transfer from one transport medium to another was enforced are almost certain to have derived some advantage from this. 'Railheads', even of small branch lines, and towns at the head of seaborne navigation (often the lowest bridging point) are typical examples, though such factors may no longer be operative today.

A word might also be added here about 'gap towns' where, as Dury has pointed out, the wrong relationship is often envisaged.[13] Today the conspicuous through-the-gap route is often a railway which, since it is later than the town, can have done nothing to foster its early development. Unlike the railways ancient roads were quite as prone to take ridge-top routes as valley ones, and the route–town–gap relationship may here be that of a hill route descending to cross the obstacle of a river gap rather than a valley

[9] For obvious reasons with major rivers the town related to the crossing point is not necessarily at the bridge but at the nearest 'dry point' site.
[10] Formal road classification is scarcely half a century old in Britain for example.
[11] Ordinary double-track railways and main roads are far too commonplace to serve here.
[12] The exchange of mails in the middle of the night is the only noticeable manifestation.
[13] Dury, G. H., *Map Interpretation*, p. 103.

route using the gap to cross the obstacle of the hills. Similarly towns which appear to be at the focus of several valleys are equally at the focus of ridge-ways running along the spurs separating these. As in the previous section there is something to be said for reversing the usual town–route centre hypothesis on maps and reasoning that towns which are *not* at obvious foci of main roads are likely to be of relatively recent development. Compare for example in Fig. 82B the *main road* network of Nantwich, the traditional market town, and nearby Crewe, the railway-based 'upstart' with little more than a century's history as an urban centre.

5 *Formalised Street Patterns within Settlements*

In many parts of the world the typical pattern of streets and buildings found in the older settlements, whether towns or villages, is compact and irregular, not too difficult to distinguish from the still irregular but usually much more spacious pattern of the later development which often surrounds it (for example, in St. Rémy-de-Provence – Fig. 82C). Both are distinct from areas where formal and recognisable patterns can be discerned in the street plan; this section examines some of the most commonly encountered patterns and their probable significance.

(a) *Chequer-board or rectangular grids of streets.* In either square or rectangular form this is easily the most commonly encountered formal street pattern, and since it has been in use from the earliest times in all manner of circumstances, only the broadest conclusions about its significance can be attempted. As a first line of approach it may be argued that, as with any formal street pattern, its very existence signifies either ownership of, or control over, land units large enough to allow the pattern to be laid down, in other words the existence of some form of direction over the evolution of that part of a settlement.

Where the core of a settlement exhibits such a plan this is often an indication that the settlement was at one time a newly founded one, either created at the bidding or for the purpose of some particular authority or land-owner. When new settlements have had to be founded a grid-iron plan has very often been adopted; the Roman *castrum* exhibited this form (a few towns, which have developed from this origin have retained that pattern to the present day, for example Como, Fig. 82D) and it was employed for many 'new' mediæval foundations, such as Salisbury (New Sarum, Fig. 31, p. 80), several of the well known 'bastide' towns and, as we have seen, for new eighteenth-century agricultural colonies on the Hungarian Plain. To many Europeans it is above all the pattern of the 'new' towns of North America, though here it has sometimes been imposed from above by public authority, as in the New York 'grid' laid down in 1811, and in other places represents nothing more than an obvious way of subdividing land which had already been parcelled out in square units (see Fig. 46, p. 124). Employed in a slightly more eccentric location the chequer-board may represent a new area of suburban development, perhaps added at a time when the town was growing rapidly. A clear example of an eccentric grid of this kind can be seen at Aix-en-Provence (Fig. 83A); but in smaller settlements the two types of grid – central and 'suburban-addition' – are not always easily differentiated for the new grid was often much larger than the pre-existing settlement which is therefore difficult to distinguish. Fig. 45 (p. 122) shows such an example at Lossiemouth where the new grid of Brandeburgh, added in the mid-nineteenth century,

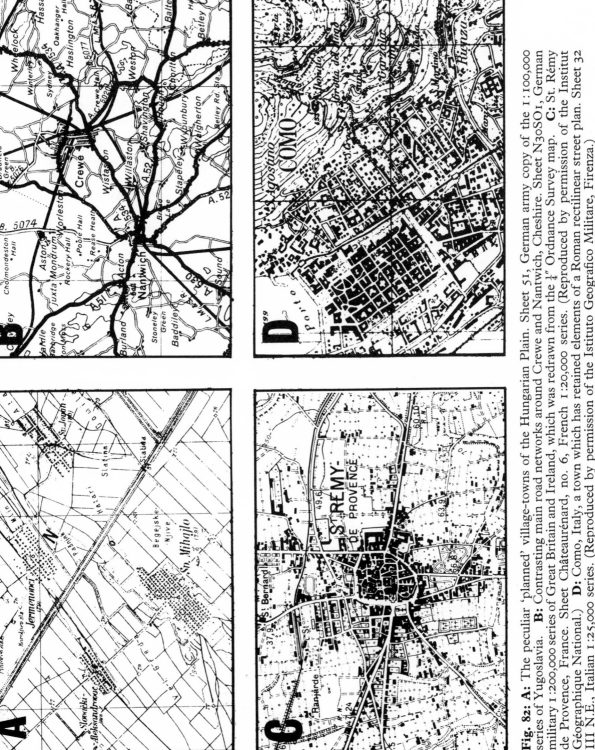

Fig. 82: A: The peculiar 'planned' village-towns of the Hungarian Plain. Sheet 51, German army copy of the 1:100,000 series of Yugoslavia. **B:** Contrasting main road networks around Crewe and Nantwich, Cheshire. Sheet N30SO1, German military 1:200,000 series of Great Britain and Ireland, which was redrawn from the ¼" Ordnance Survey map. **C:** St. Rémy de Provence, France. Sheet Châteaurénard, no. 6, French 1:20,000 series. (Reproduced by permission of the Institut Géographique National.) **D:** Como, Italy, a town which has retained elements of a Roman rectilinear street plan. Sheet 32 III N.E., Italian 1:25,000 series. (Reproduced by permission of the Istituto Geografico Militare, Firenza.)

Fig: 83: A: Aix-en-Provence. Notice the grid-iron plan of the later addition to the south of the mediæval town. Sheet Aix, no. 1, French 20,000 series. (Reproduced by permission of the Institut Géographique National.) **B:** Heavily formalised 'baroque' street patterns in the Vittoria quarter of Rome. *Citta de Roma:* a special sheet at 1:20,000. (Reproduced by permission of the Istituto Geografico Militare, Firenze.) **C:** Less grandiose formalised street patterns in the Villeparisis area of suburban Paris. Sheet XXIV, French 1:50,000 series. (Reproduced by permission of the Institut Géographique National.) **D:** Part of Liverpool; the street patterns in the Norris Green area are very typical of those in large estates of between the wars

renders unrecognisable the existence of the former hamlets of Seatown and Old Lossie.

(b) *Other formal patterns*. Although examples of whole settlements laid out in truly formal patterns are quite rare (Karlsruhe in Germany is one, Palma Nova in Italy is another), major portions of towns treated in this way are more frequent and show features such as streets focusing onto an open square or *place*, broad avenues, circles and crescents: for instance, Edinburgh New Town (Fig. 23, p. 55), and the Vittoria quarter of Rome (Fig. 83B). As with the suburban chequer-boards, these usually represent major new planned additions to existing settlements, though occasionally, as with many of Haussman's boulevards in Paris, they were imposed on top of an existing street pattern. When carried out in the grand manner with broad avenues and spacious squares or gardens (the two examples illustrated above for example), areas of this type usually represent good quality residential districts created from the seventeenth century onward. In rather more cramped and less imposing styles they are more likely to be associated with pretentious private housing developments of the last hundred years, as for example Fig. 83C from suburban Paris (notice the focusing of the main avenues on the railway station and the individual houses) or, in Britain at least, with post 1919 local authority housing schemes. Particularly between the wars these British 'council estates' regularly exhibit a rather geometric plan, at first somewhat rectangular in style, later very curvilinear, and this, along with the scattering of small 'greens', the obvious incorporation of churches, schools and playing fields into the layout and the extensive use of the short cul-de-sac,[14] render them instantly recognisable on a 1" map. The area around Norris Green, in Fig. 83D, shows several of these characteristics which contrast strikingly with, for instance, the simpler patterns of private development at West Derby to the south.

Less formal in street plan but distinctive enough in building layouts are housing developments, either private or public authority, incorporating tall blocks of flats (see Fig. 84A).

6 'Circular' Street Patterns

Although *truly* circular or elliptical street patterns within towns are often associated with formally planned areas as described above, crudely circular or semi-circular ones may have rather different origins, being often related either to topography or to former defensive elements and not infrequently to both. Not surprisingly settlements or parts of settlements built on a steep hill-side often have crudely circular streets which run along the slopes or climb them obliquely; in many other towns crudely circular patterns may derive from streets which run either just inside or outside the line of walls or former walls, as at St. Rémy-de-Provence, Fig. 82C; or alternatively have been established along the line of the walls when these were demolished as at Aix, Fig. 83A. At Cologne (Fig. 84B) two circular elements can be seen, the inner one a boulevard marking the line of the outermost mediæval wall of 1180, demolished in 1880, the outer one associated with the fortifications of 1880 and marking the position of a 500-yard wide zone in which building was prohibited. In many cases street patterns may be 'arcuate' rather than completely circular as for example at Devizes Fig. 83C.

A much later and generally fairly clearly recognisable circular or semicircular element is the twentieth-century ring or by-pass road as in Fig. 87C.

[14] The *short* cul-de-sac was much more widely employed in local authority housing layouts than in those of private developers.

Fig. 84: **A:** Typical patterns of multiple blocks of flats in suburban Amsterdam. Sheet 25D, Dutch 1:25,000 series. (Reproduced by permission of the Netherlands Topographic Service, Delft.) **B:** Circular road elements, Cologne. Sheet C5106, German 1:100,000 series. (Reproduced by permission of the West German Landesvermessungsamt.) **C:** Less obvious circular elements in the street pattern of Devizes, Wiltshire. Sheet 14, 1st edition 1″ Ordnance Survey map. **D:** A peculiar linear settlement formed of planned small holdings along a road near St. Neots, Huntingdonshire. Sheet 134, 1″ Ordnance Survey map, seventh series. (Reproduced with the sanction of the Controller of H.M. Stationery Office, Crown copyright reserved.)

7 *Linear Settlement*

Unlike the patterns just described, which are more commonly encountered in towns, the most obvious cases of linearity are usually associated with villages and rural settlements. Twentieth-century ribbon development around large towns and cities is, however, a common enough hybrid form and one which, more clearly than most, emphasises the essential feature underlying linear settlement patterns, namely that they are usually derived from the exploitation of some feature or resource which is itself linear. In the case of ribbon development this is the ready-made road (which cheapens housing costs) and the services which it usually carries as well. Other commonly encountered linear features which underlie distinctive settlement patterns are:

(a) *Linear dry-point sites.* In areas liable to flood, man-made dykes or natural levees often provide the best dry-point sites available.[15] Their linear form tends to discourage nucleation and encourages the development of long, straggling villages, such as are common in the river-clay area of the Netherlands (Fig. 85C).

(b) *Linear access features – roads, canals and rivers.* In several parts of Europe the reclamation of forest or marsh for agricultural use has been achieved by driving a road, or more rarely a canal, into the area and allotting land for reclamation in long rectilinear holdings running back from a narrow frontage on the road or canal. Dwellings established on these holdings would usually be built at the road or canal end giving the appearance of long, straggling settlements reflecting the linear nature of the means of access. This is probably the kind of background underlying the remarkable long villages in Slavonia (Fig. 85A) and the equally fantastic ones (the village of Stadskanaal/Musselkanaal is almost ten miles long) in the N.E. Netherlands (Fig. 85B), though it should be noted that a good deal of the present-day continuity of such settlements probably results from later infillings along the frontage between the original habitations as population pressure increased. Even where physical conditions are not extreme, a linear settlement pattern is often associated with markedly rectilinear holdings, as in the long villages of the not-quite-so-flat country of interior Friesland and Groningen provinces in the Netherlands where rectilinear holdings were produced by a rearrangement of former 'open-field' type lands. Fig. 84D shows an unusual linear settlement near St. Neots in England, and this too has resulted from the reapportionment of former farm lands, in this case into multiple smallholdings served by a principal access road.

(c) *Other linear features* whose exploitation sometimes tends to produce linear settlement and/or rectilinear holdings are strips of better soil, at a break of slope for example, or at a geological junction (which additionally may offer two environments to exploit), or where narrow valleys breaking a wild and inhospitable coastline give shelter and infrequent access to the sea. Examples of the first type are found in straggling settlements around the peripheries of larger *poljes* in the Yugoslavian Karst, a location which combines freedom from possible flooding associated with the *polje* floor and the use of the narrow zone of deeper soils which accumulate along the break of slope. Villages aligned along 'geological' junctions occur, for example in Vendsyssel in Denmark, where settlement appears often to have been rearranged into linear forms along the junction between

[15] Not infrequently land drainage, and/or soil quality, is also often better near to the dykes, further emphasising their attraction for settlement.

Q

Fig. 85: Some examples of linear settlements. **A:** Near Bjelovar, Yugoslavia. Sheet 31, British military series of Yugoslavia at 1:100,000. (Crown copyright reserved.) **B:** A fen-colony village in the north-eastern Netherlands near Stadskanaal. Sheet 12H, Dutch 1:25,000 series. (Reproduced by permission of the Netherlands Topographic Service, Delft.) **C:** In the poldered river-clay areas of the Netherlands near Schoonhoven. Sheet 38B, Dutch 1:25,000 series. (Reproduced by permission of the Netherlands Topographic Service.)

raised beach and low lying wet meadow lands, associated with arable and pasture areas respectively.

8 *Territorial Organisation – Boundaries of Parishes and Similar Units*

In addition to settlement itself many maps also give some indication of the territorial organisation of an area by marking administrative boundaries of various sorts. At scales of 1:100,000 and larger the boundaries marked are often those of the smallest unit to have an administrative significance – the civil parish in England and Wales for example, or the *commune* in France – and since these boundaries have in many cases been little changed for centuries, they may hint at possible relationships which existed at the time of their definition between a settlement and the lands surrounding it. Only ancient boundaries are likely to have much significance in this respect, and the antiquity of any interesting patterns which are discovered should immediately be verified against older maps. In this respect it is worth noting that the boundaries of urban units are unlikely to be very ancient, having often attained their present form only after many recent adjustments.[16] Although the units defined by these boundaries will often present a bewildering variety of shapes and sizes the following patterns or relationships may be worth further investigation.

(a) *Rectangular parishes.* Elongated, crudely rectangular parishes, of the type shown in Fig. 86B are usually associated with areas showing marked physical, geological or pedological diversity, the long dimension of the parishes running across the diversity; in this way portions of several different types of land, exploitable in different ways, were included in the village territory: for example Ditchling parish in Fig. 86B which straddles chalk scarp, gault and greensand sub-scarp, and Wealden clay vale. Parishes of this shape are particularly common in scarpland areas.

(b) *'Circular' or 'square' parishes.* In contrast to the rectangular shapes just described parishes of crudely 'circular' or 'square' shape (see Fig. 86A) suggest a relatively uniform background at the time of their evolution, so that a village gained little advantage by possessing territory in one direction in preference to another. Usually too the relief is too feeble to impress any definite pattern on the boundaries and in Britain the 'circular' parishes are often associated with extensive clay lands, such as the area covered by Fig. 86B which lies on the Essex–Suffolk border.

(c) *Relationship of parish boundaries and relief.* In addition to their shape the disposition of parish boundaries relative to relief units may also hint at former relationships. The areas covered by Figs. 86C and D are both largely composed of pervious rocks – chalk in Fig. 86C, massive limestone in the eastern two-thirds of Fig. 86D – so that surface water is limited in both cases; the deep, narrow valleys of the Dove and Manifold, however, could never play the same type of focal role in their area as the broad open Bourne valley in the area of Fig. 86C, and in the former case settlement sought instead the gentler slopes of the plateau and interfluves. The contrasting 'hill-centred' and 'valley-centred' parishes neatly underline the difference.

[16] See, e.g. Dickinson, G. C., *Statistical Mapping and the Presentation of Statistics*, pp. 144–46.

9 *Place Names*

Place names form yet another aspect of settlement which can be studied from maps, and an analysis will often throw interesting light on the history of settlement in an area or on former topographical features. In Britain for example there are elements of place names associated with the presence of particular 'racial' groups in an area – Roman, Welsh, Saxon, Danish or Norwegian; it must be stressed, however, that the detection of these elements and interpretation of the names generally needs expert guidance, and hence the map can do little more than yield the names for checking against an established source, such as Ekwall's *Concise Oxford Dictionary of English Place Names*,[17] or the publication of the English Place-Name Society. Once again it is the historic form of the name which is significant, modern forms being often much altered and sometimes very misleading. The many English Normantons, for example, are the 'tuns' (or villages) of the Norsemen (i.e. Norwegians), not the later Normans as the layman might believe; but perhaps the neatest example of all is provided by the Leicestershire village of Willoughby Waterless; the second element is in fact derived from 'water leys', the *riverside* meadows which distinguish it from the other Leicestershire Willoughby 'on-the-Wolds'.

[17] Clarendon Press, London 1964.

Fig. 86: Shapes formed by parish boundaries. **A:** 'Circular' parishes, north east of Halstead, Essex. **B:** 'Rectangular' parishes, east Sussex. **C:** Valley-focusing parishes, north-east of Salisbury, Wiltshire. **D:** Plateau-focusing parishes, north Staffordshire.

Key (Figs. C&D)

Scale
0 miles 4

Villages
Parish B'dies

Streams which are also boundaries
Streams which are not boundaries

Communication Patterns

The pattern of the modern communications network, like that of modern settlement, is one of great complexity underlain by centuries of change. In many areas as settlement patterns have changed communication patterns have changed with them, necessitating adaptation of, addition to and discard from the pre-existing network. For the student of the history of communications there is an intriguing challenge in the idea of revealing this pre-existing network by successively stripping off each round of additions and modifications, but unfortunately this has rarely proved feasible outside the narrow time limits of the past two centuries. A major deterrent here is undoubtedly the diffuse and often incidental nature of much of the documentary evidence relating to communications; masses of material may have to be searched to produce only a handful of references pointing to the existence or functions of a particular road, and any technique which could reduce the magnitude of such a search would be of considerable assistance. It is here that map examination, using significant patterns to detect likely candidates for further investigation, can possibly be of real help, and this brief review of road communication patterns and their possible significance has therefore been designed with this idea particularly in mind. It begins by considering patterns which are often associated with relatively late additions to the network, and concludes with a description of those patterns which seem most likely to be of significance once these later elements have been discarded.

Roads – *Patterns Frequently Associated with Modern or Late Additions to the Road Network*

10 *Motorways, Ring Roads and By-passes*

Few communications features on maps are more readily recognised than the patterns formed by these latest additions to the road network. Motorways are in any case clearly differentiated from other roads but the smooth curves and characteristic position of earlier ring roads and by-passes is almost equally distinctive, for example, the very obvious Chichester by-pass in Fig. 87C.

11 *Roads which are Consistently Intersected by Other Roads*

Motorways, by-passes (and railways) have one feature in common on maps; because all were laid down on top of an existing communications pattern, they will cut across that pattern rather than join it. This characteristic is not restricted to motorways and by-passes; many other lengths of main road may be seen to cut across the minor road network in similar fashion and it seems reasonable to speculate whether these roads too may not have originated, as motorways and modern by-passes do, as new roads laid across an existing pattern in response to the requirements of some particular time. During the past two centuries the need to adapt roads to cope with increasing amounts of wheeled traffic rather than pack-horses was a powerful stimulus to the construction of many

Fig. 87: Road patterns. **A:** Road diverted to pass around a park at Harewood, near Leeds. Sheet 70, 3rd edition 1″ Ordnance Survey map (Crown copyright reserved). **B:** The straight roads produced by major enclosure movements at Fewston, near Harrogate, Yorkshire. Sheet 61, 3rd edition 1″ Ordnance Survey map (Crown copyright reserved). **C:** An obvious by-pass round Chichester, Sussex. Sheet 181, 1″ Ordnance Survey map, seventh series (Crown copyright reserved). **D:** A typical Devon ridgeway between the Tamar and Tavy river. Sheets 337 and 348, 3rd edition 1″ Ordnance map (Crown copyright reserved). *All* are reduced to about two-thirds original size.

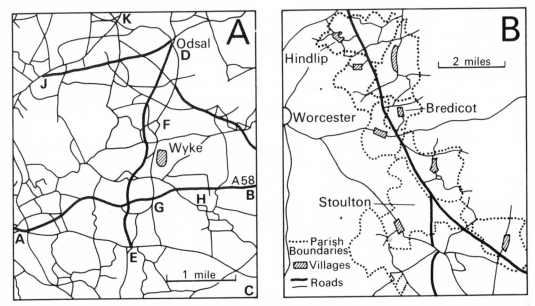

Fig. 88: Road patterns: **A:** south of Bradford, Yorkshire; **B:** near Worcester.

brand new main roads, and it is at least worth considering that lengths of modern main road with the 'cross-roads' characteristic may have originated in this way, as relatively late new and better main roads from A to B – the 'motorways' of a century or two ago – or as early 'by-passes', smaller-scale improvements designed to avoid particularly difficult sections.

In Britain main roads of this kind abound in industrial counties such as Lancashire and Yorkshire, and Fig. 88A illustrates one or two fairly clear examples from the West Riding. The road AB, for example, is part of a completely new main road from Leeds to Halifax constructed as recently as 1832, long after most of the local road network was established. Not surprisingly it exhibits between A and B only two T-junctions but eight cross-roads; in contrast the very ancient Wakefield–Halifax road, marked CEA in Fig. 88A, which has acted as 'parent' to the local road system, shows only three cross roads but nine T-junctions in a similar length CA. A further interesting speculation, once 'new' main roads of this sort are suspected, is the location of the former main road which they replaced. In the case of the Leeds–Halifax road the ancient route lies outside the area of Fig. 88A but another example will illustrate the point. The direct road DE with ten cross-roads and one T-junction aptly reflects its origin as a new and late Bradford–Huddersfield road; the directness of the closely parallel DFGE just as aptly suggests the presence of the former route.

12 *Straight Roads, Smoothly Curved Roads*

The moral here is a fairly obvious one. Ruler-straight or very smoothly-curved roads do not happen; they are conceived first on a drawing board and later executed as part

of some predetermined scheme. The same might also be claimed for roads which exhibit smoothly curved and neatly engineered alignments, and both forms suggest a relatively late origin, after the application of surveying to such problems as road construction had become widespread. Several possibilities may have to be considered however.

(a) *A formerly winding or irregular road has been improved and straightened.* In this case the modern lines would in fact disguise the more ancient forerunner but fortunately traces of the older course are often visible in the form of 'cut-offs' to suggest where this has occurred.

(b) *The road was a late-surveyed new main road* of the type described in 11 above. In this case the relation with the minor road pattern should hint at such an origin and often there will be a similar relationship with the field pattern as well, if this is marked on the map.

(c) The road, or more often in this case network of roads, *was laid down as part of a scheme to open up or newly exploit an area* in some way, in connection with the enclosure of former open fields, draining of marshes or clearing of forest, for example. Schemes of this sort which were formally surveyed (hence the ruler-straight roads) are probably relatively late, so that the straight roads will be of no great age generally, though they may occasionally be straightened versions of former routes through the area. The straight alignments of some typical 'enclosure roads' in the Forest of Knaresborough can be seen in Fig. 87B where they contrast very noticeably with the older winding lanes around the villages of Fewston and Kettlesing. The fact that one of these straight roads is also a Roman road, Watling Street, raises an interesting point, for here is a much *older* type of straight road. Generally speaking, however, quite apart from the fact that the extent of Roman roads is becoming increasingly known and marked on maps, there is usually a marked difference in the types of straightness. Roman roads which have survived are normally associated with general straightness but minute irregularities and deviations, at least where they are marked only by minor roads, footpaths or parish boundaries. Where their course is now followed by a main road, however, as in the section in Fig. 87B, they may have been 'remade' back into something like their original straightness. Even so long stretches of Roman Road would be quite distinctive by their straightness – Ermine Street for instance in Fig. 89 – though shorter sections, as in Fig. 87B, would remain undetected without additional evidence.

13 *'Elbows of Diversion'*

An 'elbow of diversion' may be defined as *a point at which a modern main road makes a marked change of direction whilst the original alignment is continued by a less important road.* The explanation usually associated with such features is that the straight road is the older road, and that the modern main road has been made by utilising part of the older system until this became 'inconvenient' and then adding a new section on a different alignment. A very obvious situation where this will happen is at the two ends of a newly added by-pass around a town – the turn, for example, which the trunk route A27 makes at each end of the Chichester by-pass (Fig. 87C), while the older route continues straight on – but the feature occurs in many other situations as well. There is another 'elbow' just east of Croxton Kerrial (Fig. 89 top left); the present Melton–Grantham main road

bends sharply here, but the straight alignment is continued by what is known to be a much older road, Roman or even pre-Roman, which may also at a later date have served as a 'high-level' approach to Grantham.

14 *Roads which Follow the Edges of Large Parks and Country Estates*

In a situation such as this it is quite possible that the road network may have determined the shape of the park; but the reverse may also be true, the road having been diverted to allow the creation of the park, particularly where at the park edge there is an 'elbow' as above with a footpath continuing the original alignment. In Fig. 87A diversion of the east–west main road which formerly ran directly between Harewood and Weardley is known to have occurred, and perhaps, at an earlier date, diversion of the awkwardly aligned north–south Leeds–Harrogate road as well.

Patterns often Associated with Important Ancient Elements in the Road Network

15 *Roads Following Long, Direct Alignments*

Two distinct elements normally contribute to the overall road pattern in an area; a mass of irregular, short lengths of road and a few more smoothly-aligned ones maintaining a continuous direct path for several miles. Usually the roads in the latter category are the modern main roads and their alignment does not seem surprising; if they are to function efficiently a reasonably direct course is essential and we might expect the 'pressure' of continued use exerted over centuries to modify main roads until they exhibited this form, unless there were good reason to the contrary. Occasionally however the map will reveal a similar continuous route, smoothly aligned but of no modern importance, and marked only by minor roads, lanes and footpaths. The directness of such a route inevitably suggests an analogy with modern main roads. The road has an air of 'going somewhere' and prompts one to ask whether this may not be an ancient route, formerly fulfilling some important function which has since disappeared or been transferred elsewhere. Consider, for example, the remarkable road which skirts Sewstern in Fig. 89. Its continued directness distinguishes it from most other *local* roads and additionally for several miles it forms the county boundary between Leicestershire and Lincolnshire. In this particular case the inference above would be correct, for Sewstern Lane is almost certainly a pre-Roman trackway. But what of the other roads associated with it? There is an obvious branch made up of minor roads and footpaths via Skillington to Grantham and this too is known as an ancient way from Grantham to Stamford, one in later years at least probably used as a drove road for cattle passing south to London. On the other hand no comment has yet been made on what must surely be a second branch, with similar directness, passing between Sewstern and Coston. These continued alignments are among the most intriguing elements in the road patterns found on maps. Two more, for example, run parallel and north–south on either side of the Witham Valley in Fig. 89. One we know is Roman, but what of the other? Equally intriguing is the way the Great North Road slips from one alignment to the other, through Colsterworth, with a clear 'elbow' at each end of that section. It is at this point that the Roman and 'mediæval' 'Great North Roads' part company as the latter begins the great cut-off avoiding Lincoln;

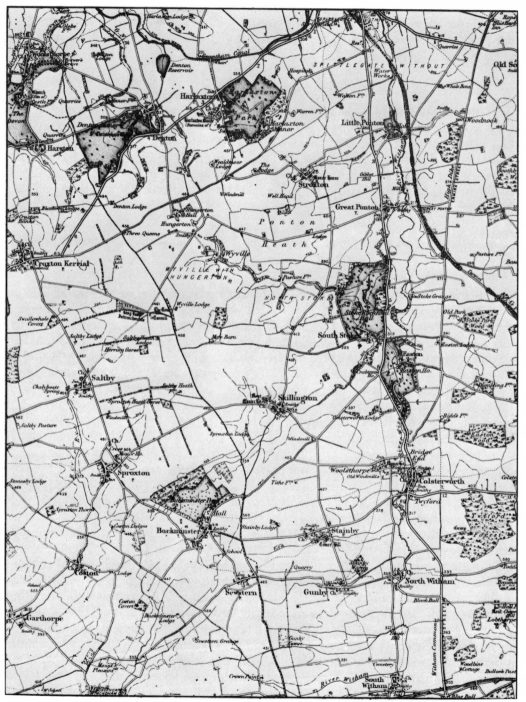

Fig. 89: Road patterns in the area between Grantham and Stamford, Lincolnshire. Sheet 143, 3rd edition, 1″ Ordnance Survey map reduced to about two-thirds full size (Crown copyright reserved).

was the first stage in this deviation simply to slide across the Witham valley and use a convenient length of another old route?

Not all these direct alignments are significant of course. Wherever there were no important features, which had to be avoided – extensive areas of cultivated land or marsh for example – even local roads would tend to take a direct line; and so in areas which were formerly heath, moor, or downland such roads are particularly common; it is when these alignments continue for several miles, beyond the immediate local scale, that such roads become interesting.

16 *Roads Followed by Boundaries*

Here again a common example suggests a wider analogy. In Britain Roman roads frequently are followed by parish boundaries, the road presumably acting as a useful 'marker' for this purpose when the parishes had to be defined. This coincidence is not confined to Roman roads, however, and the possible inference is obvious: might not some of these other roads be old roads useful as markers when boundaries were delineated, particularly where the roads show other interesting features such as directness. In Fig. 89 the coincidence of the county boundary and Sewstern Lane has already been mentioned; another example, in this case connected with a minor Roman road, is found east of Croxton Kerrial. At this point the coincidence is scarcely maintained for long enough to be very significant, but becomes much more so in conjunction with a further six miles of aligned road–boundary coincidence beyond Fig. 89 east of the Witham Valley, correctly hinting at the antiquity of the roads.

A word of caution is necessary about roads and boundaries, however. In many instances the road and boundary relationship is the reverse of the above, the road having arisen to mark the boundary and so being of purely local interest. Such 'mere-ways' are quite common. On Fig. 89 the well-marked coincidence of roads and boundaries for four miles east west through South Stoke probably arose in this way, and there are many other shorter sections to be seen which probably have no significance. As with alignments it is the long-continued examples which are intriguing.

17 *Ridge-Ways*

In many parts of Britain prominent ridges such as structural scarps or interfluves are found to carry a road continuously aligned along them, often on or near the crest, hence the term 'ridge-way'. Roads such as these may have originated a very long time ago when movement along ridges was easier than in the forested valleys and lowlands. Certainly many authenticated instances of such ancient routes are known, for instance the Berkshire Ridgeway along the chalk scarp, or the many examples in Devon (see Fig. 87D, p. 232), and whilst not every ridge-way need be ancient, minor examples may be worth further investigation.

18 *Roads which Ignore the Settlement Pattern*

Roads which ignore the village settlement pattern in an area, i.e. pass between rather than through the villages, are often significant for two possible reasons. They may be

roughly contemporaneous with, or later than these villages, in which case the fact that they ignore them seems to indicate functions more pressing than mere local needs, i.e. they were 'main roads' or regional routes; or they were established before the settlement pattern, which then ignored them. It follows from this reasoning that minor roads with these characteristics may be worth investigating, and a good example of such a 'promising' road is shown in Fig. 88B (p. 233). The direct alignment of the road is striking, but so is the fact that the road serves neither to link the villages with lands of their parish nor with their county town, Worcester, which it ignores. On the other hand the fact that the route heads directly for Droitwich, a salt-producing centre of considerable antiquity suggests that it may have been one of the network of 'salt-ways' radiating from that place and by means of which salt was carried throughout much of the South Midlands. Similar routes for the distribution of coal or lime, are known in several areas, as too are drove roads along which Welsh or Scottish cattle were formerly driven to London or other English Markets.[18]

Railways

The pattern of railway communications, like that of roads, is complete on most maps at reasonable scales but because of the much greater availability of other documentary evidence relating to railways there is far less need to draw inferences from the pattern. This subject will therefore be dealt with much more briefly than the preceding one.

19 *Railways and Physical Features*

The important control exerted by physical features on the alignment of railways is well known and need not be referred to in detail here. It should be remembered, though, that there were often powerful pressures for making the railways overcome physical difficulties by unusual means (long tunnels or viaducts for example), and the supposed effectiveness of any physical barrier to railway development must always be judged in the light of the potential traffic flow across it. An estuary which might be an effective deterrent to a local line need not necessarily be so to a trunk route.

20 *Single and Multiple Railway Networks*

If the railway networks of different areas are examined two basic types of pattern may be found. In the first, though the mesh of lines may be quite close, only a single network or system is present: there is no duplication of facilities, even important towns have only one station, and only rarely can the journey between two local centres be made by alternative routes. In the opposite case, where there are multiple networks, there may be two or more systems independent of each other giving considerable duplication of

[18] Distinctive names are often retained by such former routes. The Collier's Gates, Limer's Gates and Salter's Gates of northern England proclaim their obvious origins while the name 'Welsh Way' or 'Welsh Road' is still retained by some earlier droving routes in the Midlands.

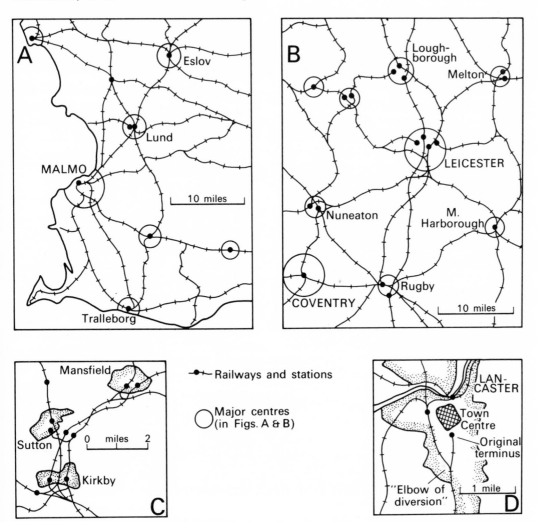

Fig. 90: Railway patterns: **A:** southern Sweden; **B:** English midlands; **C:** near Mansfield, Nottinghamshire; **D:** Lancaster, Lancashire.

facilities – railways running closely parallel, two or more stations in towns and alternative routes between centres. Figs. 90A and B illustrate the two types and many of these points. In only one instance, Malmo-Tralleborg, is there duplication of route in Fig. 90A and only at Lund are there two (adjacent) stations; the whole network contrasts clearly with the disconnected systems, and multiple stations of Fig. 90B where alternative routes are (or rather were) also seen between Leicester and Rugby, Loughborough, and Melton Mowbray.

The latter type of pattern, very common in Britain and the United States, is usually found in areas where the railway network was developed by several competitive companies, implying an official attitude favourable to such a situation, and also the belief (often

unjustified by results) that the area offered sufficient traffic to make this duplication worth while. In particularly competitive areas, or areas of marked physical restriction there are often lines very closely paralleling one another, as in Fig. 90C, a type of network explicable only in terms of this competitive background.

The single-network systems do not necessarily suggest simply development by one company, but rather imply merely lack of competitiveness, often caused by the State itself constructing the trunk lines and leaving only construction of local and feeder lines to private enterprise. Circumstances such as this encourage simple, locally focusing networks, though where light local traffic prompted narrow gauge local lines, dual termini and occasionally parallel routes may be found.

21 *Stub Terminals, 'Circle' or 'Belt' Lines*

In the early period of railway construction, when lines were often only local in scale, they usually attempted to establish at each end termini as close to the town centre as resources, property values, physical features, etc., would allow. If at a later date the line had to be extended beyond the town, or to a more convenient terminus this was usually done by going back a little way and beginning a deviation, leaving the original alignment as a *stub terminal*, often used today for goods traffic, (see Fig. 90D). A railway pattern of this type should always be suspected of having such a history, particularly where, once again, there is a clear 'elbow of diversion'.

In larger cities, where many separate termini were established at first, the need to transfer traffic between them often prompted the construction of complete or partial 'circle' or 'belt' lines around the city – as in Cologne Fig. 84B (p. 226) – leaving in consequence multiple stub termini in many cases. Such lines are easily recognised by their form.

Patterns shown by other features on maps

It is no accident that the patterns of settlement (or rather buildings) and communications are the two great features of the human landscape which occupy pride of place on maps. This is, after all, only commercialism written large, for it is on these two items that the interests of the great majority of map users are centred. Chapter 4 indicated however that many other features of the human landscape were also marked on maps – specialised buildings such as factories or specialised land uses, for example orchards; can we also make with respect to these items, an approach similar to that used above for settlement and communication?

On balance, even speaking generally, the answer is probably 'no', and certainly it must be within the limited scope of this book, for the difficulties, both cartographic and non-cartographic, besetting such an approach would be enormous. On the cartographic side alone it is often very difficult to determine how complete such distributions are; specialised land uses are in many cases fairly reliably recorded, but features such as factories – often simply vaguely marked 'factory', 'works', 'mine' – are equally likely to be confined to

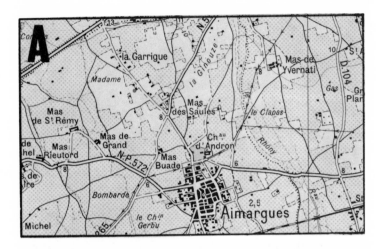

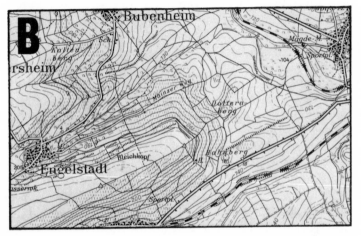

Fig. 91: Three different patterns produced on maps by the distribution of vineyards. **A:** Languedoc, France, near Lunel. Sheet XXVIII–43, French 1:50,000 series. (Reproduced by permission of the Institut Géographique National.) **B:** The Rhineland near Mainz. Sheet L6114, German 1:50,000 series. (Reproduced by permission of the German Landesvermessungsamt.) **C:** In the Rhone valley, France, near Tournon. Sheet XXX–35, French 1:50,000 series. (Reproduced as for **A**.) The vineyards are indicated by the coarse grey dots in **A** and **C** (the finer blacker dots in **C** are orchards), and by the hatched areas in **B**.

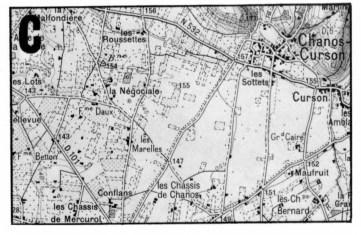

prominent or isolated examples. Then again, whilst it might be expected that full revision would correct the distribution of these features along with the rest of the content of the map, 'partial revision', so often resorted to under pressure of work, will usually mean 'settlement and communication only' on the human side, leaving obsolete patterns elsewhere.

The cartographic limitations are, however, not the most serious obstacle to the classification of such patterns. In many cases the circumstances underlying the distributions which can be seen on the maps are so complex, often so *local* that it would be pointless to speculate on them from map evidence. Consider Fig. 91, for example, which shows the patterns produced by land under vineyards in three areas. Fig. 91A shows an area in Languedoc where vines form so dominant a land use that it is the areas not devoted to this crop which are distinctive. In Fig. 91B, in the Rhineland a more restricted distribution can be seen, based on strong linear emphasis as vineyards are confined to steeply sloping land, and in Fig. 91C vines form only a sporadic element in a mixed pattern. Here then we have three basically different types of pattern, massed, linear and sporadic, all associated with the cultivation of the vine; but quite obviously it would be foolish to draw any inferences from these patterns save in the broadest possible terms.

One might suspect, reasonably enough, that viticulture held a dominant, specialised but important, and rather unimportant position respectively in the economy of these three rural areas, but it would be impossible to speculate from map evidence why this should be so, particularly with so specialised a tree crop as the vine. Even in Fig. 91B where the pattern of the vineyards has a distinct association with one element – slope – there are still very many factors, such as shelter, insolation, drainage, soil differences, lack of an alternative use, which might be related to this besides factors quite unconnected with the physical form of the ground but perhaps determining the total scale of the cultivation, for example local land holdings, their arrangement and size, labour supply, government policy, limitation or otherwise of the local market, and so on. Quite obviously in a field as complex as this the map is not the place to begin the search for the answers. What we can use the map for, if the cartographic limitations described above do not apply and a reasonably complete and up-to-date representation of any feature seems feasible, is to define the distribution which has to be explained. Let us finish this section as we began it by emphasising that here, as in so many other examples, a prime function of the map is to pose the problem, not to answer it.

Plate 3: A: Oblique air photograph of Selby, Yorkshire. Compare this view with that in plate 5; identification of many features is much easier from this more familiar viewpoint. (Reproduced by permission of Yorkshire Post Newspapers Limited.) **B:** Beach, with offshore bar, Island of Spiekeroog, W. Germany. For explanation of letters see p. 252. (Reproduced from Gutkind, *Our World from the Air*, by permission of Chatto & Windus Limited and the Hansa luftbild, G. M. B. H.) **C:** Bare rock surface, with small lakes, Mackenzie, N.W. territories, Canada. (Reproduced from Gutkind, *op. cit.*, by permission of Chatto & Windus Limited and the National Air Photographs Library, Surveys and Mapping Branch, Department of Energy, Mines and Resources, Ottawa.) **D & E:** Part of Brown Clee Hill, Shropshire on portions of two air photographs from two different sorties. Differing amounts of distortion cause the block of fields to assume noticeably different shapes on the two photographs – visual proof that an air photograph is not a map. Scale *c.* 1:40,000. (Sortie no. CPE/UK/2512 (14/3/48), print nos. 5103 and 5148, reproduced by permission of the Ministry of Defence, Crown copyright reserved.)

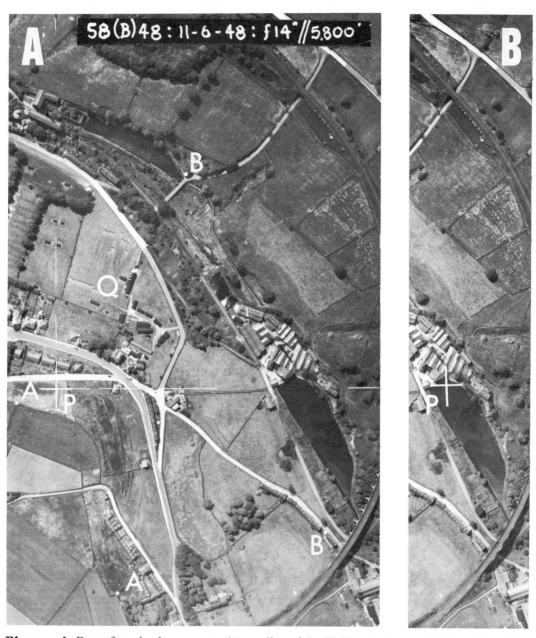

Plate 4: **A:** Part of an air photograph of the valley of the Hebble Beck near Halifax, Yorkshire. There is little *direct* indication on the photograph of the nature of this deep, steep-sided valley, though its presence and form can be inferred from several features. Scale *c.* 1:5,000. (Sortie no. 58(B)48 (11/6/48) print no. 5032, reproduced by permission of the Ministry of Defence, Crown copyright reserved.) **B:** Part of the detail of **A** taken from the adjacent photograph in the strip (P is the principal point in both cases). Instructions for using the strip as part of a stereo-pair are given on p. 249. (Sortie no. as for **A**, Crown copyright reserved.)

PART FOUR
AIR PHOTOGRAPHS

Chapter 15 Looking at Air Photographs

The basis for the inclusion in this book of a short section on air photographs has already been outlined in the Introduction. The air photograph will form an invaluable complementary source of information wherever maps (or other sources) are being used to study the nature and characteristics of the earth's surface, and should maps not be available for an area it can act as a most acceptable substitute; in these circumstances it seems highly relevant to include a brief section on what is manifestly a closely parallel research tool to the topographical map. Of the three chapters in this section the first is concerned with the potential of the air photograph as a source of information on the nature and content of the earth's surface, the last two deal with theoretical and practical aspects of simple techniques whereby this information can be added to existing maps or used as the basis of new maps.

General characteristics

1 *Types of Air Photograph*

There are two great classes of air photograph, (a) *verticals*, in which the camera is intended to point vertically downwards[1] so producing a view resembling a plan of the ground, and (b) *obliques* where the camera axis points at an angle to the ground, producing a view not unlike that obtainable from a vantage point or very high building. If the camera is tilted sufficiently to allow the horizon to be shown, the photograph is said to be a *high oblique*; other obliques are *low obliques* (for example Plate 3A), or the photographs which would result in Figs. 95D and F.[2]

[1] In practice it is impossible to *guarantee* absolute verticality (see chapter 16, p. 259) but photographs where this was the intention and the camera axis is within two or three degrees of the vertical are usually considered as verticals.

[2] Notice that the terms 'low' and 'high' here have nothing to do with the altitude of the camera.

R

The air photographs most often seen by the layman are low obliques taken for illustration or publicity purposes (for example, of a town or factory), but in fact the great majority of air photographs are verticals and it is this class of photograph which forms the main concern of this section. Oblique air photographs with their retention of at least some aspects of the elevation of objects (see Plate 3A) present fewer problems of interpretation and, since they cover a larger area than the same size vertical photograph, may often cover an area more cheaply, but this advantage is only gained at the expense of extensive dead ground, wide variation of scale and much more complicated properties from a mapping point of view, so that verticals are usually preferred. Something of the best of both worlds is obtained with photographs taken by multiple camera installations, the chief aim here being to reduce cost or time by increasing the area photographed during each run; well-known types are the 'twinned', slightly overlapping near-verticals of the 'F21–F22' type (Fig. 92A), and the American *Trimetrogon* type where one vertical camera is flanked by two high oblique cameras giving continuous cover from horizon to horizon at each exposure (Fig. 92B). Photographs of the first of these types are not uncommon in the official air-photograph cover of Britain. Because the tilt is small they are apt to look like verticals, as in fact do most very low obliques; they can, however, be distinguished by the F21 and F22 in their numbering, and it should be remembered that

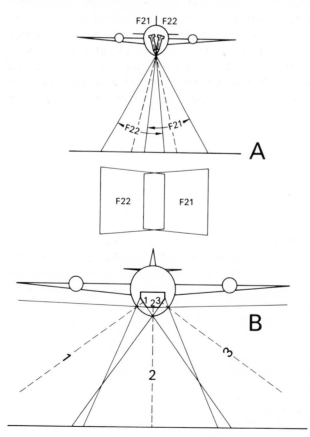

Fig. 92: Multiple camera installations for taking air photographs. **A:** Twinned near-verticals of the 'F21–F22' type. **B:** 'Trimetrogon' type arrangement. Pecked lines mark the axes of the cameras.

their properties are those of low obliques (see chapter 16) not verticals. Less common are photographs taken by five or nine lens cameras, where a central vertical lens is surrounded by four or eight outward-pointing lenses. Unlike the previous examples all five or nine photographs are printed fused together into one image, the obliques being 'transferred' or *rectified* into vertical views before printing.

2 *Arrangement of Air Photographs*

The inclusion on an air photograph of printed information (see below) enables one to distinguish between its top and bottom, but unlike maps, which maintain north at the top, *an air photograph has no consistent orientation.* A plane taking systemmatic air-

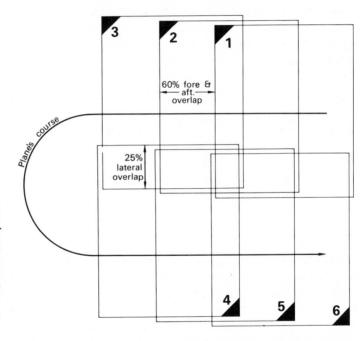

Fig. 93: Typical arrangement of six air photographs at the end of two 'runs'. Notice the very considerable amount of duplication: the areas of 2 and 5, for example, are entirely covered by 1, 3, 4 and 6 respectively. The black triangle represents the top left-hand corner of each photograph as indicated by the titling strip.

photograph cover of an area does so by making successive trips back and forth across it, so that air photographs are usually arranged in long strips or runs[3] whose direction is conditioned by factors such as navigational considerations and the size and shape of the area which is being covered. The orientation of the prints is at 90° to that of the runs, and since the plane turns at the end of each run the orientation of photographs in adjacent strips will differ by 180° (see Fig. 93).

Fig. 93 also illustrates the very considerable overlap which normally exists between adjacent vertical photographs, usually about 60% overlap fore and aft (i.e. between successive photographs in the same strip), and 25% lateral overlap (i.e. between adjacent

[3] These runs are usually intended to be straight, though curved flights are sometimes found where radar has been employed to keep the aircraft on a chosen course.

strips). Overlaps as large as this are imposed by the requirement of stereoscopy (see below) and photogrammetry (see chapter 17) and greatly increase the cost of photographic cover for an area; if continuous but non-stereoscopic cover is satisfactory this can usually be obtained by purchasing only alternate prints in each strip (see Fig. 93).

Not surprisingly, as with maps, considerable variation of size and scale exists among air photographs, though the commonest sizes are 7″ × 9″ and 9″ × 9″ and cover is often at scales of about 1:10,000, 1:20,000 or 1:40,000. Much British cover is at 1:10,000 scale, much of that of the U.S.A. at 1:20,000, and in many parts of the world where both air photographs and maps of an area exist the former are at a larger scale than the latter.

Printed along the top or bottom of each photograph, sometimes in the form of a continuous *titling strip*, will be found certain items of information relevant to it. This will include certainly the print and sortie[4] numbers, and possibly the authority or body responsible for the sortie, generalised location, date,[5] time of day, focal length of the camera and flying height. By no means all of this information is given on each photograph, but it is relatively easy to recognise which items are referred to; some examples are given below:

093 (print no.)	11/FJ 17 (sortie no.)	Viti Levu (Location)	August 1954	152·72 m/m (focal length)	20,000 ft (flying height)	6″ (focal length)
0174 F22: (print no.)	82/RAF/1107 (sortie no.)	11 Mar 55:	12·05Z: (Time GMT)	F 20″ // (focal length)	18,500′ (flying height)	Rest'd (restricted—security)
8–5–41 (date)	B006. 23b (sortie No.)	– 1/6 (print no.)				
5226 (print no.)	V(Pt 3) 3G/TUD/UK 204 (sortie no.)	12 May 46				

3 *Purchase of Air Photographs*

Two main types of agency are responsible for taking air-photograph cover. These are (i) government departments including official survey establishments, military or air-force authorities and (ii) commercial firms flying cover on contract for particular clients. Cover flown by the latter type of agency is already surprisingly extensive and in Britain at least is often of better quality than that produced by official bodies. In Britain enquiries concerning available air-photograph cover should be made in the first place to the Ministry of Housing and Local Government, Air Photographs Officer, Whitehall, London S.W.1, for officially produced cover. The largest commercial concerns are Hunting Surveys Ltd., and their associated company, Aerofilms & Aero Pictorial Ltd., both of 6 Elstree Way, Boreham Wood, Herts.[6] The usual practice is to send a sketch map or grid references delineating the area concerned and request details of date, scale, number of prints, etc. More detailed information about coverage is contained on index

[4] A set of photographs taken during one flight is usually known as a *sortie*.

[5] Notice that 3rd May, 1965 would be written 3.5.65 in British notation but 5.3.65. in American notation.

[6] The latter company maintain a library where air photographs are available for inspection at 4 Albemarle Street, London W.1 and in addition publish a useful classified index, price 7/6d.

diagrams, known as *sortie plots*, which may sometimes be purchased for particular areas. In this connection it is worth noting that on many maps of colonial and former colonial territories, produced from air photographs by the Directorate of Overseas Surveys, the position of the principal point (i.e. centre) of each photograph and its sortie and print number are marked with a cross, making the map also an index diagram to the air photographs. In addition there is also often an index 'box' at the foot of the map showing the bodies responsible for the photography and its date.

Generally speaking air-photograph cover of an area is much more expensive than map cover. Naturally prices vary but current examples are 3/6d. per print for 7″ × 9″ photographs from the Ministry of Housing and Local Government, and 5/- per print for 8″ × 6″ photographs from commercial firms.

Interpretation

General Aspects and Characteristics Underlying the Appearance of Objects on Air Photographs

The enormously detailed record of the features of the earth's surface found on an air photograph is far more complete than that presented by even the largest scale map. Unfortunately the unfamiliar appearance of this record (and indeed its very completeness) also render it far less easily interpretable than similar detail shown on maps, so that the main purpose of this chapter must be to familiarise the reader with the appearance on air photographs of certain commonly recurring classes of feature and to indicate a rational approach towards the interpretation of less familiar objects also.

In normal vision 'on the ground' we distinguish an object by a combination of the three processes of observing (a) its size and shape (b) its colour and (c) the features with which it is associated. The same processes will help to identify objects seen on air photographs but with different conditions and emphasis within each group.

Size and Shape on Air Photographs

Many differences are immediately apparent here. In the first place shape on an air photograph[7] usually means the *plan* of an object, not its elevation, and this aspect is not only less familiar to us but many objects vastly different in elevation may have similar plan forms, for example a row of houses and a row of shops. A few categories of building do, however, have distinctive roof patterns, as, for example, maltings, the broad rather low-pitched roof of many cinemas and the ridged roof of a factory with 'north lights', whilst size will help to differentiate between similar-looking objects, as also will their setting, number or general arrangement. Thus a dog-kennel, a haystack and a house have not dissimilar plan forms but they are not likely to be mistaken one for another on an air photograph. For an accurate interpretation of size a knowledge of scale is needed

[7] A vertical photograph is intended here, and throughout the whole of this chapter. As mentioned earlier obliques normally present far fewer interpretational problems.

(see chapter 16) but comparison with distinctive objects of familiar size – such as railway carriages, cars or sports pitches – may also help.

Fortunately, since air photographs are normally taken on sunny days, the shadow of an object may give a useful indication of its elevation. Dark shadows occasionally obscure important detail, but they usually help to distinguish buildings or vegetation of different shape or size (see Plate 6A) and may be the only substantial indication of the presence of objects with insignificant plan-forms, like pylons, chimneys or deciduous trees in winter. Certain very distinctive objects such as cooling towers or churches may be immediately recognisable from their shadows and, in certain circumstances, so too may be relief features.[8] In this connection it should be noted that an air photograph should always be interpreted with the shadows falling *towards the observer*; if this rule is not followed a *pseudoscopic* effect of inverted relief may be produced.

A much stronger impression of relief, and indeed of all three-dimensional features on air photographs, will become available if these are viewed stereoscopically, but this is a sufficiently important aspect of air photographs to be treated separately below.

Colour on Air Photographs

As yet colour film is relatively little used in air photography so that on the vast majority of air photographs the colours experienced in normal vision appear translated into black, white and intermediate shades of grey. It is for this reason that we do not refer to the colour of an object on an air photograph but to its *tone* and in this respect it is worth remembering that, though the black-and-white film still differentiates between objects of different colours, it does not necessarily do so in a manner consistent with the impression made by our own eyes: for example, a bright red object may appear darker on the film than a dark blue one. Even so the colour of an object is only one among several factors contributing towards its tone on an air photograph. Tone is affected as much by the amount of light reflected back to the camera from an object as by the colour of that light, hence smooth surfaces, for example, roads, acting as reasonable reflectors, tend to produce a fairly light tone whatever their colour, whereas rough objects appear generally darker. The terms 'rough' and 'smooth' should be interpreted fairly liberally in this context, for example a field with a broad-leaved crop such as sugar-beet might provide a 'smoother' reflecting surface than, say, young wheat. Where objects absorb light – the commonest cases being water and chlorophyll-rich vegetation – there will also be less light to reflect and such objects will appear quite dark in tone.

Still further features affecting the tone of an object are weather conditions and photographic processing. Even with the same landscape a greater range of tone will be obtained on a sunny day than on a dull one and bad photographic processing may produce prints which are generally too light or too dark, often with loss of important minor tone differences. Almost inseparable from the tone of an object on an air photo is its *texture*. Different textural appearances such as smooth, mottled, striped, 'bobbly' etc. will often help to differentiate certain features one from another, for example growing crops or various forms of vegetation.

[8] e.g. sharply defined features such as crags and glacial overflow channels, particularly under low, winter sun.

Associated Features

The kind of reasoning that tells us that the none-too-clearly-seen person who waved to us from the passing red car was probably Smith because he is one of the few people we know who has a red car is used more often than we think in normal vision; it becomes extremely important in air photograph interpretation. For example many modern schools are large buildings with a playing field attached; so too are many modern factories but the latter will often have extensive car parks and more evidence of vehicular use than the former. In the same way industrial processes may be identified or narrowed down by the presence of associated waste heaps, large quarries or specialised plant and if in this category we also include all items associated with particular, distinctive patterns or features a far wider range of objects becames more easily recognisable. The unusual combination of bunkers, fairways and greens will identify most golf courses; stooked corn presents a distinctive pattern, as also do the formalised shapes of flower beds in parks and ornamental gardens. It is perhaps in this aspect of air-photograph interpretation that experience becomes the most valuable teacher and the layman will be surprised to find how many features in fact possess distinctive patterns or arrangements of whose existence he was formerly unaware.

Stereoscopes and Stereoscopic Vision

Except in unusual conditions of light or terrain, air photographs convey only a relatively weak impression of the relief or other three-dimensional aspects of the area they cover; fortunately this defect can be overcome and a full, clear three-dimensional impression obtained by the use of stereoscopes or stereoscopic vision.

The three-dimensional impression which we obtain in normal vision derives from the fact that with two eyes, set about $2\frac{1}{2}$ inches apart, each eye is able to present to the brain a slightly different image of an object that is being observed, and from the difference between these two images the brain is able to assess 'depth' and build up a three-dimensional picture. By the same line of reasoning if we take two slightly different views of the same area, for example two adjacent air photographs with a considerable overlap, let the left eye see one of these and the right eye the other, the brain will react as it normally does and from the slight difference between them will produce a three-dimensional image of the area.[9] This is the property of stereoscopic vision which is inherent in our natural viewing mechanism, as the following experiment will show. Place a piece of stiff card or a slim book about 9″ high vertically between the sections A and B of Plate 4 and lower the face slowly downwards until the nose is resting on the card. As the face is lowered the images of points of detail (for example the reservoir) common to both photographs will be seen to slide together forming a fused image which will, however, be out of focus; with a little practice it will be found possible to focus this fused image when a clear three-dimensional impression will be obtained.[10]

The use of a *stereoscope* merely makes this same process of fusion and focusing simpler

[9] Notice that the two views must be different. Two copies of the same photograph will not do.
[10] The three-dimensional nature of the fused image is normally already apparent even when out of focus and blurred.

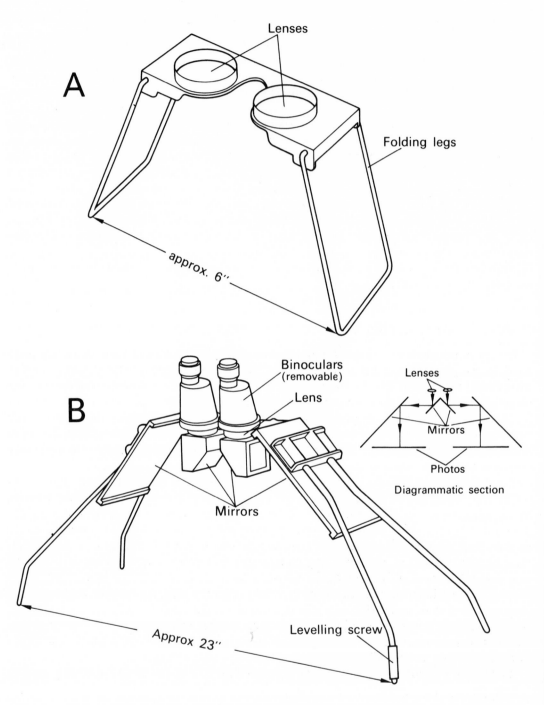

Fig. 94: A: A lens stereoscope. **B:** A mirror stereoscope.

and much less of a strain to the inexperienced observer. In the commonest and cheapest version, known as the *lens* or *pocket stereoscope* (Fig. 94A), a pair of lenses carried on a frame assists the focusing, separates the line of sight of the two eyes and usually magnifies slightly too, so that fusion is immediate and effortless provided that the photographs are of the right type and properly positioned. Photographs of the right type will be what is known as a *stereo-pair* i.e. two adjacent photographs from a run, taken so that there is a considerable overlap between them; while proper position implies that the photographs will be placed under the instrument overlapped so that detail common to both is in line horizontally but separated laterally by about $2\frac{1}{2}$ inches. The photographs should also be arranged so that any shadows on them fall towards the observer. If on looking into the lenses a double image is observed slide the uppermost photograph up, down or sideways slightly, until fusion occurs.

The main disadvantage of the lens stereoscope is that because of its restricted width photographs must be overlapped when placed beneath it and only a limited area can therefore be examined at one time. The more expensive *mirror stereoscope* (Fig. 94B) uses pairs of parallel mirrors to 'spread' the line of sight, thus permitting whole photographs to be placed underneath it and enabling the whole of the overlap to be seen three-dimensionally at one go. Binoculars may also be attached to the mirror stereoscope to give greater magnification.

When examining photographs under a stereoscope it will usually be apparent that the vertical component of the image, and hence all heights and slopes, are greatly exaggerated. This is easily explained. Two eyes $2\frac{1}{2}$ inches apart looking down at Halifax from 5,800 feet (as in Plate 4) would obtain impressions differing by such infinitesimally small amounts that the brain would be unable to produce from them any impression of depth;[11] in this case however, two 'camera eyes' about $\frac{1}{5}$ mile apart have been substituted for our own eyes and, from the much greater differences which these reveal, the brain is able to build up a grossly exaggerated impression of depth. Fortunately this exaggeration is quite regular so that though slopes, for example, are distorted comparative or relative heights are not.

Appearance of Specific Features on Air Photographs and the Potential of Air Photographs in Studies of these Features[12]

1 *Relief*

Relief is probably the most weakly represented category of major features on single air photographs and its essential outlines may often have to be inferred from the presence of viaducts, cuttings, embankments, hairpin bends, terracettes and similar features. Conversely with a stereoscope and photography of good scale (about 1:10,000 preferably) quite small relief features such as overflow channels or river terraces are easily detectable, far more so usually than on a contoured map.

[11] Except perhaps in the case of the largest relief features.

[12] The subsequent list makes no pretensions to being more than the merest introduction to this subject. For a fuller treatment of these topics and themes see, e.g. *The Uses of Air Photography* edited by J. K. St. Joseph, London 1966, or *Photographie Aérienne* edited by R. Chevallier, Paris 1965.

2 *Rocks and Soil*

On rock surfaces unmasked by vegetation (for example Plate 3C), the air photograph will often reveal the intricate patterns of joints, bedding planes, faults, mineral veins, etc., and from this potential a whole new science of photo-geology has emerged. In bare or nearly bare soil, too, intricate patterns produced by variations in the composition, colour or moisture content of the soil can be seen and in all these cases the air photograph offers the easiest, sometimes the only, satisfactory method of recording the distribution of these features. Both bare rock and soil are apt to appear lighter on photographs than would be expected from their normal appearance, and though freshly turned soil may be medium to dark grey in tone, this can change to nearly white as the soil dries out.[13] 'Disturbed earth', for example a ploughed field, soil placed along a newly dug ditch or the trampled earth of a building site, is often among the lightest features on a photograph (for example field f in Plate 6B) though not surprisingly beaches and sand-dunes show the same characteristic whiteness (Plate 3B).

3 *Water*

Because of its light absorbing properties water may appear very dark, nearly black on an air photograph (see the lakes in Plate 3C), and in the same way moist or marshy ground will appear darker than dry areas. Even on the same photograph, however, there may be considerable variation. Muddy or silty water gives a rather lighter tone (for example the River Ouse in Plate 5); ripple or wave markings may give a texture to the surface, and in particular circumstances the water may reflect the sun directly into the camera giving very bright patches (such as can be seen at J in Plate 5). Shallow water, on the other hand, is often inconspicuous, being penetrated by the light and allowing bottom details, such as channels and sandbanks, to show through, a property of considerable use to river and harbour authorities. In Plate 3B only the double bar GG and beach H are above the water line, the ribbed area J and ripple marked lagoon floor K are both seen through shallow water; notice the shadow of the bar LL masking detail and also indicating variations in the bar's height.

4 *Vegetation – Woods*

The 'rough' and chlorophyll-rich surface presented by woods causes them normally to appear dark on air photographs. Coniferous trees will usually appear darker than deciduous ones, and very obviously so in winter when young deciduous trees may be too insubstantial to record well; at such times deciduous woods are often more clearly revealed by the striped pattern formed by the shadows of the main trunks than by the trees themselves. Plate 6B gives an idea of the remarkable amount of detail concerning woodland revealed by an air photograph. Size, tone and texture differences are related to variations in age and species of tree, and these properties have been widely used to produce forestry surveys and inventories from air photographs. The nature of individual trees, as well as variations in woodland height may often be deduced from shadows (see Plate 6A).

[13] A similar change to a lighter colour can, of course, be observed in a newly dug garden.

Grassland. A good rule to adopt here is that the better the quality of the grass the darker and more even in tone it will appear. Whereas a good lawn may show an even, medium grey tone, poorer pasture, for example almost all the fields on Plate 4, appears both lighter in tone and more mottled in texture due to the presence of grasses and plants of mixed species and lower chlorophyll content. With very rough pasture and moorland the intricate patterns of bracken, heather, cotton grass, etc., can usually be distinguished on air photographs.

Crops. Enormous variety exists here and the most useful asset for specific identification is a detailed knowledge of agricultural techniques coupled with a good deal of luck relating to the seasonal nature of the photography. To give examples, some crops not dissimilar in appearance at certain stages of growth, for example mowing grass and young wheat, potatoes and turnips, may become quite distinct on maturity or by being harvested in very different ways or at different times. Patterns of harvesting are probably the most distinctive guide of all, but care is needed here for at harvest time a crop may appear in several guises according to the stage reached. In Plate 6C it seems possible that fields a to e all contain the same crop – probably alfalfa. In a the crop is still standing but the field is covered with a last flush of irrigation water; at b this has dried out and mowing is in progress as shown by the border of partially mown crop; c is the completely mown crop lying flat, whilst at d this has been partially raked into rows to dry and fully so at e. f may be a field where this drying has finished and the crop has been completely removed. By way of contrast air photographs of rural areas in winter will often reveal intricate patterns of farming operations – for example, ploughing, harrowing, manuring – but these will tell little about subsequent land use. Where individual crops cannot be recognised it may still be possible to distinguish between different types of land use or agricultural technologies. Plate 6D reveals a clear four-fold division into valley floor meadows m, vineyards v, unconsolidated strip holdings s and rarer large estates or consolidated holdings e. In Plate 4A the dark rectangles of poultry houses Q are obvious evidence of an agricultural activity very characteristic of these steep Pennine valleys while features such as glass-house areas, extensive orchards or plantations of tree crops are easily recognised.

5 Communications – Roads

The important point to remember here is that a conspicuous light tone exhibited by a road indicates only the nature of its surface, *not* its importance. Very often prominent, white roads may have only bare soil or loose gravel surfaces, whereas because of metalling, oil drip, tyre marks, etc., main roads may appear much darker, as at R in Plate 5. Even on the same road, tone may vary abruptly due to surfacing, as in Plate 4A, and the class of a road will usually have to be inferred from other evidence, such as cut-off corners, cut-and-fill, traffic densities, well-defined kerbs and so on. At the other end of the communications range footpaths and tracks are normally recorded by the air photograph in amazing detail, largely because the flattened earth or vegetation produced by the passing of even only one vehicle or person usually forms a distinct and rather better reflecting surface than its undisturbed surroundings.

Railways. Although railways are much less conspicuous on air photographs than on

maps and the number of tracks may be impossible to distinguish (see Plate 5), their distinctive form and associated features (cuttings, tunnels, under- and over-bridges, smooth curves, stations, etc.) render them quite unmistakable.

6 *Towns and Built-up Areas*

Plate 5, which shows a reasonable cross section of urban features, indicates some of the difficulties of air photograph interpretation in this field. While buildings of different ages and types can often be differentiated, as the old 'yard' property A, nineteenth-century terraces B and more modern units C, it is not easy to distinguish the possible uses of these buildings, the distinction, for instance, between housing, shopping and business areas. In the same way sizeable industrial buildings are usually distinctive as a class but rarely allow specific identification. Only the shipyard D, with two vessels building, offers a clear indication of its identity though, under different conditions of sun, the flour mill E might have cast a distinctive shadow, suggesting the tall buildings characteristic of that industry, and the combination of large size, wasteponds, rail access, etc., at F might perhaps be recognisable as a beet sugar factory by an expert. On the other hand there is little to identify G as a large vegetable oil and cattle-cake works (despite obvious evidence of water-borne raw materials and/or finished products), H as a paper mill (the pond is quite misleading here: it antedates the industry), and certainly not J as a works where citric acid is manufactured.

Apart from industry, housing and commercial uses other characteristic urban features possess varying degrees of distinctiveness. The abbey church K is clear, so are the allotments L; cemeteries too (none shown) are often recognisable from their combination of miniscule texture (graves), formal layout and typical border of trees. Modern schools may be distinguished by their size and adjacent playing field, but older schools may be 'given away' by their hard-surfaced playgrounds, as M on Plate 5 (there is a small playing field too). Even so in most urban areas there remains much that is obscure and unrecognisable and this is one branch of study where the good, large scale map (say 6″ or 25″ in this case) often emerges superior as a source of information.

7 *Archaeological and Historic Sites*

The results produced by the air photograph in the field of archaeology have been both striking and of enormous importance. Where visible remains of former sites exist, for example banks, ditches, mounds, the shadows cast under a *low* sun by these often insignificant features may reveal patterns far more complete than those recognisable by ground inspection only. Even more spectacular, however, are results obtained at sites where all visible trace appears to have vanished. The presence of archaeological remains is prone to affect the nature and/or quality of the soil, for instance former walls may leave thinner, stonier soils, and silted up ditches and post-holes deeper soils, and the patterns formed by these variations are often visible from the air either directly or more usually through their differential effect on vegetation at critical stages of growth or under critical climatic conditions. An air photograph specially taken at times such as these can reveal the outlines of these former features with startling clarity, as in Plate 6E which shows the clear

plan of a Roman fort at Glenlochar, Kirkcudbrightshire revealed by its effect on vegetation at a time of drought; in this photograph the positions of ramparts and streets are clearly visible, though a second photograph taken on another occasion revealed absolutely no trace of their presence.

General Rules for the Interpretation of Objects or Features on Air Photographs

An air photograph will often present puzzling or unknown features even to an interpreter with considerable experience, and in these cases it is sensible to approach the problem of interpretation systematically. The first step is to obtain as much information as possible from other sources. If the approximate location of the photograph is known, books and articles on the area can be consulted and the exact location identified on a map. This is not difficult. Crudely orient the photograph if possible (see below) and select on it a pattern or shape which will also be boldly marked on the map, for example, particularly distinctive railways, lakes, coastlines, or isolated patches of woodland. Search the map for such a feature and once this appears to have been located check the solution carefully against several other points of detail. The crude orientation required above is best obtained from shadows. Since many air photographs are taken in the middle hours of the day (to obtain the best lighting conditions) it will often be correct to assume that, in northern, temperate latitudes for example, shadows point somewhere between north-west and north-east;[14] failing this the characteristic roughly east-west orientation of older Christian churches offers a less reliable guide.

On the photograph itself a useful rule is to *interpret from the whole to the part*. Attempt to define broad distinctions first, for example the distinction between farmed land and 'rough' land, arable and pasture, housing and industry; and then examine the *general* characteristics and distribution of each pattern or feature (number of occurrences, characteristic setting and associated features), before attempting to make any specific interpretation derived from its size, shape or tone.

[14] This rule should be taken as a likely but not infallible guide.

Chapter 16 Thinking about Air Photographs

The physical properties of air photographs

A layman, looking at a vertical air photograph might reasonably conclude 'here is a map drawn in a different way'. Unfortunately this is not so. A vertical air photograph is not a map since features shown upon it do not have exactly the same shape as they would on a map of the area; there is a slight difference and it is the purpose of this chapter to describe the nature and origin of this difference, or distortion, and to examine the form it takes. With oblique air photographs the difference between map and photograph is much more obvious and the distortion much greater, but since the nature of this distortion is equally relevant to processes concerned with mapping from air photographs (described in the next chapter) the properties of both types of photograph will be considered.

Scale

Determination of scale is an essential requirement before full use can be made of an air photograph, and fortunately the topic may also serve to introduce and illustrate certain aspects of the distortions referred to above. The scale of an air photograph may be determined by comparing the measured distance between two points on that photograph with the distance separating these same two points on the ground or (more conveniently) on a map of known scale. Consider length AA which measures 0·188′ on Plate 4A and 0·084′ on a 6″ (1:10,560) map of the area. Since:

$$\text{ground distance} = \text{map distance } (D_m) \times \text{map scale factor } (S_m)$$

and also, by analogy,

$$\text{ground distance} = \text{photo. distance } (D_p) \times \text{photo. scale factor } (S_p)$$

We can write therefore: $D_m \times S_m = D_p \times S_p$, or

$$\text{photo. scale factor } (S_p) = \frac{\text{map distance } (D_m) \times \text{map scale factor } (S_m)}{\text{photo. distance } (D_p)}$$

In this case then $S_p = \dfrac{0·084 \times 10,560}{0·188} = 4718$, and

the scale of the photograph obtained by measuring AA is therefore *1:4718*.

For length BB in Plate 4A, however, the corresponding values are $D_p = 0·336′$, $D_m = 0·157′$, giving $S_p = 0·157 \times 10,560 \div 0·336 = 4934$ – a photo.scale of *1:4934*.

Here is an odd situation; two different measured lengths give two different scales, and in point of fact had ten lengths been measured they would have given ten scales, for the simple rule is that unlike a map an *air photograph has no fixed scale.* The reason for these slight differences is not hard to explain – it is caused by relief; since AA lies on the valley side 200′ above BB on the valley floor it is nearer to the camera and so appears slightly larger in scale. This is where distortion must obviously be introduced. A photograph can only accommodate hill-tops at larger scales than valley bottoms by doing some 'shifting around' to make room for the larger features, but before we consider the problems involved there let us consider scale determination a little more fully.

Because of scale variations of the kind that have just been revealed there is no point in trying to measure the scale of an air photograph exactly, and an approximate answer can often be found much more quickly using the formula:

$$\text{Approx. photo. scale (as a fraction)} = \frac{f}{H} \text{ or better (if possible) } \frac{f}{H-h}$$

where f = focal length of the camera lens, H = altitude of the aircraft and h = mean or approximate altitude of the area within the photograph. Both f and H (but not h) are usually recorded on the titling strip at the top of the photograph. Fig. 95A shows how the formula has been derived: since ground length $G'G''$ has been reduced to photograph length $P'P''$, the photograph scale (as a fraction) will be $\frac{P'P''}{G'G''}$. Because the triangle $P'P''L$ and $G'G''L$ are similar triangles we shall get the same fraction as $\frac{P'P''}{G'G''}$ by comparing *any* pair of corresponding lengths in the two triangles – the perpendicular heights for example – so that we can write $\frac{P'P''}{G'G''} = \frac{PL}{GL} = \frac{f}{H}$.[1] Since H is derived from the aircraft's altimeter it refers, of course, to the *absolute* height of the plane, whereas the geometrical relationship just calculated really refers to the height of the plane above the ground, hence the preferable modification to $\frac{f}{(H-h)}$ as shown in Fig. 95B. In Plate 4A the titling strip gives the information $f = 14″$, $H = 5,800′$ whence[2]

$$\text{approx. photo. scale} = \frac{14″}{5800 \times 12″} = \frac{1}{4971}$$

Scale on Oblique Photographs

So far only vertical photographs have been considered but we can reason from these into what happens on an oblique. As Fig. 95D shows the scale relationships on an oblique will be exactly the same as those on a vertical photograph of a steeply sloping hillside (Fig. 95C), i.e. scale at G'' (foreground) is greater than scale at G (middle ground) which

[1] In any camera the distance between lens (L) and film (P′P″) is equal to the focal length (f) of the lens; GL obviously represents the height (H) of the camera lens (or aircraft) above the ground.

[2] Notice that f and H must be brought into the same units for this calculation.

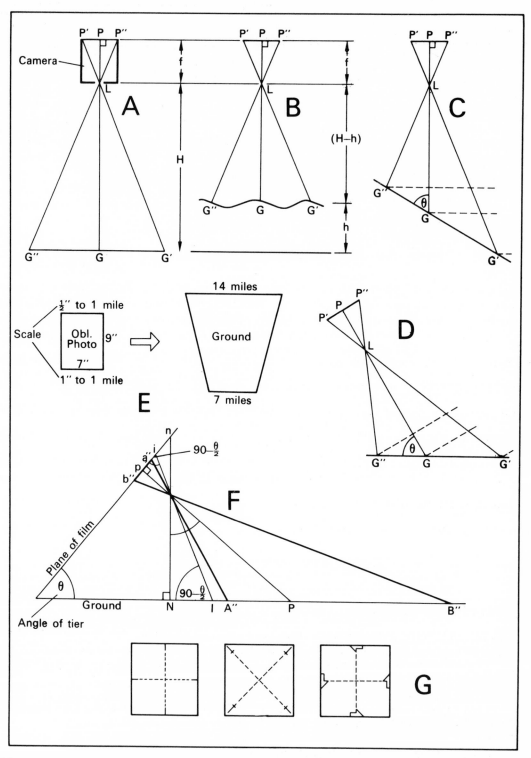

Fig. 95: Some physical properties of air photographs. **A, B, C** & **D:** Scale on vertical and oblique air photographs. **E:** Ground coverage of oblique air photographs. **F:** Principal point, plumb point and isocentre on oblique air photographs. **G:** Examples of collimating marks.

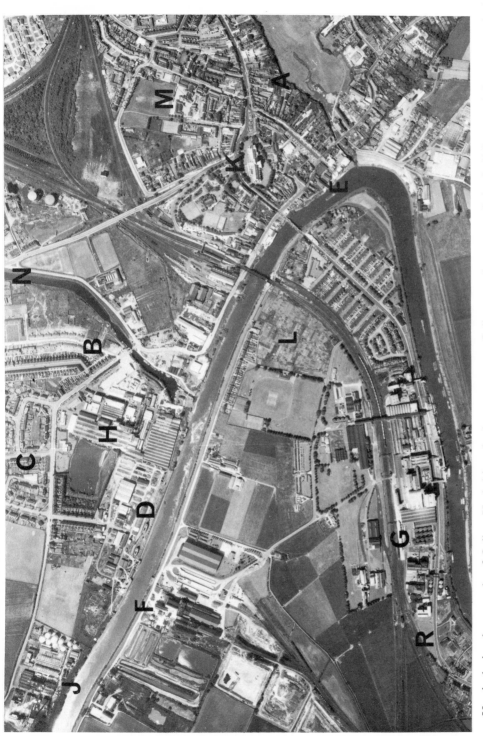

Plate 5: Vertical air photograph of Selby, Yorkshire. Scale *c.* 1:10,000. Selby contains most of the buildings and features typical of a country market town – schools, shops, churches, cinemas, etc. – yet few of these are clearly identifiable on a photograph at this scale. For explanation of letters see p. 254. (Sortie no. West Riding Area 3 (14/6/67) print no. 60 67 095, reproduced by permission of the County Planning Officer, West Riding of Yorkshire County Council.)

Plate 6: **A:** Shadows revealing differing heights and species of trees and hedges in winter, Denbighshire, N. Wales. Scale *c.* 1:10,000. **B:** Trees of many different sizes and species in summer, Beeca Park, near Aberford, Yorkshire. Scale *c.* 1:40,000. (**A** & **B** respectively sortie nos. V(Pt.2) 3G/TUD/UK 34 (16/1/46) and 541/30 (17/5/48) and print nos. 5220 and 4007, reproduced by permission of the Ministry of Defence, Crown copyright reserved.) **C:** One crop (alfalfa) appearing in five different forms on one air photograph, Colorado, U.S.A. For explanation see p. 253. Scale *c.* 1:40,000. **D:** Different types of agriculture and land holdings visible on an air photograph in Central Europe. For explanation see p. 253. Scale *c.* 1:40,000. **E:** The ramparts and streets of a former Roman camp clearly revealed by their effect on growing vegetation at a time of drought. Glenlochar, Kirkcudbrightshire. (Reproduced from J. K. St. Joseph, *The Uses of Air Photography*, John Baker Publishers Ltd., by permission of the author.)

is also greater than scale at G' (background). In the case of an oblique, however, the scale differences may be very large indeed, far more than those on a vertical, and this has important effects on the area covered by an oblique photograph (Fig. 95E). Suppose that the foreground scale of an oblique is about $1''$ to a mile while the background scale is only $\frac{1}{2}''$ to a mile, then a $7'' \times 9''$ *rectangular* photograph would cover an area 7 miles wide in the foreground but 14 miles wide in the background, marking out a *trapezoidal* area on the ground. Visual, proof of the fact that oblique photographs cover trapezoidal areas can be seen in Fig. 98B.

Tilt Distortion

It has just been shown that on an oblique air photograph a trapezoidal-shaped area of ground becomes represented by a rectangular or square-shaped photograph. This is a very obvious manifestation of the fact that all oblique air photographs will suffer from tilt distortion, i.e. shapes shown on them will be distorted from their true form because of the tilt of the camera. There is nothing new in this idea that oblique views of an area will result in apparent distortion of shape, but in normal speech we should simply refer to this as the effect of perspective, and in fact tilt distortion is perspective under another name. Fig. 96 shows something of this idea of tilt distortion and perspective. The grid of squares in Fig. 96A when viewed at an angle of $40°$ becomes distorted by tilt (or perspective) into the shape of Fig. 96B. This is easy enough to envisage. What is less expected is that there is order and rule in this distortion, as Fig. 96B proves; the shapes in Fig. 96A have been turned into those in Fig. 96B simply by displacing all points radially inwards or outwards about a fixed point known as the *isocentre*, so that we can formulate a rule that *tilt distortion is radial from the isocentre*. Any displacement of a point from its true (i.e. plan) position due to tilt, will therefore be radially towards or away from the isocentre.[3]

A moment's reflection will make it apparent that the amount of distortion increases with the amount of tilt. In Fig. 96C, where tilt is only $10°$, distortion of shape is a good deal less marked but it is still there, and will always be there so long as the camera is not truly vertical: even with only a $1°$ tilt some distortion will be present. Unfortunately it is impossible to guarantee that a photograph is truly vertical. Mounting an air camera on gimbals[4] will enable it normally to hang vertically but cannot prevent momentary and slight deviations due to swing caused by certrifugal forces resulting from any climbing or banking in the plane's flight. Tilt distortion is therefore a possible hazard even on 'vertical' photographs as well as those taken with a deliberate tilt, for example the 'twinned' photographs of the type shown in Fig. 92A, (which usually look like verticals) and all 'normal' obliques.

Because of tilt distortion the slightest tilt involved in the taking of an air photograph will prevent that photograph from being a true 'map'; we have also shown that a truly vertical photograph cannot be a map, either, if any relief is present. Let us now consider

[3] Away from the isocentre for points lying to the rear of that point; towards the isocentre for points lying in front of the isocentre.

[4] A device which enables the camera to hang vertically whatever the tilt of its mounting. A similar device is used, for example, to preserve the horizontality of a ship's compass.

S

Fig. 96: Effect of tilt on the appearance of a grid of squares. **A:** Grid in plan. **B:** The same grid viewed with 40° tilt. **C:** The same grid viewed with a 10° tilt. Notice that in both **B** and **C**, the 'new shape' is obtained from the plan shape by moving all points radially inwards or outwards from a 'perspective centre' or isocentre.

this second type of distortion, introduced by relief, in a little more detail. It will be a great help in doing this, however, if we first define two critical points in the geometrical relationship between shapes on the ground and shapes on the photograph.

Principal Point

The principal point (p.p. for short, usually marked p on diagrams) of a photograph is defined as the point where a line drawn through the centre of the lens at 90° to the film, meets the film. Fig. 95F will make this clear. To the layman this line is the centre-line of the camera and the principal point is therefore the 'centre' of the photograph. Its position is dependent only on the camera and it can always be located on the photograph by joining the opposite pairs of *collimating marks* (alternatively called *fiducial marks*) which are automatically recorded by the camera on each photograph as it is taken[5] (see Fig. 95G).

[5] Most of the cameras used in air photograph work are designed to produce photographs complete with collimating marks, though occasionally these may be absent, especially on oblique photographs.

Plumb Point

The plumb point (usually marked n on diagrams) is defined as the point where a vertical line through the centre of the lens meets the film (see Fig. 95F). Notice that both principal and plumb points have *homologous points* on the ground (i.e. equivalent points at the ground end of the lines, usually marked P and N respectively), and that on a truly vertical photograph the positions of p and n will coincide (as in Fig. 95A).

Isocentre

Fig. 95F also shows the position of the isocentre (symbol i) which forms the centre of tilt distortion. It occurs where a line drawn through the lens at an angle of $\left(90 - \frac{\theta}{2}\right)^\circ$ to the film meets the film. θ is the angle of tilt of the camera measured with respect to the horizontal plane at the ground or the vertical plane at the camera (Fig. 95F). In a photograph with fore-and-aft tilt (but no sideways tilt) p, i and n lie, in that order, along the centre-line of the photograph. In such a photograph, or on a true vertical this centre-line, marking the intersection with the photograph of a vertical plane drawn through the lens, is known as the *principal line*.

Height Distortion

The inevitable presence of distortion on an air photograph due to scale differences caused by variations in height (i.e. relief) has already been shown; here we are concerned to study the nature and effect of this distortion, a task best achieved by considering first the appearance on the photograph of tall thin objects such as chimneys. Fig. 97A shows a section through a camera taking a vertical photograph of two chimneys AA' and CC' both of height h. As with any point on an air photograph we can find where these chimneys will appear on the film by drawing straight lines from the top and bottom of each through the lens to the film. A' will therefore appear on the photograph at b whereas A will appear at a, making the chimney appear as a line, not a point as would be the case on a map; the images of the top and bottom of the chimney have become separated on the photograph so that the top appears further away from p than does the base, and in fact on the photograph the top occupies the same position as would a point B on the horizontal surface beyond A. On the photograph therefore A' appears to be at b, i.e. displaced a distance ab from its true (plan) position, and this displacement is called the *height distortion* of the point A'.

Let us examine briefly the factors which will affect height distortion on a vertical photograph. Distance from the principal point is one. The chimney CC' of the same height as AA', but much nearer to P, produces the much smaller distortion cd, so that height distortion increases with distance from the principal point. Suppose we also consider a chimney AA" of 2h units in height; distortion will now be rather more than two times ab; thus the greater the height of an object, the more increasingly marked will its height distortion be. Conversely it is easy to see that increasing the height of the plane would reduce the distortion. In fact it is not difficult to prove that the height distortion of a

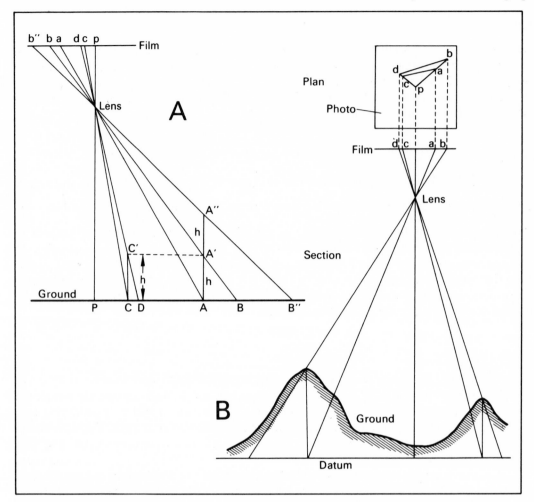

Fig. 97: Height distortion on air photographs (1).

point (i.e. its displacement from its plan position) $= \dfrac{hD}{H}$ where h = the height of the object and H the height of the plane above sea level: D is the distance of the photograph-image of the point from the principal point on the photograph.[6] Thus a mountain 1,000′

[6] This proof is also dependent upon similar triangles, in this case triangles AA′B and bpL: ba is the height distortion of point A′ in Fig. 97A.

$\dfrac{BA}{AA'} = \dfrac{bp}{pL}$, but AA′ = h and bp = D in the definition of terms above, and pL = f.

Therefore, $\dfrac{BA}{h} = \dfrac{D}{f}$ or BA $= \dfrac{hD}{f}$. But since photograph scale $= \dfrac{f}{H}$, ba = BA $\times \dfrac{f}{H}$.

Therefore, ba $= \dfrac{hD}{\cancel{f}} \times \dfrac{\cancel{f}}{H} = \dfrac{hD}{H}$ Q.E.D.

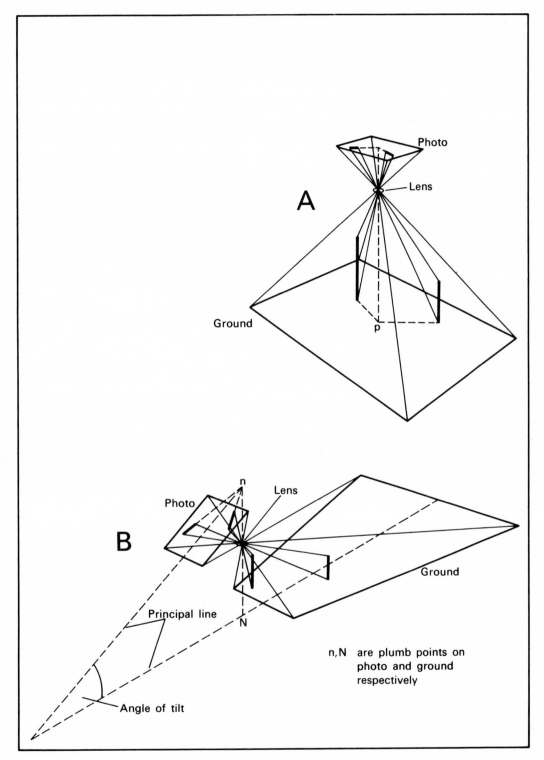

Fig. 98: Height distortion on air photographs (2). These figures show how two chimneys standing on a flat surface would appear, on a true vertical (**A**) and oblique (**B**) air photograph.

high appearing 3″ from the principal point on a photograph taken from 10,000′ would appear displaced $\dfrac{1000 \times 3}{10,000} = 0\cdot 3″$ from its true position on the photograph.

So far we have considered only the amount of displacement involved; what of the direction of that displacement? Fig. 98A, which represents a model of two chimneys being photographed with a vertical camera, shows that both chimneys appear on the photograph as straight lines (this we already know from Fig. 97A), and that these appear to radiate from the principal point, which in this case is also the plumb point as well. It is obvious now how an air photograph 'accommodates' hill tops at larger scales than it does valley bottoms: it displaces them radially outwards from their true position 'to make room' for their increased size, thus introducing the distortion of shape which we call *height distortion.*

Fig. 98A dealt with height distortion on a vertical photograph: what will happen on an oblique? As Fig. 98B shows once again the effect is the same, the chimneys become two lines but this time radial not from the principal point but the plumb point, n; since in the vertical case which has already been considered the principal point and plumb point are one and the same, we can formulate the general rule that on all photographs *height distortion is radial from the plumb point.* Further proof of this can be seen in the photograph in Plate 4A and the greatly enlarged sketch of the relevant detail in Fig. 99; the two mill chimneys and the piers of the viaduct all appear as straight lines radiating from the principal point, which is also the plumb point on this vertical photograph.

It must be stressed at this point that height distortion is not, of course, restricted to chimneys, tall buildings and other similar objects. It is more easily observed in these cases, but is present in any feature which possesses altitude and most universally in relief features, as Fig. 97B shows. All points lying above datum, i.e. sea level, will appear on the photograph displaced outwards beyond the position they would normally have on a map of the area drawn at a scale of $\dfrac{f}{H}$. Moreover, as the upper part of Fig. 97B shows, this differential radial displacement will distort on the photograph all angles except those measured at the plumb point: for example ∠cpa (angle derived from true positions) = ∠dpb (photograph angle) but ∠acp (true angle) ≠ ∠bdp (photograph angle). We shall see something of the consequences of this in the next chapter.

So long as tilt distortion is considered only on a dead level surface, and height distortion only on a truly vertical photograph, neither raises unsurmountable problems since in both cases a point exists – the isocentre in the first case, the plumb point in the second – where angular bearings remain correct. If both are present, however, much more complex circumstances arise. Consider Figs. 100A to E, which also illustrate several points made earlier in this chapter. Fig. 100A represents a plan of a group of radio masts of varying heights standing on a level surface, Fig. 100B an oblique air photograph of the area with masts removed. Only tilt distortion is now present and its radial nature, maintaining correct angles at the isocentre but distorting them elsewhere, for instance at the principal point P, can be seen. In Fig. 100C masts have been erected and height distortion radial from the plumb point is introduced: angles measured from the *top* of the masts to the isocentre are now incorrect. Suppose now that for the radio masts we substitute a more normal situation treating the mast tops as 'spot heights' and stretch a 'skin of country'

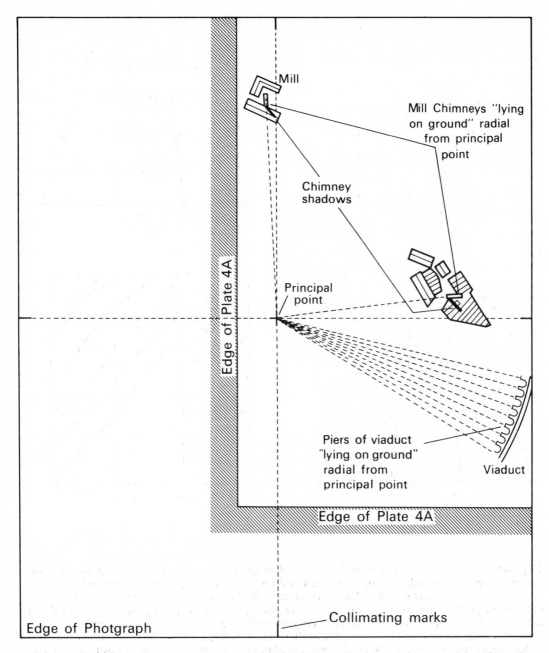

Fig. 99: Height distortion on air photographs (3). This drawing shows (much enlarged) portions of detail on plate 4A, which manifest obvious evidence of the effects of height distortion. Notice that in each case the top of a vertical object is displaced relative to its base and that, since plate 4A is a vertical photograph, displacement is radial relative to the principal (=also plumb) point.

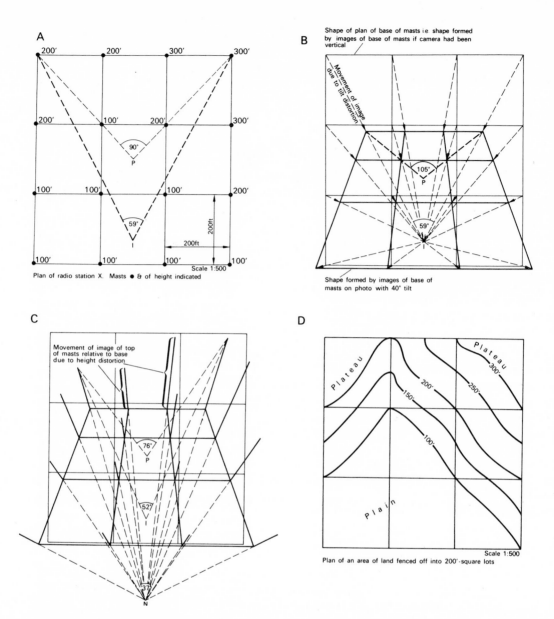

A: 200' 200' 300' 300' / 200' 100' 200' 300' / 90° P / 59° I / 100' 100' 100' 200' / 200ft / 200ft / 100' 100' 100' 100' / Scale 1:500 / Plan of radio station X. Masts ● & of height indicated

B: Shape of plan of base of masts i.e. shape formed by images of base of masts if camera had been vertical / Movement of image due to tilt distortion / 105° P / 59° I / Shape formed by images of base of masts on photo with 40° tilt

C: Movement of image of top of masts relative to base due to height distortion / 76° P / 52° I / 37° N

D: Plateau / Plateau / 300' / Plateau / 200' / 250' / 150' / 100' / Plain / Scale 1:500 / Plan of an area of land fenced off into 200'-square lots

Fig. 100: A practical illustration of the effects of height and tilt distortion on oblique air photographs using, as a model, a group of sixteen radio masts of varying heights arranged in a square grid on a horizontal surface. **A:** Plan of the group. **B:** Appearance of the square grid only on an oblique air photograph with 40° tilt. Notice that the distortion of shape produced by the tilt (tilt distortion) is not haphazard but *regular*, all points on the old shape (plan) being displaced radially inwards or outwards about the isocentre to their new position. This proves that tilt distortion is radial from the isocentre. **C:** A similar oblique photograph with the masts in position, introducing an additional element of height, and hence height distortion, into the photograph. Notice that height distortion is *not* radial from the isocentre, but from the plumb point, N, and that its effect is to separate the position of the top of a mast from that of the bottom by a varying amount: on plan of course both top and bottom of the mast occupy the same position. If angles are now measured from the tops of the masts, *none* remain true (compare with the angle at I in **B**) because of the *compound* effect of both distortions. **D:** A situation more akin to reality can be produced by stretching a 'skin of topography' over the tops of the masts in **A** and marking out the grid on this surface. The relative positions and heights of the intersections of the grid remain the same as those in **A**.

E: Shows the same landscape when photographed with a 40° tilt (as in **B** & **C**). The positions of the grid intersections are identical with those of the tops of the masts in **C**, and the displacement of these grid intersections from their true (plan) position (**D**) is the result of the varying interaction of the two factors of height and tilt distortion. **E** makes it obvious that oblique air photographs which contain height distortion present difficult problems as a basis for mapping. If no height distortion is present, as in **B**, the problem is less difficult, and the method of perspective grids can be employed (see p. 272).

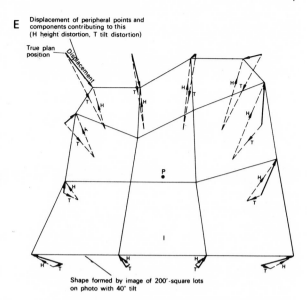

E Displacement of peripheral points and components contributing to this (H height distortion, T tilt distortion)

True plan position

Displacement

Shape formed by image of 200'-square lots on photo with 40° tilt

over them as in Fig. 100D. If this landscape is divided into square lots each with a corner at a 'spot height' (i.e. mast top), we know that on the oblique photograph these positions will be those of the mast tops in Fig. 100C and the area would therefore appear as in Fig. 100E. Notice that because two distortions are present there is no simple relationship between the true plan position of a point and its photograph position; the latter position results from the interaction of two components which may sometimes partly augment, sometimes partly contradict one another. Quite obviously in mapping from air photographs this is an extremely difficult situation to analyse and resolve, and it is not surprising that the simple techniques for constructing maps from air photographs are derived from the ideals of either truly vertical photographs or oblique photographs of level areas. As the next chapter will show, any deviation from these conditions introduces errors and difficulties.

Chapter 17 Working with Air Photographs

Simple techniques for plotting detail from air photographs

Now that the physical properties of air photographs have been described, it will be possible to understand more fully the origins and limitations of some of the simpler techniques available for plotting detail from air photographs, either *de novo* or as additions to existing maps. In chapter 3 it was explained that the development of the air photograph and the associated techniques of photogrammetry[1] have revolutionised the progress of world mapping; but unfortunately the methods used to make new maps of extensive areas are far too elaborate for inclusion here, and, moreover, are only practicable when expensive equipment is available. The techniques described in this chapter will therefore be confined to elementary methods which can be undertaken by anyone interested in air photographs and require little more than simple drawing equipment; for a description of the more elaborate techniques the reader should refer to a full-scale textbook of photogrammetry.[2]

Techniques for Dealing Mainly with Single Air Photographs Where Pre-existing Maps of an Area are Available

In many cases air photographs are needed not to make new maps but to revise or add further detail, such as geological structures, archaeological remains or vegetational areas, to existing maps. Several methods are available.

1 *Transference by Eye-Sketching*

Wherever the map shows considerable amounts of fairly close detail it may be possible with a satisfactory degree of accuracy simply to sketch in further detail from an air photograph. If detail is sparse however, further guidance may be necessary; the methods below are applicable in this case.

[1] Photogrammetry is the name given to the science of taking measurements (and hence making maps) from air photographs.
[2] e.g. Kilford, W. K., *Elementary Air Survey*, London 1963 which is a very useful introductory work to the more complex techniques.

2 *Direct Transference after Reduction or Enlargement of the Photograph to the Scale of the Map*

For this process a Grant Projector, or similar device capable of enlarging or reducing the photograph to a given scale, is required. The photograph is placed in the machine and projected, enlarged or reduced as necessary, onto the map which is to be amended;[3] detail is then drawn in on the map. The method is only suitable for vertical and very near vertical photographs and even then, as the previous chapter has shown, because of the presence of height distortion (and possibly tilt distortion too), however accurately the enlargement or reduction is made, a perfect fit cannot be obtained. Nevertheless, *provided that the photograph is taken a small area at a time*, and the enlargement/reduction readjusted for each small area to get the best fit, the differential distortions present within the small area being considered may be reduced to negligible amounts and transference of detail achieved without much difficulty.

3 *Transference by Grids, Triangles and Similar Devices*

This is a group of methods derived from one basic principle: that a straight line on the ground will appear as a straight line on the photograph. The methods are equally applicable to both obliques and verticals, but since the presence of height distortion invalidates this basic 'straight line' principle, appreciable relief will introduce small errors with verticals and possibly intolerable ones with obliques.[4] All methods demand that at least four points can be identified on both the photograph and the existing map.

(a) *The Polar Grid*. This method is illustrated in Fig. 101A, identical constructions being performed on map and photograph. Let the four points used be A, B, C and D. AD and BC are produced to meet at E, AB and CD to meet at F. Through G, the intersection of AC and BD are drawn EGH and FGJ. Detail can now be copied from any triangle on the photograph into the corresponding triangle on the map. Where the triangles are inconveniently large for accurate work they can be subdivided by adding further straight lines, for example, HJ and HK until a suitable size is obtained.

(b) *Polygonal Grid*. Where more than four points can be identified on photograph and map there is no need to construct external points as at E and F above. The points are simply plotted on both map and photograph and the area within the resultant polygon sub-divided by joining each point to all the others in the first instance. Further subdivision can be made by drawing in any suitable straight lines through any pair of points or intersections on the grid (Figs. 101B and C). With both polygonal and polar grids the plotting of detail, which falls outside the boundaries of the grid, can be achieved by adding construction lines produced beyond the original limits of the grid, for example at S in Fig. 101C.

[3] If the projected image of the photograph lacks sufficient clarity, a trace containing the detail to be transferred plus an adequate amount of background detail may be substituted for the actual photograph.

[4] No simple rules can be formulated describing suitable limits. The desirable factor is that the amplitude of relief should be small relative to the flying height; an amplitude of 2% or less of the flying height is preferable when dealing with obliques but with verticals rather larger tolerances would be possible.

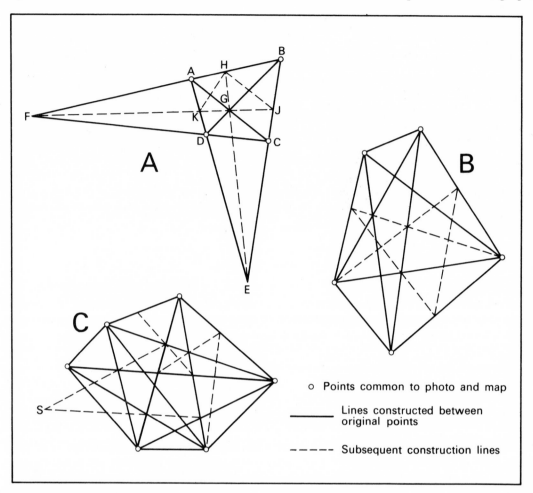

Fig. 101: Grids for transference of detail from an air photograph to a map. **A:** Polar grid. **B** & **C:** Polygonal grids.

4 *Transference of a Single Point from Photograph to Map by the Four-Point Anharmonic Method*

The four-point anharmonic method may be used on both vertical and obliques to transfer the position of an individual point from photo to map: for example, a point needed to act as a corner of a grid in 3(b) above where no convenient point exists on the map. Once again four other points recognisable on map and photograph are necessary. The following construction is illustrated in Fig. 102A. On photograph and map join any one point – D for example – to each of the other three, and, on the photograph, add also the ray to the point X which has to be transferred to the map. Place a strip of paper on the photograph across this pencil of rays radiating from D and mark where each cuts the edge of it. Transfer the strip to the map and adjust it until the rays to A, B and C cut the

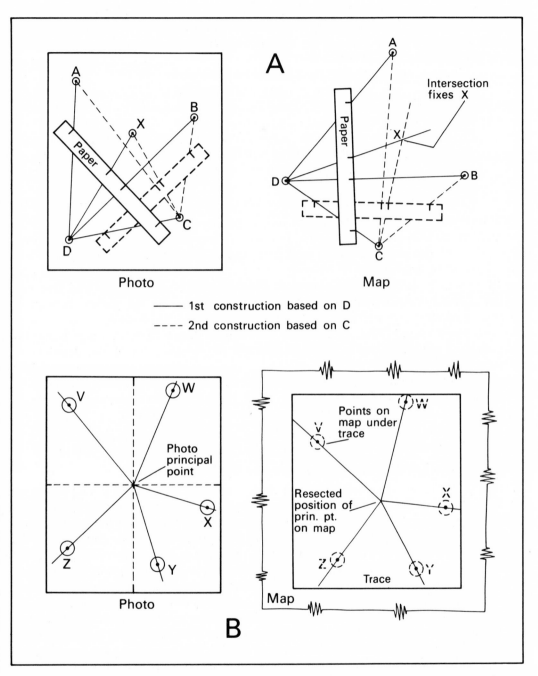

Fig. 102: A: The four-point anharmonic method for transferring the position of a point from an air photograph to a map. **B:** Determination of the map position of the principal point of an air photograph by resection.

edge at the corresponding marks. Mark the position of the tick for X and draw in a ray through this tick; X lies along this line. Repeat the process using another point, for example, C, as 'pole' thus fixing X by intersection. In practice a third pole should also be used to give a trisection, in which case any triangle of error results from faulty draughtsmanship. The method can also be used in reverse, to transfer, for instance, a calculated position or grid reference from a map to an air photograph.

General points concerning methods 3(a) and (b) and 4. As indicated earlier height distortion will introduce errors when any of these methods is used. If possible therefore sharp, clearly defined points lying at about the same altitude should be used as grid corners or basic points; errors due to height distortion will also be reduced by using areas near the centre of a vertical photograph, if more than one photograph is available due to overlap.

5 *Fixing of Detail Position by Intersection after Resection of the Position of the Principal Point*

In this method the detail to be transferred to the map must be in the overlap common to a pair of vertical air photographs. For each photograph prepare a trace showing the position of the principal point and lines radial from this to the points of detail which have to be transferred to the map and to some four or five points of detail common to both map and photograph, as well. Place the trace over the map and resect the position of the principal point, i.e. adjust the trace until each ray passes through the appropriate point on the map (see Fig. 102B). Prick through the position of the principal point and rays to detail points. These rays can then be drawn in on the map. Repetition of the process using the second photograph will fix the position of the detail at the intersection of the pairs of rays. This method is derived from the same theoretical basis as the radial line method described below; height distortion will not affect the result but tilt distortion would introduce errors preventing perfect resection. In the latter case the best mean fit through the four or five map points should be obtained.

Techniques for dealing with Photographs where no Pre-existing Maps are Available

6 *Plotting from 'High' Obliques Using Perspective Grids*

Fig 96 showed that the appearance of a grid of squares when seen in perspective will vary with the tilt; this method uses the same basic principle. A plotting sheet is first prepared carrying a grid of squares of given size at the scale required for the finished work; the tilt of the photograph is then calculated and the appearance of this same grid at that particular tilt is found by construction. When this grid is placed over the photograph detail can be copied from each 'square' into the appropriate square on the plotting sheet. To enable the tilt to be calculated without pre-existing maps the obliques must be 'high', i.e. show the horizon, and f (the focal length) and H (the flying height) must also be known: as with all obliques undue relief will introduce intolerable errors. Since the construction lines involved in this method will extend well beyond the photograph this should either be fixed to card or the required details, i.e. perimeter, position of p and horizon, marked out on a trace. The necessary construction is as follows:[5]

[5] There is not room here to explain the logic of the various stages but a fuller explanation will be found in Trorey, L. G., *Handbook of Aerial Mapping and Photogrammetry*, Cambridge 1952, pp. 23–25.

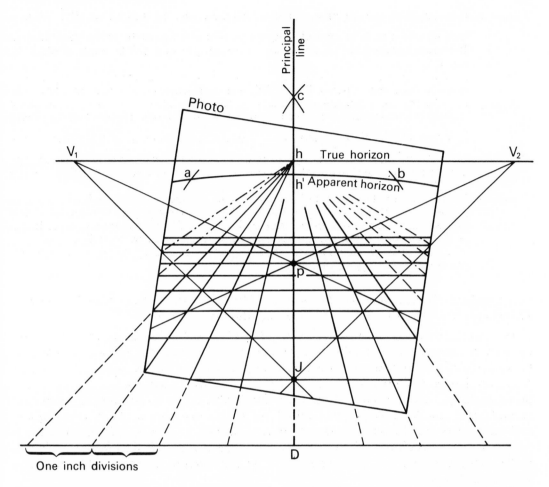

Fig. 103: Construction of a perspective grid for plotting from oblique air photographs. (After L. G. Trorey, *Handbook of Aerial Mapping and Photogrammetry*, Cambridge University Press, 1952.)

Stage 1 Establishment of the principal line on the photograph. From p strike an arc to cut the apparent horizon[6] on the photograph at a and b. From a and b strike the same arcs to intersect at c. cp is the principal line of the photograph.[7]

[6] The line which appears as the horizon on the photograph is known as the apparent horizon. It is not the true horizon (i.e. horizontal plane through the lens) so far as the camera is concerned because of the elevation of the camera. Because of the earth's curvature the apparent horizon will in effect be very slightly curved and in Fig. 103 this curvature, and lengths such as hh′ are shown much exaggerated for the sake of clarity.

[7] If the tilt of the camera were known to be fore-and-aft only a line joining the two vertical collimating marks would suffice but since sideways tilt may also be present it is as well to introduce this simple construction. Rather exaggerated sideways tilt is shown in Fig. 103.

Stage 2 Calculation of the tilt of the camera. Measure ph': let this be x". If $\frac{x}{f}$ = tan α
look up α in a table of natural tangents (note x and f must be in the same units).
If a second angle β (in *seconds* of arc) = 58·82 \sqrt{H} find β. The angle of tilt, θ =
α + β.

Stage 3 Establishing the true horizon V_2hV_1. ph = f tan θ. Calculate ph and step off this
distance along the principal line. V_2hV_1 is at right-angles to the principal line at h.

Stage 4 Establishing the converging 'verticals' in the grid. These will all be lines which
'vanish' (i.e. converge) at h. Let the size of the grid square required *on the ground*
be y feet. If A = H Sec θ and hD = $\frac{A}{y}$ calculate hD and step off this distance back
along the principal line. Through D rule a line at right-angles to hD, mark this line
in inch divisions and join each of these to h. This establishes the 'verticals' of the
grid (Fig. 103).

Stage 5 Establishing the horizontals of the grid. Along the true horizon establish vanishing
points V_1 and V_2 so that hV_1 = hV_2 = f Sec θ. Rule in V_2p or V_1p produced and
through each intersection of this line with a 'vertical' rule a horizontal line. If V_2p
or V_1p 'runs out' before all the photograph is gridded rule in other line from V_2 or
V_1 as diagonals to the 'squares' already established and apply the same rule, for
example the line V_2J on Fig. 103.

7 A Simplified Adaptation of the 'Radial Line' Method to Allow Detail from Four or Five Photographs to be Plotted where no Pre-existing Maps are Available

The radial line method, in its 'mechanised', i.e. slotted template, form and suitably
checked by ground control established through normal survey, has formed the basis for
the mapping of very considerable areas from air photographs. In this version the essential
procedure has been simplified to one suitable for use with short runs of say up to five
photographs, i.e. an area too small to allow intolerable errors to accumulate or to need
ground survey checks. It should be realised that the normal form of the process requires
both more elaborate draughtsmanship techniques as well as checks and adjustments not
described here; enough will be said however to give the reader an insight into the principle
underlying the method and an inkling of how air photographs may be used to map large
hitherto unmapped areas.

The radial line method is applicable only to vertical photographs and depends on the
reasoning that since (1) height distortion is radial from the plumb point and (2) on a true
vertical the principal point is the plumb point, then on a true vertical angles measured
about the principal point will be correct[8] (see Fig. 97B, p. 262). As was explained earlier,
(see Fig. 100C), the presence of any tilt distortion will invalidate this radial property, but,
provided that the tilt is small (less than 2° is often specified), the method assumes that
the correct angular relationship exists and ignores any tilt distortion. This is the *radial
line* or *Arundel assumption*. Since height distortion is allowed for in the theory underlying
the method, even pronounced relief on the photographs can cause no problems. The
practical stages in the method are as follows:

Stage 1 *Preparing the Photographs* (a) *Baselining the prints.* Lay out the prints in numerical
order and on each photograph mark its principal point and the positions of the

[8] The method is therefore surveying by the *graphical* measuring of angles about a point and
may be compared in this sense with the *instrumental* measuring or recording of these angles
encountered when using a theodolite or plane table.

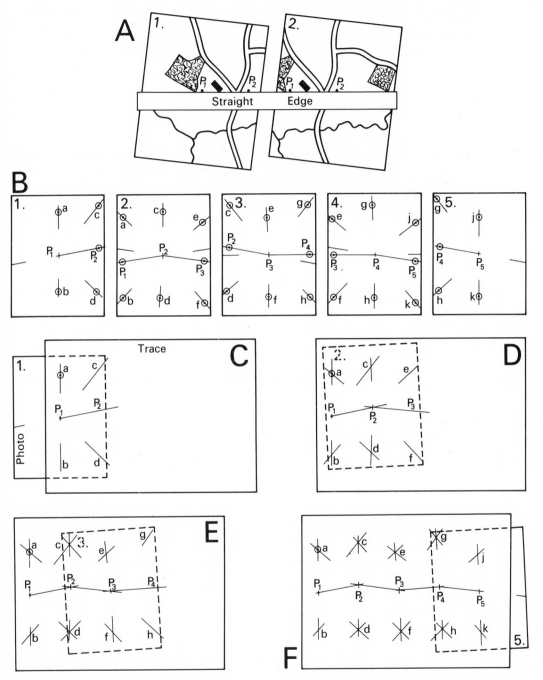

Fig. 104: Radial line method of plotting positions from air photographs. **A:** Fixing the position of principal points by alignment.

T

principal points of the photographs on either side. It will be seen that this demands something like 60% fore-and-aft overlap between prints but as was explained in chapter 15 this is normal (for this reason) in formally flown air-photograph cover.

It is important that this identification of the position of the adjacent principal points be done as accurately as possible; where the principal points exactly coincide with a point of detail, their positions can be carefully plotted with respect to this on the other photographs but if this is not the case, identification may be assisted by aligning the prints, as shown in Fig. 104A. Place both prints underneath a straight-edge whose edge touches p_1 and p_2; rotate them until the straight-edge cuts exactly the same detail on both prints, when the line p_1p_2 will have been correctly established on both. Rule in this line on both prints (plus a short 'tail' on the opposite side of the print – see Fig. 104B) and estimate the position of the principal points along this line. In fact it is the direction p_1p_2 which is needed, and estimation of the actual positions can be omitted, if desired, once that direction is marked on both prints.

(b) *Establishing control points.* On each photograph select two sharp, clear points of detail lying astride the principal point and about as far from it as are the adjacent principal points. Mark in the positions of these points on that photograph and on adjacent photographs,[9] and through each plotted *control point*, rule about an inch of the ray which joins it to the principal point. The photographs will now appear as in Fig. 104B. In this stage and the preceding one the greatest possible accuracy should be used in marking and transferring the points. Fine lines are essential and points are better pricked through lightly than marked, being subsequently ringed with a chinagraph pencil to aid identification.

Stage 2 *Preparing the Trace.* Select a piece of stable transparent material[10] slightly broader than the height of the photographs and slightly longer than the run of prints when placed in order and fully overlapped.

(i) Place the trace over photograph 1 and on it mark the position of p_1, the lines p_1p_2, p_1a, p_1b, p_1c, p_1d and the position of a (see Fig. 104C).

(ii) Next place the trace over photograph 2 so that the line p_1p_2 on the trace lies exactly over the line p_1p_2 on the photograph. Keeping these two lines superimposed slide the trace over photograph 2 until the ray p_2a exactly passes through the position of a on the trace. When this is achieved weight down the trace and mark in the rays from p_2 to p_3, a, b, c, d, e, and f. a, b, c and d will now be represented by intersections (see Fig. 104D).

(iii) In the same way place the trace over photograph 3 so that the lines p_2p_3 coincide on photograph and trace and slide the trace along until the rays p_3c and p_3d pass exactly through the bisections fixing c and d. Weight down and mark in rays from p_3 to p_4, c, d, e, f, g and h. c and d now have trisections, e and f intersections (see Fig. 104E). It is at this stage that errors may begin to show: for example it may be impossible to maintain trisections at c and d and the colinearity of p_2p_3 on photograph and trace. In theory such errors may be brought about by the presence of tilt, but they are more likely in our cruder version to result from poor transference of points or poor draughtsmanship. Errors of this sort may be removed by maintaining colinearity and allowing the back rays to miss the intersections by equal amounts.

(iv) Repeat this procedure until all the photographs have been used. With a run of 5 photographs the trace will now appear as in Fig. 104F.

[9] It follows from this that the control points must be chosen so that they *do* appear on adjacent points.

[10] e.g. Ethulon or Kodatrace.

Scale of the Trace: in the above construction only one actual distance p_1a, has been used (everything else has been established by direction only) and it will be obvious that the scale of the length p_1a on photograph 1 must also be the scale of the plotted trace. For this reason a should, if possible, lie at approximately the same altitude as p_1 and a trace of scale (approx.) $\dfrac{f}{(H-h_a)}$ will result.

Stage 3 Finishing the Plot. The above construction has, of course, only established the positions of the principal points relative to one another and the position of some eight control points. Further detail can be added by using methods referred to earlier either (a) as in method 5, fixing innumerable points by intersection from two principal points or (b) fixing, by intersection from two principal points, enough points on each photograph to act as corners for a polygonal or polar grid and transferring detail as in method 3.

Index

All references to mapping agencies and to official map series are listed by country, with the exception of the Ordnance Survey which is to be found under its own name; topographical features appear under their proper names; map projections are all listed alphabetically under the general heading 'map projections'; references in bold type refer to figure numbers.